The Nevada They Knew

ALSO BY ANTHONY SHAFTON

Fiction

The Apostate Heriger

Non-Fiction

*Conditions of Awareness:
Subjective Factors in the Social Adaptations
of Man and Other Primates*

*Dream Reader:
Contemporary Approaches to the
Understanding of Dreams*

*Dream-Singers:
The African American
Way with Dreams*

The Nevada They Knew

Robert Caples
and
Walter Van Tilburg Clark

*for Gale —
Comrade in arms*

Anthony Shafton

America Through Time is an imprint of Fonthill Media LLC
www.through-time.com
office@through-time.com

Published by Arcadia Publishing by arrangement with Fonthill Media LLC
For all general information, please contact Arcadia Publishing:
Telephone: 843-853-2070
Fax: 843-853-0044
E-mail: sales@arcadiapublishing.com
For customer service and orders:
Toll-Free 1-888-313-2665
Visit us on the internet at www.arcadiapublishing.com

First published 2017

Copyright © Anthony Shafton 2017

ISBN 978-1-63499-030-1

All rights reserved. No part of this publication may be reproduced, stored in a retrieval system or transmitted in any form or by any means, electronic, mechanical, photocopying, recording or otherwise, without prior permission in writing from Fonthill Media LLC

Typeset in 11pt on 13pt Constantia
Printed and bound by CPI Group (UK) Ltd, Croydon, CR0 4YY

in memory of

Jim McCormick

artist, historian, teacher, writer, punster, friend

Contents

Bowers Mansion & Death Valley	9
A Can of Tomatoes	15
The Conservation Center	23
American to the Bone	27
A Youth of April	35
Clay Turtles	41
A Cowpoke Washes His Face	47
Somebody from Fostoria	51
Circus Stories	55
They Laughed When I Sat Down at the Piano	59
Byron Is Ruining That Child!	63
Couldn't Spell League	67
Shipped to Father to Be Straightened Out	71
Scraps and Scrabbles	75
Wingfield Park without Wingfield	81
Barbeque Held at Pyramid Pinnacles	87
Nevada Desert Wolf	93
A Lean Horse for the Long Race	99
The Peavine Cabin & Pyramid Lake	105
A Lack of Interest in People	111
The Good Life	115
The Waggish Cartographer	119
A Hecatomb of Portraits	127
Life Spent among the Paiutes	133
The Scene as It Might Have Been	137
All the Evil Would Be in Man	145
Here Is the World	149
Indian Images	157

Moving Subject Matter Around	165
Beads and Seeds Project	169
Eighty Million Sandpaper Money	175
Indian Springs	179
Fascist Nativity & Letter to the Living	189
Sargasso Sea & Promised Land	195
And There Was the Navy	201
Narrow, Elegant and Tight	209
A State Historic Place	213
He Was Just Robert Caples	217
Godfrey's Desert Museum Shop	221
Carson Hot Springs & The Flying ME	229
The Last Cigarette	235
In Search of the Mountain	241
A Globe of Heavy Light	249
Where Is the Little Man Inside?	255
The Doten Project	261
A Dream of Woman	265
The Falsity of Mary	269
A Setting and the Means	277
Star Passage	281
The Wind That Blows between the Stars	289
This Posthumous Feeling	297
Memorable Salvage	303
Gaining Height against the Wind	309
Nevada's Second Most Famous Recluse	311
Deep Hunger for Pathless Aridity	317
Ten Thousand Connecticuts	323
His Own Landscape	327
I Will Miss Him in This World	349
Sevenmile Canyon	355
Sources and Credits	361

Bowers Mansion & Death Valley

Which side of the Continental Divide the used book store was on I no longer remember, much less the town where I found Walter Van Tilburg Clark's *The City of Trembling Leaves*. I was kicking around, a fledgling 'Writer' on a long leave of absence from an accommodating Eastern college, a Jewish middle class wannabe beatnik with the instincts of a nineteenth century Romantic. There was a kind of magical thinking about the avid way I read fiction then, hoping to be pollinated like a flower by the secrets of the art. I had liked Clark's *The Ox-Bow Incident*, so went looking for something else of his, and found *City*. That used copy, a first edition, became a precious possession, an ikon of youth. Clark's novel has impacted my life like no other. Every year or so I would find a way to return to *City* locations: Reno, Washoe Valley, Nevada's basins and ranges, Pyramid Lake. Once I almost moved to Palomino Valley close to Pyramid, but had to renege when my only brother got hit with a terminal diagnosis in Chicago. After that things took a turn and I didn't make it back for many years. But the bond of place incited in me by Clark's novel is indelible. Because of it I am in Reno now, in my seventies, finally living in Clark's city of trembling leaves, and sitting here thinking once again about the book and the people it portrays. On a nearby shelf stands that same used copy more than fifty years later, an ikon of continuity, its pale tan linen binding the tint of Nevada dust.

In *Ox-Bow* (1940) and then in *City* (1945), Clark explored the culture and landscape of the West, aiming in both novels to stretch what the literature of the West had previously accomplished. Beyond that, the two novels might as well have come from different authors. *Ox-Bow*, set in the Old West, tells of three men strung up for a killing they didn't commit. Clark reimagined clichés of the dime Western and shoot-'em-up matinee in a spare, straightforward parable indicting humankind-in-society for violence and injustice. *Ox-Bow* was made into a trend-setting adult Western, starring Henry Fonda, Dana Andrews and Anthony Quinn. The film earned an Oscar nomination for Best Picture. But Clark never 'went Hollywood' in the least, never even got much gratification from that success; nor did he take the consolation he might have when a

film of *The Track of the Cat*, his third and last published novel, came out after he had already faltered into silence as a writer of fiction at a year or so past forty. He was a man of conscience, of rectitude, and as far as he was concerned print fiction was what counted.

Where *Ox-Bow* is economically told and detached in tone, *City* sprawls over nearly seven hundred pages and overflows with emotive triggers, if you identify at all with young desire, anxiety and wonder. It reads like a first novel, and in fact Clark made a pass at it before *Ox-Bow*, then returned to the material. He had unfinished business with his past. As apparently do I. *City* tells of artistic young souls in Reno, Nevada. And wasn't I an artistic young soul, confusedly enchanted by life and struggling to find my way like Tim Hazard the central character and his enigmatic friend Lawrence Black? The story went straight to my heart.

Lawrence is a painter, Tim a composer. Near the end of the novel Tim sees erratic Lawrence off to Salt Lake City, dissatisfied but still seeking. We leave Tim, by contrast, back in Reno and married, surpassingly content, his children playing around a small quaking aspen in their yard on Plumas Street. Tim, an inspired young man, has struggled against artistic setbacks to reach fulfillment, finally achieved by virtue of drive and persistence; he has completed his illusive symphony of leaves and titled it The City of Trembling Leaves, the same title as the book in our hands—and so Clark tells us, if we ever doubted, that the novelist's life and Tim the composer's, while not identical, run parallel.

We first meet Tim as the child of a working class family living near Reno's race track. No parallel to Clark's life here, rather a deliberate rejection of his own upbringing. From the lifestyle of his family's well-staffed mansion Clark acquired an aversion to wealth that was visceral more than political: he could well have become at least a sentimental socialist, as I describe myself, but he didn't. Never a political radical, in the 1930s Walter counted "socialistic orators" among the blights of the twentieth century.

You never see ten-year-old Timmy running with a pack of boys, in that respect more resembling his creator, who held himself apart, if not above. Timmy has no special pals, not before he chances to meet Lawrence Black at Pyramid Lake—except for one, Jacob Briaski, a Jewish

boy, and the comradeship never goes beyond their shared love of music and the violin. Jacob will later kill himself, in despair over a defective sense of pitch that dooms any musical aspiration. In after years Tim will never speak of Jacob, will seem to have forgotten him, yet you could say that Jacob's failure and suicide will shadow the rest of Tim's life.

Timmy is pretty much a loner at home as well. He is closest to his mother, if to anyone. Mrs. Hazard is sensitive like Timmy, and similarly spiritual. She understands her eldest son's wonder at the world, but worries that her weaknesses, her inhibitions have passed down to him. His self-absorption prevents him noticing Mrs. Hazard's gentle, melancholy empathy until too late, for she will die. Timmy's father had been a merchant seaman who settled on land to marry. Mr. Hazard works at a lumber yard now and pitches horseshoes, but misses his young manhood and is skeptical of Timmy. There is an older sister who will soon marry away, and a brother Willis. Not until later when this taunting canny delinquent little brother gets in trouble and leaves home will Tim discover in himself the special love of brothers. Tim will always be slow to distinguish the nuances of feelings, a similarity to the author which I'm guessing was not intended.

Willis embodies everything profane that repels naive Timmy, especially sex. Sex bewilders Timmy. The precocious boys who know their way around daunt and anger him. Girls who put out appear to him dangerous, almost monstrous. When he forms a chaste crush on a teacher, Willis spoils it by calling her a "floozy" and seeming to know what he's talking about. Timmy has an innocent crush on Mary, daughter of friends of the family. Years later he'll realizes he still loves her, they'll marry and start a family on Plumas Street. In the meantime, much of the action of the novel revolves around Tim's head-over-heels adoration of Rachel and his tentative, ineffectual pursuit of her through school years and beyond. Eventually, adult Tim will become reconciled to disappointment. The center point of the novel, and its most perfectly realized episode, comes upon graduation from high school when Rachel, soon to leave for college and moved by life's passages, agrees to picnic and dance with Tim at Bowers Mansion in the Washoe Valley south of Reno. A public venue by the Twenties when this transpires, the

mansion, built and lost by Eilley Orrum and Sandy Bowers, epitomizes no less the region's pride in its silver mining glory days than the law that all is vanity. Tim's love of Rachel will prove as vain as Eilley's ambition, but on this occasion the teenagers chance into a sacred zone at the Comstock relic, the charmed hours there outside of time yet saturated by time. The episode is a rhapsody of nature and love, beauty and loss. It soars and subsides, heartbreaking and satiating. All of it is alive with utter conviction—but whether as fantasy or fact, I can't say.

Tim's date with Rachel at Bowers Mansion takes place near the midpoint of the book. Toward its end comes the episode that implanted Lawrence Black in my psyche, the one where he courts death by traveling on foot and alone in Death Valley. I didn't realize it at the time, but one reason Lawrence captivated me so powerfully was that I'd been traveling with a college friend who resembled Lawrence. This was not long before I found my copy of *City*. Robert Kenler was another risk-taker, another nonconformist who spoke in bemused riddles charged with despair and spiritual ambition. I held Bob in the sort of indiscriminate, erotically-tinged admiration such as can possess a half-formed youth searching for identity. Some years later, Bob told me how badly I'd once upset him by saying his outlook was so dark I didn't see how he lived. I'd meant it as praise, in my innocence unaware that he was in a sense protected by the real weak spot in his makeup, precisely a lack of innocence, the very thing that drew him to me, though I don't suppose he thought of it that way then any more than I did. Clark's Tim may well have wondered the same about Lawrence, how he lived. Tim was attracted to that kind of personality, as was Clark, I would later learn, and as was I. Bob Kenler gave up writing, I believe, but last I heard still lives. Hello, Bob, if you read this.

The Death Valley episode. Tim cuts short his apprenticeship in composition with several free-thinking musical outsiders in Carmel to answer a call for help from Lawrence's wife Helen in her opulent Beverly Hills mansion—another symbolic mansion, come to think of it, which Tim finds as suffocating as had Lawrence. Lawrence has taken off, and Helen doesn't know where he went and is worried about him, but really about herself. Tim gets the picture and after a week sets out to

find Lawrence, betting he's gone to Death Valley to be cleansed by the place. At a gas station café in Baker Tim learns that the eccentric, likeable artist who traded drawings for meals and beer left there for the valley the morning before, hitching a ride with the bread truck as far as Furnace Creek. It's the hottest time of the year. The year is 1935.

I have been to Death Valley several times. Once I climbed the rim of a canyon and was lying flat to look over the edge when a hawk stooped past, in the stillness its feathers loud as wind-flapped awnings, the sudden sound carried down and away to leave desert silence booming from the hundred-mile rampart of the Panamints, their vast alluvial fans canted like the drain floor of creation. I can imagine Tim in his open jalopy Jeremiah, himself dazed by the 120 degree heat, scanning for Lawrence trudging the shoulder, or Lawrence disappearing behind some distant mesquite, or Lawrence prostrate on the tiling of desert-varnished stones too hot to touch. Clark relates how Tim has reached the dunes on the valley floor when by good luck he catches sight of footprints up the bank that he figures Lawrence made heading for water at the standpipe past the junction up to Beatty.

Tim turns around, pushes Jeremiah the five or so miles to the cut-off, and there at its end, sure enough, immobile beside Stovepipe Well on his haunches like a desert Indian squats Lawrence. Gradually becoming aware, Lawrence turns the burnt and swollen face of a desperado. With roasted feet anchored under treatments of wet sand Lawrence stiffly rises, reaches, and the two clasp hands.

"Lord God, Tim," mouths Lawrence through puffed lips, and here I'm quoted Clark's text, "I thought you were a mirage." Almost at once Lawrence recovers his aplomb. Gesturing to the standpipe, he offers, "Will you have a drink of mineral water? It scalds when it first comes out, but after that it's like drinking your bath. I seem to have finished the tomatoes."

On the sand by Lawrence's distressed white tennis shoes lies an empty tomato can. Tim will soon hear how a tourist, frightened by the man's appearance, could barely bring himself to bestow the tomatoes from provisions in their car before he and his wife drove off leaving Lawrence to his fate. If Tim hadn't found him ...

They seemed to me, when I first met them on the page, Tim and Lawrence, well along into adulthood by the end of the almost seven hundred page novel. Today I realize how young they were—scarcely more than my green age when their story first absorbed me. But Tim, what an instinct he had for meaning and beauty. Whatever his highs and lows, and they were many, he held his course. Lawrence is the foolhardy one. At book's end he has yet to find his way. All the same, an observation of Tim's proved right, that Lawrence "has faith in time. I'm afraid of it"—Tim's observation proved right, that is, not so much inside the novel as outside of it.

Of course back then the outside story was still playing out, while I, a young man from Chicago with writerly ambitions, couldn't be certain to what degree this adventure of youth, art and love in the West was autobiographical, as it felt to be. But a few years later, in 1963, on the mountainous Paiute reservation surrounding beautiful Pyramid Lake, Walter Clark himself confirmed the main thing: Tim, Timothy Hazard, was he; while Lawrence Black, Clark told me, was a painter named Robert Cole Caples, the "R. C. C." to whom Clark dedicated *City* and the man Clark regarded as his dearest friend, as Tim does Lawrence in the novel.

A Can of Tomatoes

Half a century after my hours with the much-esteemed author at Pyramid Lake, I described the experience to Clark's son in an email. Our exchange came in the course of investigations I then thought might or might not become a book. I informed Robert Morse Clark that I'd written a fan letter to his father, who'd responded by inviting me to visit him if I should pass through Reno, which that summer of 1963 I did.

> Seeing Pyramid with Walter Van Tilburg Clark was a momentous occasion, as you can imagine. Yet I can't recall very much about the day. I think he was in a reflective mood, not particularly voluble. Of course he talked about the atmosphere of geologic time as we sat on a rise looking at the lake. He may have said something about Doten. We certainly talked about the novel that had become a part of my own identity, as treasured artworks do. I must have shown myself drawn to Lawrence Black in a way that resonated with his own attachment to Robert Caples, because he told me about the friend who was the model for the character, and put me in touch with him....
>
> To cap the day, he took me to a bar in ... Fernley, where he set us up with boiler-makers. I've never been much of a drinker, and had previously in my young life acquired an aversion to bourbon, but I manned up to it as a rite of passage.

When I learned on that special day in 1963 that Robert Caples was Clark's model for the character whom I so admired for venturing on foot into midsummer Death Valley in tennis shoes, hatless and unprovisioned, I as yet had no idea that Caples was a personality in his own right in Nevada, a legend no less. Nor could I have guessed that Caples would shortly become my treasured friend. After meeting once, we would correspond for fifteen years until his death. I had the privilege to observe him from a distance through his letters as he approached the inevitable. His courage and grace then were far finer than the willful derring-do of the Death Valley ordeal and rescue which, thanks to *City*, entered the Caples legend.

Probably because Robert Caples (1908–79) moved away from Nevada for the last twenty years of his life while Walter Clark (1909–71) died in

Reno, the epithet 'legendary' attaches to the painter's name but not the novelist's here in Nevada where I now ponder their careers, their friendship, their life trajectories. It's said that both men ceased producing after their artistic primes. Clark's difficult silence, evident to those here on the ground, became and continues to be a source of speculation, some of it not flattering. Whereas in Caples' case, his supposed failure off in distant Connecticut to paint more pictures only enriched the mystery of a man who had always seemed inscrutable. His 1979 obituary in the *Nevada State Journal* already proclaimed it: "Legendary Nevada Artist Dies." Nevada's art historians and curators have perpetuated the honorific ever since.

The rest of the legend goes like this. Robert Caples arrived in Nevada from the East at age sixteen to live with his father, a doctor who had settled here following a Reno divorce from Caples' mother. Nevada's first contemporary artist of note and its first modern writer of note, Walter Van Tilburg Clark, quickly made friends. Caples, who upon arrival had immediately been awestruck by the desert, lived much of his early life among the Paiute Indians, whom he would famously draw. He also loved and painted the old mining towns he haunted, and the mountains, above all the mountains, which he saw and rendered in a newly revealing way. He was a serious, solitary man, tall, thin, and exceedingly handsome, usually taciturn, but captivating when he spoke. Always gifted as an artist, he suffered from extreme perfectionism, was never satisfied, usually refused to sell his works, and destroyed many. For money, he womanized. He married five wealthy women, discarding each wife but the last with whom, unexpectedly, he left Nevada for Connecticut at age fifty, never to return, and, largely for that reason, never to paint again. Yet he missed the place so intensely that he created a haven he called "the desert" on his wife's estate. He lived out his life reclusively, virtually inaccessible even to old friends until his death in 1979.

Like most legends, this one has a basis in reality, but only a basis.

There is a second, less well known Death Valley story about Caples. I first heard it from Jeff Nicholson, another notable artist of the Great Basin landscape, in a magnetically realistic style. Caples became

disgusted with his work, said Jeff, foreswore art, and took off for a wander and a sweat lodge in Death Valley. But when he returned he brought brushwork drawings made on any paper at hand, using antiseptics from his first aid kit.

My search of newspaper archives turned up an early version of the story in arts journalist and painter Lillian Borghi's weekly feature "Arts and Artists" in the *Reno Evening Gazette*, which in May, 1939 publicized an exhibit at a "local art store"—that would be Brundidge's, on Virginia Street—of over a hundred drawings Caples made on a hiking trip from Death Valley to Reno. He'd been traveling light with just one Chinese brush. For ink he improvised with Mercurochrome, Argyrol and iodine from his first aid kit. Accompanying the article was the reproduction of one of the drawings, a sketch of a deserted Chinese laundry in Tonopah, the seat of Nevada's second mining boom just into the twentieth century.

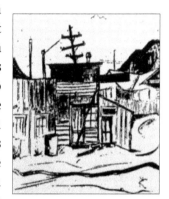

Untitled (deserted Chinese laundry), 1939

But is it likely that any hiker's first aid kit would include three separate liquid antiseptics, much less enough to complete over one hundred brush drawings? Caples presumably tweaked the details for Lillian Borghi and in later tellings. What the story surely establishes, however, is that Caples made a practice of traveling alone in that uniquely inhospitable place, Death Valley. He also went there in company, with Clark in the 1930s, almost certainly with his friends the Houghtons, and with his fifth wife Rosemary and her children in the 1950s, at least. It was a focal location in his geography, together with such places as Pyramid Lake, Austin, and Virginia City. There is a dramatic painting he made of Telescope Peak in the Panamint Range, at just over eleven thousand feet the highest elevation in the park. He had been inspired by the sight of it on yet another walking tour. That trip, again reported by Borghi, came in 1941 or 1942, several years after the Mercurochrome sketch series. Caples titled the picture *Dharmakaya, the Golden Path*. He had been studying and in some manner practicing Buddhism. The article announced that a local art shop—that would be

Brundidge's again, across the Truckee River from the Riverside Hotel—was now carrying Caples works reproduced as small Kodachrome prints, which the artist had signed in limited editions for the purpose of making fine art accessible to the general public at an affordable price. It was one of these reproductions, a 4" × 6" print of *Dharmakaya, the Golden Path*, which Walter Clark referred to in a 1971 letter, where he informed his old friend that he was dying. "Yes," Clark wrote, "the doc gave me my one way ticket for the long voyage." In a postscript he added: "And thank you very much for the Panamints. They are beautiful, and they sit on my bureau. There's a clock beside them, but it does no harm, I don't really see it anymore."

Clark's son Robert, who is named after Robert Caples (as Tim's son in *City* is named after Lawrence), brought out the print for me in 2012, when I visited him at his home in Helena. We had to put coins on the corners of the curled old photo paper so I could get a picture of it on my phone. Bob Clark, longtime archivist and librarian at the Montana Historical Society, and held to be the most brilliant of that generation of Clark siblings and cousins, warned me that a biographer of Caples would find even less material of a personal nature than Clark's biographer Jackson Benson found for him. Bob was Benson's chief informant, virtually his collaborator, and there is no Bob Clark around as informed about Robert Caples as Bob is about his father. Still, more exists on Caples than Clark's son predicted, I'm glad to say. Besides, I never had it in mind to write a conventional biography.

Dharmakaya, the Golden Path, 1941

― Bob Clark at one time intended to write and publish a doctoral dissertation about his father, but chose not to complete the degree or the writing. Later he asked Benson, a capable literary biographer, to tackle Walter's life. Benson, by his own account, hesitated, then finally agreed. Nevertheless, Bob Clark said more than once to me that he didn't know why Benson did his book, *The Ox-Bow Man*, published in

2004; by that late date in Benson's career, he figured, Benson didn't need it for academic promotion. The reason, I feel certain, is that Benson is a man who has to write. Earlier Bob remarked that Wallace Stegner made the most of the piece he wrote about Clark after his death by publishing it in maybe four different places. Bob seemed tolerant, though, of my vague explanation of my project as a personal search, when he asked me what I was doing. I added only that I hoped for my seeking eventually to become a book. I suppose he preferred open-endedness to a firm thesis, as far as his father went. He was ready at the end of a good part of two days in conversation to broach an interview on my behalf with his sister Babs in Reno (Barbara, named after their mother, Clark's wife, as Tim's daughter Mary is named after Tim's wife in *City*). Bob decided I was "safe and interesting."

Just before leaving I asked, "Do you get many pilgrims like me coming through?" "Not many," answered Bob. "Not for Robert."

In 1972, three decades before Benson's biography, Bob traveled to Connecticut to interview Caples, who found his old friend's son (so Caples told another friend, Sam Houghton) "a terrific young man." The interview was for an earlier collaboration on Bob's part, this one with an English Department colleague of Clark's at the University of Nevada in Reno, Charlton Laird. Laird proposed a lecture series honoring the recently deceased Clark, with Laird himself and Bob Clark chief among the contributors. The lectures were meant to be and would later be published as a festschrift, titled *Walter Van Tilburg Clark: Critiques*. Well after our talks in Helena, Bob Clark sent me his notes from that 1972 interview with Robert, where I found this: "The Death Valley scenes close to RC's experience, but WC not there, no such rescue necessary—story told by RC to WC."

Caples told Clark about it? Clark not there? No rescue necessary?

Lois Battle, the woman I would marry and divorce, once asked if I'd had pets as a child. Yes, I said, Punky, a Siamese cat. What became of it, she wondered. "Oh, the cat went to the country." She gave a quizzical look, then it hit me: "*The cat went to the country?!*" Bob Clark's notes caused just such a seismic realization. I'm not an unsophisticated reader. Of the novels in my life, only *City*, and of its episodes, only the Death

Valley rescue and perhaps one other did I never question happened. That naive mistake lingered from my youthful first read, just like my parents' never-questioned euphemism. *No rescue necessary?!* I had to clear this up.

In Laird's *Critiques* it says that Bob Clark came back from Connecticut and told Laird that "Lawrence's dessication in Death Valley was a Caples exploit, 'right down to the can of tomatoes.'" Those are Laird's words, quoting Bob Clark. No mention by Laird of Walter. So Bob, or else Laird, chose not to bring out that Walter wasn't actually part of the "Caples exploit." As for Benson, he cites friends of Clark's as affirming that the Death Valley scenes "have a basis in life, describing a trip Clark made to Nevada in 1937." That was the year Clark began *The Ox-Bow Incident* while teaching at Cazenovia Central School in New York State. Without his wife Barbara he made a driving trip back West with his brother David and a cousin. He saw much of Caples, in Reno and traveling together. Robert's first wife Virginia was just leaving for a trip back East. "I like the notion of a lot of time alone with Robert," he wrote to Barbara.

> I'll spend four or five days with Robert in Virginia City, where he's doing a lot of drawing.... He has a big, top floor, chimney pipe room in one of the hotels in Virginia; showed me a couple of chalk drawings of it.... After that there's a new hideout back of the Pyramid at the lake, and possibly a jaunt together down to see the Great Smoky.

The "Great Smoky" is the Big Smoky Valley in Nye County, west-central Nevada. They would visit Tonopah at its south end. They would also spend some days at the Clark family cottage on Lake Tahoe, and more in Reno. But no Death Valley. As far as Clark's role in the episode, it had no "basis in life."

With this perspective, something Caples said in 1977 took on new meaning when I reexamined our correspondence. He was reacting to something I'd said in the letter he was answering, about how in the previous letter from him I'd seen evidence of the appealingly foolhardy Lawrence Black who hiked ill-prepared in Death Valley. Robert's reaction: "I *still* don't glimpse the connection between my easy-go-lightly note to you and the occasion of blistered toes and tomatoes..."

Just "blistered toes." Granted, Robert consistently minimized his accomplishments, out of genuine reticence, even diffidence, complicated by an almost superstitious aversion to self-aggrandizement. It's also true that Robert could be coy. His friend from WPA days, painter and photographer Richard Guy Walton, made this observation on an oral history tape recorded in 1975. Said Walton of Caples, "He was very underspoken, he always has been underspoken, in fact he's so underspoken that it amounts to an occasional affectation.... There's a way of underspeaking that is actually overspeak. Caples is a master of underspeak-dash-overspeak." Still, just "blistered toes"? It looks like Robert's dessication was not as dire as Clark painted it. "No such rescue necessary." Clark took something from life and, as any novelist might, changed and embellished it to tell a story, and it's a good one.

Clark's son Bob deems *City* an "autobiographical trove ... a key" to Clark's biography—and who would know better? And so, while the gambit is one some critics disapprove, I'll have no compunction, as I proceed, overlaying Clark's texts and his biography to see where they match, and if they don't, asking why not—a novelist's 'artistic license' to be sure, but to stop there would be superficial and dogmatic. Lives, life stories, are in play here, not simply Walter's fiction—Walter's own story, Robert's story, and my own.

In reality, if a Clark/Caples rescue of any sort ever took place, it was Robert who rescued Walter. Benson relates the story of a prodigious swim Walter made at Pyramid Lake. This happened in the early 1930s. Walter, a powerful and gifted athlete, and physically courageous, was at the beach with friends when he took it into his head that a swim across the lake to the Pyramid would be just the thing. Granted a swimmer gains some buoyancy from the lake's brackish water, but still. When his companions demurred, Walter stripped and set off alone. At its closest, the Pyramid is about six miles from the western shore. Clark misjudged the distance. Once across, he was too cramped and drained to swim back. There he was, many miles by land from Nixon, the Indian town—and naked. By luck, the story goes, a solitary boat passed within hailing distance, a speedboat full of women, to Clark's embarrassment.

What went through the friends' minds, watching Walter swim out of

sight? Did they go home without him? Did the women deliver him back to his clothes while the friends dithered for hours on the spot? But is that even how it all happened?

Robert was among the friends standing on the beach when Walter entered the water that day, as appears from a 1967 letter to Robert where Walter alluded to "the fool swim to Anahoe Island" as something "you will remember." And the swim ended not at the Pyramid but at Anaho, a large island which is now a national wildlife refuge—itself an impressive swim at half the distance, and maybe more than that depending where he entered the water. Judy Nash, daughter of Walter's University of Nevada English Department colleague John Morrison, heard that the swim ended at Anaho, adding that Walter tried to "make swim trunks out of pelican feathers" to hide his nakedness. Daughter Babs confirmed Anaho. But she also said unequivocally that Robert got a boat and it was he who rescued Walter, not women in a speedboat. That's consistent with Walter's reference, in the 1967 letter to Robert, to "a drink by the fire back of the Pyramid after my comic strip rescue."

About that can of tomatoes, which apparently a skittish Death Valley tourist really did open and set on the ground for Robert at the wells before fleeing: because it was so imprinted in me, I couldn't help marking, as I was reading for this book, where other cans of tomatoes appear here and there, before and after *City*, always as a token of survival, modest luxury or hospitality in mountains and deserts—from Owen Wister's groundbreaking Western, to Will James' cowboy's life, to A. B. Guthrie, Jr.'s celebratory if ironical mountain men saga, and half a dozen or so more. I'd like to think that Clark, an authority on the Western myth, recognized the humble staple as a minor trope and played it up for that reason. So it must have evoked poignant memories when in the laborious course of editing the journals of Comstock newspaperman Alfred Doten late in life, Walter came across the tidbit that at a theatrical performance by a "fakir" in Virginia City, Doten "got as a prize a can of tomatoes."

The Conservation Center

If I believed in such fatalities, which I don't, I'd say I was meant to see the announcement: there would be a talk dealing with murals created during the Depression under the Works Progress Administration. The notice of the event grabbed my attention like a prompting or instruction, as I sensed but hadn't yet processed when on September 13, 2011, I drove expectantly into Chicago from my home in Northwest Indiana to attend.

The City of Trembling Leaves had recently been crossing my mind for no apparent reason—like an old song that runs through your head before you realize you're in a certain state of being, or are about to revisit an important time in your life once again. Driving in, however, my thinking had got only as far as, *This has to do with Robert.*

The presenter at The Conservation Center was C.E.O. Heather Becker, conservator, artist in her own right, entrepreneur, and author of a book on the evening's topic, Chicago's murals from the Great Depression and before. The book grew out of her initiative locating and restoring many of the murals which make Chicago the U.S. city with the largest number of such works enhancing its publicly owned spaces, especially its schools, post offices, and park fieldhouses.

Before the presentation I went up and told Heather Becker that an old friend, long dead, had painted a WPA mural for the courthouse in Reno. Of course I hoped she'd heard of Robert Caples, which she hadn't. I promised to send her an image of the Caples mural.

Next morning I went online looking for Robert's *Washoe Indian Legend of Creation*, a nine by three foot panel mounted in 1935 just inside the then main entrance of the Washoe County Courthouse, the famous venue of countless divorces during the decades of "the cure." All those plaintiffs and defendants from all over the country once passed Robert's mural as they apprehensively or aggressively entered and later in one mood or another departed. There are actually three courthouse

buildings. Frederic DeLongchamps designed the famous domed one to surround the 1870s structure, its swallowed spaces now used for storage. DeLongchamps was father-in-law of Robert's good friend the poet-artist

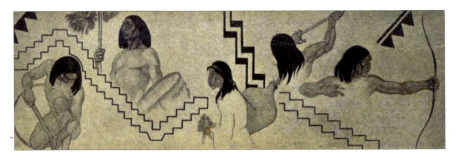

Washoe Indian Legend of Creation postcard (detail), 1935 or after

Joanne de Longchamps (who redesigned the name). The third, modern courthouse with county offices was merely appended indecorously to the back side of the well-proportioned second, the DeLongchamps. In consequence, the old Virginia Street entrance with its steps where Marilyn Monroe was filmed in *The Misfits* has been permanently closed. The mural, now protected to its disadvantage by a wavy plastic covering, still adorns the north wall in what has become a neglected corner, to be viewed these days only by those who know to seek it or by students on school tours. The crux of the Washo legend is that deadly strife among the first human children required their separation, thus bringing the tribes into existence. Available to litigants and tourists back in the day was a picture postcard with the panel and an anodyne version of the legend it illustrates, toning down the element of strife for 1935's public, in Reno to divorce or recreate, or both. The panel fittingly depicts a Washo-centric version (the Washo was "the strongest and finest") of a creation legend which other tribes of the region tell differently. How appropriate, and at the same time how subversive to assert the native order of things in Washoe County's halls of justice. But I can't say if Robert thought of it that way.

The morning after the talk I knew just a few of these facts as yet, and had known none of them the day at Pyramid Lake in 1963 when Walter

Van Tilburg Clark told me the things I must do before leaving Reno: eat family style at the Santa Fe, the old Basque sheepherder hotel, and see Robert's courthouse mural. I couldn't find an image of the mural online that morning, so instead sent Heather Becker an iPhone photo of Robert's painting *Dark Range*, which hung in my dining room. She replied with thanks, and that was that. But something had been sparked.

I thought of Robert's letters, stored in a file box with some other old papers. What a treat, just to contemplate that inimitable handwriting. And then to rediscover his mastery of the letter form, the beauty of his mind. I also reread the several letters extant on my side of our exchange. Were these copies I'd made? That's not something I did before email's keystroke save. Still I must have. But not so: when I came to a note in Robert's unmistakable hand on one of the pages, I realized that undoubtedly Rosemary his widow had returned the originals to me after Robert's death in 1979. I'd completely forgotten.

> To say the past is 'over and done with' simply is not true. I found myself laughing a few weeks ago at something my father had said to me when I was about twenty-four. I just got the point — and I can realize now why it was he looked at me rather quizzically when I failed to smile. Imagine, almost a life-time to catch on — ! And that applies to so many other things — there were things whispered to me once that shout to me now; things shouted that have dropped out of hearing. And it took almost fifty years for me to realize who it was who tied the tiny handkerchief to the steering wheel of my car, an object almost as delicate as a moth in the moonlight.

Caples' last letter to the author (detail), July 18, 1979

Rosemary also returned Richard Guy Walton's letters to him, and Walter's letters to the Clark family, which is how Walter's made their way to the Clark archive in Special Collections at the University of

Nevada, where I did much of the research for this book. I was still unacquainted with the place and its resources when it occurred to me as I turned the pages of Robert's letters that I should gift them to the university. I had already bequeathed *Dark Range* to the Nevada Museum of Art in my will.

My will! That summer I had redrawn my will. That's what had been stirring up the past. Today as I write this, I go to the will and discover that it was actually executed on September 8, just days before the talk on Chicago murals. And what is the very first paragraph, after I, ANTHONY J. SHAFTON etc.?

"My painting entitled *Dark Range* by Robert Caples to Nevada Museum of Art in Reno, Nevada."

American to the Bone

Another user of Special Collections signed in, a robust woman with close-cropped gray hair wearing tight jeans with a big silver buckle on a worked leather belt. Head of Special Collections Donnelyn Curtis and she were on cordial terms. I gathered she was a regular there for research having to do with land use. She received the materials Donnie brought her at the table next to mine and got right to it, never looking my way. I didn't possess the social database for Nevada to decide if she were a scholar or rancher or both or something else.

It was 2011, the November following the September talk on public murals, and I was on a voyage of rediscovery. I had flown into Reno for interviews, pilgrimages to Caples and Clark special places, and sessions at both men's archives, after which my son, Matthew Spiegler, would join me. He'd never been to Nevada.

I'd spent the previous two days perusing the Caples archive in the Center for Art + Environment directed by William Fox at the Nevada Museum of Art. The center doubles as the museum's archival department. The Caples archive came into being after Rosemary Caples' death (1918–2001), when the museum's archivist Sara Frantz got a call from a banker in Connecticut to say that Rosemary's children, Robert's unadopted stepchildren, had gone through the property at New Preston and taken what they wanted, and that the rest would be disposed of unless Sara wished to claim any of it for the museum. I suppose the banker was acting as executor in accordance with Rosemary's will, which had included bequests of numerous paintings of Robert's to the museum. Sara traveled out and brought back a heap of papers, memorabilia and unspoken-for artworks, most of it from Robert's studio. A decade later the Caples materials still hadn't been organized—archives are generally underfunded and understaffed. I opened a box at random.

Incredibly, almost the first thing that came to hand was a letter from me, thanking Robert for the wedding present of his painting *Dark Range*. Rosemary hadn't returned this letter to me with the rest after Robert's death. He'd obviously kept it in a different place, it dating so early. On Christmas Eve, 1964, Lois and I were married in Chicago

with my family, then flew back to Los Angeles where we lived. After Christmas we drove up to Pyramid Lake for our honeymoon—where Tim honeymoons for two days near the end of City. Was I emulating? Of course. Lois used to say it proved she loved me, to have let herself be persuaded to honeymoon in the desert on Pyramid in winter. One of Robert's early wives, Virginia or Shirley, gave him a harder time about the lake, as he confided to me much later as an aside to extolling Rosemary:

> It's a long upward climb to enduring companionship. I thought I had just such a one many years ago. I told her she shared my heart with the magic of a certain desert lake. She replied, thrusting me aside, that she wasn't about to share anybody's heart along with some God-forsaken deadwater lake, 'Me or your big pond,' she said. 'No, not both—not me.'

Back home, Lois and I received a large parcel, the sensational gift from Robert, whom I had met only once, a few months before. I thanked him with a full heart:

> The painting came today—humming with silence. It's hung ... in neutral, unreflective semi-darkness. It alters the light of the entire room, which is a large one. The darkness seems an emanation of the painting—I have always liked paintings that alter the space between the viewer and themselves.

The moving discovery of my forgotten letter to Robert encouraged the hope of finding my fan letter in Clark's archive. Following the two full days it took for Caples, this final day before my son Matt's arrival was dedicated to Clark. Once Jacqueline Sundstrand, my contact at Special Collections, had conducted the formalities of accepting my gift of Caples letters, I sat down with the Clark boxes.

Clark in 1963 damned Special Collections as a "windowless mausoleum." He was doing research there, and didn't like it. The year before he had left his post of six years heading the writing program he established at San Francisco State, gladly hired home to Nevada, for the balance of his life as it turned out, to work up the journals of Comstock newspaperman Alfred Doten for the University of Nevada Press. But it

wasn't really the interior design of Special Collections, then still housed in the old Getchell Library, that elicited Clark's "windowless mausoleum" disparagement of the facilities, it was his dawning sense of entrapment in a Sisyphean labor, a labor he finally relinquished only with terminal illness—the "one way ticket for the long voyage"—eight years later. After his father's death Bob Clark wrapped up the much-delayed preparation of the Doten journals for publication in 1973.

Special Collections' new home in the Knowledge Center (read Library) is pleasant enough, made all the more so by a congenial staff. It was already three o'clock before I had sifted through most of the boxes and arrived at the one I'd been aiming for, Clark's correspondence. Clark had received my half-century-old fan letter during the very same year, 1963, that he wrote to Caples about the "windowless mausoleum." I didn't actually suppose I'd find my letter, but of course was disappointed not to. What I did find, as I knew to expect, was the Clark/Caples correspondence. Benson had already made extensive use of it for his Clark biography. The bulk of it runs from 1956 into 1971—that is, into the year Clark died, and beginning after the Capleses moved to Dayton below Virginia City and the Clarks moved from his teaching position in Montana to San Francisco State. Virtually nothing from earlier years, the trembling leaves years, remains—nothing whatever resembling source material for the many letters where part of City almost becomes an epistolary novel. But the true disappointment was to find only Clark's letters to Caples, none from Caples to Clark. Walter didn't save Robert's letters, or else later destroyed them for privacy, as he did many other papers. He preserved few personal letters, something Bob Clark told Benson, and I was to hear the same from him the following summer. All that survives from Robert's side are a few illustrated cards with supportive messages, dating from Walter's last illness. Bob Clark held onto these and showed them to me. Bob and Babs were both under the impression that Robert, when he did communicate by mail, only composed illustrated brief messages of that kind. "He seldom, maybe never, wrote a regular letter," Bob was certain. I could see disbelief, even cognitive dissonance on their faces when in separate interviews I described Robert's longish letters to me. Written exchanges between

the friends had presumably been unsymmetrical. As most relationships are. The Lawrence Walter created in *City* writes brief, "cryptic" notes. His one proper letter is described as "a long letter, for Lawrence."

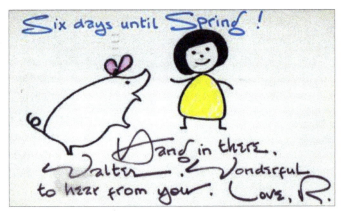

"Hang in there, Walter," postcard from Caples to Clark, March 15, 1971

Brevity was not a hallmark of Walter's writing, letters or otherwise. Besides, his tiny, Arabic-looking script in blunt no. 2 pencil was a strain to decipher. There were far too many pages to read on the spot, anyway, so I requested them all to be copied and mailed to Indiana. I had become a bit numb. Clark hadn't saved my letter. Why would he have? I decided I'd had enough. I gave my thanks, signed out, retrieved my backpack from its locker, said my goodbyes and left.

The sky was almost too blue, the clouds unbelievably white, smooth and long, like abstract whales. Reno clouds. Eastern slope lenticular clouds. I paused on the steps to savor the campus atmosphere of exemption. Two students were practicing flying 360 degree martial arts kicks on the lawn, one of them clearly more advanced than the other. Then at the parking facility, as I was pushing the elevator button I suddenly remembered that I had come away without seeing one of the items I had most wanted to examine, my old teacher Wallace Stegner's typewritten review of *City*. Stegner had still been heading the graduate writing program at Stanford and occasionally still led seminars when I attended there. He had been Clark's peer in pioneering such programs, and Clark's rival

in the unofficial rankings of mid-century Western writers. The online catalog for Clark singled out this Stegner review in Clark's scrapbook for *The City of Trembling Leaves*, Box 10. I hadn't got that far. I returned to Special Collections with apologies. Donnie Curtis didn't seem to mind. The scholar/rancher was still at work, still didn't look up.

The scrapbook for *City* held publisher's correspondence, proofs of the cover, and so forth. Next came the contemporary reviews, quite a lot. I was selecting some to be copied when I came to Stegner's—a published piece, not the promised typescript. Another disappointment. I wouldn't find out how he'd edited himself. Stegner found plenty to fault in the novel, concluding, with a backhanded positive amounting to a negative, that he expected Clark to "write even better books than this." He nevertheless unequivocally endorsed the aspect of the book closest to his heart, as it is to mine, Clark's rendering of youth: "I believe in the childhood and adolescence sections of the novel with a belief I reserve for very special things."

Following the reviews came a slim folder with correspondence from friends or the public concerning *City* that Clark had saved, only four or five items—and there among them was my letter!

> For the third time in my young life I have just finished reading CITY OF TREMBLING LEAVES. Tim, Lawrence, Rachel, all those others are part of my fabric now, the way only childhood and great literature can be. Pyramid and Tahoe, Mt. Rose and the Truckee, too. Last summer I made a sort of pilgrimage to those places....
>
> I've been proselytizing ... several years now, trying to arouse the interest your book deserves. No one has heard of it or read it, and of those whom I force to it, all are caught up by its beauty, its unbelievably thorough informing of life, yet none, I think, has understood all its implications. Perhaps that's because they haven't read it as Americans, or as artists. I excite interest by saying you have tried to discover an indigenous American art....
>
> As a novelist myself, I have learned immensely from your work: technically; in discovering what is meant by vision; in discovering my artistic identity; and from an encouragement which you must be acutely aware of in the book, since (I guess) so much of it must have been directed toward yourself. In

> reading CITY OF TREMBLING LEAVES I have come to know myself under
> the forms of beauty and potentiality. I don't know higher praise.

I don't know higher praise. I cringed. Such a pretentious, over-punctuating young man wrote to Clark in 1963! But high-minded and passionate, and insecure. I expect Clark saw that and made allowances if he saved the letter, even invited the earnest acolyte to visit. Also, he will have liked the bit about "an indigenous American art," and that I can stand by.

The Boston Daily Globe judged *City* favorably as "wholly American … formless and sprawling." A scholar, L. L. Lee, said the same thirty years later: "the formless form is alive.… It is a very American sort of book." Clark himself, I'm quite sure, thought of *City* as original along American lines. The originality lies, I'd say—but I must admit I can't say precisely where it lies. Somewhere in the rhythms, the shifts in tone, the illusive omnipresence of Lawrence Black, the evocation of love in a Western town adrift in the dark. And the tender, anachronistic chapter titles, elastically distancing us even as they pull us in ("About Divine Mary, and the Pagan Goddess Who Taught Art, and Jacob the Terrible Fiddler"). And "Walt Clark" the narrator, who is also a character in the story. And the undiminished trust in nature. And the spacious sense of time, youth's sense—time being the book's raw material and fundamental theme, and its greatest beauty. Something in the fabric Clark made of all this with so much energy is both American and original—and unsuccessful. In Book One the parts intuitively connect to create a gestalt; in Book Two, they don't. Book One seems much, much larger than Book Two, yet purely in pages, Book Two with its dead wood is actually a little longer. Better to say, the novel both succeeds and fails. It wins us, then wanders. For those of us it wins, its failure, its negligence of form, may even be part of its enduring hold on us. So very much is there, and something isn't—that too, the something missing, is also American, American to the bone.

So I had read the long novel three times before addressing its author, and by then had been promoting the book for "several years"—in that case, I first read it at age twenty-two or -three. And my pilgrimage—I retained only isolated images from that cross-country hitchhike, but

sharp ones: shooting stars watched lying at the edge of an Iowa cornfield; the Truckee rushing past the sacred island of Reno's Wingfield Park; a night with frost below Virginia City in my mummy-bag in the ditch beside the Geiger Grade. Curious: all images of edges—just as I have positioned myself at the edges of these other lives, now, late in my larger journey.

I believe in neither predestination nor the guiding hand, and in karma strictly as a psychological metaphor. But when the stars align, we nonbelievers have much the same reactions in the body, I'm pretty sure, as those who do believe. Recently we were driving down the west shore of Pyramid on a overcast morning when the clouds slightly parted, enough for a spray of sun-sparks to sweep up off the wind-roughed surface like a dust devil of light. The Paiutes and Shoshones believed, or believe, that dust devils are spirits of the dead. *Robert's ashes are in the lake*, I thought as my eyes brimmed, although I don't believe in spirits. It's the pious atheist's as-if. That afternoon at Special Collections the as-ifs were piling up. Just as Robert had saved my thank you for *Dark Range* and I had come upon it almost the very first thing in his archive, so now almost the very last thing I came upon in Clark's archive at the library was my fan letter saved by him. What's more, I wouldn't have found my letter to Clark had I not decided to return for Stegner's review—so Stegner indirectly facilitated my personal connection with Clark a second time, just as he had half a century earlier by accepting me into the Stanford writing program. For it was the trip to Palo Alto to enroll at Stanford which gave me the opportunity to stop in Reno and take up Clark's invitation.

One more thing: the envelope clipped by Clark to my letter had gone to four addresses, forwarded by two publishers and a post office, before arriving. What are the odds of a letter being successfully forwarded through so many organizational addresses? Had it not, I would never have met Clark, therefore would never have met Caples, and would not have been sitting in Special Collections in Reno thinking about their lives and mine.

Softly I announced my discovery to Donnie Curtis and gave her my new copying requests, which in addition to my letter included the only

other in Clark's *City* scrapbook from an unacquainted fan, one Hubert D. Saal, who wrote from Paris in 1949. All in all, a much finer letter than mine. Saal, I later learned, was an autodidact writer who went on to become *Newsweek*'s music and dance critic. He lavishly and aptly praised much of what Clark himself valued in the book; at the same time, he didn't hesitate to tell Clark how he thought the work might have been improved, something all the more presumptuous since in Paris he had somewhere picked up the World War II Armed Services edition ("Condensed for Rapid Reading," 510 pages down from 690). As I told Saal's daughter, Drucie Saal Belman, to whom I afterwards sent a copy of her father's letter, by 1949 Clark had already received quite a lot of adverse criticism for the book, from sources more hurtful to absorb than from an overconfident young man. Drucie wrote back, "My brother, sister and I adored getting the letter that Dad had written. It was so characteristic of him. When he begins to edit Clark's writing I must admit it made me cringe." Good: I wasn't the only one to cringe at the pretensions of youth. Yet Clark wouldn't have preserved Saal's letter, as he later did mine, if he hadn't appreciated it.

A Youth of April

Around the time I was beginning to catch stares from empty page one of this book, I turned up another old letter, a forgotten one that had moved with me to Reno. I'd saved enough money to close my little business and relocate for the sake of the book, and for love's sake, but which was which? Talk about the stars aligning. We had an appointment to meet at Louis' Basque Corner to discuss books about Nevada. She told me I looked exactly as she imagined. Two of Louis' Picon Punches didn't hurt. When I found myself cradling her head hugging good night in the parking lot, with a gentle jolt I discovered I was already all in, if she would have me. That was in July, 2012. In November, I emigrated West, not my first time, but for good at last, my last frontier, come what may.

The forgotten letter was written in 1980—shortly after Robert's death in 1979—by Carl Heintze. He was researching Clark's life, particularly the conundrum of Clark's unproductive final decades. Heintze's letter commented about an excerpt I'd previously sent him from a work of my own, the part about Clark and Caples.

Really? I had already written about these men? I don't know which struck me more forcefully, the fragility of memory (mine) or the way my life was circling.

Who was Carl Heintze? A California native, I discovered online, an author of short stories, nonfiction books on medicine, nature and war, and a journalist. My web search brought another surprise: Heintze has an archive in Special Collections at the university. The online catalog gave no clue why this Californian merits an archive in a Nevada institution. But eventually Donnie Curtis ascertained that Heintze has a second, uncatalogued archive, and there I found Heintze's Nevada affiliation: his writings and research materials on Clark. Like me, Heintze had read *The City of Trembling Leaves* as a young man and been smitten. The novel and its author became "a long term obsession." He had completed or begun four separate biographical pieces, but only one was ever published, a gloomy 1985 newspaper feature in my hometown paper the *Chicago Sun-Times* on "The sad saga of Walter Clark." The manuscripts, none longer than a dozen pages, bore titles

such as "The Stilled Leaves," signaling Heintze's preoccupation, Clark's baffling silence.

Heintze, again like me, had addressed a fan letter to Clark for *City*, and he too had received a reply. Unlike me, Heintze didn't go on to meet our mutual idol, which is puzzling in light of his obsession, his location not far away, and Clark's accessibility to young writers. There must not have been an invitation. Clark didn't save Heintze's letter. Probably Heintze overstepped by probing Clark's sore spot, his publishing silence. Heintze died in 2014 at age ninety-two.

In Heintze's archive I also found reminders of how I happened to communicate with him in 1980. He had placed a notice in *The New York Times* seeking information for a book-length biography of Clark he projected. Lois, my by then ex-wife, saw the notice and sent it to me in Oregon where I was living. Among the responses Heintze received I found my letter and a follow-up from me, together with the perplexing excerpt, nine pages of a novella, *Bea & Sherman*, whose title I remembered but of its plot only that it was a road story about characters with no connection to Nevada. My letters informed me that I'd written the piece in 1964—so the year after meeting Clark, and months or possibly weeks after meeting Caples. Here was virtually a journal of those encounters. How could I have forgotten so relevant a document of personal history? Disoriented and apprehensive, I began reading. The Clark material was a shock. I hadn't liked him.

To get the whole picture I dug up the complete manuscript at home, in a file of abandoned efforts. *Bea & Sherman* did prove to be a road story. I and "Sherman" separately answered "Bea's" ad to share driving and gas from Chicago to the Coast. I had traveled with them and her twittering gerbil cage as far as Reno, where I met Clark. My fictionalization juxtaposed the two eponymous lowlifes to Clark (Asher) and Caples (Robert Ross) in an immature attempt to discern a common thread in the worst and the best of the American character. The pages I'd sent to Heintze, it turned out, contained all I'd written describing the writer and the artist.

The Caples pages supported my recollections from overnighting with Robert and Rosemary at their rural Connecticut estate called Turtle Hill:

the richly comfortable appointments of the rustic colonial mansion, the companionship between them, the artist's gentle intensity, his sonorous voice, our game of chess (but I didn't remember that I'd won), the pond, the "desert," our common interest in the symbolism of maps, his thoughts on silence and art.

The Clark section was something else. The shock, as I say, lay in discovering, or being reminded, actually, for it did come back, that I hadn't much taken to Clark. In addition there were some particulars truly lost to memory, which I now assimilated as if from someone else's story: that we had exchanged more than one letter prior to our day at Pyramid, most likely to arrange logistics; that I may have briefly met Clark's wife Barbara; and even that I had conveyed my impression of Clark to Robert and got his reaction—how did that get blotted out?

> We spent an afternoon and evening at Pyramid Lake. He was very hospitable. His wife packed a picnic dinner for us, and afterwards we drove down to Fernley for a drink. He talked. About his childhood in Reno, the Paiutes on the Pyramid Reservation, the miners, the ranchers, the silver boom, the gambling boom, the wedlock boom. He talked about books too, though not his own. And about you. He showed me the glow in the valleys of the mountains after sunset, when the peaks are already dark—he said you put that into many of your canvases once.... He talked for hours, always gazing across the lake—he talked about that too, its ancientness. 'Jurassic' I think he called it. He was fluent. He was fascinating. But he almost never looked at me, and any time I started saying something he cut me off. During all those hours he asked only one question and cut off the answer. At last I just looked at the lake too, and stopped listening. He was sealed.

I then theorized to Caples, Robert Ross in the story, that Clark/Asher was trapped in the personal and historical past: "It was as though the very sensitivity of his memory had caused the past to swamp the rest of his life from behind." Caples, I think, pegged this as a young man's theory, as surely it was, and made excuses for his old friend: that his years of teaching tired him of "young men and their ambitions"; that he felt called upon to lecture to me, a pilgrim "to the great man."

Well, a cherished brush-with-greatness is just what the encounter had morphed into. No wonder the unearthed *Bea & Sherman* excerpt had made me apprehensive, for it contained the irreverent record which memory had buried. I winced, thinking of the sanitized tale I had related to Bob Clark in all sincerity when requesting an interview. I'd had to tell him I couldn't recall terribly much about the day, because I couldn't, I'd repressed it. And I was still trading on the reverent anecdote in good faith to introduce myself to anyone I approached about Clark or Caples.

The irony is, I had good reason to welcome the correction of the record. For it hadn't taken much research and contemplation to bring me around—independently, so to speak—not exactly to that young man's interpretation of Clark's demeanor, but at least to a view of his life's trajectory consistent with the description. No, not the same theory, but the intuition holds up, that his past had in some manner made a casualty of Clark, that something had become "sealed" or scarred that might have remained fresh and growing.

Clark's first novel and the one that made his name, *The Ox-Bow Incident*, appeared in 1940. Over the next ten years came *City* in 1945, *The Track of the Cat* in 1949, and finally in 1950 *The Watchful Gods and Other Stories*, old works plus the title novella, a collection Random House published, surmises Bob Clark largely from conversations with his father, because *Track* had sold well "and they wanted to keep Dad happy." Really *Ox-Bow* and *Track* mark the boundaries of his one-decade run of major publications. He didn't actually stop writing fiction, though. He had reached forty. He would live just over two more decades. Spells of writer's block were to alternate with surges of productivity cut short by dissatisfaction.

Not that not writing well, even not writing at all, much less not publishing, spells human failure. Not a bit. But for himself Clark thought so, and in his case it seems so. He seized on the Doten project as a last best chance to jump-start his creative engine—and Clark did have a motor, as they say: he was known as a person of great physical and intellectual stamina. Where he intended to transform the substance of the journals into a novel of the epoch, instead he ended up becoming

Doten's editor, doing a service for Doten scholars—no unworthy job, just not what Clark wanted for himself. I don't believe he consciously foresaw this destiny, but there was prescience when he wrote in *City* that he/Tim feared time, where Robert/Lawrence had faith in it. How self-punishing was fifty-, sixty-year-old Clark. How unfair to himself. How intolerantly *young*, you could say.

 Clark never really outgrew a young man's values. Young Tim—young Walter without question—was "full of spontaneous hymns of praise and canticles of wonder." Those are Clark's words; that was his self-image. I think again of the near-perfect Bowers Mansion episode: "Then they all felt that the world was rolling over to expose the moon, and when this sensation finally expanded their space conception immeasurably, ... they clung to a flying world and felt confusedly the beauty and unhappiness of mortality." *City* is a fictionalized reminiscence of the process of growing older for someone in whom the capacities for youthful ecstasy and pathos flourished to an uncommon degree. But an idealized reminiscence. Clark registered age change happening in himself, then conjured an idyll of maturation, a fantasy of creative fulfillment achieved within a domestic paradise. The long-sought completion of Tim's symphony of leaves, crowned at last with its inspired title The City of Trembling Leaves, comes about by reason of the haven Tim has found within his idyllically adult marriage to Mary. This happy climax was meant by implication to certify—to anyone who knew the backstory, as more than a few Nevadans did, not least himself and Barbara—the happiness of the parallel, actual marriage within which Clark composed his novel of the same title. But the ending is the novel's glaring flaw, for the arcadia on Plumas Street doesn't ring true. That had been Hubert Saal's big complaint: "Tim never should have married Mary Turner. I didn't want him to. No one I know, after they read the book, will want him to, and I don't think you wanted him to." I agree, adding that Clark did not realistically portray what an artist's nuclear family life—what any life, for that matter, past, say, thirty—can be other than a preserve for further hymns of praise.

 Robert's trajectory of life was different from Walter's. Not to suggest that Robert discouraged praise as such by the mature. For doesn't the

fatherly, grandfatherly Potter, the creator of man in Caples' late-life book-length fable *The Potter and His Children*, "Praise the day!"? But there is more to a well-lived life than praise, which if overindulged behaves as a wasting asset, or even as a craving like any other that flips on itself to become its own negation. Once in a letter to Joanne de Longchamps Robert contrasted "praise" and "prayer." He was musing about youth and age, disclosing the prayerful attitude he had attained, though he didn't claim it baldly, he never would: "[W]ho knows how to pray in April?" reflected Robert. "Praise—yes. But prayer is a shy visitor. Prayer wears night feathers and lives in a dark tree, under the moon."

April's praise. I so much identified with Walter, with Tim. The "leaf-broken shining of the street lights." The "wanderlust of autumn." The "bewildering beauty of life." I too saw the stars "sink away from their common plane," and disliked to wear a hat as too unfree. Robert must have known me for such a youth of April when I was that callow fellow in 1963 and 1964 who hadn't seen enough of life to forgive the lionized Walter Van Tilburg Clark for letting himself become closed. Robert understood how that can happen, and for his old friend's sake made plausible excuses that such a one as I would comprehend.

Clay Turtles

City is divided into two Books of roughly equal length, each alone longer than many novels. Tim and Lawrence meet only twice in all of Book One, that is, before Tim graduates from high school. The first time is at Pyramid Lake. The Hazards and Turners are picnicking there together. Timmy adores little Mary Turner. For now we have to surmise what Mary thinks of Timmy. Readers will never know very much about Mary's inner life. We won't really even know what she looks like.

When Willis baits Timmy about his crush, he goes off by himself down the beach to regroup. Before long he is singing out loud, improvising a kind of aria/art song/hymn to the glory of the hot sun at Pyramid, to Reno, and to Mary. When he sees the other boy, Timmy takes him at first for an Indian, sitting upright as he is in the shade of a shelter the Indians use for drying fish, and his hair as black as it is and his skin as dark. But he is only very suntanned. Beside him on the sand lies an ancient-looking desert tortoise which the boy's father's car, we'll learn, nearly drove over.

They introduce themselves. Lawrence admires Timmy's "grand" singing—that's the way Lawrence talks. He has been deftly sculpting a turtle, using clay he collected at the shore in a bucket. He invites Timmy to make his own turtle. It isn't as easy as it looks. Timmy settles for making several smaller, baby turtles without so many details. Lawrence is the sculptor, Timmy the singer. Walter is showing us a meeting of budding artists.

The boys decide to build sand castles, envisioning a whole city for art lovers, with no army or police. They go down to the waterline, where heat wafts a taste of sea-life and minerals off the fine black sand and lacy windrows of fragile tiny shells shaded from white to black, made of the same stuff as Pyramid's imposing tufa castles. I can't be sure, having written that, what part is Walter's evocation, what added from my own hours and weeks at the lake. The place I first knew as Walter's and Robert's became a symbolic center of my own, if inseparable from them—symbolic being the operative word. The place defies proprietorship. I wonder if its Paiute residents feel the same.

Before they can complete the construction, Lawrence's father Mr. Black lands in a rowboat with his Indian fishing guide. (Why wasn't Lawrence out fishing with his father? I think because, as far as I know, neither Walter nor Robert had any interest in the sport.) Mr. Black addresses Lawrence as "Black." Tall father and tall son conduct themselves with the formality of two recently met adults who admire one another. Mr. Black invites Timmy—"Timothy" he calls him—to visit them. Timmy watches as they walk away toward their car with Mr. Black's heavy catch of cutthroats (Walter didn't actually identify Pyramid's world class game fish). Lawrence looks back, then raises a hand with slow dignity, like an Indian How. Timmy quickly returns the gesture.

Tim and Lawrence's second meeting takes place accidentally like the first, this time on the Blacks' front lawn while Tim forlornly wanders the streets of the Court Street Quarter vainly searching for any sign of Rachel. Since Pyramid, much has happened in Tim's life. Amid heights of pantheistic exultation and depths of anxious misery he has fallen head over heels for Rachel, won glory at school in a violent rite of passage, suffered excruciating humiliation in the eyes of Rachel at his first post-office party, discovered the exquisite little lake on the flank of Mt. Rose that years later will witness his loving renunciation of Rachel, enjoyed and suffered flights of poetic and musical creativity—all this and more in five or six weeks—"more than a month," Clark says. Yet the new friends who parted as playing boys meet now as adolescents. It doesn't add up. Hundred of pages later Clark says, more plausibly, that three years passed between the Pyramid and Court Street Quarter meetings.

But the inconsistency doesn't matter. *City* generates the dimensionality of a fine young life out of isolated vignettes a reader remembers in vivid detail. As I realized rereading *City* yet again recently, those vivid vignettes are *all* that Clark provided, they amount to dots he placed for the reader to connect so as to create, with the colored pencils of one's own imagination, a view of the young life in full perspective. It succeeds, and therefore any stretches and gathers in the fabric of time don't matter. The Jacob Briaski history may not jibe either. I doubt many readers notice such discrepancies. Subliminally

they may even add to the enigma of Lawrence, the fatality of Jacob. And to the book's poignant, ever-present theme, pathetic and profound: the mystery of time.

At Pyramid the day they first meet, Timmy takes Lawrence's cue in molding turtles. Timmy makes his smaller ones babies to Lawrence's large one, a detail signifying Lawrence's leading role; and by extension signifying, as I believe, Robert's leading role in the friendship with Walter. The boys part at Pyramid with one's slow hand gesture, quickly imitated by the other. This contrast, between Lawrence's containment and Timmy's reactive haste, exposes the dominance of one, the subordination of the other; as I believe Robert was the dominant one in that friendship. At their second meeting, Lawrence leads Tim into the backyard, then Lawrence draws Tim's attention to the leaves that look like fishes in the sunlight, then Lawrence shows Tim the painting he's working on in his basement studio. Lawrence's mind works out ahead of Tim's, who follows Lawrence's lead, always a little behind. Again, Robert and Walter.

"You must come and see us some time, Timothy," Mr. Black offers at Pyramid. Not 'We must see you again' or 'Where can Lawrence find you?' Later, whether in weeks or years, Tim does find Lawrence, not Lawrence Tim. That will be their pattern. We'll see in Book Two, after Tim has graduated high school, that usually for the friends to meet Tim has to go to Lawrence: either to Lawrence's studio (and Robert had actually set up already as a portraitist, chiefly of women, in the high-rent Clay Peters Building at 140 N. Virginia Street), or to the Blacks' house (and Robert was as a matter of fact living at Dr. Caples' house at 241 Ridge Street in the Court Street Quarter), and then to the cabin in the Peavine Quarter, under the influence of Mt. Peavine, when Lawrence and Helen moved there (1045 Bell Street, the small house behind the house at 1051, at the time on Reno's north outskirts, today deep in the university district). When Lawrence goes on a wander, Tim worries about his friend, but Lawrence sends not a word for many months. Really there's little to indicate that Lawrence ever dwells on Tim, wonders what's happening in his life. Walter's characters reflect the reality that it was he who oriented to Robert.

Thinking again about the Death Valley episode, I wonder if my initial, naive assumption of its fidelity to life was not constrained by Walter's drive to implicate himself in Robert's life. Artistic license or not, that's what energizes the scene, I now believe. So perhaps Walter's cathexis helped propel an already susceptible young man's misunderstanding.

Robert lived his final decades on an estate he called Turtle Hill. With lizard and fish, turtle was a totem animal of his, symbolizing, I suppose, the inward life and a long view of time, but also self-concealment and isolation through drink or depression. Walter's totem animal was the mustang stallion Tim once saw running on a slope at Pyramid, the stallion he imagines himself running with to find grace when racing on the track or free in the hills. Was Lawrence even aware of Tim's stallion? Again, Lawrence doesn't seem to reciprocate Tim's intense interest in the other's life—or only once did Lawrence do so, in a large painting he titled "The Promised Land" after Tim's song "The Sweet Promised Land of Nevada." But that painting was wholly a product of Walter's own imagination, corresponding to nothing Robert ever actually painted. It was Walter who dwelt on Robert's life, Walter who titled the chapter where Tim traces Lawrence to Death Valley "The Tracks of the Turtle." And see how Walter inscribed the copy of *City* he sent to Robert upon its publication: "Here it is, Robert—your book, a home grown product of the Indian Springs Ranch—and thanks for the loan of the Turtle. Love—Walter." Indian Springs Ranch was Robert and second wife Shirley's artist colony north of Las Vegas, 1940 to 1942. There Walter wrote a good part of *City*. I don't know what Walter meant about "the loan of the Turtle." It may have been code from almost a private language that cemented their friendship, something both Bob Clark and Rosemary remarked. But in any case the inscription typifies Walter's way of hearkening to something of Robert's as a way to reinforce their bond. *I love you, my friend. Love me.*

Walter's first bound book, privately printed, was a collection of poems, *Ten Women in Gale's House*. The long title poem concerns a painter, a roadster-driving portraitist of women! *Gale's House* appeared, ironically enough, in 1932, the year Robert—known for his fast cars—backed away from the easy success he'd achieved as Reno's portraitist

of women, a turn Walter would treat more or less realistically in *City* where Robert repeated as Walter's subject and inspiration.

Walter knew Robert's father, Dr. Byron H. Caples, and closely simulated the doctor's courtly formality in the character of Lawrence's father, Mr. Black, only making him a lawyer instead of a urologist—and why not? Reno is a city of lawyers. For some time law offices have occupied many of the Court Street Quarter mansions. And in another respect the fictional father in *City* differs from Robert's own: Walter described the lawyer as tall, whereas the doctor was quite short. Robert's artist friend Richard Guy Walton—who knew Byron Caples even better than Walter did, having through Robert's good offices earned his living for several years working for Dr. Caples when he headed Nevada's venereal disease program—Walton described Byron thus: "He was a very small man." And described Robert thus: "Caples himself—Robert was very slight, slender, about five-nine perhaps. Not five-ten, I don't believe."

Yet the Robert Caples one pictures is tall. Even Rosemary his wife described him as "tall and lean." Rosemary's son Denny thinks he was six feet. In life, Robert was lean, yes, at least when young; but tall, no. The realistic Walton's guesstimate wasn't too far off, although even he erred on the generous side with under five-ten. Robert's Navy Personnel Records reveal that at his physical in 1942, at age thirty-three, he stood 5' 8¾", weight 136, chest 35½", resting pulse 84, hair and eyes brown. Thin, certainly. And small-chested. With a rapid pulse, even for a nervous volunteer. During Navy service he underwent repeated hospitalizations. He had a history of respiratory problems reaching from his childhood infirmities to his death in 1979 of chronic lung and heart ailments. And Robert's hair was brown, not black like Lawrence's. By giving him black hair, Walter probably meant to accentuate Lawrence's likeness to the American Indian: Robert represented for Walter things genuine, primary. And not even five-nine, yet Walter made Lawrence tall and thin, like Mr. Black—Walter, who was a basketball player, though you wouldn't know it from *City*, where much of the dramatic action during Tim's high school years hinges on Tim's passion for track and tennis, individual sports. Excluding

him from team sports emphasized Tim's solitary nature. The choice may also have arisen spontaneously out of Walter's self-image—the adult Walter, for all his sociability, harbored the introversion of young Timmy. In an essay about his father, Bob Clark paraphrased something from *City* which amounts to the introvert's credo: "each of us is made less than what we are at our best by the presence of others." The line could have come from *Ox-Bow*, as Walter's judgment of the lynchers, of society. But why did the tall Walter make Robert tall in the character of Lawrence? Because subjectively Robert overshadowed him.

A Cowpoke Washes His Face

In an interview published the year of his death, 1971, Clark told how when he was returning to the West by train following his first prolonged teaching stint in the East, he looked out the window upon awakening, to catch a glimpse of "a cowpoke washing his face, and his horse was standing alongside the door." Clark saw the foothills, and beyond them the Rockies, whereupon he "burst into tears." This little story made the point that "it matters" being a Westerner.

Clark had as good a right as most authors we associate with the West to call himself a Westerner. If he was born elsewhere, so were most of this cohort, and not just the icons of the frontier—Mark Twain, Dan De Quille and Bret Harte—, but twentieth century writers as well—Zane Grey, A. B. Guthrie, Jr. and Wallace Stegner, to name a few. Moreover, Clark arrived as an eight-year-old, a younger immigrant than many of the others. In an author's bio he used to send out in response to inquiries, to compensate for not being native-born Clark massaged his bona fides by claiming to have been born in a "log cabin." He failed to mention that the natal cottage on Toddy Pond near East Orland, Maine belonged to a summer colony for prosperous families. The Clarks resided during the academic year in Manhattan, then later in West Nyack, a New York suburb on the Hudson.

Walter's father, Walter E. Clark, a respected economist and successful investor—"a financial wizard," said grandson David Chism, Walter's nephew—, chaired the Political Science Department at the City College of New York before moving his family to Reno in 1917 to become president of the University of Nevada. Expecting President Clark to put the small university on a solid footing, the regents met his demands of a huge salary, more than the governor's, and an ostentatious president's home built for him on campus—again, Walter the son grew up with servants, not by the race track like Tim in *City*, a choice that masked the autobiography and simplified the plotting, besides mitigating the inauthenticity that may taint the self-regard of young writers from affluent families. Walter had a son's nagging resentment for a father whose class values he rejects while benefiting from the father's

support—expensive tuitions, it had been in my case, and funds via Western Union when I was stranded, sent without complaint by own fond father, Dr. Shafton, no capitalist but successful in his field. In Walter's case it was clearance at the university, for example, to satisfy the master's thesis requirement with creative writing, and later, help finding teaching posts. Walter, son of the financial wizard—whose own father died when he was five, and who as a boy cleaned spittoons after school to support his family and later invested every free penny—that son refused on principle to open an interest-bearing bank account with his earnings from *Ox-Bow*. And this was after the stock market maven's comedown. "The Depression broke him," David Chism grimly confided. This man who dreaded poverty had meant to give each of his children a million dollars at age twenty-one, but the crash shrank his fortune from ten million down to about a hundred thousand. To make matters worse, the very year of the crash, 1929, he was accused of improprieties as university president. In 1937, he suffered "a nervous breakdown," then resigned and eventually moved from the campus mansion to a bungalow in a mid-range neighborhood. Walter did inherit some residue of "blue-chip stocks" when his mother Euphemia died—the only stocks Walter ever owned, his son surmises.

Where Walter's father was a self-made man, Walter's mother "never cooked a meal," claims a grandson, Gordon Chism, "until she was over fifty," that is, not until Walter Senior's financial reversals deprived the household of cook, maid and butler. Grandson Bob Clark found her "snooty." Euphemia (Effie) Murray Abrams, daughter of a prominent physician, was a product of the educated, civic-minded society of Hartford, Connecticut. She graduated from Cornell, then went on to Columbia to study piano and composition with the popular composer Edward MacDowell (Woodland Sketches). A liberal whose role model was Eleanor Roosevelt, with whom she corresponded, Euphemia gave up music for settlement house work and for her children, Walter (August 3, 1909), another Euphemia (1911), David (1913) and Miriam (1915), all born before the move West. The children woke every morning to their mother's piano playing. The fact that Tim in *City* is a composer betokens the influence on Walter of his mother, who oversaw his early

education and taught him violin. Also, the fact that Rachel in *City* does social work as had Euphemia may betray the Oedipal stamp of Tim's great love. While living East, especially while *Ox-Bow* and *City* were in process, Walter wrote long letters to Euphemia about his work and his life. These would have been "a trove" for a biographer; but Walter, Bob Clark said, destroyed this correspondence to keep it from prying eyes, first, for privacy; second, because a writer's work, he held, should be judged solely on its merits; and third, to preserve his "Western man" persona for posterity. Bob told both Benson and me that when Clark plotted *City*, he had to kill off Tim's mother because he found the relationship with his "cultured, encouraging but domineering mother" more problematic psychologically than that with his "Philistine, somewhat distant father."

After receiving his Master of Arts degree, the degree he partially fulfilled by a verse retelling of the Tristram legend, Walter went to the University of Vermont with a teaching fellowship for further study. From Vermont in 1933, Walter sent a manuscript of poems to Robert and Virginia in Reno, "as a reminder of one ... of the very few friendships which I continually hope will not terminate short of the inevitable termination." This may well have been the manuscript for the book of poems *Ten Women in Gale's House*, advertised without its title in Reno in 1932 as poetry by "Walter Clark, Jr." The bookstore Comptons' displayed the book in its window together with Robert's charcoal portrait of Walter from 1928. Although Walter and his father, who subsidized the self-publication, had different middle names, and hence they weren't technically junior and senior, Walter was commonly known in Reno then as Walter Clark, Jr., to distinguish him from the university president. Clark's friend Ray B. West thought Walter later published

Walter Van Tilburg Clark, 1928

using his grandiose middle name Van Tilburg because another Walter Clark was publishing soft porn at the time and Walter wished to avoid being mistaken for the other.

None of the Clark family members I spoke to, his two children, his son-in-law, and a nephew, knows where the name Van Tilburg came from. Walter's birth record from Orland, Maine proves the middle name not to be, as some have meanly surmised, a *nom de plume*— though funnily enough the "Child's Name" was first misrecorded as the even poncier "Walter Van Pilbury," later corrected to "Van Tilburg" in a different hand and ink. Bob Clark supposes the name came from the maternal side. Babs asserted that its provenance wasn't talked about. Could she have been implying it was because Walter's mother Euphemia Abrams was Jewish? Grandson David Chism affirmed that Euphemia was indeed Jewish, but that the fact was more or less suppressed. Euphemia herself denied being a Jew at least once in her twenties, to save an opportunity for a year in the Balkans as traveling companion to Emily Greene Balch, peace activist and *Nation* editor who would be awarded the Nobel Peace Prize in 1946. Balch, to allay concerns raised by her parents, assured them on Euphemia's word that the Abrams family wasn't Jewish.

Tilburg is the name of a university town in the Netherlands, a country with a large Jewish population before World War II. I'd guess the Van Tilburgs in Euphemia's genealogy were Dutch Jews, of Tilburg. It intrigues me that I, a Jew, gave Clark a Jewish name, Asher, in *Bea & Sherman*, without realizing at the time that his mother was Jewish. Walter didn't disclose his Jewish heritage in his "Autobiographical Information" nor in anything else of his that I've read, published or private. Nor do I remember any other Jews in half-Jew Walter's fiction aside from his shadow in *City*, suicidal Jacob Briaski the flawed violinist, and Jacob's parents. Walter's Jewish mother taught him to play violin. Through high school he practiced two hours every afternoon. In an early year of his difficulty producing publishable fiction he confessed to friends, "I kill a lot of time playing the violin."

Somebody from Fostoria

Both of Robert's parents came from Fostoria, a small manufacturing and farming center south of Toledo, Ohio. Fostoria was created in 1852 when the town of Risdon, where Robert's great-grandparents on the Caples side had settled, united with an adjacent village. Great-grandfather Robert Francis Caples came from Maryland, Great-grandmother Charlotte Laffer Caples from Pennsylvania. The Caples Street to be found today on Fostoria's east side memorializes the settler great-grandfather's son, doctor/farmer Robert Cole Caples, the artist's strict and silent grandfather and namesake. Caples Street runs along one edge of the Caples Division, a land speculation subdivided by Grandfather Caples. Robert's father Byron and Byron's older brother Ralph were offspring of the widowed Dr. Robert Cole Caples' second marriage, to Mary Elizabeth Barber.

Robert's father Byron Caples was born in 1877, Walter's father in 1873, in Defiance, Ohio, only some fifty miles west of Fostoria. Thus the friends' fathers grew up nearly neighbors in the same part of north-central Ohio. The fathers' biographies have other parallels, their sons aside. Byron's father, the doctor/farmer, died of complications from a traffic accident when Byron was still a boy; Walter Senior's father, a Methodist minister, likewise died when Walter Senior was a boy, of yellow fever. Byron and Walter Senior both came to Reno from New York, both died in 1955, and they were buried within shouting distance of each other.

Edith Jessie Richards Caples, Robert's mother, was also born in 1877. After attended grammar school together, Byron and Edith became doting sweethearts at Fostoria High. Byron's brother Ralph recalled that in restaurants the lovers would "order dishes which could be eaten with one hand so they could continue to hold hands." Edith later attributed Byron's infidelities to his lack of wide experience before marriage. They wed in 1899, as soon as Byron received his undergraduate degree from Oberlin College, just eighty miles east. Immediately the couple moved to Manhattan, where their first son John, Robert's older brother by eight years, was born in 1900, eight and a half months after the couple

honeymooned at Cleveland's best hotel, the Hollenden. Edith "many times" told her son John "that this coming to New York was her idea. She wanted to get away from the small town. She wanted father to

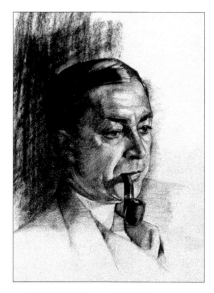

Untitled (Byron Caples), *ca.* 1930 Edith Caples, before 1930

follow his chosen profession of medicine in the big city and she herself wanted to get a college degree at Columbia." And so it happened. Byron trained and practiced at Bellevue Hospital, and Edith, with a domestic to help care for John at home, graduated in 1904 from Barnard, back then the women's branch of Columbia University.

(Here I must add a parenthesis concerning a small doubt raised about the circumstances of John's birth by his birth certificate. As expected, the father is shown as Byron, born in Ohio, resident of New York City, age twenty-four. However, the mother is not Edith but one Mary R. Caples, maiden name Mary Richards, resident of Ohio, age twenty-two. So the mother on John's certificate has a different name, a different age relative to Byron, and a different place of residence from Edith—an array of discrepancies not easily explained as recording errors. Was John's birth mother some relative of Edith's back in Fostoria?)

Edith had aspirations. The family lived for years at 540 W. 122nd Street in an apartment she found inadequate. Finally, in 1913, Edith selected a house, a brownstone at 349 W. 121st Street, with ten rooms, high ceilings, impressive woodwork, and a fireplace in every bedroom. "It was a fine old house," reminisced son John in 1933 before its sale, remembering "all the people who used to come up here from the Liberal Club in Greenwich Village, ... poets, writers, painters, sculptors—some of them have since become famous. My, the parties [and] the fine conversations that mother loved so well."

Caples as a boy in Manhattan, *ca.* 1915

Robert, born in 1908, was exposed to the cultured atmosphere on 121st Street until 1924, when at age fifteen he first arrived in Reno on a summer visit to his divorced and relocated father Byron. Like Walter, Robert was raised in New York City, but for twice as many years. The meeting of the two boys at Pyramid Lake in City is, therefore, a symbolic piece of make-believe. They almost certainly didn't meet at Pyramid, but if so, definitely not as ten- and eleven-year-old boys playing with clay turtles and sand castles.

Robert contended that "[o]nce acquainted with Nevada, [Byron] never returned East—and I mean *never*." That's not quite true: he returned at least twice for certain. Moreover, to the end of his life he kept his New York medical license current. In Reno he tended a garden of corn in the backyard of his home on Plumas Street in the late 1930s and 1940s. Byron's corn patch may well signify nostalgia for the corn rows of his Ohio childhood. At the same time, it wasn't only Edith who looked down on their hometown. John wrote: "I remember once when father and I were waiting for a streetcar,"—this would have been in New York City, before Byron's departure for Reno—"I said, 'Seems as if the streetcar will never come'—Father smiled and said, 'That's the type of remark I'd expect from somebody from Fostoria.'" Byron was something of a snob himself. While he always treated "charity patients with the

same deference he used for his regular, paying patients," son John told his own biographer, John wrote privately that his father "didn't want me in public school, mixing with the masses—the foreigners, the toughs, and the common herd."

In fairness to both parents, Edith rented out rooms in their expensive home to supplement the family income, often complaining of Byron's indifference to money. John's first wife Mabel came into his life as one of Edith's roomers.

Circus Stories

While driving east from Indiana on business—the business I would cheerfully close half a year later when I moved to Reno—, I took the opportunity to detour off the interstate to Fostoria. There the stars aligned again, as if to reassure me that I was right to be delving into the past: first I discovered Caples Street in the town of Robert's Ohio roots, and then, that Caples Street crosses Fremont Street, the latter honoring "the Great Pathfinder," Captain John C. Frémont, the non-Native American who first beheld thirty-mile-long Pyramid Lake and who gave it the name. In *City*, as in life, the friends camped onshore behind the Pyramid, Fremont's Pyramid as it used to be known. Behind that formation of tufa rising four hundred or so feet out of the water is also where Robert gave Walter a drink by the fire after his "fool swim to Anahoe Island." No natural setting figured so greatly in the friendship as Pyramid lake.

The street intersection was one happy discovery in Fostoria. Another, thanks to resources of the Kaubisch Memorial Public Library, was Robert's connection with the circus on both sides of his family.

Robert's Uncle Ralph C. Caples, Byron's older brother by five years, became a wealthy advertising man with a lavish winter home in Sarasota, Florida. A pioneering out-of-state resident of Sarasota, Ralph persuaded many celebrities to take up winter residence there, among them his friend John Ringling, who may also have been a client of Ralph's ad agency. It was Ralph who got the circus giant to move his headquarters to Sarasota. That's the circus connection on Robert's father's side, a tangential one, but of lasting import in the circus world. The actual show folk are on the side of Robert's bourgeois, rather uptight mother Edith.

Robert descended from an historic English circus family. His great-great-great-grandfather, strongman Thomas Cooke, founded one of the very first traveling circuses in the 1700s. Cooke's son, Thomas Taplin Cooke, brought the family circus to America in 1836, ambitiously erecting performance venues in New York and Baltimore. After both buildings burned down with the loss of all the horses, he went home to

reorganize. But Cooke's eighteen-year-old daughter Mary Ann, Robert's great-grandmother, stayed in America with her husband William Cole (no known relation to Robert's paternal grandfather, Dr. Robert Cole Caples).

Mary Ann and William worked at various circuses, she as highwire performer and equestrienne, he as India rubber man, clown, dog handler, and Chinese nondescript (whatever that is). After their separation and his death, she joined the Orton & Older circus out of Wisconsin, where at age forty-four she remarried to the owner's son, twenty-six-year-old Miles Orton. They divorced over his infidelity with a snake charmer.

Mary Ann had two children. Her son, William Washington Cole—universally known among circus folk as Chilly Billy for his reserved manner—, would found one of America's great circuses, the W. W. Cole Circus. Mary Ann's daughter, Jessie, adopted between marriages, was Robert's maternal grandmother. While the facts of Jessie's birth weren't passed down to Robert's generation, evidence I've pieced together from census reports, an obituary, a death certificate and a will suggests that Jessie was born in Iowa to a John Finn and wife from Ireland.

Jessie was nineteen or twenty in 1871 when she left the Orton circus to work in her brother's first venture, a small wagon show based in Quincy, Illinois. With Jessie came Albert E. Richards, whom she married in 1874. Robert's circus genes came from that marriage. Al was a gymnast and ringmaster, later a concessionaire, press agent, then independent promoter and vaudeville theater owner. Jessie was an equestrienne, did slack-wire walking and wire ascension, and organized an all-girl orchestra, claimed by Fostoria's *Review Times* as the world's first. She was performing on the high wire in 1877, the year she bore her first child, Robert's mother Edith Jessie Richards.

I was well along researching this family background when I discovered that not long before the Cole Circus disbanded, it listed Edith Richards as an equestrienne. She would have been nine years old. Somehow neither Robert in his many letters, nor John in his diaries and family histories, took notice that their composed mother Edith Jessie Richards Caples, with her Upper West Side tastes and cultural refinements, began life as a circus artiste.

After Al's death in 1892, Jessie traveled for three years in Europe. Someone must have been looking after Edith in Fostoria, since she graduated from Fostoria High. Jessie returned to Fostoria to live, but spent time in New York. In a photo from 1909 or 1910, an Edwardian woman who must be Jessie stands looking out from a porch in Fostoria, Brooklyn or Manhattan with her grandsons John and Robert.

"I'm not surprised" was Babs's reaction, upon learning from me that Robert came out of a circus family. So it wasn't part of Robert's story among the Clarks. You'd think that if Robert didn't actually boast of it, at least it would have been something for creative friends to smile about. Yet there is no trace of any of this in Walter's letters to Robert, nor in *City*, nor in Walter's biography of the artist, "On Learning to Look," written for the 1964 Caples retrospective exhibition catalog.

Jessie Richards (?) with John and Robert Caples, ca. 1910

It's hard to say how much Robert knew. He definitely knew that Edith's brother Will Richards kept up the family tradition, and must have known that Will's sons, Robert's cousins Jimmy and Bill Richards, had a nationally successful band during the big band era. Robert's brother John visiting in Fostoria heard Grandma Richards' circus stories—among them, that Edith "was born in a circus tent." John may or may not have passed such stories along. Robert himself wasn't close to his grandmother. He was back in New York after his first summer in Reno and about to turn sixteen when she died in a Toledo hospital. Edith and John traveled over to Ohio to be with her, but not Robert, who didn't attend the funeral. He sent his mother a telegram that was correct but remote, as though he were someone not very close to the mourning family. Robert was young and unsettled: his parents had recently divorced, his schooling was erratic, and it hadn't yet been decided where he would be living, with his mother in New York or his father in Reno.

"I'm not surprised," Babs said, a bit severely. Had a stereotype of circus folk aligned with what she viewed as Robert's bohemian irresponsibility around money and the license of his record with women? If so, Babs was being unfair to the circus relatives, whose family stability surpassed Robert's, to say nothing of their business acumen. My own reaction upon discovering Robert's big top antecedents was a delighted claim of kinship. A cousin of mine performed in circuses, "The Amazing Mr. Shafton, America's Premier Poodle Illusionist" and "Master Hypnotist." That's all I know about him. My Aunt Clara on my mother's side worked for a while in the Yiddish puppet theater in New York, and Aunt Deana wrote and performed in one-act plays with her husband John Sweet, whose acting career peaked in 1944 in England with a large role in a wartime Powell and Pressberger film.

The legend of Robert Caples makes him out as quiet and serious. Yes, but there was a touch of the sophisticated clown (and not-so-sophisticated clown) in his need to satirize himself and in his irrepressible appetite for whimsy, as his Mouse Series, largely lost, attests. To go by the legend he was profoundly private and solitary. Yes, but he was also convivial, and could perform, too, in his own way, putting on an artistic persona behind which he kept many things private. Robert also had a paradoxical streak of conventional correctness which he owed to both parents. That might explain why he never divulged, if he didn't, this circus lore to Walter, son of a university president.

Let Heaven and Nature Sing,
date unknown

Dr. Mouse,
date unknown

They Laughed When I Sat Down at the Piano

On the peak of Mt. Rose, resting with my son Matt among the hikers admiring the view, I struck up a conversation with a man who had read all Clark's novels. Scott had taken a writing seminar at the university from Robert Laxalt, Nevada's other heralded twentieth century prose artist, had gone to end-of-term meals at Louis' Basque Corner with Laxalt, and remembered daughter Monique's eulogy at Laxalt's memorial in 2001. For Scott, Clark and Laxalt were names that resounded. And Caples? Scott, an advertising man, knew of

John Caples' famous ad (detail), 1925

a John Caples who created the most emulated (and satirized) direct marketing ad of all time, "They Laughed When I Sat Down at the Piano But When I Started to Play!" My Caples, I informed Scott, was that one's younger brother.

John Caples (1900–1990) was just twenty-six and a junior copywriter when he composed the award-winning ad. An innovator of systematic market research as well as a gifted copywriter, John was quickly hired by a premier Madison Avenue agency, Batten, Barton, Durstine and Osborn (BBDO), where he became vice president in 1941, retiring at age eighty-two as creative director. In his day he worked on such accounts as DuPont, GE and US Steel. Three different advertising halls of fame inducted him. John is another legendary Caples, indeed more of a legend in his chosen field than Robert in his. And it is only on account of John's fame in a certain world that I was able to uncovered many things about Robert that would otherwise have disappeared as most lives disappear. For the advertising legend kept voluminous diaries, and these have been preserved with his other papers at the Smithsonian's National Museum of

Untitled (John Caples), ca. 1930

American History. All the recognition Robert gets from the Smithsonian in his own right is a folder containing a single clipping at the American Art Museum.

Even more of Robert would have survived in John's diaries, had the brothers been close. Sibling issues and differences of age, temperament and values conditioned their affection. In 1930, in Reno, the thirty-year-old and twenty-one-year-old discussed Robert's future. John wrote: "I'd like to sell him two ideas (1) Get a regular job. (2) Save a dollar a week" —a program that might have done Robert no harm, in moderation, as he once conceded. (In his seventies the Madison Avenue adman would still disapprove of his artist brother for never having had a "regular job.") They also disputed the relative merits of commercial and fine art.

> I maintained that the artist that designed a beautiful package for Old Gold cigarettes was doing a bigger and more useful job than the artist who painted a picture to hang in a museum [and] that the world was getting better due to mass production.... Robert claimed that these things were making the world worse because they made people all think and act alike.

Yet to characterize John solely by the Oxford-style debating position he took against his equally adamant younger brother would be misleading; for John's values were conflicted, really compartmentalized.

When small he hoped to emulate his doctor father, but as his parents grew estranged and with Byron favoring Robert, John came more under his mother's sway and "switched from medicine to literature," deciding to become a novelist as Edith had once dreamed of becoming. John's education was bumpy. In high school he developed a public speaking phobia so severe it would force him to drop out of Columbia. He enlisted in the Navy, then through an officer training program reached Annapolis (where he wrote poetry), then upon graduation opted out of his commission. Soon an old mentor of his mother's advised John that a job in advertising would hone his writing skills while earning him a living. Thus literary ambition led him roundaboutly into his very successful vocation. Although eventually John became an accomplished teacher and speaker in his field, he never overcame shyness. "Wouldn't

it be wonderful," he fantasized at fifty-one, "if at long last I could learn to mix with people pleasantly and easily without feeling too much inner strain." He turned his social unease to advantage in devising the psychology of his ads: the little guy dreams of coming out on top.

When John proudly showed his mother the ads from his enormously successful first year, he was taken aback by her reserve about "Overnight I stopped being the underdog" and "60 Days ago they called me 'Baldy'!" Edith "made it painfully apparent" that her son "had become the wrong kind of writer," and warned him not to show his work to Byron. John never drew the moral; resolutely he rationalized not only the creativity of his occupation but its social benefit: if an ad made the customer think she was getting more than her money's worth, "That is what you call 'illusion.' And life is full of illusions. It has to be. Otherwise more people would become mental cases."

"He has learned," continued his biographer Gordon White, another BBDO vice-president, "that *self-interest* dominates all!" Once when his father attended a lecture John gave on the subject, Byron grew "quite upset," for the doctor believed in altruism. "Caples tells this little story ... to show that he really does understand and respect the altruistic point of view on life, even though he cannot endorse it when it comes to writing advertising appeals."

No doubt John possessed altruism. He advised or served on the boards of several major charities. The wish to be "of service" is a recurring theme in his diaries. However, John displayed astonishing blindness to the conflict between service and self-interest. Service gave him "peace of mind. Why? Because ... people will want to protect me and keep me around." The naive pathos of this aspiration places it beyond a charge of cynicism.

John, who over the years authored several widely read books in his trade, went on imagining himself a literary writer. He conceived of an autobiographical novel, created from segments of his diary. Its publication would be a kind of service: others would benefit from reading the story of his life. In 1963, he did actually submit such a manuscript to respected editors he knew at Harper. I can well imagine why he received a polite rejection. A formal, impersonal tone detracts from much of the diary, all the more after his literary pipe dream took

root. There are scant disclosures, much less outpourings. Increasingly he kept a pane of security glass between himself and his emotions, apart, that is, from his chronic shyness and its repercussions. Mostly he recorded without much affect how he slept, his health, who he saw, what he accomplished. A man of rules, he settled into the routine of handwriting exactly one 8½" × 11" page a day, edge to edge and top to bottom—some four million words, enough for fifty books. It made for tedious, interminable reading for the sum of weeks I required myself to spend over it in Washington. John's richest reports about Robert, I found, come not from diary entries but from short free-standing memoirs of childhood. Written before middle age, these stories are more expressive than the diary, having been generated, I judge, to vent an unacknowledged resentment of the little brother John's revered father preferred.

John's affection was compromised by defensive condescension. Robert, apprehending as much, apparently never disclosed Lawrence Black in *City* to John. And Rosemary, when she spoke to her brother-in-law in mid-July of 1964, didn't discuss with him the September 15–October 15 retrospective exhibition about to open in Reno, possibly the pinnacle of Robert's career (though Robert didn't think so). Either that, or John didn't bother to record the fact. One explanation is as indicative as the other. John nowhere, until after Robert's death, commented substantively about Robert's work, not when talking about Robert, nor about art or literature, as far as I discovered in his archive. The Madison Avenue adman never figured the jobless artist out. Or if he did, to acknowledge the other's perspective would have been to admit that he himself had failed his own inmost values.

You'd think that John must have acknowledged the existence of a brother to his biographer. He didn't. Turning it around, neither did John exist in Robert's notes to Walter for the retrospective foreword. Walter, knowing better, mentioned "an older brother." In later years Robert grew to overlook John's emotional obtuseness for the sake of family ties. Still, nowhere in Robert's many letters that I've read did he allude to John, except once, when he lightly disparaged his brother for being so "exact-minded" as to plan his Christmas holidays in March.

Byron Is Ruining That Child!

His parents' marriage "went well during the first 7 years," adult John reflected in his diary. "Then in 1907 came Mrs. Noland from Virginia, a patient of father's with Southern charm.... Mother was not noted for her charm." Mrs. Noland, just divorced from an institutionalized husband, was received by Edith as a guest until the state of affairs became clear when the interloper moved into a nearby hotel. Whereupon Edith began unburdening herself to seven-year-old John. Byron, who had begun to affect Mrs. Noland's high-toned manners, smirked Edith, justified himself by renewing an old complaint, that Edith had pushed him into medicine instead of encouraging his ambition to become a singer. Edith told him he didn't have the range. I suppose she'd seen enough of the performance world as a child.

Robert was conceived to save the marriage, even though Edith didn't really want another child. A friend of hers confided this to John after Edith died in 1930. And "for a while it worked. Your father was fascinated with Robert." Meanwhile, Byron carried on with Mrs. Noland. Then around 1915, he took up with his office nurse, Sarah O'Brien. They rendezvoused at a downtown apartment he rented. It was Sarah O'Brien who accompanied Byron to Reno in 1923, when Edith wouldn't grant a divorce in New York. "Mother said, sarcastically: 'Why does he want to marry her? None of her other men friends thought it was necessary!'" That was the kind of remark Byron found "rasping," an off-putting style Edith apparently got from Jessie: when Edith's brother Will told their mother that he was going to run away from home, Jessie retorted to the boy, "You don't have to run. You can walk." That was Edith's favorite story about her mother.

Edith would die in Reno, in a spare bedroom of Byron's, who had accepted her plea for care. She died of uterine cancer that developed from a fibroid tumor already present when Robert was conceived. It caused him to be born prematurely. Edith was unable to breastfeed.

Having myself grown up in an educated, liberal, twentieth century

family, I struggle to imagine such a family, and a doctor's family like mine at that, where an eight-year-old son would not have been told his mother was expecting. Yet so it was. Nor did the parents announce the birth, nor introduce John to his new brother. A private nurse did that, and from her John learned Robert's name.

Robert was Byron's favorite, John knew, and Byron Robert's. Robert "said 'Papa' before he said 'Mama.'" One day when Byron was blowing smoke rings for him, the two-year-old exclaimed, "Bobba 'moke!" Next day Edith claimed that Robert had said "Mama" months previous, but she wasn't believed. I would never have predicted from Walter's one-dimensional descriptions of the "courtly" Mr. Black in *City* and the "courtly" Dr. Caples in the retrospective exhibition essay that Byron was the sort of indulgent father he was to Robert. But such he was, by John's account. He allowed Robert to climb on the dinner table, "knocking over glasses and pitchers…. Mother and the maid [Rose] were horrified. 'This is no way to bring up a child!'" they protested, in Byron's absence.

Byron spoiled Robert; Edith withheld affection from Robert as well as from Byron; Edith gave affection to her older son John; John hero-worshiped Byron but clung to Edith while resenting Robert—that looks to have been the family dynamic. John's twelve hundred word memoir, "When Robert Was Three," might well have been subtitled "Why I Resented My Little Brother," had John been more candid or self-aware. John's memoir recounts Byron's ploy for getting Robert to eat his breakfast. I grinned when I read it, to learn that the first story Nevada's virtuoso of mountain paintings heard as a child, as far as we will ever know, was about a mountain.

> "Once upon a time, a long time ago, there was a mountain in a far away land," said Father to Robert one morning at breakfast, point[ing] to the pile of oatmeal in the cereal bowl on the tray in front of Robert's high-chair. Father had a fine baritone voice and Robert was entranced! Mother watched with a resigned attitude. She didn't believe in baby talk. "Along came a big wind," said father. He made a sound like the moaning of the wind. "The wind brought a snowstorm and the snow fell on the mountain."

That was the sugar. The mountain became a volcano, with cream for lava to melt some of the snow/sugar, then milk to finish the job.

> "And what do you think happened after that?' said father in that same tone of wonder and amazement. Robert looked at father expectantly. "A little boy came along and he took a spoon in his hand and he ate up the whole mountain!" said father.

And when Robert had done so, Byron showed him what the boy found under the mountain: the three little bears, painted in the bottom of the bowl.

After that, Robert demanded the performance again every morning, until one day Byron was absent. When the "colored maid" Rose tried to give Robert his oatmeal, he threw a tantrum. "Then mother's face flushed. She said sharply, 'Stop this foolishness and eat your cereal!' She clapped her hands with a sharp crack." After hesitating, Robert ate. "During the next two years," John continued,

> Robert developed two patterns of conduct. When father was around, Robert demanded and got fairy stories, games, soothing talk and pats on the back. If anything bothered him, he yelled and screamed and father came running to his rescue.
>
> "When Byron is around, Robert is impossible to handle," said mother. "But when Byron is away, Robert behaves himself like any normal child. He stays in the kitchen with Rose and draws pictures and plays with his toys. Then along about five o'clock, Robert knows that his father will be home soon and Robert becomes difficult. He cries when the least little thing annoys him and by the time Byron arrives, Robert is usually bawling at the top of his lungs! Byron calls out, 'What are they doing to my boy! Oh, what are they doing to my child!' Robert hears him and lets out piercing screams! Byron runs up the hall and picks up Robert in his arms and pats him on the back and says, 'There now, there now, Papa's home! Everything is going to be all right!'
>
> "What does that kind of carrying on do to Rose and me," said mother. "It makes monkeys of us! We can't spend all day entertaining Robert. I tell you, Byron is ruining that child!"

That was Edith's view, and the view that John would hold throughout Robert's life, that he was spoiled. Three months before his death in 1979, Robert phoned John to say that Rosemary was determined they would go to Greece again, and that even though his health was poor, he really didn't have much choice. John's ruminations over the call, although lopsided, do get at dimensions of Robert's relationship to their father, to money, and, no doubt, to women:

> Tough. A psychological novel could be written about a man who grew more and more dependent until he became completely dependent on the say so of someone else, and on their money. Whose fault? Father left for Reno in 1923, when Robert was 15 and failing in school. Nobody to discipline him. And mother was never good with me or Robert in seeing to it that we did our school work. After I left Annapolis, I tried to discipline him. It didn't work. He left for Reno where father spoiled him with money and no regular schooling. And gradually he came to depend on someone else to support him.

Couldn't Spell League

The first story we know Robert heard concerned a mountain. And his earliest artwork to survive depicts mountains. John's archive contains a single juvenile drawing of Robert's. The draftsmanship is boyish, as is the subject, but what stands out is the dynamics: on eager chargers jousting knights lean forward into the clash with helmet plumes flowing, against the background of still mountains and castle. Robert Caples of New York's earliest known drawing depicts bare Nevada-like mountains.

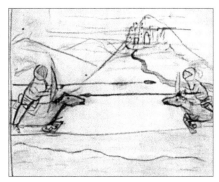

Untitled (jousting knights, with mountains), Caples' earliest extant artwork, date unknown

It was Edith who first encouraged Robert to draw—"just to keep things peaceful," as Robert recollected in a unique radio interview while back visiting Reno in 1975. Yes, Robert did visit Reno after moving away. Interviewer George Herman of the university's English Department asked, "When did you begin to draw, as one might say, consciously?" "I started drawing long before I undertook to spell or write anything," Robert replied. "I communicated to myself and others through drawings and scribbling." Robert had told Herman in a pre-interview conversation, Herman then reminded him, that "drawings made things real to you, that it was a way of taking possession of them. ... What did you mean?" Instead of being drawn into art-speak, Robert opted for an underspoken reply about "play-acting on paper":

> [A]t that time I did draw things in order to make them come true. I found that if I drew a battleship, why I could then draw a torpedo and sink the ship, and arrive at results that were seeable, they were there: tangible results. Or if I wanted to burn a building, I'd draw a fire engine and get everything ready, and then draw the flames, and then the engine would come tearing in, and the whole event was very real to me.

Most of what else can be known about Robert's pre-Reno artistic activity is summarized in "On Learning to Look," the foreword Walter wrote at the invitation of another notable Nevada artist, Craig Sheppard, chairman of the university's Art Department, for the catalog of the 1964 Caples retrospective exhibition mounted as the department's contribution to the state's centennial celebrations. By then Walter was already bogged down in the Doten project and having grave problems completing that assignment or any of his own work. As I imagine his frame of mind then, he must have jumped at the opportunity to reconnect in a substantial way with Robert to reconsider the past through this occasional piece, which against form he seems to have delivered on time without difficulty. The essay has a fluency, or rather a pleasantness exceptional in Walter's later writings.

For research Walter prepared two documents. One, not preserved, pulled together data about Robert's works for him to comment upon. Robert responded by letter. The other document was an "impertinent" questionnaire with spaces left for Robert's answers, some of which overflowed and buried Walter's next questions—thereby graphically asserting Robert's resistance to containment, something evident also in the polite contrariness of the answers themselves. This business of being questioned directly about himself, on top of the anxiety and depersonalization of a retrospective exhibition in the first place, went against Robert's grain. Although expected to attend, he didn't. Yet agree to the exhibition he did. And answer Walter's questions he did. He had not lost all appetite for recognition.

Walter's essay, "On Learning to Look," subtitled "a Note on the Working Life of Robert Cole Caples," took one of Robert's answers as its organizing theme:

> To be aware. I must remind myself. To look with awareness. How long it takes to find that out. To look with, to look for, to look through—not to look *at*. To look in every way except 'at'.

Walter himself had earlier and on his own behalf authored a dictum to the very same effect—"The eye has to look *through*"—in connection not with visual art but with spontaneous creativity in fiction. Walter wrote the

article containing that sentence in 1959, then revised it for publication in 1962, a few years before Robert's replies for the foreword. I don't know, but I conjecture that Robert had shared the thought with Walter during their days as young friends in Nevada, that Walter had long ago integrated the idea, and that now he seized upon it for his biographical essay, running with it, making it more decisive than Robert intended.

Walter's structure is somewhat forced, or simplistic, built as it is on this idealization. When I interviewed Bob Clark in Helena, he told me his father "idealized almost everything." But that hardly matters here, because of a more insistent impression the piece makes, which is of reminiscence and of fondness transcending the essay form and the purposes of art criticism or biography. It emanates, this aura, from the eagerness brought to the portrait of an old friend, and from its flourishes, such as the description of the Caples Manhattan brownstone. There is an intimacy palpable, I imagine, even to readers unacquainted with the back story, who might wonder whence arises their empathy and slight discomfort. From unavoidable eavesdropping. The reader witnesses an undemonstrative man, one who never hugged or kissed, his son says, making an implicit declaration, *Robert, old friend, I have always loved you.*

A comparison of Walter's foreword with Robert's information for it shows how much Walter retained from bygone times about Robert's life, details Robert didn't think worth elaborating here: his boyhood study habits, for example. Robert played hooky from school in the basement of the 121st Street brownstone, where he explored mind-expanding books by the likes of Stevenson and Dickens. Eventually his report cards and wan appearance gave him away. At twelve his parents tried something new. They sent him to the stodgy National Academy of Design. Walter might have said, but didn't, that a novice could have learned a good deal there from "Drawing from the Antique," however cramped the approach or unsympathetic the teacher. But Robert was gone after two weeks and back in school, where "things went no better." Then came a stint at the more up-to-date Art Students League of New York, from October of 1923 through February of 1924, five months. He would later enroll there again with more inner direction as an adult after the Navy. Why didn't he stick there as a boy?

His explanation is vintage Caples at his charmingly obscure best: "Couldn't spell League—didn't sign up again. The woman with glasses said, 'Too many vowels?' I went down to the Aquarium." The explanation isn't an explanation, unless you accept it, as you almost must, as spontaneous Imagist poetry. Then emerges the persona of the irrepressible free spirit. Taking the bait, Walter quoted Robert verbatim and without comment, instead improvising on what we are to imagine were young Robert's spellbound perceptions at the Aquarium: the empty solidity of illuminated tanks with their circumscribed spaces transected by living occupants. This is something else Walter had written about previously, almost two decades earlier, in "The Fish Who Could Close His Eyes," a short story drawing on a summer job of Walter's feeding fish at the Scripps Institute of Oceanography in La Jolla, where President Clark vacationed with his family. In the foreword for the retrospective, was Walter projecting experiences from his own past onto Robert at the New York Aquarium? Or did Walter's short story absorb Robert's aquarium experience from a long-ago conversation? I incline toward the latter.

In any event, Walter was satisfied that Robert was "possessed" early by artistic "urges" which "wrought havoc in the realm of what might have been his formal education." Such a soul couldn't be constrained by "the dull regularities of school." This reductive analysis, while aiming to be the opposite and while true to life as far as it goes—for Robert was a free spirit—, suppresses the real possibility of causes—emotional, cognitive—which may have contributed to academic failure. Walter's idealizing ignores the likelihood of a lower layer beneath "Couldn't spell League." While purposely misdirecting Walter with the-artist-as-a-young-man, at the same time Robert, with an intuitive introvert's sense of exposure, may have believed that by this hint he was disclosing something more: a disabling resistance to following instructions, or a learning disorder, or deep feelings of inadequacy. Feelings of inadequacy dogged Robert his whole life. Of fellow Nevada artist Craig Sheppard Robert later wrote, "I always feel clumsy and inadequate around people who appear to know exactly what they're doing," adding that a certain Sheppard painting "has haunted me pleasantly as one of the most effectively beautiful jobs ever."

Shipped to Father to Be Straightened Out

"Ever since he was a baby he has had that awful cough. And never very strong health. Poor Bo." So wrote John in 1928, upon learning that Robert had contracted tuberculosis. The diagnosis proved false, but his health was bad enough. Byron and Edith had agreed in 1924 that Reno's clean, dry air would be good for him. This at least was the half of the truth Walter already possessed for his biographical foreword when he received Robert's questionnaire answers, where Robert flippantly evaded his respiratory problems with the other half, that he'd been "shipped to father to be straightened out."

Actually, Robert went canoeing with John in Canada first. Robert "said it was the best he ever felt in his life" when on a day of high wind they surfed their canoe on Lake Champlain. He then, as planned, spent the rest of the summer of 1924 with Byron in Reno before returning to Edith. The *Nevada State Journal* "Society" column reported that the doctor's fifteen-year-old son "Billy Caples" left for New York to attend "a boys' school." They got his name wrong, but his age right. Edith enrolled him in Dwight, a college prep school on Park Avenue. But apparently he crashed again. Whether in his best interest or from perplexity, Edith dispatched him back to Reno, this time for good. Quite likely Robert asked to go back. His indulgent father was there; the handsome youngster had already found his social footing in the big-little city of fifteen thousand; and he had discovered the Great Basin.

Robert was "awestruck" by the Basin, especially Pyramid Lake: "Lord, but that first view of that blue water was an event. Such unexpected beauty really hurt. It was like being struck with the sky." Anyone who has made the bend coming over low Mullen Pass on a bright day will appreciate Robert's description. By now I've met that vista at least a hundred times and it still opens my eyes wide. The general landscape took longer to make an impression on young Robert, however. In *Bea & Sherman* I recreated a little story Robert told me at Turtle Hill:

> "I came to the Great Basin as a boy, from the East. Of course I had in mind the Easterner's movie version of the desert—sand dunes, cactus, painted buttes.

My father took me for a drive. After an hour he turned back to Reno. I asked why we weren't going all the way to the desert. He said, 'We've been in it since we left the city.' I guess it took me a year to get over that disappointment."

As for Robert's education, Walter's daughter Babs told me unequivocally, "He never went to school here." That's at least essentially true. Once relocated, he wrote to John asking to be sent his Dwight textbooks; it seems he "rate[d] special" at Reno High School with some kind of temporary admission: "it was the best I could do until the first of the year—then I can get in as a special at the U." He presumably meant enrollment without a high school diploma. But nothing came of it. Nor, if he did attend Reno High, did he get beyond eleventh grade. Aside from two University of Nevada summer session courses in 1926 (French and Psychology), that was the end of Robert's standard education. The traditionally educated, socially prominent Dr. Caples assented to an unorthodox direction for his gifted son. This "courtly" father of Robert's, whose "unfailing manner" the tightly-wound young Walter found restorative when he would join Robert for dinner at the doctor's house a number of years later, was something of an original himself. His correctness was deep-seated ("so polite he's impenetrable," Walter once said of him), yet he had the freedom of thought to approve unconventional behavior. Thus Robert became a high school dropout, to draw and paint and study on his own, under Byron's patronage. In *City*, Walter admiringly described his self-motivated friend's basement studio in Byron's house at 241 Ridge Street: a long sloped worktable topped by a level space holding Lawrence's supplies; an easel leaning on a post in the middle of the room; a shelf of mostly art books; a west window and drop lights; a cot for napping, and above it a plaster Parthenon frieze. These were the sorts of details in *City* that led Robert to praise Walter's "amazing recall."

One painting from this period survives, a 1926 portrait of the son of a transplanted Brooklyn gas tycoon, Ralph Elsman of California, who built his summer home on two thousand acres in Washoe Valley between Reno and Carson City. The *Journal* noted the display of "Reno boy" Robert Cole Caples' portrait in the window of Brundidge's, the art supply store. The sweet painting exhibits impressive

technical skills for an artist of so few years and such limited training. But its Flemish master ambience bespeaks the limitations of the young artist's grasp of modern styles.

The "Society" column marked his departure when Robert voyaged through the Panama Canal to spend the summer of 1927 with his mother in New York. Then, back in Reno, and three years after "Couldn't spell League," he decided to try art school again. That fall he attended the Santa Barbara Community Arts School. He was still thinking he might go back to New York to live, but was hindered

Untitled (Ralph Elsman, Jr.), ca. 1926

by poor health and lack of funds. So in 1928–29 he returned to the California coast for a full school year. SBCA (1920–33) exemplifies the flourishing of the arts after World War I. It came into being through the efforts of local people of means and a colony of accomplished artists in all fields. Its style was modernist, but not *avant garde*, as typified by its most famous faculty member, British composer Arthur Bliss.

Robert's training at SBCA proved to have a crucial indirect impact on the course of his career. His teacher there was Frank Morley Fletcher, another of the school's British contingent. Neither Fletcher's Western landscapes, influenced by Japanese woodblock prints, nor those of Fernand Lungren, the school's director, impacted Robert's own later landscape style. Nevertheless, it was under Fletcher's instruction that Robert executed his first surviving portrait drawings from life. And one of these, of Native American Geronimo Mirabel, when later displayed with another of an Indian in Brundidge's window, won Robert, he believed, his Federal Art Project assignment to draw Indians, his "best break ever."

Geronimo Mirabel, 1927

Almost a decade would pass before Robert sought any further art instruction. In 1938, Lillian Borghi in Reno's *Gazette*, keeping track of Robert, had him studying oil painting over the summer with the noted author on technique Frederic Taubes. Actually, Robert studied under Taubes then for just one week, as Dick Walton recalled. Robert, living again in Santa Barbara, generously invited Walton down, all expenses paid, to get in on the week-long "special seminar" Robert had hired Taubes for, a luxury afforded by second wife Shirley's money.

Robert's next formal instruction came during the summer of 1940, at San Francisco's California School of Fine Arts. Perhaps he felt a need for further training after backing out of a mural commission on Treasure Island in the Bay, overawed by Mexican master Diego Rivera at work there with a score of assistants. In a matter of months he and Shirley left San Francisco to established their Indian Springs artist colony near Las Vegas, again on Shirley's money. During Robert's two years there, several teachers and mentors stayed in the guest houses, among them Taubes and influential printmaker Stanley William Haytor. Another was Greek artist Jean Varda, friend of Picasso and Henry Miller, later renowned as the colorful and priapic genius of the bohemian/beat Sausolito houseboat scene.

Robert's further art training was concentrated after World War II and the Navy. He used the GI Bill to enroll again at the Art Students League in New York. Illness forced him to withdraw after three months; then following recovery he re-enrolled, for courses scheduled to run from mid-September, 1946 through May, 1947. After his brief third marriage ended, he moved back to San Francisco, transferring his GI Bill benefits to the California School of Fine Arts, where he studied for another year. From both these postwar art school experiences he took encouragement from his fellow students' commitment to the path of art, at a time when he was deeply discouraged.

And that is the extent of Robert's formal art training, less than many artists, but as much as or more than some, for example Whistler, Degas, Van Gogh, Duchamp, Pollock and Johns.

Scraps and Scrabbles

In spring of 1939, Robert went to Goldfield in central Nevada to sketch. A boy of the semi-ghost town saw him at work and hung around. On and off over several days the thirty-year-old and ten-year-old, another Robert, "talked about drawing and painting." Our Robert was a better teacher than pupil. Thirty-five years later, the boy's mother published a Christmastime reminiscence in the *Journal*:

> Robert [her son] never mentioned his new friend. I was surprised, when in the mail shortly after, came a letter to Robert and a package. It held expensive artist paint brushes of all sizes. The letter of four pages, written with a brush in brown, told him how to use, clean and care for them. A little picture of a house, a cloud and a mountain illustrated his instructions.

Boone Hellmann, son of Robert's architect friend Ray Hellmann, related how when his brother Taylor was just three or four, they were left alone where Robert had a makeshift studio in the Hellmann home under construction. Little Taylor got busy on an unfinished painting of Robert's. When Robert found out, instead of becoming angry, he told the child, "You actually made it better." The boys were "captivated" by Robert, "an extraordinarily nice man, who seemed to like children." Taylor grew up to be an artist.

"He loved to teach," volunteered Rosemary Brittain, daughter of Robert's last wife (known as Rosemary Senior). "He tried to teach me how to think," said Denny Lake, Rosemary Junior's younger brother by four years. "You could ask him anything."

Yet Robert insisted that he wouldn't be qualified to teach any subject, not even art—perhaps least of all art, he claimed. As far as basics and intermediates go, or art as expression, that's certainly false. But as for advanced technique, perhaps he rated himself correctly. It's not that he wasn't technically-minded, as proven by the copious notes on procedures and experimental protocols he left. For example:

> drawing established with soft charcoal—pastel (greenish grey) and light rub of charcoal powder. Lights built with eraser—slight pastel color rub—red—

Lacquer—shellac—Thin oil-varnish medium, grey + b. umber—no white—in upper reaches—Raw sienna + white + grey + umber—lower half—Whites in sky and middle mountain found with cloth—rubbing back to original charcoal forms (one touch, thin white, summit cloud.) 5½ hours –/ later: 1 hour—white brushed into middle passages. Several contours altered (by lamp light)—(black added)

The Remembered Mountain, 1962

The Remembered Mountain (detail), 1962

But such attention to technical detail notwithstanding, Robert never attained thorough competence with materials. Once searching online I came across an inquiry by the owner of a Caples painting. Stephen Schaubach had been living with a work he'd picked up at an estate sale for a hundred dollars, and was seeking information about the artist. I recognized *The Remembered Mountain*, which happens to be pictured on the same page of the 1964 retrospective catalog as my wedding present from Robert, *Dark Range*, both of mountains, both painted in 1962. Schaubach didn't want to hear that the painting's unusual textural effects, beloved by him, resulted from unintended deterioration. I don't think he fully accepted the opinion I solicited from Sara Frantz at the Nevada Museum of Art:

> Caples tended to experiment with materials and use plenty of non-archival substrates, resulting in damage such as you see.... I'm sure that is not how it looked when he finished it, so yes, I would think it needs some type of conservation. (As much of his work does....)

Robert, I think, was hypersensitive to impingements on his boundaries; he required a high degree of self-sufficiency, could tolerate only so much guidance before losing his sense of self. As a result, in spite

of the packets of instruction he sought from time to time he remained largely self-educated as an artist, with the autodidact's strengths and weaknesses: on the one hand, assimilating disparate information to an independent viewpoint while making connections uninhibited by a standard curriculum; on the other hand, losing the advantages that come with collective knowledge: accelerated learning, useful guidelines, appropriate restraint.

If this was true of Caples the artist, all the more was it true of Caples the intellectual. And without question the high school dropout was an autodidact intellectual. To Ken Robbins, business manager and friend

Caples napping, probably at 1045 Bell Street

at the University of Nevada Press, Robert wrote just months before dying, "so much to do, so much to learn. And that hurts most of all, so much to learn. They told me when I was young but I was too busy looking to listen." Too busy looking? Not really: at the Peavine cabin, Robert (Lawrence) was reading Swedenborg the visionary spiritualist, Havelock Ellis on human sexuality, and Frazer's *The Golden Bough* for mythology. A snapshot of Robert napping at what I think is the cabin shows a small, well-provided bookcase. Robert continued his thought to Ken, "Now I start reading at six in the morning, hoping to make up. I

like to believe that it helps—yet, deep down inside, I know better; it's an illusion." An illusion? Of course an illusion: more than anything at the Peavine cabin Robert read his "little leather pocket copy of Buddha."

Robert's library at Turtle Hill included dictionaries of Sanskrit, of English (*The Oxford English Dictionary*, no less), and of The Bible. In that epoch he read fiction (including Wallace Stegner and Nikos Kazantzakis) and poetry (Whitman, Dickinson, Frost and Eliot were favorites, along with Donne, Shakespeare and Blake). Also travel and Nevadiana (Wheeler's *The Desert Lake* about Pyramid Lake, for example), also astronomy, particle physics, anthropology (Ruth Benedict's *Patterns of Culture*, Theodora Kroeber's *Ishi*), archaeology of the Middle East, biology (e.g., Lewis Thomas's *Lives of a Cell*), psychology, and all flavors of religion, along with Joseph Campbell's then fashionable integrations of world spirituality. Though he mastered none of these subjects, his world view absorbed something from all of them. His 1971 book *The Potter and His Children* contains echoes of North American, Mesoamerican and Greek mythology, Plato, African practices, Hinduism, Judaism (he read a verbatim translation of the Old Testament), Christianity, Gnosticism, several varieties of Buddhism, along with physics and genetics.

That said, Robert was intolerant of what he judged to be mere intellectualizing, as I learned from his reaction to a 1976 monograph of mine on the subject of paleopsychology. I strove in vain to convince him how deeply embedded humanistic concerns can be in the seemingly dispassionate scientific "literature."

One of Caples' "scraps and scrabbles," date unknown

Another of Caples' "scraps and scrabbles," date unknown

Robert would have loved the Post-it. His desk and studio had slips of paper "thumbtacked everywhere about," with "scraps and scrabbles" of thoughts—thus he described them when sending an assortment to Walter for the retrospective essay. Robert called them "genuine, if ingenuous.... You are free to use, to cast out, to ignore the scraps. Just so I don't see them again. I'd be embarrassed

probably." He was pretty much right. We peer into his mystical, intuitive mind at work, but not at its best, as far as his capacity to verbalize goes. Other "scraps and scrabbles," ones not mailed to Walter, contain quotes or study notes. Others reveal the autodidact eager to expand his vocabulary or get right the pronunciation of a difficult word, and so on. Some are uninterpretable.

Something demonstrating the pitfalls of autodidacticism for Robert is the essay he sent to Galen and Joanne de Longchamps concerning the philology and mythology of Ursa Major, the Great Bear constellation. About two months earlier he'd written to them about this interest, declaring he shouldn't bore them with it:

> I got to digging around and (as usually happens) came up with a lot more than anyone could possibly want to hear. You know how it can be with easily worked-up people, they get hold of something, worry it to death, and then want to share the kill, bone by tiresome bone, with innocent friends. I'll try not to do that to you.

But he did. He was apparently helpless. His obsessive ten-page treatise is astonishingly erudite in detail, but unforgivingly undisciplined in form. As brother John, the professional copywriter, said of something else Robert had written, "He writes novel, ... original and effective phrases. But he lacked guidance in how to put this writing into a clear, well-knit, effective whole." Robert's natural letter style, however, depended on a principle different from the kind of discursive clarity John was comfortable with. The tedious Ursa Major treatise came from somewhere else in the brain that, in a different letter to Joanne and in a different register, hearkened back exquisitely to the time when he lived in Santa Barbara for his first session of art school in 1927:

> I envy you your trip to faraway Santa Barbara. That pleasant place was once home for me—twice really. But it's the first year there that I remember with the most gratitude and affection. I was not yet nineteen—an awkwardly appreciative age—and I had the good fortune to live very near to the sea, almost at the very edge of the big shoulder of land called the Mesa. It was a great joy to have my own house, books, music, a glorious tub on four iron feet—and the big reach of blue everywhere about! And, of course, the ocean.

I remember, a favorite walk was from the land's edge down to the sandy places of quiet surf—and from there, on to a lovely reach of wide sandy beach where the wind seemed always to be stirring, as if impatient to fill sails and get the dreams moving.

And by night, with the moon lighting the way, it was beautiful beyond telling.

There were no people then, quite none. Just the land and the sea—and the ploppy little things that wobble and stick in their pulsing ways to the deeper pulse of the sea. I didn't realize in those wandering days that, in gazing into a tide pool, I was gazing into the cupped hand of Creation.

Wingfield Park without Wingfield

Signatures at all angles crowd the blank inside cover pages of Walter's senior yearbook, the *Re-Wa-Ne* (Reno-Washoe-Nevada) of 1926. In the upper left corner, flush with the top and smaller than any other—underspoken while claiming pride of place—is the signature of non-student Robert Caples. It thrilled me my first day at Special Collections to make this discovery, the sole contemporaneous proof I've ever found that the two knew each other before Walter graduated Reno High.

Rosemary had it from Robert that he met Walter through their fathers. The university president and the prominent doctor and their wives attended some of the same civic and social functions. But daughter Babs doesn't remember Walter "ever talking about Robert as a close friend in high school years." In *City*, Tim the boy sees Lawrence only twice, both times by chance: first at Pyramid, then at Mr. Black's home in the Court Street Quarter (where Byron lived on Ridge Street, 1925–38). The natural friends will begin to spend time together now, we feel—except that Lawrence, we learn, is about to depart for school away somewhere. Thus the impression is left with a reader following the back story that Robert was absent from Reno during those years. He wasn't. His first enrollment at Santa Barbara came the year following Walter's graduation. It appears the two were friends then but not the kind of friends they later became.

Light is shed on that stage of the friendship by the oral history of Thomas C. Wilson, founder of the eponymous advertising agency, Reno's first. Wilson, who left his mark with the slogan "Harolds Club or Bust," said he "ran around with the same bunch of kids" as Robert. A year ahead of Walter at Reno High, Wilson was "not sure that they"—Clark and Caples—"even knew each other" then. Walter's yearbook proves they did; but Walter didn't 'run around.' After describing how much loose fun his friends and he had back then, Wilson drew the contrast:

Walter did not have the freedom the rest of us did. His family were extremely strict. They were afraid they would be criticized for sure, because he was in the family of the president of the university. So they held Walter down to the point where they really damaged him, in my opinion. It put him far enough apart from his generation so it probably gave him the objectivity that made him a damn good writer.

Walter, as the university president's son and a prominent Reno High student in his own right, made the papers for sports and school activities, but only twice for social activities, a Christmas dance and a family vacation.

Judge George Bartlett, Lew Hymers, 1939

When Robert made the papers then, it was for parties and country club dinners with famous divorce judge George Bartlett and family. Wilson met Robert at the home of Judge Bartlett, who went by the nickname "Judgie," conferred on him by a young actress grateful for her freedom. He looks the part as caricatured by Lew Hymers in the *Gazette*. Phyllis Walsh, another colorful Reno figure and Caples friend, remembered Bartlett in her oral history as "one of the most amusing of all the Reno barristers who recounted tall tales at the Riverside's Corner Bar.... 'Judgie' was an inspired raconteur, and his memory was incredible." In spite of the frivolous diminutive, Bartlett had an excellent reputation on the bench. His impartiality comes across in the character of Judge Cooper in Cornelius Vanderbilt, Jr.'s 1929 novel *Reno*, and is substantiated by a case from that same year, when Bartlett, who as congressman and then judge was close to George Wingfield, ruled against "the King of Nevada" in the property settlement of a divorce action.

The Bartlett scene was evoked in the 1972 obituary of Dorothy, one of the judge's daughters: "[T]he Bartlett home at 232 Court Street was a haven for many notable figures in American life [and] other famous people who came to visit their divorce-seeking friends." Celebrities listed include Clare Booth Luce, Jack Dempsey, Sherwood Anderson, Tallulah

Bankhead and more, culminating with Robert Cole Caples, his name alone singled out for attention by a line of biography. During that epoch Robert, who had done portraits of the judge's three good-looking daughters, had a local reputation as a socialite and artist, but was by no stretch a national personage like the others. So the family was seeking to emphasize for the Reno readership their connection with the by then legendary Robert Caples, already long gone to Connecticut, but who later that year would have his second retrospective exhibition in Reno, at the Nevada Art Gallery. A name absent from the list is Walter Van Tilburg Clark, a person of both national and local fame, whose death there in Reno less than two months before Dorothy Bartlett's would have been fresh in everyone's mind. Walter, who knew the judge and his daughters, must not have been as active as Robert in their social nexus—further evidence that the lives of Walter and Robert didn't much intersect at an early date, in spite of Reno's compact social world.

Margaret Bartlett, ca. 1930

Dorothy Bartlett, 1928

To illustrate just how small and intra-connected that world was: Tom Wilson once worked for Dr. Byron Caples in the state venereal disease office to make ends meet after he started his ad agency, as did artist Dick Walton, for the same reason; and earlier Judge Bartlett's daughter Margaret (Monte) worked for Dr. Caples as secretary at his group practice in the Masonic Building, the same building where Robert and Walton shopped and exhibited at Brundidge's art supply store; and Walton's mother was friends with one of Byron's women friends; and Byron had been both married and divorced before his friend Judge Bartlett; and Monte Bartlett saved a 1927 drawing by Robert

Georjean Bartlett, ca. 1930

of "*Our Tree* in Wingfield Park," a token of their youthful affair; and Robert and Wingfield attended the same arts event in 1931, the year Wingfield's banks failed; and in 1932, Robert produced commercial artwork for a restaurant whose owner lost the business due to pressure from shady gambling associates of Wingfield's; and Wingfield was a university regent when Walter's father was president; and Walter's wife Barbara used to shop for shoes in the dress shop of Virginia Caples, Robert's first ex-wife, in the Riverside Hotel owned by Wingfield to capture the trade of those biding their time till their dates at the courthouse next door; and William W. Bliss of the Lake Tahoe lumbering and development Bliss family remembers seeing Caples paintings on display in Virginia's shop; and Bill Bliss's father William M. Bliss and Basque Dominique Laxalt, father of Walter's protégé Robert Laxalt, used to feud over Dominique's sheep running on Bliss land, then drink together; and before the livestock crash of 1921 wiped him out, Dominique lived on Court Street overlooking newly created Wingfield Park, in a mansion where another son, Governor/Senator Paul Laxalt, was born; and in *City*, crucial scenes between Tim and Rachel take place in idyllic Wingfield Park, "the Center of the Universe" for Tim. I could go on.

Reno's web of connections is one reason Walter gave Timmy a working class family, strangers to the Reno mirrored to itself in the social columns. Walter was out to represent love, friendship and the natural world in the formation of a small town American artist—that side of his life. He had neither the impulse nor, I suspect, the gifts to represent more than glancingly the rather amazing society of his upbringing. The novelist's sidestep clarifies the sharply dualistic Reno painted in *City*'s "Prelude," a text dear to literate Reno's collective memory. Tim belongs to the exalting Reno of poplars in the lee of Mt. Rose, but not to the other, the worldly Reno. So Walter gives us Wingfield Park without Wingfield.

Actually, the idea of there being "two Renos" was not first formulated by Walter, in fact it was more or less the smart take on Reno during those decades. Thus in the novel where Judge Bartlett is portrayed by proxy, Cornelius Vanderbilt, Jr. contrasted "the real Reno," roughly

Walter's city of trembling leaves, to the Reno of divorces, roughly the Reno Walter belittled in the "Prelude" as "moribund," an

> ersatz jungle, where the human animals, uneasy in the light, dart from cave to cave under steel and neon branches, where the voice of the croupier halloos in the secret glades, and high and far, like light among the top leaves, gleam the names of lawyers and hairdressers on upstairs windows.

So it's the city of trembling leaves vs the biggest little city in the world. Today's Reno if it isn't careful with its gigafactories and public art will become the littlest big city in the world, or just big. But that's another story. Or is it?

Anyway, in spite of its not being a novel of society in breadth or depth, the worldly Reno dismissed in *City*'s "Prelude" does seep in, most explicitly in Book Two, with Tim by then an adult. Tim resides for quite a while in one of those upstairs rooms with a lawyer's name still lettered on the window, and makes his living as a musician in the dives of Douglas Alley and around. For years Mary too rents a room downtown. Lawrence keeps his portrait studio in an office building on Virginia Street in the heart of downtown, as Robert really did. Lawrence finds most of his sitters—his "victims," as Robert once called his clients—among women in Reno for "the cure," and Lawrence's wife Helen is one of them—as Robert's first two wives, co-patterns for the composite Helen, both really were.

This is the line I took, that worldly Reno isn't missing from the novel, when I met to discuss my project with University of Nevada historian and Wingfield biographer Elizabeth Raymond. I especially stressed that Tim's brother Willis conducted his shadowy life in the other Reno, and when its tough men came after Willis at the Hazard home, Mr. Hazard reamed them out with Walter's own precise knowledge of how that other Reno worked. To my gratification, Raymond agreed. She, an avowed regionalist and like me an enthusiast for the book, even asserted that by virtue of its pictures and intimations of the coexisting Renos, *City* is the best single source for getting the tenor of the whole place in the 1920s and 1930s.

But now, in rethinking Walter's two Renos months later, I'm newly mindful of how the novelist displaced himself from Reno society. In

word-painting the Court Street Quarter, the urban focus of all Tim's longing, Walter starts by distancing its anonymous and melancholy mansions, as if they and their moods transcended the occupants; whereas Walter knew those occupants, their positions and their stories—occupants such as Judge Bartlett and other social peers of Walter's father, in whose campus mansion Walter grew up, in a "house literally on the hill," as Bob Clark observed, "one that looked down upon" Tim's home near the fairgrounds.

Several adults from worldly Reno appear briefly in Book One: Tim's girlfriend Marjorie Hale's Eastern mother, superficial and dissatisfied, as is Marjorie, for whom Tim—Walter all but says it—is too good; and Rachel's world-weary, Cadillac-driving father, Mr. Wells. To the only worldly adult of Book One portrayed without darkness, Walter paradoxically gave the name Black: Lawrence's father, of course, a lawyer—worldly Reno's signature profession. His name is Mr. Black only because Walter gave Lawrence the surname Black—not to symbolize Robert's demons, as you might suppose, but to wink privately at Robert about their mutual love of chess. "I'm sure he was thinking the chess board," said Robert to counter my going on about dark Lawrence in a letter.

Robert's father Byron Caples lacks dimension in the character of Mr. Black, a man immutably composed, tasteful, considerate. We glimpse nothing to the contrary, no trace of a working attorney, nothing of an unmarried man in his prime in such a town. Whereas the real Dr. Caples indulged in Reno nightlife, went through wives and affairs at least as fast as Robert, and even caught the mining bug. The portrayal of Mr. Black more than justifies Bob Clark's assessment of his father as someone who "idealized almost everything." But why did he idealize Byron Caples to such a degree? Because he idealized the doctor's son Robert, his beloved friend, who as a young man and not so young man was, while an artistic soul to be sure, also unapologetically worldly. Whereas Walter didn't 'run around,' and resisted seeing Robert as that person.

And so, if Walter used the simplifying notion of two Renos as a strategy of composition, it was a strategy to which his personal inclinations forcefully led him, and one with the advantage of protecting his idealization of his friend Caples, a young man with a foot squarely in both Renos.

Barbeque Held at Pyramid Pinnacles

After high school Walter took an academic year off to drive truck and paint houses for a maternal aunt and uncle's hardware business in California's steamy Imperial Valley, an experience that confirmed his "distaste for business," states Bob Clark. Walter read, wrote poetry, and with friends from work made "brief visits to Mexican Border towns." Bob said he didn't think so, when I asked if he thought Walter got up to the same things in Mexicali that young men typically used to get up to in Mexican border towns—things that I got up to when I briefly sold encyclopedias door-to-door in the humid furnace of El Centro in 1959. I was a green middle class young man, on my second break from college in pursuit of authenticity in the real world. I'd assumed that Walter took his hiatus for the same reason; but Bob thinks it was in conformity to his "father's educational notions." Walter's younger brother David took a similar hiatus.

Walter lived at home in the president's mansion when he entered the university in 1927. His sophomore year he met Barbara Morse, a junior, whom a sinus condition had led to transfer from Oberlin, Byron Caples' Ohio alma mater. Walter graduated in May, 1931, and by December had earned his unconventional master's degree. For the spring, 1932 semester he took practical courses toward a teaching credential, then vacationed with his family, then left for the University of Vermont, where he earned a second master's in June, 1934, by then married to Barbara.

Between matriculating and leaving for Vermont, Walter's name appeared about thirty times in the *Gazette* and *Journal*, where we glimpse a literary man's first public steps, and a future teacher/lecturer's appetite for an audience. Then not two weeks after his departure, Walter's and Robert's names were linked when an ad appeared for the "First Book of Poems" by "Walter Clark, Jr.," on display in Compton's window with Robert Caples' 1928 portrait of the author. The ad appeared on "The Journal's Page for Women" (poetry in Reno then was for women), without its title, *Ten Women in Gale's House and Shorter Poems*. This was only the second time Walter and Robert's paths

had crossed in the hometown papers. The first was a few months earlier, on page 2 of the *Journal* of May 13, 1932, where adjacent to coverage of the Lindbergh kidnapping a small headline reads "Barbeque Held at Pyramid Pinnacles": "The Desert Inn entertained this week with a barbeque and picnic party for a large group of guests. The affair was held at the Pinnacles at the north end of the lake." The guests, hailing from both coasts, Canada and Great Britain, joined locals including "Mr. & Mrs. Robert Caples" and "Walter Clark Jr."

The Pinnacles, or Needles, form an irregular file of tufa castles starting well onshore and reaching far into the lake. The Paiutes hold the Needles sacred. Sea of Galilee scenes of *The Greatest Story Ever Told* were shot there. The whole lake, just thirty-odd miles from worldly Reno, feels like a holy land. Today the lake is even less developed than formerly, thanks largely to the tribe and its allies, what with rail line and white ranches gone. So is the bath house at Warrior Point, and the light standards I watched hunting bats circle when I camped and wrote there for three weeks. In 1980 the Needles were closed to the public. Too much traffic, and of the wrong kind. In the days when you had the place to yourself, I and my then partner and her little son soaked naked in the pool of the hot spring there where Paiute hunters once steamed hides, then we cooled in the brackish lake. I used to smoke. The air was so hot and dry the tobacco shrank and crackled in the paper.

Special Collections holds a photo of the Pinnacles outing. The picnickers pose in the miscellaneous attires of 1930s Reno's conglomerate society. Walter and Robert sit together on the sand. Behind Robert grins a little boy in shirt and tie; to the boy's left stands a shirtless man in jodhpurs and riding boots and a Stetson, likely brand-new—a dude epitomizing Reno's insouciant amusements. Virginia Caples kneels near Robert, a hand resting on his shoulder. Walter's date sits behind him on some low tufa. Walter is twenty-two, Robert twenty-three. What jumps out is the physical contrast: the muscular Walter, proud of his athleticism, wearing shorts, the most naked person in the group; and the smaller Robert, concealed wrist-to-foot in stylish white interrupted only by a faint design banding the chest of a spotless cotton sweater.

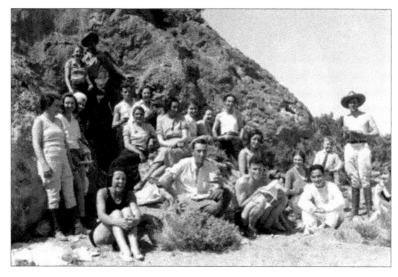

Barbeque Held at the Pinnacles (Needles), 1932

In a snapshot taken almost forty years later, Robert sits on a different, Eastern beach picnicking in a nearly identical outfit. And in another snapshot, he sits in the same posture on a beach in Greece, again in whites, this time a t-shirt, squinting against the dazzling light, a

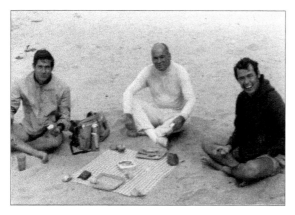

Caples, 1970 (the young man to his right may be his son Cricket)

Caples on Samos, 1972

fit-looking man of about sixty. But such wasn't his self-image. This and one of him at fifteen or sixteen are the only images I know with Robert not fully covered.

I commented on the bodies of the two men when showing the Pinnacles photo to Babs. She replied that Robert was "uncomfortable" about his slight build, and didn't want to compete with athletic-looking men. Also, "he got cold fast." Had he, I wondered, been playful with her and Bob? Like ball or roughhouse? Babs asked. No, he would draw pictures with them and hold conversations. Robert's stepdaughter, Rosemary Junior, told me that Robert never played physically with her or her brother Denny. Reno Columnist Karl Breckenridge, who as an early teen knew Robert when he would have been in his forties, said they "shot baskets" together. "What?" I exclaimed. "I'd heard he was unathletic." "He was," said Karl. "He didn't shoot baskets well?" "No." Bob Clark, a tennis buff like his dad, said that Robert was "unathletic," and that he "always moved slowly." Robert himself attributed his slowness to a chronic bad back. Usually evasive about his infirmities, Robert wrote to fellow sufferer Ken Robbins about his back in 1974; the "wretched affliction finally melted away some years ago," so he could commiserate from that vantage. Robert, a compulsive punster, spoke of

> a 'back' ground of incandescent pain; the kind that puts rings of prismatic light around the most commonplace objects and nails one's breath right behind the old Adam's apple. Truly, I used to have one hell of a time, ... to the point of being totally unable to sip water from a patiently held glass.... I still move with deliberate caution—a gun could be fired behind me and I'd turn around real easy like—too many Westerns? Not at all, I still remember that back.

Bicycling, he advised Ken, "has helped enormously." I imagine Robert undertook the activity at the urging of fit Rosemary, who installed a ballet barre at Turtle Hill to stay in shape for dancing and who kept horses at a nearby stable and rode to the hunt. And she personally landscaped their extensive grounds. Robert helped modestly in the garden and raked leaves (he once boasted offhandedly to Ken of injuring a wrist pushing a wheelbarrow). And she bicycled. I don't suppose Robert overexerted himself on the bicycle either. His history of

health problems impacted his activity and body image. Ailments were never far away—shingles, pneumonias, hepatitis, recurrent colds and flus, heart, kidney and intestinal problems entailing various surgeries.

In younger days Robert did roam the desert on foot. Whether he climbed the mountains he painted I'm not sure. On the real Pyramid Lake camping trip with Walter fictionalized in *City*, Robert climbed part way up the Lake Range with his friend, but stopped and went back when Crocker his Springer Spaniel gave out. Or was it his condition, the dog his excuse? He didn't seem to have the climber's up-instinct. His mountain paintings typically look at a range from a basin, or view ranges from an abstracted perspective in space. Ones where you might be looking down from an actual place may represent views accessible by car.

In 1950 or 1951, Robert did join a square dance group in Virginia City, presumably the one that met in St. Mary's social room. The punster bestowed on it a perfect name, the "Square-set," after the manner of timbering hard rock mines invented by Philip Diedesheimer for conditions on the Comstock.

In the Pinnacles outing photo Robert is smiling, something unusual for him in photos, I noticed. "No, he didn't smile for the camera," Babs confirmed. It was something about the camera. Really he was a man of "easy smiles," as Rosemary's son Denny volunteered, and that is how I remember him from my too short a stay at Turtle Hill, as a smiling man. But there are actually three more pictures of Robert smiling that I came to know of. All are with Rosemary. One was taken on Ray Hellmann's sailboat on Lake Tahoe in 1975.

Robert and Rosemary Caples with the Chism sage, 1975

Another was taken by David Chism the same year, when on a business trip to Boston he brought a sage from Nevada to Turtle Hill in a box. In the third,

grinning Robert self-consciously plays the sheik to extrovert Rosemary's harem girl at what may be a shipboard costume party. Rosemary made him happy and relatively spontaneous.

Nevada Desert Wolf

In 1973, Robert contracted to design a silver medallion for the University of Nevada's 1974 centennial. The Franklin Mint coins were sold for one hundred dollars apiece to raise funds for the restoration of Morrill Hall, which featured on tails. Morrill, once the university's sole building, later housed the administration offices, library, and alumni office, and for long the University of Nevada Press, which by 1973 had already published the two Caples Indian portfolios. Robert's university contact for the medallion was the press's business manager, Ken Robbins, who worked in Morrill Hall. Robert wrote his friend Ken in bemused retrospect about being "half scared to death when I first signed up for classes there—the Registrar's office was there in early days." The classes Robert signed up for with the jitters were two 1926 summer session courses. Walter graduated from Reno High that June, then took an academic year off. So although these classes would be Robert's last outside of art school, technically Robert beat Walter to matriculation at the university.

University of Nevada centennial medallion (tails)

In 1928, probably with his father's assistance, Robert briefly acquired a studio in the Masonic Building across the river from the Riverside Hotel, the same prime location where Byron's office and Brundidge's art store were both situated. "Had a view of the Truckee, a rubber plant in the southwest corner, a model stand and a linen smock hanging on a hook. (The smock had belonged to Sherwood Anderson.)" By this selective description of his atelier Robert self-mockingly conveyed, in 1964, the outdated conception of doing art from which he hadn't yet liberated himself in 1928. The smock is an interesting detail: Byron Caples and the author of *Winesburg, Ohio* were old friends of some degree from their Ohio boyhoods before meeting up again in Reno when

Anderson came to town for a divorce. Byron and his son both socialized with Anderson at more than one Court Street Quarter home as well as in their own homes over a span of years.

Robert let the Masonic Building studio go when he returned to art school in Santa Barbara, but in 1929 acquired another, this one above the Waldorf Club in room 406 on the top floor of the Clay Peters building at 140 N. Virginia. This was where his occupation of portrait artist prospered. An inkling of his social life during the period comes from a "Society" notice of his attendance at a musical evening in an apartment at the Riverside Hotel, with the Bartletts, Cornelius Vanderbilt, Jr., and a count among the other guests. Seven or eight years later Robert's friend Dick Walton took as his studio the room across the hall—"actually a closet," exaggerated Walton. Robert's windows faced north. "You could see the treetops and Peavine in the distance," Walton recalled. "Bob liked the view."

Beginning in October, 1928, while attending SBCA in Santa Barbara, Robert took part in at least one student activity at the U during Walter's time: Robert's artwork began appearing in the campus humor magazine, *Nevada Desert Wolf*. The October and December, 1928 issues include five humorous woodcuts and two full-page portraits by the nineteen-

– AND HAVE ONE YOURSELF, 1928 – AND NO ICE," 1928

Untitled (courtship), 1928　　　Untitled (marriage), 1928

year-old. Three woodcuts indulgently josh drinkers. Both Robert and Walter were pretty heavy drinkers from an early age. I don't believe either ever conceived of it as an addiction issue, in that respect being typical of their generation. The other woodcuts comment with wry sentimentality on life's passages, or on the advantage men have in marriage, if you look at them that way. The portraits are especially interesting, because portraiture was how the young artist first gained success. And sad to say, his national reputation was never higher than when his portraits were taken home by divorced sitters and admired,

 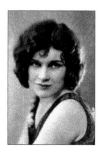

Bessie Davie, 1928　　Bessie Davie, Mackay Day Queen　　*Evelyn Turner*, 1928　　Evelyn Turner, Mackay Day Queen

especially in New York City, where he could have made a career doing society portraits then, had he chosen to. As it happens the Desert Wolf subjects, both campus actresses, had full-page photos in the 1928 university yearbook, *Artemisia*, for being among the six coeds selected from photos by Cecil B. De Mille as the most beautiful on campus to be Mackay Day queens that year—that's John Mackay, one of the kings of the Comstock bonanza, whose wife and son gave the university the Mackay School of Mines. It looks to me as though Robert made these particular charcoals from the photos. Chances are he mailed them in from Santa Barbara. To my eye they're expertly drafted but without ambition to be anything more than appreciations of attractive coeds.

Walter also contributed to *Desert Wolf*. Did the magazine play a part in Robert and Walter's friendship? That circumstance, like so much else, is lost in the past. Looking at *City*, at the part of Book Two before Tim leaves Reno to study music and compose in Carmel, is no help: the university's humor magazine could have no place in Tim's story, since the university had none.

Tom Wilson the advertising man, class of 1929, variously artist and editor for *Desert Wolf*, recalled that stories submitted by Clark were sometimes not printed because, while "beautifully written," they were "always very, terribly sophisticated we thought" for a humor magazine. That was Wilson's way, I take it, of saying Walter's efforts weren't funny. As a matter of fact, I can't find where any of his stories made it in until "Walter Clark" himself became literary editor in academic year 1930–31, whereupon a piece by "Walt Clark" appeared in each of the year's four issues, two stories then two poems. One story, "For the Love of Sal," is an off-key satire censoriously lampooning the violence of night football. The other, "Blow Hard Enters Heaven," inventively but angrily satirizes the self-importance of a frat boy and offers a humorless send-up of traditional ideas about heaven and hell. Walter had a penchant for ungentle satire. Even the sober *Ox-Bow* started out as a satire of the stereotypical Western. *City*, exceptional among Walter's fiction in this way as in many others, has the saving grace of tolerance, really love, in its ironies. But even in *City*, bitterly satirical sections lengthen Book Two unproductively and mar its tone. The judgmental inflection

of Clark's later fiction evinces the satiric impulse, but devoid of any softening by humorous intent.

At the same time as Walter was aiming these jagged thrusts at fellow students, he and his family privately published a narrative poem of his for their circle at the holidays. *Christmas Comes to Hjalsen*, over six hundred lines long, tells the story of a soul-damaged World War I vet, aroused from a torpor of escapism in the city by the coming of spring. Hjalsen's instinct leads him to seek healing through a year of virtual isolation in the high mountains. By the time the Christmas season comes around, Hjalsen's mind has stilled and his heart opened, but something is lacking. To his nearly snowbound cabin arrives a stranger. Hjalsen and this Santa/Christ figure share food and drink and conversation through the night until Christmas morning. "It's hard," says the wise stranger,

> "... for most to understand, I know,
> Why too much living among men makes understanding of them
> Difficult.... To know men one must be among them, yes,
> But he can never find the solid rock beneath
> The shifting sands of this unconscious knowledge
> Without taking time apart from men, where other things,
> Less complicated in their being, show the plan more clearly."

So far Santa/Christ has reinforced what Hjalsen had already discovered for himself. But now as the guest departs he gently guides Hjalsen further by suggesting that Hjalsen might go down the mountain to help the villagers struggling in poverty. Walter had hit upon the teaching of the sages compelled by wisdom to return to the world after getting only so far seeking enlightenment in isolated mountain caves.

The poem's themes—redemption through love, the healing power of nature, the indispensability of isolation—are all themes handled masterfully later in the prose of *City* with its almost all-embracing openness—openness remarkable anyway, but all the more remarkable for a man so dubious of his fellows as Walter Clark. As for Hjalsen's attenuated Christian trappings, Walter would leave those behind, as philosophically he already had pretty much left Christian doctrine.

Only once, I believe, did he return to its symbology. By then he was in the slow-motion throes of his long unbroken drought of published fiction. When Bob Clark and I were batting things around in Helena, he brought up the problem of over-thinking in Walter's late efforts, offering as an example *The Man in the Hole*, an unfinished novel, he explained, with a contrived seven-day plot scheme based on the New Testament. Bob found this "curious," since "the Gospels never meant anything in particular" to his father.

A Lean Horse for the Long Race

When Edith wouldn't give him a divorce in New York, Byron brought his office nurse Sarah O'Brien to live with him to Reno. His Reno divorce was granted in June, 1923, by Judge Bartlett. But when he married again in January, it was to a different woman, a recent divorcée, Elsa W. Bandler, who was therefore living in the house when Robert arrived later that year. I don't know what became of Sarah O'Brien or much else about Elsa Bandler. Meanwhile Byron kept up responsible, distantly affectionate relations with Edith. She visited Reno during the summer of 1929 shortly after Byron divorced Elsa, again before Judge Bartlett. Then in December, Byron welcomed Edith to a spare bedroom for her care and comfort while she underwent treatment for uterine cancer. I doubt he had any idea of a reconciliation; he would pay her medical bills, and she would either recover and return to New York, or she would die.

"For two months he treated mother super-humanely—never stirred an inch from her room—picked her a bunch of flowers every morning etc. etc. Then he met Mrs. Slater and suddenly started staying out all night and just sticking his head in mother's room as he passed." That's what John learned from Robert after arriving a day too late to see their mother alive. (When John was booking tickets following Byron's urgent telegram, he discovered he could save on the train fare by departing a day later. He missed seeing Edith alive by that one day.) Mrs. Margaret A. Slater, Margot, was a woman of John's age. Even some of Byron's worldly-Reno friends thought it unseemly when they saw him "out dancing at the Grand some of the last days."

Edith attempted to keep up her appearance for Byron in her sick room while heavily sedated with morphine, unaware that she was dying. "I think he loves me, don't you?" she asked the nurse for reassurance. Edith's pattern with Byron was like Robert's as a small child: "Mother always started groaning and carrying on when she heard father come in the house. She was quiet when she was alone with the nurse." Twenty-five years later, when John recorded these memories

following his father's death in 1955, John supposed his father had still loved his mother in a way, since "he always made trips to her grave and left flowers there." At the time, though, John's opinion had been that, while Byron had once loved Edith, "she succeeded, after years, in killing that love." And neither of her sons really loved her, John thought, not ever, "and she knowing it."

If Walter ever witnessed the side of Byron that went dancing at the Grand and stayed out all night with younger women, he suppressed it, choosing instead, in his 1964 biographical sketch of Robert, to admire Dr. Caples' "unexpressed mystical outlook." Although Walter didn't make plain the basis for this appraisal of Byron's spirituality, comments from both sons corroborate it. Robert said that Byron "believed in life," and that his father had taught him "to be profoundly grateful for the gift of morning." And "Who among us," Robert once asked of Joanne de Longchamps with a rhetorical smile in 1976, "remembers BHC singing: 'But when old age came creeping in, old age with all its qualms, King Solomon wrote the Proverbs and David wrote the Psalms.' Well, I do." John, who was fully secular, said that his father without admitting it was "deeply religious." About eight years after Byron's death, John remembered something his father once said to him during a later visit to Reno: "'Stay near me. I like to hear you breathe.'... It was just about the nicest thing anybody ever said to me. He liked to hear me breathe. He liked to hear the evidence that a heart he started beating many years ago was still beating." I'm generally pretty hard on John for his limitations, but I'm inclined to give him credit for perceiving what he meant by "deeply religious" in his father's touching request.

Apparently neither son saw their mother in such a light. That's why, I suspect, Robert couldn't "bear to stay with her much" during Edith's last illness, as the nurse told John. And why there's no sign of Lawrence even having a mother in *City*. The one time Robert communicated her existence to me, he wrote something unforgettable: "She said, 'A lean horse for the long race,' and then, all bones, she died." Were those really Edith's words? Or did Robert give the aphorism a twist to intimate something about his mother?

Just Robert and the nurse were with her when she died. Dr. Caples had gone out to make arrangements with the undertaker, and for some reason brought the man back with him to the house thinking Edith still alive, not knowing she'd died only ten minutes before. That breach of decency momentarily caused Robert to regard his father as a hypocrite. But Byron was Robert's parental life principle. The day after Edith's funeral, father and son were back to what John recognized as their regular way of life: drinks together before lunch, a cocktail party at 4:30, then dinner at Mrs. Slater's with more drinks. John in his diary disapproved of how his father was "just carrying on with Mrs. Slater."

Why shouldn't such a man become, in John's words, "fascinated, almost enslaved by this 30 year old, sexy, smoky, good looking divorcée" Mrs. Slater? But infatuation in one's fifties wouldn't in Walter's mind have born a credible relationship to an "unexpressed mystical outlook." Walter definitely hit the mark on Dr. Caples, however, with Mr. Black's invariably "courtly" formality of manners. "It seems too bad," worried John, "to see father paying all this refined high class attention to Mrs. Slater. She doesn't rate it…. While she sits gambling at '21' father lights fresh cigarettes for her. Whenever she stand up, father stands. Today he forgot to pass her the syrup. He apologized as much as if he had broken a beautiful vase or upset the coffee pot."

Robert had his own misgivings about Mrs. Slater. He thought it was because of her that "so few attended the funeral or sent flowers." He described her to John as "one of these women who get up at noon and spend the rest of the day taking beauty baths." And there was something else. Gossip about Mrs. Slater and her "colored chauffeur" was tarnishing Byron's reputation by association. There's no telling what words Robert used, and nowhere else have I picked up race prejudice on Robert's part—or only once: a black lawn jockey in a photo of Turtle Hill from the 1960s or 1970s, about which, at best, he took no action. I'd like to believe that when Robert repeated the gossip about the chauffeur it was out of amusement at the human comedy. John, on the other hand, is self-convicted of racism and antisemitism by other pages of his diary.

Whatever reservations Robert had about Mrs. Slater, it didn't stop him from living the fast life with her and Byron. Friday of the week of

Edith's death they all went to The Willows, the famous roadhouse, for dinner, drinks, gambling and dancing until 2 a.m. The next night Byron, Mrs. Slater and John went to The Willows again, arriving at 11 p.m.

> When we got out there we saw Robert in his tuxedo with a dinner party of about 12 people at a big round table. Among the people in his party was Mrs. Marshall Field of Chicago, whose husband is worth 100 million. Later Robert sat with us. He said, "I got the breaks tonight." "You mean you got some prospects for portraits?" "Yes," he answered. "Got some good ones. I'm going to telephone Mrs. Field Monday." We didn't leave until 5 a.m. But instead of going home, we went to the Grand Hotel for bacon and eggs. This is a favorite stunt of father's—to go for bacon and eggs at the Grand after leaving a party.

As a born Chicagoan I wanted to track the portrait down. Marshall Field V informed me through an assistant that the Mrs. Marshall Field in question would have been the wife of Marshall Field III, his grandfather, but that he's unaware of any portrait.

Byron's affair with Mrs. Slater was soon to end violently. Byron had been meaning to marry her. But three months after Edith's death, the *Gazette* reported that Mrs. Margaret A. Slater was killed in a car accident when Dr. Caples' "big touring car" hit a post with Byron driving at excessive speed. They were traveling at night on the Reno-Carson highway back from Carson Hot Springs, a rather racy nightspot (where Robert would take up residence years later). They had almost certainly been drinking. The report said that Mrs. Slater had been in Reno from Toronto for six months with her three small children for a divorce, which had apparently not yet been decreed.

John first learned of the accident three weeks later from his father's letter. Byron's shoulder was injured badly enough that he was hospitalized for two weeks and he expected to have to turn over his practice for up to a year. He claimed that the accident had happened in the afternoon, and that he'd been driving just thirty-five when "my car suddenly became unmanageable." Byron also told John he planned to visit Margot's elderly parents in Ottawa (not Toronto) to console them. He made no mention of Margot's three young children. I don't know if he ever made the trip.

On the same highway two years earlier, near Steamboat, Byron cut his face and broke a thumb going through the windshield. On that occasion the *Gazette* reported that an oncoming car had "forced him to drive into the ditch, the doctor said."

In spite of the pace father and son were keeping up after Edith's funeral, John did get some one-on-one time with Robert, which both brothers desired. They drove to the Sierras (purists prefer 'the Sierra') once, and had several long talks. In John's eyes, young Robert was not made happy by his lifestyle. They spoke about their parents, Robert's art, his future, and his girlfriend Eleanor, whom Robert wanted to marry. He'd met her in Santa Barbara in 1928. "She is 23 years old, partly Jewish, beautiful and attractive to men and carefree and pleasure bent." Robert was trying to sell the lot Byron had given him for his twenty-first birthday to raise money for a Ford to go get Eleanor and for an apartment where they could live. He wanted a quick sale of the Ohio farm he and John inherited from Edith, for the same reason. Neither brother had much confidence in the plan. "He says she has been waiting for him for two years but that he can tell from the tone of her letters that she wouldn't wait much longer." It was in the course of this conversation that John proffered the sound but obtuse advice to "(1) Get a regular job. (2) Save a dollar a week." He counseled Robert "to come to New York and take a regular job," or else he and Eleanor should both take regular jobs in San Francisco. None of this addressed an enamored twenty-one-year-old artist's hope and dreams.

The hitch John himself acknowledged in this program was Robert's poor health: "his doctor says he should stay in Reno altitude for another year or he might develop asthma which could last his life." Respiratory conditions repeatedly confined Robert to bed for days at a time, and indoors for weeks. John, who quickly tired of Reno's pleasures, considered Byron a bad influence on Robert, on his morals and on his health. Byron had taken up smoking, so of course Robert smoked. And drank. "Imagine him [Byron] criticizing me about drinking!" wrote John. "He drinks steadily and he has let Robert get the same way." By then Robert had been consuming heavily for a couple of years.

John was concerned about Robert's mental state as well:

I can just see Robert tying himself up in knots and just getting so discouraged and disgusted that he will do something desperate. He has a pistol in his room. I'm just afraid that he might ruin his already weak health and get some fatal disease or maybe Eleanor might prove untrue or something and he would go on a drunk and end by shooting himself. I think the chances are he will have a tough time and pull through. But I hate to see him walking so close to the edge.

I don't know the end of the Eleanor story. Perhaps she didn't wait for Robert, as he feared, or he lost interest.

The Peavine Cabin & Pyramid Lake

The same year Robert came to Reno, 1924, Virginia Palmer of New York married a Harvard football and baseball star, Caleb Eddy. Virginia divorced Eddy in Reno when their daughter Virginia Lou was just eighteen months old. That was in March, 1931. In April, a hybrid art and society news item appeared on page two of the *Journal*:

> CAPLES PORTRAIT DISPLAYED HERE
>
> The work of Robert Cole Caples, Reno artist, a portrait of Mrs. Virginia Palmer Eddy, who recently returned from New York, is being exhibited at the Riverside hotel where other sketches by the same artist are to be shown occasionally. Caples has won wide recognition for his work here.... [T]he young artist ... maintains a studio in the Clay-Peters building.

A month later, on May 15, came the announcement in the *Gazette* of a marriage license issued to "Robert C. Caples, son of Dr. B. H. Caples, and Virginia P. Eddy."

Days earlier, Mrs. Elsa W. Caples, Byron's divorced second wife, had been shown in the Journal standing next to a very large automobile as user number one of Sears-Roebuck's new West Street parking lot. Also during that April and May there appeared a flurry of stories in both papers about Walter: Walter reading or publishing verses, attending a formal dance at the Riverside, playing tennis, speaking on campus at the university, and receiving academic honors there, as did his sister Euphemia, with photos of both. All this newspaper activity gives a kind of remote sensing of the superficial texture of these lives.

Virginia Caples, 1931 (?)

In *City*, Walter created a more dimensional view of Robert's marriage and the Clark/Caples friendship at that time. Dimensional doesn't necessarily mean accurate, however, so I take care extrapolating from novel to biography. So, for example, Walter left out baby Ginny-Lou

and the fact that twenty-two-year-old Robert became her stepfather, in effect if not in law, when he married twenty-six-year-old Virginia. Walter was avoiding narrative complications. I was able to interview one of Ginny-Lou's classmates at the private school Virginia sent her to. Former Reno mayor Sam Dibitonto assured me that Ginny-Lou never questioned that Robert was her natural father. She was still going by his surname Caples when she married in 1950. By the time I learned all this, it was too late to contact her, she had recently died in Idaho.

Weeks, even months go by, during this part of *City*, when Tim sees little or nothing of Lawrence. The distance between them is probably true to the lives of Walter and Robert at a comparable stage of their friendship. Then one day Lawrence shows up with Helen Aikins, as Robert must have met up with Walter to introduce Virginia, another one of the string of good-looking portrait clients Robert dated. There's not much more than a hint of Robert's promiscuity in *City*. Walter liked Virginia, to judge by Tim and Helen. Soon Helen gets her divorce, then Tim hears they've married—from which I infer that Walter wasn't invited to Robert and Virginia's wedding, possibly a private civil ceremony. I also infer that Walter heard about the marriage from someone other than Robert.

1045 Bell Street, "THIS LITTLE HOUSE"

Walter had Lawrence and Helen living for the first year of their marriage in Mr. Black's house, as in fact Robert and Virginia lived with Byron. Walter simplified his story by having Mr. Black retire to the coast, which Byron never did. Then the couple moves to the Peavine cabin, as Robert and Virginia (and Ginny-Lou) moved to 1045 Bell Street.

In *City*, money comes between Lawrence and his wife Helen. He looks down on her commitment to gainful employment, something he didn't anticipate from an impulsive, not quite coherent young beauty with a background of "pink-coated fox-hunters and Parisian sojourns,"

a description evidently true to Virginia and her Eastern socialite past. The older Helen we meet later is an articulate but very unhappy woman of abundant wealth, blinded by good taste to her own materialism, the thing which finally drives Lawrence away for good. That's also essentially true. What's misleading is the impression of a person changed for the worse by her life choices. In actuality, Walter modeled the earlier and the later Helen on two different wives of Robert's: the Helen of the Peavine cabin on the well-to-do Virginia, and the Helen of Beverly Hills on the extremely well-to-do Shirley, Robert's second wife.

Walter based the dissolution of the fictional marriage on observations made while living at the Caples artist colony at Indian Springs in 1941–42, before and after Robert left Shirley. He was writing *City* then. The first tensions in Lawrence's marriage Walter based on observations made while visiting Nevada from the East in 1937, when Robert still lived with Virginia in the Peavine Cabin. They would divorce in 1938. It happens that Dick Walton left a description paralleling Walter's.

> I witnessed the infighting of that situation. There was no struggle on his part. But Bob lived on Bell Street, in a little cabin back by the alley, in kind of bachelor seclusion, and she didn't want the separation, I could see that. And the struggle I saw was one in silence.... An awful thing to witness such a struggle. And he was indifferent, actually. But then he had this loving regard for her, because he did care for her. She later was very bitter about the whole thing.... I knew her for feeling sadly abused. I don't know the details of it at all, but Bob had some misgivings about her bringing home the shop with her. She worked at the Riverside Dress Shop. Later she was to own it. And he felt that he didn't care to live that life that was brought home.

Neither version, Walter's nor Walton's, mentions Ginny-Lou. Both spotlight Robert's silent treatments of Virginia and his discomfort with her work ethic. Walter changed her employment at the dress shop—where Barbara Clark shopped for shoes—to a cashier's job, and changed Virginia's eventual ownership of the shop to work in real estate development—the kind of urban progress Walter abhorred as a threat to his city of trembling leaves. Walter projected his own aversion to money in a negatively idealized Virginia and a positively idealized Robert.

"It is up in the Peavine quarter that Tim's friend Lawrence lived," Walter wrote in his "Prelude" to *City*, "during the best years of their conversations." You wouldn't guess from this, or from the way Tim and Lawrence's comradeship at the Peavine cabin seems to encompass a whole swath of their lives, that Walter knew Robert at the cabin only briefly, and not when both lived in Reno but when Walter was back visiting. In February of 1933, Byron told John in a letter that "Robert has rented a cabin on the edge of town." By then Walter had gone to Vermont. The friendship was renewed during the summer of 1937, when Walter used his summer break from teaching high school in upstate New York to visit home. He and Robert spent time together traveling and camping. For the week or so both were in Reno, Walter stayed with his parents in the president's mansion on campus. That very small window of time is when he knew Robert at the Peavine cabin.

I have been living so long with Walter's characters that their experiences at the cabin, especially Tim's heightened experiences, bleed though and run together with the colors of my imagined Walter, and more misleadingly—or is it misleading?—with the colors of my own "best" times. The wild grass growing three feet high in the yard on the alley—is that detail from *City* or somewhere else? Or the green six-foot fence Lawrence built around the yard? And from where, if anywhere, do I remember the golden ochre of the setting sun that briefly saturates, then fades off the green fence as silent comrades savor the impermanence of it? All of us, though—Tim, Lawrence, Walter, Robert and I—relish the sensations of being alive in the world, that much is sure. Each of us has low spells, too. And each has sought in his own way to transform these experiences into art, while observing in another and ourselves the transformation of experience by art. That is our bond. The panic attacks, as far as I know, are mine and only mine, or were until they, too, faded away.

When Tim and Lawrence go back inside the little cabin, things pretty much return to being *City*'s roseate expansion of Walter's few days knowing Robert on Bell Street. The books, the chess board, the junk shop Morris chair (is the Morris chair in *City*?), the pictures Lawrence makes, the ones he studies, the music, the whisky, the talk. The talk!

Lawrence, like Robert, is lapidary, Tim talkative, like Walter; Lawrence solemn and amused, Tim enthusiastic. There was an innocence about Walter that comes through in Tim. Lawrence's innocence is in his art, as was Robert's. Helen (Virginia), with her bright impulsive sentences left dangling and her physicality and her cooking fits right in; or else Tim, Walter, fits right in. Everything fits. Some nights Tim stays over in the tiny spare bedroom, falling asleep on the cot below a new painting of Lawrence's, an icon of truth floating on the wall above him. Tim—and now I'm back in the scene—sleeps like a traveler abroad on a wonderful adventure and like an infant tucked in its cradle. It was the "best" time.

One detail I can't manage to reconcile with what must, therefore, be my own idealization of the reality behind *City*'s Peavine cabin is something Dick Walton mentioned on one of his oral history tapes. Several years before his death in 2005, Walton gifted his papers and 180 audio cassettes to the Nevada Historical Society. I believe no one had opened these boxes until I did so in September, 2013. Historical writer Andria Daley alerted me to their existence, and Walton's widow Vivian pinpointed their location for me. What Walton mentioned is that Robert amused himself by making an alcoholic of a friendly mouse who lived behind the living room baseboard at the Peavine cabin.

Walter devoted a chapter of fourteen pages to Tim and Lawrence camping at Pyramid Lake for two weeks, with Helen joining them for the second week. In reality, they camped at Pyramid for one week that summer, Virginia joining them the fifth day. Into the chapter Walter folded earlier days when the friends would camp there, most likely not before 1931. Walter would write, Robert sketch or paint, the two of them swim, play chess and drink beer and bourbon. *City*'s depiction of camping behind the Pyramid is a composite of those 1931 trips and the one made during Walter's 1937 visit to Nevada from the East. Those passages of the friendship, separated by six years and telescoped in *City*, were also peak experiences for Walter. The chapter, like those about Death Valley and the Peavine cabin, is so intense, so laden with sensation and meaning, that you may not notice how little actual depiction there is of the focal character, Lawrence Black. Lawrence is almost transpersonal, the imago of Walter's idealization of his friend Robert.

Death Valley, Virginia City, the Peavine cabin, Pyramid Lake—places where Walter grounded his spiritual bond with Robert. Pyramid above all symbolized their bond. This significance endured for Walter to the end of his life, as stands out in his letters to Robert. Increasingly during Walter's final years he recurred to the lake, wishing the two of them could go there together one last time, sometimes almost pleading. Robert must have responded, but those letters don't survive. The friends would make one last sentimental journey to the lake when Walter was dying.

I don't believe the experiences shared with Walter at the lake had the same prominence in the trajectory of Robert's remembered lifetime. I have read letters of his, indeed received letters from him myself where he talked raptly about the lake without touching on being there with Walter, even though Walter and Walter's *City* had brought me into his life. Byron introduced Robert to Pyramid. He went there with at least two wives and with other friends. Notably, he camped there with Tom Wilson when they "ran around" together as much as five years before he camped there with Walter: "Bob and I would go out to Pyramid, camp for maybe a week, and try to paint the lake. And that's a miserable thing to do, because the light changes every ten seconds."

A Lack of Interest in People

> Lawrence buries himself at the cabin for days at a time. He eats almost nothing, and the pint whisky bottle is always out on his table.... Helen protests almost tearfully that she could keep them going, if Lawrence would ... stop knifing her about her jobs. But he can't. I think he is constantly mistaking the tread of his own enormous conscience for a following of mockers. Helen knows this, and cries at me that Lawrence must sell his work.... He won't believe that it isn't the money she wants, but himself as he used to be, and she can't see that he must sell only what seems good to him, that an arbitrary decision of any sort would be fatal to him now.

pint whisky bottle ... fatal to him now. Tim's fears for Lawrence—Walter's fears for Robert—bring to mind older brother John's anxieties about Robert's drinking and the chance he could "end by shooting himself." Like a brother, Walter was the stable one looking out for his inspired, erratic, self-destructive friend.

John saw Robert coming "close to the edge" as a consequence of joblessness, dissolute habits, ill-health, and a girlfriend who might jilt him. Tim, by contrast, thought Lawrence precarious because his extreme ethics about money put him at odds with the world, and because nobody could measure up the high standards he set himself as an artist. In attributing Lawrence's moods to lofty values, Walter was, again, idealizing Robert, who in his sixties admitted to Bob Clark that he used to try "to be what he thought WC expected when around him—aware of a certain implicit demand by WC for people to be what he wanted them to be." So Robert was aware all along of Walter's trait of idealizing, as Bob said of his father. To illustrate his deeply held conviction with regard to this trait of his father's, Bob cites Walter's departmental secretary at San Francisco State in the 1950s: she couldn't be just an excellent secretary, Walter had to make her out to be "the finest secretary that ever was." And Walter's ex-miner friends in Virginia City who took part in hand drilling competitions had to be "the best" double-jackers in Nevada.

If you look for it in *City*, you'll find this tendency to idealize already in the "Prelude," where, for example, *all* those living in the Mt. Rose

Quarter will *always* be more attuned to the mountain than to *anything* in their own houses. It isn't so. I grew up in a prairie city. Today I live in Reno's Old Southwest, the Mt. Rose Quarter, and am still surprised by Rose and Peavine daily, but it just isn't so.

Bob Clark associates Walter's idealizing of people with his not really being interested in personal psychology. Bob put it even more bluntly, asserting and repeating to me that his father had a "lack of interest in people." That must be a hard thing for a son to say about his father. He told Benson he didn't think Walter was terribly interested in being a father. Oddly enough, the family never went camping. It seems he wasn't much drawn to children. Monique Laxalt remembers Walter and Barbara's many visits to her parents' home. Years earlier Robert Laxalt, then a journalist who had yet to publish the first of his many books, had sought Clark out for writerly advice, and they'd becomes friends with a mentoring relationship. Monique can't recall Walter "ever saying anything to any of us kids, or crossing eyes, or anything."

lack of interest in people—that's a peculiar thing to say about any novelist, especially one whose style, as Bob judges Walter's to be in *City*, is psychological realism. He once made the case by pointing out how slightly Tim is shaped by his natal family, his father and mother; instead Tim is shaped "teleologically," said Bob, by his destiny, the destiny of an artist. Walter's other two published novels, *Ox-Bow* and *Track*, have conventional third person narrative voices. In both, the style is only quasi-realistic but really allegorical and thematic, and certainly nothing like slice-of-life. Bob associates this trait of his father's, a lack of interest in others, with excessive "self-sufficiency" (think of Hjalsen on the mountain). He believes the weakness of characterizations resulting from this pattern (self-sufficiency/disinterest/idealizing) causes *City* to fail as a novel. Some early reviewers called out the scant dimensionality of the characters without divining this cause, among them Stegner, who blamed Lawrence's not being fully realized on the way Walter forced his material into his symphonic formal scheme for the novel. Stegner reversed cause and effect, by these lights: the symphonic scheme, such as it is, suited an author whose tendency was to idealize his characters into motifs due to "lack of interest in people." Still, neither Stegner nor I would say the novel fails.

Walter "never gossiped," observed Bob. "I never heard him just have a discussion with Mom of just what somebody was like"—or only under two circumstances: when he was angry at them, and when idealizing. As to talking about himself, all concur that this very loquacious man was exceptionally close. Laird wrote: "For a time I was privileged to share an office with him, but I never felt I shared his mind. Nor, so far as I could observe, did anyone else. One knew superficial things." Robert recalled once becoming "alert at the unusual nature of the opening" when Walter told him he'd had a dream about Barbara. In Bob's notes for his uncompleted doctoral dissertation about his father, he recorded "RCC's impression, that Dad always remained ironic rather than personal. He would not tell, nor did he want to hear, personal matters." This from his closest friend!

Robert remarked that Walter had an exceptional memory for places. But when it came to people and events, Walter's memory was distorted—this is Bob Clark's judgment—by his tendency to idealize. Bob illustrated with the Luigi's bar scene of *City*, a chapter based on a trip Walter and Robert made from Indian Springs without their wives. Walter was sure his chapter was true to life, so when he asked Robert what he thought of it, he became "quite upset, somewhat stiff when RC said he liked it as [a] scene but it was not the way he remembered it." Bob took Robert's side in this minor "discord," putting his father's distorted memory down to a "general inability to accept shadings in his acquaintances any more than in his characters."

The Good Life

"I don't think there was that," said the reliably blunt Babs—but "that" wasn't the sort of thing talked about in the Clark family, she added. I'd asked if she knew whether Robert had cheated on his wives. His reputation for prowess with women made me wonder. No one I've asked can say for sure, and there's nothing in his letters. But I found one smoking gun: a story Walton repeated on tape.

Walton had an appetite for stories, as had Robert. Back in the 1930s Robert favored Walton with his war stories, who remembered one about

> the divorcée who was squiring about one summer. These ladies tended to be from very elite families from the social register in New York. He was married to Virginia at the time, and here he was socializing with this very attractive girl with an ample bosom. It was early in the morning, three or so. And he heard the sirens, and the fire department came and surprised him, and a crowd had gathered, and he was just flat-footed, you see.

There was also the "J. P. Morgan story," but Walton didn't say whether Robert was married at the time. Since he was usually married, odds are he was.

> He told me he was in the bedroom of the young daughter of the Morgan family. And the phone rang, and the clerk said that her aunt was on her way up. Now her aunt was the sister of J. P. Morgan, a great dowager. He said he just pulled himself together that fast and hustled himself out into the hall and they passed in the hall.

City hints nothing about sexual improprieties on Lawrence's part, nor much about proprieties, for that matter. Missing is the Robert Caples seen tuxedoed at The Willows in the small hours. What the never-risqué author omits, no less than the sober diarist John, is the downright enjoyment Robert took from what life afforded, an aptitude which, in the fullness of time, would mature to become acceptance at depth. In that respect Walter had the insight to emphasize the "master dictum" which Lawrence/Robert, though a young man, had the spiritual self-knowledge to profess. This is Tim quoting Lawrence and commenting,

in a letter to narrator "Walt Clark": "'Everything will work out in time.' He does not mean this loosely, or as a mere put-off. He means just what he says. He has faith in time. I'm afraid of it."

During 1931–32, while still attending social events that got his name into the papers—bridge luncheons, dinner dances—, now Caples the artist was receiving notice in connection with portraits, art association business, a class he offered, and so on. Society and art news usually appeared on the same pages. Willy-nilly, artists were social actors— particularly if they happened to specialize in portraits of divorcées in Reno, Nevada. The overlap is conspicuous in this Journal gossip item: "One of the things which attracted [the] attention of people on Virginia street yesterday was a caricature in a store window of Robert Caples local artist, by Peter Arno who is famous for his drawings, among other things." Walton remembered Arno's caricature hanging by the door in Robert's studio years later. What trait of Robert's did the caricaturist intend to exaggerate? Caples the baleful? Caples the suffering artist? After more than a year of casually studying the image among other Caples and Clark images on a magnetic board I see from my desk, it struck me that Arno had given Robert the aspect of a vulture—a scavenger feeding on what else but the same abundant delectables as Arno, to judge from the salacious insinuation of the "other things" Arno was "famous for" while in Reno for his divorce.

Caricature of Robert Caples, Peter Arno, 1931

It takes nothing away from this interpretation that Arno clothed Robert in what at the time was his signature attire, a fact I unearthed in another *Journal* gossip item of three weeks later:

> The young artist, Bob Caples, still appears around town in a black sweater. Reno would not be Reno without Bob's black sweater. In defense of his uniform, the young artist declared stoutly, "Why, I wear my other black sweater sometimes."

We get another look at Robert around town from Sessions S. Wheeler, a writer well-known here for his books on Nevada. After Robert's death, a third portfolio of his art was again proposed by the university press. Wheeler, who was just a few years younger than Robert, was asked to draft an introduction, where he reminisced:

> I never met Robert Caples, but I remember watching him drive by in his convertible roadster with its top down. He was a handsome young man, his black hair slicked down in the style of those days, his face deeply tanned. Strangely, perhaps due to his reputation as an artist, in mind's eye I can see him as clearly as if it had been yesterday rather than forty-some years ago. Always he was looking straight ahead, his face expressionless as if he were oblivious of everything except his thoughts.

It's clear that Robert lived the good life and wasn't averse to being seen living it, however modest the Peavine "cabin" in back on Bell Street— Byron, Walter and Walton all called it a "cabin," perhaps because Robert had styled it that ironically. Walton frankly thought father and son socially ambitious. He spoke on tape about the many people of wealth and status who frequented Reno during that epoch, with the result that Reno's "middle classes had affectations of social position, simply because of this influence." His judgment of Robert and Byron may have been colored by envy, without that necessarily invalidating his perception of them:

> It always seemed to me that my friend and benefactor Dr. Caples was a gentleman of the upper middle class. But this word [middle class] offended him—I can see him getting red in the face, and his son also. They always associated with the wealthy and such high and mighty as they could come by. And I met some very prominent people both through Robert and his father. Of course the uncle [Ralph] was a tycoon.... [Robert] thoroughly enjoyed someone who is quite poor, if they're colorful, but they typify pretty well the upper middle class of the Reno area.

Robert "fit in perfectly with the leisured rich," was Bob Clark's succinct analysis. It wasn't meant as praise.

In *City*, during the Peavine cabin period, Lawrence drove an "old Cadillac" which lack of means forced him to sell. A Caddy nonetheless—Byron's hand-me-down convertible, it could be. Robert had an enduring taste for expensive cars, especially convertibles. A time would come when Robert, low on money after his divorce from fourth wife Bettina, was living back and forth between Virginia City and Byron's house in Reno. This was 1951. John had learned from Robert that ill-health and competition from younger doctors had halved Byron's income; he'd had to sell the house on Plumas and move to a smaller one at 1006 Manor Drive (still a good address). Byron had been helping Robert financially, but no longer could when his income dropped. Hazel, Byron's third wife, who had been living in San Francisco, returned. Byron and Hazel divorced three times, and married four! It was obviously a volatile relationship. John on a trip to Reno found "Hazel spending [Byron's] money as quick as he could make it—and complaining that they had not money for old age security—Robert had his good car and father was driving a 1937 Buick."

Years afterward, Robert wrote to Joanne about his "long-suffering father" and his "punishing marriages." I fancy the change in Byron's signature from a forward to a backward slant between his marriage license applications of 1932 and 1948 was due to those "punishing marriages."

The Waggish Cartographer

> It is the dark region with him, all right, and full of fitful marsh lights. He tries everything. He has cast a model for a new dollar, designed signs for two clubs, done a mural for another, a letterhead for a mining company, and a wall map of the bright spots for a hotel.

This is from another letter of Tim's to "Walt Clark" the narrator of *City*, about Lawrence during Peavine cabin days: Lawrence plagued by anxious depression, squandering his talent on unworthy projects out of aimless desperation. Robert was in truth intermittently depressed. And Walter's list approximates real projects of Robert's. The "model for a new dollar," for example, matches Robert's entry in the Treasury's competition for a new Washington head quarter in 1931. But what Walter left out of Lawrence's profile is Robert's pleasure in some of these commercial jobs—he still had the plate-size plaster models of his quarter's heads and tails when he died. Other jobs gave scope to the worldly, the naughty, and above all the whimsical in his personality.

1931 was also the year when, in the midst of the Great Depression, which hit Nevada particularly hard, a revenue-minded legislature reduced the residency requirement for divorce to six weeks and relegalized gambling. In 1932, a new club opened at 39 W. First Street. Soon the Town House merited attention as a hot spot of Reno's "divorce mill" in a *Fortune* magazine article titled "Passion in the Desert." Management fully intended the ironic dissonance between the club's urbane name, the Town House, and the kerosene lanterns (electrified) illuminating frontier weapons hanging on rough ranch house walls. By 1932, the so-called divorce ranches were up and

Town House interior, *Fortune*, 1934

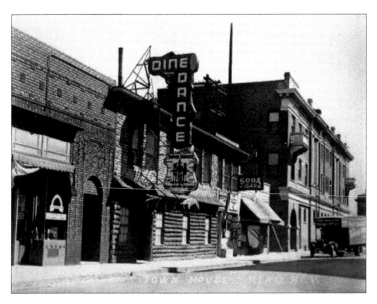

Town House exterior, with Caples' sign

running. Real and faux cowhands alike were attracted to Reno for the easy pickings. Hence Robert's sign for the Town House features a tall cowboy in a conspicuously erect hat, standing between two wasp-waisted women, their shapely bottoms poised invitingly on bar stools with permissive suggestiveness. And in case anyone missed the point, Robert provided a wickedly clever caption, "THE RIDING LESSON," a triple pun: riding horseback (what wranglers teach guests to do at divorce ranches); riding as sexual metaphor (the other service a cowboy might provide); and riding a bar stool (so come on in).

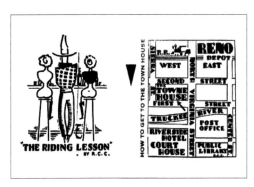

"THE RIDING LESSON" on the Town House postcard, 1932–36

The Town House utilized Robert's popular cartoon for its ads, postcards, business cards, match books and even gambling chips. Where "THE RIDING LESSON" is best known to connoisseurs of Reno memorabilia is dead center on the map of Reno

which Robert created for the Town House 12" × 16" place mat. To later printings was added the accolade: *Grand Prize Winner, 1935 — Chicago National Wine & Liquor Show.*

Robert's reputation as the waggish cartographer of Reno stems from this map. But not generally realized is that the Town House map had

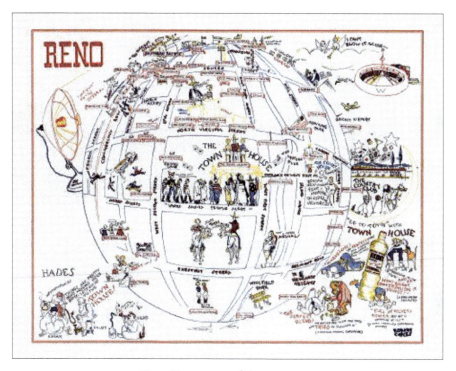

Town House map of Reno, *ca.* 1934

at least two predecessors and that Robert's cartographic career began at Belle's School.

Belle Livingstone, or Big Town Belle, was a New York night club owner, gossip column topic, and author of books which she touted as "not highbrow, if you know what I mean." She arrived in Reno in July of 1931, to open, she told the national press, "a new whoopie palace." Apparently Reno society took her crude style of smutty innuendo on board: in January, the "queen of the night clubs … was feted" at a Riverside Hotel apartment for her birthday. The party then moved across the river to

the Town House. Among the prominent guests was Virginia Caples. Her husband had just fulfilled a commission for Belle. As a sideline, Belle had launched a downtown luncheon club with a pedagogical theme: "Belle's School" offered town gossip on a school blackboard, and such classes as "alimony arithmetic." Robert, the *Journal* reported, had painted "a huge map of Reno to adorn the school room wall ... showing Reno's most famous places and people."

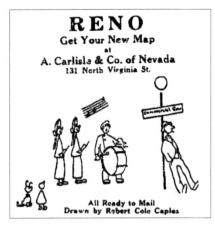

Ad for Caples' A. Carlisle & Co. map of Reno, 1932

Belle's School and her "whoopie palace" were short-lived ventures. Soon after announcing a run for the U.S. Senate, audacious Belle came up against Wingfield's shady associates Graham and McKay (as would Charles Rennie of the Town House), and soon had to leave town. Robert's wall map, however, was so popular that the printing and office supply firm A. Carlisle & Co. brought out a paper version. The map, "Drawn by Robert Cole Caples," was first advertised in the *Journal* in June, 1932. Its success must have suggested to the Town House a map of its very own.

The earlier map, the Carlisle, is simply a line drawing, an aerial view looking east with just a bit of exaggeration of the earth's curvature for visual interest. Reno landmarks, including all the major clubs and bars, are in correct relation to each other. Hence the Carlisle map actually functions as a map, whereas the colorized Town House map is a conceptual image of Reno, a world in itself, a globe but with its own laws of perspective, with New York at one pole, San Francisco at the other, and the Town House its central feature. The name Town House occurs in six places while all but a few competitors are ignored, and those minimized.

The Carlisle map's cartoons range over the whole human comedy, from ambulance chasers to fortune tellers to lovers to dudes. The Town House map's cartoons highlight booze and sex, several being variations

on the riding lesson theme, such as the grinning cowboy hazing three forlorn sweeties in Eastern riding habits toward the Town House to the tune of "Git along little dogies."

On both maps, Robert gave himself a plug. On the Town House map, these words issue from the north-facing window of his Clay Peters Building studio: "Draw One!" On the Carlisle map it's the voice of an unseen portrait subject: "Do I Look Like That?"

"I knew it was a horse," A. Carlisle & Co. map (detail)

There is another cartoon map of Reno which may or may not be Robert's work. After I left Bob Clark in Montana, I drove on to Roseburg, Oregon to interview Craig Jackson. Craig's mother Nancy Jackson had been involved with Robert, and Craig's uncle Nick Jackson sold Robert's work at Newman Silver Shop on Second Street. Craig inherited a guest book from his grandmother, Brownie

"Git along little dogies," Town House map (detail)

Jackson, a page of which is occupied by the map in question, dated 1932 and signed "by Peck." Family lore, Craig told me, holds that Peck is Robert, who was friends with the whole family. For a number of reasons I later concluded that Peck is really Edward Peck, an illustrator for *Desert Wolf* at the same time as Robert. Craig, made acquainted with my evidence, remains certain the map is Robert's. It may be so.

.

"You can't teach an old dog new tricks."

That was Wallace Stegner's reaction, and about his only reaction, to the half-baked fragment of experimental fiction I brought with me to

his Stanford graduate writing program. Down the center of the page ran a prose-poem about an explorer of imaginary spaces, while marginalia told two different, intuitively parallel stories: to the left, the Antarctic exploits of Scott and Shackleton; to the right, Columbus's true mission, as I imagined, to sail to the edge of the Earth. Stegner's remark was gently indirect but unmistakably dismissive. I had no inkling then of his childhood in the authentic late frontier of southern Canada, told beautifully in *The Big Rock Candy Mountain* two years before *City*. This happened in 1963, just after I'd come through Nevada and been shown Pyramid Lake by Walter Van Tilburg Clark.

I can only wish that I'd asked Stegner about Clark. It never occurred to me that the two men must have known each other, and it never came up. I didn't actually have much contact Stegner, who was turning teaching duties over to his successor Richard Scowcroft. Besides Stegner's "old dog" remark and his handsome hound eyes, my sharpest memory of him is the time he led class for a public television program. We preplanned some of our discussion, and the class was held in his living room, as if we always met on his sofas with a picture window view of the mountains. It must have been the producer's idea, but I thought poorly of Stegner, and still do, for going along. That kind of fiddling of reality saturates us now. The expert pretends he's unaware of being filmed as he walks to his office before the cut to the interview—a tiny example, seemingly innocuous, but corrosive. Where exactly the boundary lies between such insidious stylizations of reality and a book such as this one I would have trouble saying, but I'm sure there is a boundary.

Of course Walter's Lawrence who nearly lost his life in Death Valley appealed to a young man who envisioned a Columbus who deliberately sought the edge of the world. Soon I would use Clark's introduction to meet Robert Caples. I can't imagine I betrayed the existence of this failed piece of mine to Robert, but I may well have discussed my geographic preoccupations, disclosing the impulse to conflate spirit and space, for I remember him suddenly saying something, as we stood by the edge of the placid pond at Turtle Hill, which impressed me as a liberating insight. It was that there's no necessary reason for north to be up on maps.

I was familiar with the fact that cartographers of classic Islamic civilization put south at the top of maps. Robert put east at the top of his Reno maps, and also of his historical map of Virginia City, published as a postcard when he lived there in 1950. Robert meant something more

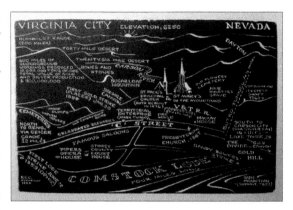

"Virginia City, Nevada" postcard map, 1950

far-reaching in Connecticut that day. He meant that once you visualize the ball of the Earth as an object in open space—this was before the Blue Marble photo—, your picture of the globe floats free, able to be turned any way you fancy.

In February of 1963—about the time I wrote my fan letter to Clark—Rosemary spent an afternoon and evening in Manhattan with John. They viewed the Mona Lisa on loan at the Metropolitan Museum of Art, then had cocktails and dinner at the Stanhope, a luxury hotel at 955 Fifth Avenue across the street from the Met. When Robert and/or Rosemary stayed in the city they stayed at the Stanhope. Rosemary could afford it, and would afford it. On this day, Rosemary told John that Robert was working on *Potter*, something begun "25 years ago." It seems John wasn't aware of Robert's personal fable of the creation until that conversation. Standing beside Robert's pond just months after John heard about it at the Stanhope, I as a newcomer into Robert's life was also unaware of *Potter*, but now I'm convinced he was thinking of it when he said what he did about up on maps.

The last map Robert created, the one of the Potter's world, also has east at the top, a choice going back at least to 1934, the probable date of a twenty-two-page typed manuscript titled "Manta The Earthmaker." This was Robert's first go at a personal creation myth in the form of a children's story, where a drawing of the creator, Manta, is also an image of the Earth's land masses in the shapes of the animals which

Manta has created. The Manta map is a rotated Rand McNally Mercator projection, with animals for land masses. (Oddly, though, he put 'W' at the top, to the right of the north-south axis, I don't know why.)

1934. The waggish mapmaker of Reno was all the time thinking on another cartographic plane, which he would articulate in a different context as "the subconscious ... summoned up to meet the spaciousness of the open world"—the apt conflation of space and spirit.

"Manta the Earthmaker" Rand McNally map, 1934

A Hecatomb of Portraits

The old Caddy is parked on Virginia Street, powdered over and caked deep in every crevice with desert alkali. Lawrence has been off on a wander, and is still away inside himself, Tim guesses. But Tim misses him, and on the second try hears movement inside the studio. After a delay Lawrence unlocks the door—never before locked from inside. "I'm just cleaning up a bit," Lawrence mutters with a half-wave to the room. Tim gapes, then almost smiles as he gets it that Lawrence's life is changing before his eyes. The portrait artist is tearing up his portraits.

This sketch of Lawrence tearing up portraits is my imagining based on Walter's two vivid descriptions of Robert doing just that. The first description was published in *City*, with Lawrence in the role; the second came two decades later, in the 1964 retrospective foreword. Robert said nothing about the ritualistic deed in his written recollections for the foreword. Possibly the episode didn't much stand out for someone who routinely gave away works, traded them for a pittance (once for "a toy stuffed kangaroo," recalled Walter's sister Miriam), left them, trashed them, and even asked for them back to trash. Walter brought up this pattern three times in the novel; but it was the hecatomb of portraits at the Clay Peters studio which left the deepest impression on him: Robert repeatedly tearing four or five portraits in half, then in quarters, then dropping the fragments into a trash can. This really happened, in 1932.

Robert did say this to Walter in 1964, in connection with the retrospective: "I don't remember one picture from another.... I destroy two, keep one, sell one, lose two, paint three, destroy three, build another, lose another, keep one, get one back—it's gone on that way for years.... Even in a few weeks they blank out. Only a few that I'd like to see burned remain unpleasantly clear in my mind." Robert may have exaggerated, but there's other evidence. When Congresswoman Barbara Vucanovich bought Byron's house on Plumas, she found several Caples works in the basement. Robert's painter friend Betty Bliss found others left behind in his backyard studio in Dayton, eight years after Robert departed for Connecticut. He was living East when Reno Gallery owner Peter Stremmel chivvied him for reluctance to exhibit by informing

him of "several works you discarded [which], when once resurrected, provided a tremendous amount of pleasure for the owner." Rosemary used to save torn-up sketches from Robert's waste paper basket.

I've run into several stories about Robert giving away his work. One is especially revealing for what Robert wrote to the friend who received the gift:

> It takes me ages to determine the worth of a picture, and usually they seem to perish before my eyes. And I tell you, it is a frightening thing to see a painting die, there is quite nothing to be done to save one when it begins to go. What happens, of course, is that a work suddenly becomes an objective experience, the intentions of the painter are lifted as a curtain might be, exposing the picture to be what it is rather than what it was willed to be. The effect, however, is precisely that of watching a two-dimensional creature expire, the color goes strangely shallow, the forms seem to struggle for space, lurch a bit, give a feeble kick or two, and die. And there it is hanging on the wall, dead as a stuffed cat.

In 1941, newly arrived lounge singer Alice LaVonne told Robert she didn't like Reno and couldn't sleep. So he gave her a landscape he promised would relax her. Artist Paul Coates and his family met Robert in Virginia City during the summer of 1950. Robert later gifted the artist's proof of *Triadic Fish* to Rosemary Coates with a note thanking her for appreciating his work—an interesting experiment in color by an artist for whom tones and values, as he professed late in life, "always meant more ... than color. A warm black, a cool white, golden ochre and a markedly subdued red earth, almost an earthenware brown, would just about comprise my chosen scale." Which suits me, being partly color blind and a shape person, a casual woodcarver. (And now I see where I got the "golden ochre" of the sun on the Peavine cabin

Triadic Fish, 1950
(Courtesy Nevada State Museum, Carson City)

fence.) Robert's earthen scale is well on display in a giveaway from 1955 or 1956. Robert was sitting on the back porch of the Union Brewery Saloon in Virginia City working at a large charcoal and pastel chalk drawing when a "cure" immigrant, one Helen Mossman, voiced praise. Robert promptly said, "It's done," rolled it up and handed it to her as a gift. Her son Tony Diebold told me the story.

Untitled (out past Six Mile Canyon from the Union Brewery), *ca.* 1955-56

No more than these other beneficiaries of his largesse was I any special friend when Robert sent me *Dark Range* as a wedding present in 1965 after our one meeting. *Dark Range* was among the works in the 1964 retrospective from his personal collection—his unsold works, in other words. He pleaded unsuccessfully for the pictures he sent to Reno, with one exception, to be disposed of somehow afterwards, never to be returned to him. *Dark Range* was one that came back to Connecticut, so he unloaded it on me. And here I am, writing this.

In *City*'s version of the hecatomb of portraits, Robert—who "ha[d]n't done any portraits in a long time" anyway, followed up by closing his studio for good. That makes a cleaner story, but for the record, Robert continued to maintain his Clay Peters studio. He was still there in 1937, according to that year's City Directory. I imagine the Peter Arno caricature stayed hanging by the door until Robert vacated late in 1937 or early 1938.

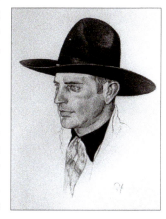

In the 1964 essay, Robert kept the studio, but had "never done another personal portrait since." That too is a clean story, an idealization. For one thing, Robert made portraits of friends. There's handsome Harry Drackert, the national rodeo champion and horse breeder who ran the Pyramid Lake Guest Ranch. There's Robert's lover Nancy

Harry Drackert, 1930s

Jackson of the Flying ME Guest Ranch, and Angela, both from the 1950s. Later there would be poet Joanne de Longchamps, also once his lover. His *Portrait of a Poet, 1975* was Robert's last new work to reach the public.

Even friends aside, it is not strictly true that Robert gave up commission work in the act of tearing up portraits that day in 1932. In March, 1933, the university's Fine Arts Group exhibited twenty Caples "character portraits in charcoal." In addition to the 1928 portrait of Walter, one of boxer Max Baer, various "character studies" of Indians and old men, and "also one colored sketch of a negro" (syntactically segregated by the *Journal*), the exhibition also included "women's portraits." Whether these were old works and/or more recent "personal" portraits can't be known for certain. But an inference can be drawn from the fact that the 1933 City Directory had Robert as "Portrait Artist." In previous years he had erroneously been listed as "Photographer" (because photographers make portraits), so Robert must have corrected the error, for commercial purposes.

What's more, Robert did not himself connect his foreswearing of commission portrait work with the hecatomb in 1932. Instead, he linked his change of direction to a different cause and a later date, when

> Along came the Federal Art Project (34–36?).... Go out, draw Indians. Draw Indians as of early days—how lived, made things, basketry etc. Best break ever. Felt needed, felt mission had importance. Big deal. Saw tie-in between Indian face—Indian country, never again did 'Society' or social portraits.

Where Walter in 1964 pegged the end of Robert's portraiture career to the hecatomb, first he identified Robert's underlying motivation: his new and more profound involvement with drawing Indians—the very connection Robert himself made. Nevertheless, when Walter quoted the words about the Federal Art Project which I just quoted, he omitted Robert's concluding statement that it was as a result of drawing Indians *for the FAP* that he "never again did 'Society' or social portraits." Why the omission? Because the FAP assignment came to pass in late 1933, the hecatomb "one afternoon in 1932." Walter wanted Robert's change of heart attached to the scene he personally witnessed earlier, in 1932.

Walter wasn't in Reno when Robert began at the FAP in 1933, having already left for Vermont—and having witnessed the hecatomb. The hecatomb story loomed so large in Walter's idealized memory of Robert that it overrode the evidence of Robert's statement that he didn't finally cease commercial portrait work for another year or more. So the hecatomb is there in *City*, Walter's monument of filtered memories dedicated to Robert—but not the FAP and Robert's famous Indians.

Life Spent among the Paiutes

Dissatisfaction with being "Bob Caples, divorcees portrait artist" of the society columns pushed Robert toward his Indian drawings, where he could apply the facility he'd acquired in a more worthwhile direction. But society portraits—"the miles of these delicate charcoal women," as Walter spoke of them depreciatingly—weren't the only thing Robert had been doing. For one, he all along did other portrait work, of Renoites, of families, of men. For another, he began "walking Commercial Row and

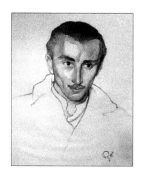

Untitled (dashing man), 1930s

Untitled (business or professional man), 1930s

Untitled (old man), 1930s

Lake Street, looking for old, weather-beaten and troubled faces." This is Walter's Lawrence, before the hecatomb, troubled himself and dead serious. Robert, though, had a way of finding the humor. He told the following story to a social columnist:

> Some time ago, Robert Cole Caples, Reno artist, was seeking types of faces for a series of portraits he was drawing. One day he came upon an old fellow with a long flowing gray beard ... and good-humored indolence written upon the face. Just the type he wanted!
>
> The man consented to a sitting and Bob gave him four-bits for the trouble. About four or five months later Bob saw the man again.
>
> "How are you, old-timer?" he greeted. "What have you been doing lately?"
> "Well," the fellow replied, "I ain't been doing nothing since that time I worked for you."

This was 1932, the Depression—so did the joke turn on unemployment or dysfunction? Either way, the story backs Walton's claim, that Robert "thoroughly enjoyed someone who is quite poor, if they're colorful."

Beyond portraiture, Robert "began to do moody allegories in the dark basement at home, a chess board lit by one guttering candle only, with the white king backed into a corner and multiply checkmated, hands occupied with pointless, pass-time activities, and others of the same sort." Here Walter, in the retrospective essay, made it sound as if Robert were flailing because "he was profoundly depressed." These were in truth somber images. They were also successful and popular images in their day. *Chessmen at Midnight* and *Bar Sinister* (later retitled *Hands at the Bar*) "gained coast-wide recognition" in the prestigious art department of the store Gump's in San Francisco. The *Journal's* front-page coverage identified the works as "[a]mong his best known"—a locution betokening the artist's standing.

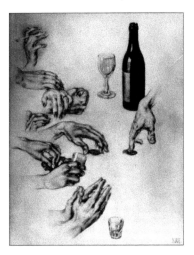

Hands at the Bar / Bar Sinister,
early 1930s

During these same years, Robert was exploring desert lakes, basins and ranges, and beginning to render Nevada's mining towns and landscapes. And "the desire to draw Indians for impersonal reasons grew stronger," said Walter in the retrospective essay. Even prior to the hecatomb, and prior to the FAP assignment, Robert "went out and sketched them in their own places."

In the portion he contributed to the excellent catalog for a traveling Caples exhibition in 2009, Robert's son-in-law unwittingly exaggerated Robert's immersion in Native America. After art school in Santa Barbara, wrote Lanier Graham, "most of his life before World War II was spent among the Paiutes near Reno, Nevada where he was given the tribal name of Longfoot." Actually not. "Longfoot" was a name bestowed, in the 1950s, on Rosemary, not on Robert, by a Paiute moccasin-maker

while fitting her. (Robert's white canvas sneakers, veterans of his many trips abroad with Rosemary, and touchingly inscribed all over in colored inks with trophy destinations, are at best size 9.) And the implication that Robert virtually lived among the Paiutes is misleading. Art school in Santa Barbara ended in 1929. Robert undertook the FAP assignment to draw Indians not until 1933. "I was being welcomed by people whom I'd admired at a distance," he later stated, "but had no thought that I could ever speak with them." The assignment lasted about a year and a half, during which time he never lived on a reservation.

Graham was married to Rosemary Junior from 1965 to 1976. Before the couple moved west to San Francisco in 1970, Graham came to look up to Robert as a spiritual mentor. Robert's often cryptic and typically ironic mode of talking about himself might well have led a susceptible young man unfamiliar with Nevada into misunderstanding about this corner of Robert's past.

Robert thought it was his 1927 portrait of Geronimo Mirabel on display in the window of Brundidge's which won him his Federal Art Project appointment. The recommendation, Robert told Walter for his essay, came from "Mr. Charles Cutts—remember?" That's Charles F. Cutts, co-founder with Dr. James Church, in 1931, of the Nevada Art Gallery, eventually to become the Nevada Museum of Art. Cutts' recommendation was made, not to the FAP directly, but instead to the university, for which the FAP was to do a public works project. Something Robert didn't add, and I don't know if Walter was aware of it, was that Cutts' recommendation went to President Walter E. Clark. Here is Robert's account, four decades on, of Walter's father's role in the genesis of the Indian portraits in 1933.

> I was summoned to Dr. Clark's office at the university, and informed that I should be prepared to work out a project that would benefit the university and myself. And I was to be hired by the Federal Art Project and I was to engage in a project of drawings that would be of interest to the university. And it was then and there agreed that Indian portraits would be the best answer.

In the Caples archive is a copy of the original drawing of the portrait later titled *Story Teller*, on which Robert wrote, SKETCHED FROM LIFE

PYRAMID LAKE, NEVADA, 1933; outside the picture margin he wrote, PROPERTY, PUBLIC WORKS OF ART PROJECT. So Robert began drawing for the government in 1933. In February, 1934 the *Gazette* announced that the "PWA" (Public Works Administration) was to present Caples' drawings of Nevada Indians to the university, for its library reading room. The preview of a selection at the university's Fine Arts Group that month "broke all previous records." In April of 1935, the complete set was mounted in the old Clark Memorial Library (no connection to either Walter Clark).

When the young University of Nevada Press began to think about publishing portfolios of art in 1967, Caples was the first name mentioned. Prints from the Indian portfolios the press brought out in 1970 and 1972 hang in the Legislative Building in Carson City, and high on the north wall of the Washoe County Library in Reno. Many a Reno home, my own among them, and many an office has one or two of the prints on its walls. Of Robert's works, his Indians are the most often seen, the best known. Today the originals are stored at Special Collections in the university's newest library, the Knowledge Center, except for the half dozen which I often stop to appreciate where they hang in a corridor one floor down. Robert said the press did a first rate job with the reproductions, but I must say you wouldn't realize from them how deep and vibrant are the charcoal blacks of the originals.

The Scene as It Might Have Been

Robert's Indian series for the Federal Art Project consists of twenty-two untitled charcoal drawings on Strathmore paper, 25" × 19.5". The titles of the eighteen selected for the 1970 and 1972 portfolios, nine in each portfolio, were added for convenience by the University of Nevada Press. In Robert's archive is a small print of one of the four not included in the portfolios, in this version bearing its own title, *War Bonnet*, in Robert's hand just above his signature within the picture space. Here is the story of that drawing.

War Bonnet, ca. 1933–35

I remember that I was enormously pleased that Pete Winnemucca would let me have the magnificent object for an entire week so that I might make some sketches of it. And, as you can well imagine, I would put it on reverently now and again and go bouncing around in my Reno studio, just to make the feathers toss and fall—it was like having a great bird on one's head. I never enjoyed making a drawing more. Besides, I was in my arrested early twenties, and that made a difference, too—make-believe left me (if ever) by very slow degrees. Later, it was pointed out to me that the Nevada Indians did not share the war bonnet culture: these were worn largely by Plains Indians. And I suppose that is why the University Press did not include this particular drawing in its series. I suppose that this should bother me a lot more than it does—I know that it would if I were more pragmatically minded. For me, the lofty headdress, with its rustling crown of mile-high flight, epitomizes the very apex of Indian glory.... I said to the remote, weather-beaten Pete Winnemucca, "Thank you." He said nothing at all. Our communication, untroubled by sound, was as simple as the small stones around us. Besides, what is there to say?

Reno Dick, early 1930s

Water Carrier, ca. 1933–35

Hunting Lesson (original version), ca. 1933–35

Hunting Lesson, ca. 1933–35

Robert's assignment, as he wrote for Walter in 1964, was to "Go out, draw Indians." He would make field trips of a week or ten days. But as Robert's endearing account of the war bonnet intimates, some of the actual drawing was accomplished in his studio. Not only that, some of his initial sketch work from life took place in the studio as well. When word got out, Indians began arriving at the Clay Peters Building to earn what they could for posing. "Big Indians, little Indians. Sometimes Pat Collins, elevator man, would haul 5 or 6 Indians—mothers, babies, etc.—whole families, up to the fourth floor.... More drawings and quick sketches—much silent commotion saying good-bye. Small amounts of silver." But when asked in 1975, "Did the Indians come to you?" Robert either suppressed or had forgotten the fact. "No, I had to go and find them," he answered. "I could then ask a guide to come with me and interpret for me, and explain to Indians that this was my assignment. I was supposed to show the scene as it might have been."

Robert's back and forth between studio and field helps explain why at least some of the drawings are composite images. "It became a game," he wrote (but Walter didn't transmit), "to build patterns and pictures that seemed to have a reality of their own." For several, the assemblage can be ascertained. Thus for the face of the *Water Carrier* Robert borrowed his portrait of *Reno Dick*. My favorite of the Indian drawings is *Hunting Lesson*. Two versions exist. The student is the same boy in both, but in the rejected version, a young father or older brother crouches to the boy's height, while in the final version, a middle-aged father or uncle stands, again with an encouraging hand on the boy's back.

And I'm pretty sure the boy is the same boy as in another of the four drawings not included in either portfolio. In the case of *Arrow Maker*, the old Indian who demonstrated knapping for Robert at Topaz Lake no longer possessed the proper tools and materials, so in place of a piece of deerskin to protect his hand he substituted cloth, for a core a random stone, and for an antler knapping tool a piece of wood. In the field Robert drew only the hands, which he later redrew with the correct objects. And along with a few arrow shafts he added a younger knapper. And for *Story Teller*, chances are what Robert drew in the field was only a head portrait, since his sitter, the ancient Paiute Jigger Bob—whom the fascinated artist would make the storyteller in his creation fable "Manta the Earthmaker"—was not that day wearing the rabbit-skin robe Robert gave him for the final drawing, nor was his hair so long.

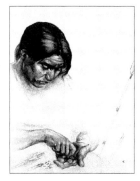

Arrow Maker,
ca. 1933–35

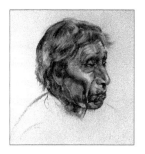

Jigger Bob, 1933

To show the scene as it might have been—such was Robert's assignment. This was 1933, the Depression. Under the New Deal, artists were painting murals in public buildings to celebrate the common man and the dignity of labor. To honor Indians in that context meant to survey their traditional roles for maintaining, ordering, and giving meaning to life. Robert saved several visually interesting labors—spearfishing, gathering pine nut cones, and harvesting with a digging stick—for the courthouse mural, another FAP project. He omitted several activities I'd have liked to see—net making, field sports, and the hand game, a form of gambling still practiced by many tribes.

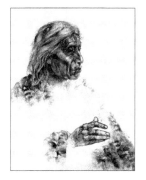

Story Teller,
ca. 1933–35

Robert made clear in his letter to Norinne Buck about the war bonnet that when it came to ethnographic authenticity he wasn't "pragmatically minded." And after all, the iconic photograph that Pyramid Lake Paiutes use in their publications features five Paiute men in such war bonnets. (The number five, I noticed while reading about Paiutes, is spiritually loaded, or was so traditionally.) Ralph Burns, who directs the tribe's museum at Nixon, told me that Pete Winnemucca, his grandfather, is the first man on the left—thus here possibly is the very war bonnet Robert drew. The others left to right are Harry Winnemucca, Mark Jones, Johnny Smith and Harrison Frazier. Ralph Burns also told me that the Plains war bonnet wasn't adopted at Pyramid Lake until 1931, which is just a couple of years before Robert borrowed Pete Winnemucca's. The Pyramid Lake Paiute children attending the Stewart Indian School near Carson City, Burns said, wanted to be able to march as Indians in a parade—they could earn twenty-five dollars each by taking part. But by then they had lost (as the school encouraged them to lose) knowledge of their own indigenous dress. A man from Fort Hall, Idaho, Charlie Bronco, a Bannock, suggested that they learn to make the war bonnets. The rest, you might say, is history.

Paiute men in war bonnets

But since Robert's given task was to show things as they "might have been," it's fair to ask whether—artistic merit aside—he did the job. I put the question to University of Nevada ethnographer Catherine Fowler. Caples "did some nice work," she generalized, but his drawings "were not always 'ethnographically accurate.'" We spent a half hour or so over coffee looking at reproductions of the two portfolios. Here are some of her observations.

Arrow Maker. For safety from the sharp chips that fly off obsidian, the stone is being held too close to the edge of the deerskin pad, which is positioned exposing too much of the hand.

Cradleboard Weaver. One arm of the shade is missing. Also, braiding was a Plains fashion borrowed by Paiute men, but not women, as pictured, via their more Plains-oriented Bannock cousins to the north around the time of contact.

Fire Maker. The hearth, the oblong piece of wood with three or more drilled holes in its flat top, should be visible. Whether the whorls drawn around the bottom of the stick are meant to be dry tinder or flaming tinder, the picture is wrong, for either would be located next to the side hole in the hearth, the channel, down which comes the spark to light the tinder.

Rock Painter. Great Basin cultures produced few pictographs (drawn on a stone surface) as opposed to petroglyphs (cut into stone), except in the far south, and there human bodies are represented by a triangular form. The vessel containing the paint is Southwest rather than Great Basin.

Burden Carrier. For correct balance, the strap rides too high on the head and too low on the conical basket ('wono' in Paiute, which is what they call the Pyramid). The lugs which the strap should pass through aren't shown; and the weave pattern is Californian. A different burden carrier not in the FAP set shows the balance correctly. Robert drew this same old woman as the central figure in the courthouse mural, there bearing a large water jug—so at least one of the two images must be another composite.

Four of the twenty-two drawings show women in head scarves, apparel adopted from Europeans.

Cradleboard Weaver, ca. 1933–35

Fire Maker, ca. 1933–35

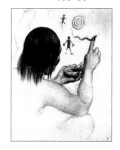

Rock Painter, ca. 1933–35

Untitled (burden carrier), *ca. 1933–35*

Fowler thinks Caples made an esthetic choice to retain the anachronistic scarves because he liked the oval framing of the face. His focus on face and hands, she believes, means he was personally more interested in portraiture than in ethnography.

Robert himself termed the drawings "portraits." But his larger purpose, larger than either ethnography or portraiture, was to convey the spirit of "an ancient and proud people." Walter had this in mind when saying Robert's Indian drawings "became less and less portraits. They sought Indian, not single Indians." Nevertheless, personally I prefer the drawings that do portray individuality, such as *Hunting Lesson* and *Story Teller*, also *Cooking Woman* and several others. As with the classic nineteenth century photographs of Plains Indians, those that best convey Indian-ness emanate experience and personality. Whereas the least interesting drawings are those with little individuality, such as *Tule Bearer* (pronounced tú-lee).

Cooking Woman, ca. 1933–35

My impression is, moreover, that Pyramid Lake Paiutes of today especially value the Caples drawings as portraits of their remembered or forgotten forebears. Two I've spoken to, Betty Aleck and Linda McCauley, prize the Caples prints they've acquired at estate sales and by other means, in part for that reason. Linda in particular, when she learned of the work I'm doing, pressed me repeatedly, "Where are his notes?" She assumed he must have kept detailed notes through which his subjects could all be named. Her desire marks a change from pre-contact Paiutes, among whom the dead were dreaded, considered too dangerous even to name, unless by circumlocution. I had to tell Linda that if he did make notes, they haven't survived. Neither the WPA nor the University of Nevada Press, nor Robert, did a good job of preserving records. It is wrong, said Linda, for an artist to take Indians as subjects without honoring their individual identities.

.

The 1964 retrospective included a portrait of *Jenny Crow*, an Indian woman once a beauty and still beautiful, her smile inward/outward, sweetly radiant. The Clarks contributed this 1933 charcoal to the exhibition. Robert drew Jenny Crow again for the FAP series, it being one of the four drawings not selected later by the press for the two portfolios. Jenny reminds me of the woman I moved to Nevada for, she was appalled to be told when I showed her the rather rough Clark drawing, which I've manipulated here to bring out the eyes. "She's old!" she cried, her voice as soft as I imagine Jenny's. Well, we all get old, if we live, and I can see the twenty-year-old and the six-year-old I know from photographs in my friend's sixty-odd-year-old face, with just such eyes where people see their simpler selves affirmed, an equivocal gift.

Jenny Crow (highlighted), 1933

In his essay, Walter explained how Jenny Crow at first refused to cooperate with the artist, fearing that an image of herself gave its possessor "power" over her, until Robert overcame her resistance by "offer[ing] as hostage a sketch of himself." There's nothing about this expedient in Robert's notes for the essay, so it must be a story Robert told him. However, Robert's general practice with Indian subjects, when he detected what he took to be the same reluctance, was something different, as he related to radio interviewer George Herman forty years on:

> When I told them that when I made a drawing that a photographic copy of the sketch would be sent to them or brought to them by me, why, that seemed to clear everything. There was immediate enthusiasm, and the Indians posed more readily. And the older Indians, who had been reluctant to pose, were now persuaded to sit for me, and I think largely because they felt that with a photograph of the drawing, I no longer had some sort of hold on them.... [T]he photograph seemed to make everything come out even, and all were happy.

I don't care for Robert's patronizing tone here. Catherine Fowler the ethnologist confirmed my suspicion that "Caples was pushing the magical/mystical aspect a bit. [Resistance to being imaged] isn't necessarily the old 'You will capture my soul' thing, at least around here.... I've not found it in the Great Basin." Furthermore, Walter's nephew David Chism remembered hearing from Robert or Walter, one or the other, that the Indians at Pyramid actually enjoyed being drawn, and tolerated being photographed.

By chance I came across a photo in a Special Collections exhibition, probably taken during the late 1890s, probably at Wadsworth on the Pyramid reservation. The subject, a woman posing with her three composed children, almost certainly is a younger Jenny Crow, with those same active eyes and seeming quite at ease in front of the camera. I can't believe that the photographer had to offer this open person a copy of the photo to persuade her to sit for him.

Jenny Crow (?) (left) in "Portrait of a Paiute Family," Heany, *ca.* late 1890s

All the Evil Would Be in Man

Walter compared teenage Tim's avoidance of the telephone to the primitive fear of soul theft. This is one of a scattering of references to Indians in *City*. From the paucity I infer that local native cultures didn't much enter the world view of young Walter growing up in the city of trembling leaves. Otherwise it might have been a Paiute or Washo runner Tim imagined himself running with in pursuit of joy on the sage-studded yellow hills outside Reno, and on the track when he beat his rival Red in misconceived competition for Rachel, instead of with the mustang stallion he'd once seen on the Lake Range at Pyramid. Both Paiutes and Washos were runners, for hunting, warfare, transport, ritual, sport, and no doubt for joy.

But then Walter's next novel, his last published, *The Track of the Cat*, revolves around an Indian. That's on Walter's word. The pivotal role might seem to belong to the two black mountain lions, the real one and the illusional, rather than to the ancient, nearly mute Paiute, yet "Joe Sam … is the very central character of the action," said Walter. Does it take away that Joe Sam is a nearly unrelatable figure? Probably not. Joe Sam, you could say, anchors the human end of the allegorical net, the cats the other, in which the more realistic characters are caught. The problem with the novel is that no character is fully realized, each too obviously stands for something. In fairness, many Clark fans regard *Track* as his best novel. For me it was a hard read, though I concede that in its own way *Track* is a *tour de force*, the word paintings of place almost as fine as anything in *City*, and of weather finer, especially the long climactic unwinding of Curt's lion hunt and self-destruction.

Just after publication of *Track*, Walter made a statement to a literary magazine affirming Joe Sam's centrality, and valorizing "The Indian": "Walter Clark finds in our overseas heritage 'a kind of borrowed depth that will not serve us very well…. The Indian increasingly takes on for me the importance of the real human product of this hemisphere, the race in which we can observe the characteristics which the land will, to some extent at least, finally produce in the white man, too.'" Walter may have been reading Swiss psychologist C. G. Jung, who proposed

something along the same lines about the American land changing the psyches of its immigrants. Jung, though, didn't denigrate the value for us of European "depth" as did Walter, who admired the literature but who never traveled overseas, who even turned down expenses-paid lecture tours of Europe.

Seven years later, in a blurb he wrote for *Go in Beauty* by novelist William Eastlake, Walter again valorized the Indian, praising Eastlake's theme "of the durable values of the Navajo way of life, deeply rooted in place, as compared with the shifting values or total lack of values of so much of the white man's life, and the strong implication that such values can have force for the white man, too, if he will only let them." This pronouncement exposes more nakedly Walter's contempt for "the white man" with his "lack of values," a species of categorical negativity pervading *Track* (if perfunctorily qualified at the very end) and overtaking Walter's general outlook on life.

Reviews of *Track*, such as one titled "Man Against Relentless Evil," equated evil with the black mountain lions. Walter countered that "the cats come near to being good, since they act against the one conscious and disproportionately destructive force in nature—man. And by the same token, all the evil would be in man." One commentator, Chester Eisinger, considered that Clark "reject[s] ... the whole complex of societal themes." Another, Clark's peer Wallace Stegner, seems to say just the opposite, that "Civilization is Walter Clark's theme." The two comments aren't really at odds. Walter's theme was civilization, but "because," as Eisinger said, he had "given up faith in man," his message was in the nature of a prophetic warning to the civilized—or as Stegner aphorized, Joe Sam is "a Paiute Cassandra." And so "The Indian," though central to *Track*, is not its theme; "The Indian" is an intellectual construct Walter shamed "the white man" with.

Ironically, Walter's words lauding "the durable values of the Navajo" virtually repeat the sentiments of the dreadful Mrs. Varney in "The Anonymous." This bleak story comes from the time horizon of *Ox-Bow*, where Walter's critique of civilization began. In the story, a Navajo teenager is sent by his wealthy patroness to a government Indian school for private instruction to render him, essentially, fit to hold his own at

dinner parties. The boy is a hollow shell, another portrait with a blank face, like Joe Sam. The story is not about his Navajo culture per se but about the pernicious effect of the dominant culture. Mrs. Varney, when she comes to collect her Indian toy, thanks the teacher for not doing precisely what she herself from pride and ignorance unwittingly has done, which is to damage "his fundamental Indian nature, with its gift for simple, deep, she said bone-deep, realities with which the white man has largely lost touch." The predatory Mrs. Varney vibrates to the same virtues Walter valorized, herself being vicious.

In 1946, Walter and Barbara spent about half a year at eccentric, utopian arts patron Mabel Dodge Luhan's establishment in Taos, New Mexico. Walter got to attend some closed Pueblo ceremonies on the

Clark's map of Taos, February 28, 1946

invitation of Tony Luhan, Mabel's husband who was a Pueblo chief. Walter's biographer Benson says that while in Taos Walter was attracted to Native cultures. That's easy to believe. But a letter he wrote to a friend indicates that he arrived in Taos without any special interest, and that Eastern philosophy preoccupied him more at the time. As a kind of

synopsis of the letter itself, Walter drew for "Helen"—possibly Helen Dailey, librarian at the high school where Walter had been teaching in Cazenovia, New York—an intriguing map "showing the important points about Taos, NM." One line of writing circles the perimeter. Another, meandering through the interior, reads:

> Strangeness, according to all the disciples of permanence, from Buddha to the newly dead, is actually merely the result of a kind of temporary astigmatism of the inner eye, which prevents the victims from perceiving clearly that all differences are purely external and therefore transient and unworthy of regard, while the inner meaning is universal and timeless. Peace and wisdom follow quickly when the outer eye has been closed and the inner eye is at last open.

Walter's gloss on this quasi-Buddhistic, not quite tongue-in-cheek improvisation on the theme of higher attainment is the dithering yogini, doubtless Walter's self-parody, struggling to meditate, but with hands over eyes and a defeated mouth. Surrounding the yogini are a bottle with two glasses beside an open book, a pistol- and sword-wielding bandito, a painter in beret attacking his canvas like a swordsman, and so on. Excluding the border of conventional Southwest symbols drawn across the bottom—clouds, eagle, corn, mountains (or lightning), arrow, sun—there is nothing Native American about Walter's Taos.

Here Is the World

He was born north of what is now called Goose Lake on the California side of Surprise Valley, in the territory of the Groundhog Eater band. Jigger Bob's father was a Kooyooe Dukaddo, a Cui-ui Eater from down at Kooyooe Pah where the family wintered, and his mother came from near present-day Gerlach on the trail between the two lakes. One day when he was near the Needles—Papepatu, Water's End, haunt of the Water Babies—young Jigger Bob spotted the smoke of strangers across Kooyooe Pah along the shore beneath Tohakum Peak. He was the first Northern Paiute, or Paviotso, who call themselves Numah, the People, to see Frémont's party, and it's said he became Frémont's guide while the explorers bivouacked there at Pyramid Lake. That was in January, 1844. Nearly a century later, when he died in 1935 at age 110 or 114, Jigger Bob's portrait hung at the university.

After sketching Jigger Bob at Pyramid Lake in 1933, Robert decided to make this ancient Indian the storyteller in a fable of creation he was hatching, "Manta the Earthmaker." So the final drawing of him Robert submitted for the FAP series shows Jigger Bob lifting a hand as he begins to tell a story.

There's no telling from "Manta" how much of Jigger Bob's biography Robert knew. First of all the name. The Bob part was sometimes spelled 'Bob', sometimes 'Bobb'. The Jigger part, according to a student of the Pyramid Paiutes, Ruth Hermann, came from his full nickname, "'Riggerdy Jiggerdy Bobb,'" in recognition of "his lively manner." He got to know the country and the different Paiute bands as an itinerant cowhand. But he settled at Pyramid. It seems he had an affinity for that northwest portion of the lake from which as a youth he had spotted Frémont, for he married a woman, Judy Winnemucca, who claimed land up there in Smith Canyon after the white settler returned the property to the tribe. In summer Jigger and Judy lived up the canyon ranching and gardening. They wintered in the unoccupied Symonds Ranch on a spring-fed creek just north of where the canyon deepens ascending toward Tule Peak. You used to go past that ranch on washboard road on the way to the Needles. Today you hit a road block a few miles past the

ranch, where a fork leads outside the reservation to a geothermal site and to Flanagan, a ghost town. These days when I fish near some tufa castles called the Monuments I pass the ranch. There are always parked vehicles, but I don't know if anyone lives there. I've seen sprinklers going, and pastured horses, but never a person. Then again, you don't often see anyone, driving past a ranch.

Jigger Bob became the patrolman for that northwest section of the reservation in Captain Dave Numana's tribal police. His main duty was to prevent cattle-rustling, poaching and unlicensed fishing. He packed a pistol with a barrel so long and heavy it had to be aimed resting on the other arm. Polk's City Directory for Reno as late as 1920–21 listed him as "Jigger, Robt, patrol," a resident of Nixon. He and Judy had moved, but actually still lived on the west side of the lake miles from Nixon the reservation town, in the hills above Sutcliffe with its grandfathered non-Indian properties (that's where I honeymooned, at Sutcliffe). "Patrol" must have been honorific by then. When interviewed by ethnographer Willard Z. Park in 1933, the year Robert drew him, Jigger Bob's mind wandered, but with the help of Judy he provided what the ethnographer thought valuable information. In the 1970s, there were still many who remembered the spry old man. Today there's a Jigger Bob Street in Sutcliffe, and Smith Canyon has been renamed Jigger Bobb Canyon.

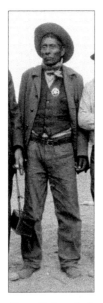

Jigger Bob, tribal policeman, date unknown

.

"This book is the story of how the lands of the earth upon which we live were made." So opens the author's preface to "Manta the Earthmaker," Robert's typescript of twenty-two double-spaced pages, a children's book. The story will explain, he tells us, "why the great lands of the world are of such curious form," and he shows us Jigger Bob's map, the rotated Rand McNally world map with the land masses

rendered as animals. Next come five pages of preamble: an historical interlude where Jigger Bob spots Frémont, then a scene in Nixon where an Indian acquaintance tips the artist, at Pyramid for the day to draw children, about Jigger Bob and his grandchildren. We learn that Jigger Bob is an "old [traditional] Indian"—he speaks English, still "the deer come when he calls, the birds hear him, animals listen." But soon "there shall be no more real Indians. Those who remain at Pyramid Lake live in little wooden cabins."

The story proper begins: the artist arrives at Jigger Bob's house in the hills, befriends Teha the old Indian's granddaughter and Numah the grandson, placates their grandmother, and persuades the fond grandfather to tell the little ones a story to keep them still for the artist to draw. Jigger Bob places his old war bonnet on delighted Numah, and begins. The artist listens intently as he draws, aware that the old man's wisdom surpasses any worth of his drawings.

Later, his story finished, the storyteller has Teha fetch a certain deerskin. This he lays on the ground before the artist and the children. On it, says Jigger Bob, is drawn the face of Manta, and "from where I sit I see the countries of the world." For the benefit of his puzzled listeners he deftly uses a charred stick to bring out from Manta's features the animal shapes of continents and islands—Rabbit, Elephant, Brown Bear, White Bear, Duck, and so on. Turtle is Eastern Europe into Russia and Central Asia. Snake's slithered track is the equator. "For a long moment he looked down at his work. Then he pushed the deerskin toward the artist.

"Here is the world," he said. And so ends "Manta the Earthmaker."

H E R E I S T H E W O R L D

And this, on the first page of another manuscript in Robert's archive, is how he (or whoever did the typing) laid out the title of his 1937 or 1938 revision of the fable. Both versions end with the same exclamation. But for "Here Is the World" Robert cut the author's preface, the historical interlude and the scene in Nixon, instead to begin by jumping right into the story: "Jigger Bob sat dozing in the sun." The rest of the simplified version is substantially the same.

"Manta, the Great Spirit" created the physical world out of darkness, cold and wind. The Earth, sun, moon and stars came next in turn. Then Manta created the animals, all but Snake, who "alone was not made by Manta, but came of himself out of the deep." Manta made the animals because snake stole the moon. To prevent Snake from keeping the moon, Manta shaped one after another of the animals, each with its special strength, yet each with a weakness causing it to fail to recover the moon from Snake—until at last Snake dropped the moon as he fled from Duck, thinking Manta himself had come after him because Duck was wearing Manta's borrowed war bonnet. Then, just when everything seemed right, the animals began fighting, each falsely claiming the honor of routing Snake. Manta got so angry that he turned them all to stone. And that is how the lands of the Earth came to be.

In "Here Is the World," the artist draws Jigger Bob, not the grandchildren. And Jigger Bob draws the face of Manta with crayons and paper borrowed from the artist. And the children's book was now to be illustrated: Robert marked ten places for illustrations, mostly of the animals, but with grandson Numah the first and Jigger Bob's map now toward the end.

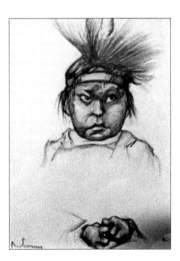

Numah, ca. 1934

A small drawing titled *Numah* was one of the works found by Congresswoman Vucanovich in Byron's basement on Plumas Street. Her daughter sold the drawing to a friend, on whose wall it hangs today just several blocks from where I sit. (Reno is still a small place.) *Numah* was an illustration for the revised fable, on the evidence of the boy's headwear. In "Manta," Jigger Bob let Numah wear his "eagle feather war bonnet"—a common description of the Plains headdress. And that's what Robert drew on Jigger Bob's map in "Manta," where Duck in "Manta's War Bonnet" is South America. Whereas in "Here Is the World," Numah dons Jigger's "deer tail bonnet, the one with the eagle feather in it." In the *Numah* drawing, he wears a deer tail bonnet with one feather.

Numah's bonnet demonstrates that Robert knew by then what was ethnographically correct in the way of hats. Ordinary cold-weather headgear was a cap woven of sagebrush bark or other fiber. Symbolic headwear such as Numah's took the form of a feather or feathers stuck vertically into a pelt band, a style seen in California tribes and others. An example is worn by Poito, Old Winnemucca, as pictured in *Territorial Enterprise* journalist Dan De Quille's book *The Big Bonanza* of 1876. The old Paiute leader is also attired in the blue army jacket given him by General Crook at Fort McDermitt in 1868. Old Winnemucca's activist daughter Sarah Winnemucca herself posed pensively wearing an impressive headdress of a similar style, one she may have worn in the Red Indian show she conceived in an effort to finance the welfare of her tribe, then in a condition near or at starvation. The little fund-raising spectacle was staged in Virginia City and San Francisco.

Duck in Manta's war bonnet, "Manta the Earthmaker" Rand McNally map (detail), 1934

Paiute sage bark cap

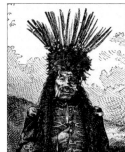

Old Winnemucca (Poito)

Old Winnemucca was the son of Chief Truckee, namesake of the river feeding Pyramid Lake from Lake Tahoe, and of the Truckee Meadows where Reno is situated. Chief Truckee—but the term 'Chief' does not quite apply to the loose political structure of Paiute bands—temporarily abdicated, so to speak, in favor of his son Poito when he decided to guide Frémont over the Sierras. He and a dozen Paiute men accompanied Frémont on into California, by a route out of the Basin through the territories of traditional enemies and trading partners that Paiutes had long been taking in order to obtain seashells at

Sarah Winnemucca

the coast. Truckee was with Frémont's force which took Los Angeles during the Bear Flag Revolt, Frémont's impromptu contribution to the Mexican War in 1846. Truckee steered his tribe toward friendly relations with the powerful whites, and to that end he told his people an optimistic version of the creation legend in which the children separated for feuding were the dark ones, the Indians, and the white ones, the "taibo," who were now returning from across the ocean to reunite. Truckee's granddaughter Sarah, born in the year of initial contact when Frémont arrived at Pyramid Lake, 1844, became the first Native American woman and the first Native American of any tribe west of the Rockies to author a book, *Life Among the Piutes*, another means by which she championed her people.

This family exemplifies Paiute adaptability when confronted with the rapid and pervasive changes that overtook them, a people that had been subsisting in more or less the same minimalist way for centuries and millennia—the Pyramid Lake Paiutes date their occupation there to 9000 B.P., not without justification. No one except perhaps the Paiutes themselves would have predicted this adaptability—certainly not Major Ormsby and his volunteers before these attackers with their superior arms were badly defeated on the Truckee south of Pyramid in the first battle of the Paiute War of 1860. Newcomers judged the natives by the seeming squalor of their material culture. I'm not sure but that if I'd been in a party to come upon them in the desert living poorly clothed behind sagebrush windbreaks, I wouldn't have thought them squalid, too. But really their lifestyle was a triumph of adaptation to an extraordinarily ungenerous environment, one demanding inventive exploitation of very scant resources by painstaking labor and subtlest attention to the nuances of nature. For someone such as myself, more than attracted to their stark country, these people hold a fascination.

I don't mean to downplay the trauma of invasion, which scars descendants down the generations. Only to say that coming out of the circumstances they had wrought for themselves, in their own prehistoric time, the Paiutes for the most part adapted to invasion with flexibility and intelligence. Even before contact the Paiutes had begun to adopt some features of Plains Indian culture, itself in part an

adaptation to European contact. Paiutes also stand out in the history of resistance, for it was Wodzibob and Wovoka, two Paiutes, who set in train the Ghost Dance movement. Wovoka's father fought in the 1860 war at Pyramid Lake.

With that background in mind, the benefit of the doubt can be given to Pete and Harry Winnemucca and the rest who posed in Plains war bonnets for the photo emblematic of Paiute pride. The same benefit of the doubt goes to Robert, ever the syncretist, for inserting Biblical darkness and water and even an evil serpent into a supposed Great Basin legend, together with elephants and polar bears and knowledge of the spherical globe. I certainly don't fault him for unpragmatically bouncing around his studio in Pete Winnemucca's Plains war bonnet. In a way, pragmatic adaptability is just what the war bonnet signifies for the Great Basin.

.

Jigger Bob, guide to Frémont at Pyramid, wandering cowboy, husband of a Winnemucca, patrolman in a blue government-issue coat, informant of ethnologists, artist model—this riggerdy jiggerdy man exemplifies adaptation as well. All the same, Robert was justified in taking him—whose face, Robert wrote, "the sun and wind has fashioned into a likeness of the mountains around him"—as the type of "old Indian." Jigger Bob's adherence to old ways in a changed world is commemorated by an anecdote from a younger friend of his, Carl Tobey, who reminisced about hunting near the Symonds Ranch when Jigger Bob was staying there:

> We killed some rabbits, and he wouldn't let us eat them until we went through a ritual. He made us take off our clothes from the waist down, then he got a wash basin, put water in it; when he'd take a piece of the raw rabbit, he'd chew it, and he'd get a little piece of new sagebrush. He'd chew this meat, then he'd put it in the wash basin. He spit it in there, mixed all up and then took this and put that sagebrush in it and then dabs our bodies with it. That he did one time and he wouldn't let us eat our rabbit until that's over.

Indian Images

When Rosemary Junior gave birth in 1971 after she and Lanier Graham had moved to San Francisco, Robert asked a Paiute friend to make a traditional cradleboard for his new step granddaughter Jennifer—not to be used, of course, but as a symbol, it must be, of connection with the past and the land. The cradleboard maker was "Princess Winnemucka," Graham told me.

Had Robert said "Princess"? No woman in the Winnemucca family was calling herself that by the 1970s. It was Graham who had the notion that Robert's "life before World War II was spent among the Paiutes." Another anecdote of Graham's to do with Robert's Paiute days is that he "underwent advanced shamanic initiation—a ritual that involved overnight in a pit of rattlesnakes. 'If I had exhibited fear,' Robert whispered to me [Graham], 'the snakes would have felt the weakness and bit me to death.'" But Paiutes don't have initiation ceremonies for their shamans. Something akin to the "pit of rattlesnakes" is described for the Hopi Snake Clan, only not in connection with shamanism. The likelihood is that Robert attended the part of a rattlesnake ceremony in Arizona open to the public and dressed it up. I can't imagine the eclectic autodidact going in for shamanism straight.

I see that I'm being hard on Lanier Graham. The truth is, I can't help feeling competitive with him. He and I are about the same age, and we got to know Robert within a year of each other. I envy Graham for all the time he shared with Robert in person, and admit to petty satisfaction that he had little if any contact with Robert while my correspondence with our mutual mentor was peaking during his final years. It didn't bother me at all to read in John Caples' diary that my rival-in-hindsight was a rather feckless young man back when he heard from Robert about the Paiute days. Nor that in 1977, Robert characterized his by then ex-son-in-law as "a sort of a Rev Moon," who "stays in his basement delving into psychic phenomena." Robert was probably exaggerating to amuse John, who had no such spiritual proclivities. Robert certainly respected Graham's intellect. As for John, he came to approve of Graham's right intentions and the way he handled himself, and to

respect him as a hard worker. Graham went on to a distinguished career. When I contacted him in the near past, he was gallery curator and professor at California State University East Bay in Hayward, and the author of many books in his field.

More like Robert is the story he told Walter in 1964. Robert was at Pyramid one day sketching. "A small Indian boy watched. 'You writum lake?' 'Uh huh,' I said, still drawing. 'You writum [Anaho] island?' I said, 'Nope—no island this time.' Long silence. 'You no writum island, you no writum lake.' He comes back to me. I think the boy was telling me something I have yet to know."

There's another story of Robert's worth repeating here. This one begins in the 1930s, continues in the 1950s, and was told by Robert to Dick Walton in the 1970s. An old Indian named Dandrew once paddled Robert out to the west side of the "impossibly large pyramid" to show him a huge and mottled cui-ui who abided near the surface in the warm boundary of a hot spring uprushing from the pyramid's base. Twenty years later Robert located the same (or what he took to be the same) ancient fish, who each year in the meantime had, as he told it, edged inch by inch ever closer to the hot center of the upsurge and was now "cooked white!"

> Just think, a few more inches a year, always closing in on absolute center. And who or what could approach him now. Lo, he was the poached unapproachable, the boiled eye near to the center of the lowering cauldron. There have been many readings of the Absolute (I know that looks like 'obsolete', but that's no more than a trick of the pen, right?) I'm thinking that we may have a sermon to us, lurking in these waters. Perhaps our absolute is to be drawn ever nearer to 212° Fahrenheit, cooked white, we put on immortality (along with hollandaise) and serve ourselves up to God. Not a bad way to go.
>
> Now let's just move another inch or so towards center, shall we?
>
> <div align="right">Love, Old BC</div>

The essential truth of Graham's stories from Robert is that years after drawing Indians for the FAP in 1933–35, Robert was still telling stories about Indians. Those times stayed with him. And for years after, Robert would return to Indian themes in his art as well. So, in

the early 1940s, Robert used improvised tools and black paint on sandstone to knock out a sculpture of legendary Southern Paiute war chief *Winnedumah*, a work which Walter transposed to 1930s Reno and made into a woman carved out of Pyramid Lake tufa, Lawrence's "Spirit of the Heights," in *City*. *Winnedumah* went to New York in 1942 as Nevada's winning entry for IBM's exhibition of art from the forty-eight states.

Winnedumah, ca. 1941–42

In 1941, developer and political operator Norman Biltz commissioned for his Lake Tahoe home a Caples mural, which in 1970 Biltz gifted to the Nevada Historical Society. With it came Robert's one-page story it illustrates, purportedly but probably not really a Paiute creation legend. Even before Biltz took delivery of *The Gifts of Hy-Nan-Nu* in 1942, his friend the ubiquitous philanthropist Major Max Fleischmann ("Nevada's Santa Claus," the *Gazette* once styled him) had already donated Robert's smaller oil study for the work to the Nevada State Museum in Carson City.

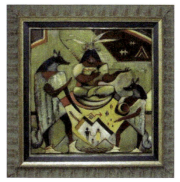

Sketch for *The Gifts of Hy-Nan-Nu*, 1941 (*Courtesy Nevada State Museum, Carson City*)

From the 1950s, when Robert was mostly painting mountains, comes *Indian Images*, an oil panel of a herd of does hunted by Indian men proportioned much like warriors on Greek vases, all amid petro-/pictographic symbols. Variants of such images appear in a number of other known works. One of the more interesting is Robert's 1954 twenty-five foot mural with men and mustangs

Indian Images, 1950s

against abstract mountains, and with a single petroglyphic symbol, probably the sun. The work hung in the First National Bank of Nevada in Reno. Another is *Coyote Summons the Animals*, Robert's 1955 study for what he called an "iron pictograph" for an exterior wall of the Paiute and Western Shoshone Fort McDermitt Indian Reservation school on the Nevada-Oregon border. The shadows are there because the forms were to be held by posts to stand off the surface of the wall. Robert's design, commissioned by his friend David Vhay the architect, a Caples collector, was rejected by the school board on the grounds that its spikes would present a hazard to the school children, who wouldn't be able to resist climbing on it.

Coyote Summons the Animals, 1955

Talking Stone is Robert's last Indian-inspired artwork that I'm aware of. It was made in Connecticut in 1962, the year Robert commenced nine years of labor on *The Potter and His Children*, his final, book-length creation story. *Potter* had germinated in 1945 in a third, much shorter manuscript, "The Potter and the Lizard," where Jigger Bob and all the Indians are gone, Manta the Earthmaker has been supplanted by a Caucasoid Potter, and Eastern philosophy prevails. The imprint of Great Basin lore remains, however, insofar as division comes about as the result of a feud among the first children. In the two Manta versions, the feud had been between the first animals, and resulted in world geography as we know it. Something even closer to the native legend resurfaces in "The Potter and the Lizard." In the legend, the feud among the first children brings about the division of humanity into tribes; in both Potter stories, into races.

Talking Stone, 1962

In *Potter*, the ultimate creative principle of the universe became more abstract, in line with Robert's late fascination with astrophysics and cosmology. Ever more knowledgeable, more syncretic, he packed his narrative with allusions to science, world religions and philosophy, beyond what I or most likely anyone else will ever decipher. But in addition to the traces of Great Basin lore, something else, the most important thing, survives in *Potter* from the Manta manuscripts: their mood of grateful presence. The words have changed, but not Jigger Bob's essential message embodied in his restrained exclamation which is also an implicit exhortation, "Here is the world." In *Potter*, the old world-maker exclaims, "Behold, the World!"

Robert was getting *Potter* ready for Carlton Press in 1970 when his first portfolio of Indian portraits came out. Robert Laxalt, director of the University of Nevada Press, deemed it "very fine, indeed" when Robert stipulated that his royalties should go to the Indian Tribal Council. The funds went through the Pyramid Lake chapter of American Women's Voluntary Services, likely because Robert's friend Phyllis Walsh was an AWVS member. Walsh lived with her partner, Comstock heiress Helen Marye Thomas, at the latter's S Bar S Ranch on the Truckee a few miles from Wadsworth, by then one of the few ranches still privately owned within reservation boundaries. Robert had been a regular visitor.

Phyllis Walsh arranged for the many Paiutes at Robert's Reno memorial to be seated in the first row. Among them was a friend of Robert's from FAP days, Avery Winnemucca, another descendent of Old Winnemucca. Avery and his three sisters were children of Herma Winnemucca, the woman Robert drew as the *Cradleboard Maker*. Quite possibly one of the sisters made the cradleboard for Robert in 1971. Avery is the *Bow Maker* in the second portfolio. Paiute Avery is also the Shoshone in the Washoe County Courthouse mural—the bowman on the far right. He attended the Indian schools in Carson City and Carlisle, Pennsylvania,

Avery Winnemucca at the University of South Dakota, 1920s

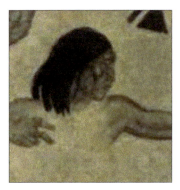

Washoe Indian Legend of Creation postcard (detail), 1935 or after

and then the University of South Dakota. At one time he acted in Hollywood movies. As tribal chairman, he led a delegation to Washington in the course of overseeing the tribe's efforts to reclaim private properties on the reservation. The tribe's "most oratorical spokesman" is how A. J. Liebling praised him in a 1955 series of *New Yorker* articles about Pyramid Lake. When the first portfolio was ready in 1970, Robert asked the press to send a set in his name to Avery—Robert's only such special request.

Robert told Phyllis Walsh the following story. In 1975, while visiting Nevada, Robert was amazed to learn from Avery that he had never found an arrowhead. Once back home, Robert mailed his Paiute friend the prize point from his own collection, one given him by Harry Drackert (another Pyramid resident who took a turn in Hollywood).

> And so it came to pass, in the mid-1970s that Avery Winnemucca, son of the desert's edge, most noble-looking of a noble people, got his first arrow point from New Preston, Conn., for God's sake. And a Lake Pyramid one at that! I think it is a story to amuse the Great Serpent of the Upper Air, coiling and uncoiling in rainbow writhings of mirth; it's a little like giving a fishhook to Herman Melville.

But is it plausible that Avery had never found a point? They aren't so very scarce really. When asked that question, first Ben Aleck, an artist who used to direct the Pyramid Lake Paiute Tribe Museum, then Ralph Burns, its current director, each said yes, they'd never found one either—but each then clarified: "We don't pick them up," said Burns. That's just what I suspected, I told them both when I repeated the story: Avery had always left them lying where he saw them, and really meant to lead Robert away from the whole matter; but Robert, a little naive, missing the cue, believed he was honoring his friend in an unexceptionable way by sending him his best point. This alternative

was greeted by Aleck, then Burns, with almost identical reactions, a just audible chortle, followed by "It could be" or words to that effect.

Here I need to make a confession. A long time ago—this was at least five years before Robert mailed his best point back to Pyramid Lake—I found some artifacts in a cave on the eastern shore of Pyramid and removed them. It was one of those shallow caves with a low ceiling blackened by generations of sagewood fires. Several inches deep in the floor of powdery gray sand sloping up to a packrat midden I discovered three items: two small fragments of ordinary basketry, and an object unlike any I've seen since in a book or museum: a rounded rectangle made of horn or shell, maybe two inches long and an inch and a half high, with a three-quarter-inch hole in the center. I still have one piece of the basketry; the other I gave away. But even at the time I recognized the shaped object as something unusual. Therefore I took it to the tribal office in Nixon, then situated, as I remember, across the road from Abe and Sue Abraham's general store, which is long gone. I imagined myself respectful, generous, selfless. Men seated behind a table received the piece from me, but I will never forget the silence that condemned my naive recitation. And so I'm in no position to be critical of Robert for his naiveté, if such it was, about the respect owed to undisturbed artifacts.

What, at the end of the day, did the ever self-critical artist think of his Indian work? In September, 1978, he learned from Dick Walton that the charcoal portraits were again on exhibit at the university. Half a year later, in the year of his death, he wrote to Joanne de Longchamps playfully wishing the portraits to perdition.

> Lord, those Indians! Joanne, those poor Indians have been spread all over the place. They hang in stairwells, waiting rooms, laundry nooks, chowder rooms—I should think people have just about had those Indians.... [T]he whole collection should be stuffed into some Lovelock cave, along with a straw duck or two, and the whole entrance blasted shut.... Just a big muffled boom, a brief spouting of yellow dust—and silence.

Robert knew that the ancient tule frames of duck decoys were among the artifacts excavated from Lovelock Cave, a major archeological site

overlooking the Humboldt Sink. Robert's fantasy suggests familiarity with the Paiute legend of exterminating a race of red haired cannibal giants by trapping them in Lovelock Cave. He certainly was familiar with Alexander Pope's condescending encomium to the noble savage in the "Essay on Man" (1734) ("Lo, the poor Indian! whose untutor'd mind ...") and probably with Horace Greeley's race-tinged ruminations after Pope ("Lo! The poor Indian!"), for Robert continued tongue-in-cheek:

> Lo, the poor Indian. I think Lo and Mrs. Lo have had their day. Someday an office nurse is going to open the door and say, 'You're next,' and one of those framed portraits is going to fall off the wall. Maybe it's already happened. The drawings were done with much enthusiasm, and, unfortunately, limited skill.

The enthusiasm was certainly genuine, and warmly remembered, as testifies that letter about bouncing around in Pete Winnemucca's war bonnet, written not long after this fantasy of a hecatomb of Indian portraits. Moreover, it hadn't been that many years since he'd been actively promoting sales of the Indian portfolios. And it was himself who went through endless rigmarole with the Soviet bureaucracy in order to donate the portfolios to the Hermitage in Leningrad.

Moving Subject Matter Around

Walter Clark told me in 1963 to eat Basque at the Santa Fe, and to go see his friend's mural in the courthouse. These days, when I drive past, I picture Paiute Avery Winnemucca loosing a Shoshone arrow toward Virginia Street from Robert's mural behind the marble wall and opaqued windows, isolated there near the locked former entrance of the renovated landmark, the courthouse, a name still tinged by the melancholy historicity and romance of *City*'s Court Street Quarter. Did Walter also talk up the Union Brewery? Why else would I have detoured again to Virginia City, which I'd already visited after that night in the ditch beside the Geiger Grade the summer before? From that first visit I remember only a spike of affinity to the touristy town thanks to finding a Jewish cemetery on the Comstock (severely vandalized shortly after); from the second, Robert's *Virginia City* above the bar and a conversation about it with Union Brewery proprietor Gordon Lane. Lane later sold the painting through the Stremmel Gallery when he retired in 1985. Not long ago I saw it again in a Reno home, now to appreciate the exaggerated perspective lines of the buildings converging at St. Mary's to heighten the hundred-mile prospect out past Sugarloaf to the Carson Sink and beyond.

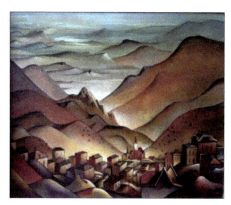

The Union Brewery's *Virginia City*, 1948

"He was a perfectionist," said the owner, an amateur painter and longtime member of the Reno arts community. Caples had treated the subject many times until he achieved just the effect he wanted in this, his "best" of Virginia City, as Peter Stremmel told her. Well, as to Caples the perfectionist, he was that, I agreed, but when he needed money in VC, he would churn out "another St. Mary's steeple," and to volunteer the fact was typical Caples ironic self-deprecation, I said.

The Union Brewery painting of 1948 is arguably the best of Robert's mining town vistas, but far from his best of mountains—he claimed later he only painted it to clear his bar tab, and said he'd "like to see [it] burned." Not until around 1950 did be begin to produce mountain images comprising a body of work and a spiritual testament of surpassing beauty. Robert's boomtown buildings have never appealed to me strongly, no doubt because I'm not an old Nevadan, add to which that I'm temperamentally resistant to that mystique. And therefore I'm grateful to Walter for putting into words what I hadn't seen in Robert's buildings, a sense of time's passage not touristic, not picturesque. "That was Austin, all right," Walter wrote of a painting of Lawrence's, "and all the other old camps like it, but greatly enriched, their fierce, brief pasts moving and whispering within them, the grief of nameless humanity deeper over them than imperial history over the ruins of Rome."

It was while painting Virginia City at age twenty-two or -three—he wasn't certain later—, that Robert discovered something important:

> Then, one day, found that I could move subject matter around without getting up from portable easel (started with telegraph pole on street parallel to Taylor St. V.C.). What a day! 1930? Moved entire building in from north corner, moved mountains to better frame foreground, went hog-wild for weeks. Began building designs away from the scene; found gaps in recall, had to go out and look again; looked differently. I mean, I looked differently at things. Tried to bring things back to studio with me—chunks of shadow, pieces of mountain, clouds and stuff.

Robert would soon apply this lesson when assembling his Indian portraits from disparate sketches and add-ons. But why did it take Robert so long to discover that perceived reality is de- and recomposable—so long to discover modern art, in fact? Was this a penalty of being an autodidact? Growing up in New York City, he must not have felt the aftershocks of the 1913 Armory Show that introduced Picasso, Matisse and other innovators to America. He haunted art museums, but didn't absorb Cezanne. His abbreviated art education in the city can't have exposed him to the art revolution: the National Academy of Design

vilified modernism, while he was either not open to or not exposed to American modernism as taught at the Art Students League by Stuart Davis, Max Weber and others. He arrived in Reno before modern art did, then attended an art school at the trailing edge of modernism. Looking back in 1964, he was perplexed by the long-ago disconnect between his own sensibilities and the values he had acquired as proper for art:

> What mattered most at all times everywhere? The desert. Pyramid Lake country and the hills around Reno. It never once crossed my mind that I might draw or paint them.

Actually he had painted Pyramid Lake, with Tom Wilson, but that wasn't his point:

> I thought painters did portraits and still lifes. It surprised me to realize this—I hadn't thought of it before but I presumed 'The Fall of Icarus' was the right and proper field of inquiry.

Bruegel's *Fall of Icarus*, neither portrait nor still life, isn't the best exemplar of outmoded canons anyway, what with its warped furrows and minimized plow horse that may have influenced the torqued farms of Robert's contemporary Thomas Hart Benton. Robert was right to be struck, though, by how late he came to modernism.

Landscape with the Fall of Icarus, Pieter Bruegel the Elder, *ca.* 1558

The moveable telegraph pole was a discovery of composition, and it might have seemed only that. But concurrently it was a deeper discovery, of vulnerability. Around this time his mother sickened and came to stay with Byron and Robert in Reno. It was also then that Robert was drawing such portraits as the Bartlett sisters: Margaret in her aviator helmet looking almost tearful, and Dorothy and Georjean,

their vulnerability plain—and not just personal vincibility, but the grief of humanity in the poignant guise of passing youth.

"They sought Indian, not single Indians," was Walter's take on the Indian charcoals, soon to follow these portraits. Robert's Indians were, in one sense, as Walter saw them, tokens of something timeless and enduring. But Robert called them portraits, and the sitters were real, their mortality palpable. "The day is not far off when there shall be no more real Indians," he elegized in "Manta the Earthmaker," regretting that their way of life was vulnerable and passing. Years later, his apperception of change over time would in turn inform his landscape art:

> [Jigger Bob's] face was lined as the desert is lined. It reflected for me the stuff of the desert. And I began to feel that these Indians were part of the scene, part of the mountains. And such landscape work as I undertook to do in future years was definitely influenced by the features and the weather-beaten faces that I had looked at and admired.

Mountains are vulnerable, too, like Indians, young women, and telegraph poles. "And thank you for ... the stone poem." This to Joanne, his last letter to her. "I like it very much. And I know of knowplace [*sic*] where God could be more neatly found—except maybe in a little stone in the middle of the road in Nevada." A little stone, a wind-shaped chip from a boulder that tumbled down the raised face of a range thousand upon thousands of years ago.

Beads and Seeds Project

Second Federal Art Project—appointed supervisor for Nevada section. (Known at office as 'Beads and Seeds' Project.) Also Index American Design chapter. Also taught art classes at night for WPA. Did big malappropriate loomers 'Last Supper' and 'Job.'... Second project confusion of papers, office meetings, interviews, own work went downhill into scattered nasties done at odd moments and hours. The checks were wonderfully welcome, contacts with other artists helpful, out-of-state contacts promising, some of the work—a very tiny fraction—might have been worthwhile. I don't remember anything.

This is Robert writing about the Great Depression on Walter's questionnaire, remembering, or not, his promotion and duties following successful conclusion of the Indian assignments.

'Beads and Seeds' Project. That's how his fellow artists and Robert (who could fall back on his father's and Virginia's money) made fun of what they needed to do to get by during the hard times.

Also Index American Design chapter, continued Robert on Walter's questionnaire. The Index of American Design program gathered objects and generated thousands of purpose-made watercolors depicting folk designs, the resulting collection optimistically conceived as an aid to artists for developing American modernism on the basis of a domestic heritage. It's a mystery why no trace of Robert's, nor indeed of Nevada's involvement survives in the records of the National Gallery of Art, which caretakes the IAD materials.

Also taught art classes at night for WPA. Robert had taught before. That item about his black sweaters back in 1931 continued: "Caples, by the way, plans to keep artistic Reno ALIVE TO THE ARTS this winter with a studio art class. There will not be any slot machines in connection with the class." By the late 1930s, the coverage lost its lingering Roaring Twenties tone of insouciant cynicism: now, simply, Robert was "conducting an interesting class in figure drawing under the auspices of the WPA."

Did big malappropriate loomers 'Last Supper' and 'Job.' Like the Indian portraits, these two 4' × 5 ½' panels were for the university.

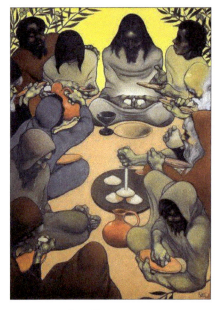

Last Supper, 1937 *Job and His Comforters*, 1937

Completed two months apart in early 1937, *Last Supper* and *Job and His Comforters* separately cycled through Brundidge's window and traveled to venues in Los Angeles and San Francisco, accompanied by a score of other Caples works, before installation at the university library in February, 1938—a few days before Virginia filed for divorce. In 1964, Robert attempted to arrange for destruction of the "loomers" from Connecticut. It still rankled him in 1979, not long before his death, to recall that when, in 1974 or thereabouts, he again sought their eradication, he discovered that "these same dead horses had been stuffed and 'prominently installed' forever." But today they sit in storage out of sight. Myself, I find both these outliers in Robert's body of work powerful and compelling—outliers, but the hands are typical early Caples. And the earthen colors would come back in some Southwest landscapes several years later. And the glow of light would become a subtle hallmark of many of his later mountains. When he saw *Job* in 1937, Walter was very taken by the power of its desert sun, "hot and close without pity." Walter's letter to Barbara from Reno continued: "I

never saw a more perfect job with bitter and hopeless suffering than Robert's got into that little, hunched, absolutely motionless figure."

confusion of papers, office meetings, interviews. Evidence of Robert's chores consists only of a few news items about committee work, establishment of an art gallery, and the figure drawing class. Walter told Barbara he thought "the project work has been good for him."

own work went downhill. Robert took part in nearly a dozen exhibitions during the second project, with works across all sorts of media and subjects, including nudes, hands playing *Twenty-one*, a flower still life, mining town landscapes, a precision drawing of a *V & T* [Virginia & Truckee] *RR Bridge* with locomotive (a solid WPA subject), and many more.

While *Job* and *Last Supper* may have been stylistic outliers, as for subject, Robert recurred to Biblical-Christian themes early and late. Some studies of heads from during the second project look like early thoughts for the big panels. *Amen*, a very dark church interior, is from 1936; *Iscariot* from around the same time; *Jonah* from 1941; *Flight from the Garden* from 1946; and *Adam* from 1952. And there are several others. Rosemary would later say that "he knew the Bible backwards." Of Lawrence the secular Walter wrote, "The intensity and sense of destination of a lost religious era was enticing to him." Although *Dharmakaya, the Golden Path* would come after the second project, *Last Supper* was already infiltrated by Robert's attraction to Eastern philosophy in Christ's pose of meditation. But I've seen nothing in Robert's biography, body of work or written legacy to explain why he made Christ Black—whether African or subcontinental Indian I can't guess.

In 1936, Robert did a cartoon of Walter's sister Euphemia desperately struggling with a recipe while her husband James Santini checks the dining room clock wondering what's holding dinner up. The commentary on the marriage would have been rough, were the drawing not presented to Euphemia as a humorous wedding present. Nevertheless it was rough enough, in view of the family's doubts about Santini as well as Euphemia's frustrated ambition, not Santini's fault but her father's. The university president forbade her from accepting

Untitled (Euphemia cooking), 1936

a Vassar scholarship to study chemical engineering. Instead, she went through the University of Nevada in the same class as her brother Walter, earning the same degree, in English, and with very nearly the same high honors. Babs had been told that her grandfather did the same thing to Euphemia's younger sister Miriam when she wanted to major in art. Miriam fared better in life than Euphemia. Her nephew David Chism thinks the disappointment is what drove his Aunt Euphemia to alcoholism. Bob Clark, another nephew, considers her "a lost soul."

Robert did another cartoon in 1936, *Santa Claus on a Bronco*, a Christmas card advertised and sold by Brundidge's.

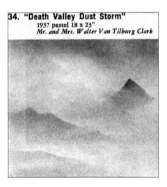

Death Valley Dust Storm, 1937

Robert's vision of Death Valley from the second project, *Death Valley Dust Storm* of 1937, is a work I know only from the 1964 catalog. The poor black-and-white reproduction suggests a Turneresque foreshadowing of his later mountains, where pure formations isolated inside the picture space convey an atmosphere of meaning redeeming the vacancy. (1937 was also the year Byron was selected to head the state's venereal disease program by the Board of Health.)

In 1938, Robert's last year with the FAP, he exhibited Pyramid Lake studies at Brundidge's. "Icarus at last vanished completely," Walter proclaimed in the essay, confusing Robert's timeline a little but getting at something important.

contacts with other artists helpful. "RC visited often in San Francisco," generalized Walter, "saw works of many different kinds, talked at length with the people who were doing the work." When he summarized for Walter's essay, Robert wasn't forthcoming about those contacts, if he

remembered them. He may have met Taubes while still with the FAP. He didn't, as Walter's timeline suggests, meet Varda then, for Varda didn't arrive in California until 1940. Likewise Walter was mistaken to connect with the FAP Robert's backing out of a mural commission when overawed by Rivera on Treasure Island, for Rivera worked there in 1939 and signed his enormous mural in 1940, whereas Robert left the FAP in 1938.

Robert and his second wife Shirley moved away from Reno before or shortly after the announcement by the *Journal* in 1938 of their marriage in Las Vegas, the final social item about Robert during his FAP employment. Actually by the second project he had pretty much ceased to be a topic of social items: just a couple of bridal showers, a reception, and his divorce from Virginia and marriage to Shirley.

Eighty Million Sandpaper Money

Shirley Behr's grandfather founded Herman Behr & Company of New York, the leading manufacturer of abrasives in the late nineteenth century. Because none of Herman's six sons had any interest in the business, through mergers and acquisitions the firm ended up in Norton Abrasives. Shirley's father was son Max, a Yale graduate and nationally ranked golfer who moved to Los Angeles. Dick Walton recounted how "Shirley was the girl with the eighty million sandpaper money. And everybody was making jokes in Nevada about Caples' polo ponies."

Money was again an issue in the marriage, as it had been with Virginia. Robert balked at staying at the pricey St. Francis Hotel on Union Square when they visited San Francisco; but that didn't stop him from ordering hot cross buns by the dozen from the St. Francis kitchen for delivery to a more modest lodging, all on Shirley's tab. Walton told this story to Andria Daley, the historian who alerted me to the existence of Walton's tapes. Not Andria, but I can see Walton smirking over Robert's ambivalence around money coming off a federal relief program. I smirk at it, too, while wondering if Walton felt, as do I, a cross-current of admiration for Robert's self-indulgence. My own conflicts around entitlement and social justice inhibit me from indulging myself like that, much less on someone else's money.

Shirley had checked into the Riverside Hotel on January 29, 1938 to begin the six-week residency for a divorce from her third husband, Walter S. Hardie, which was decreed in mid-March. That was about a week before Virginia filed for divorce. So it would seem Robert's first marriage was essentially or even legally over before he met Shirley and then quickly married her in Las Vegas. Shirley came to her fourth of five marriages with two children, a boy Weston about five at the time, son of her first husband, and a girl Eve only about one.

The new family lived first in Santa Barbara, a cultured and wealthy community where Robert had been happy in art school and where Shirley had connections. There Cricket Caples was born. On Walter's questionnaire Robert said, "Santa Barbara (Cricket born there—1939 (?))." Why the uncertainty about his only natural child's year of birth? I couldn't forget

Caples holding Cricket, 1939

the year my son Matt was born—and there were uncertainties to spare surrounding Matt's birth. Could it be that Cricket was born earlier, in 1938— and possibly not in Santa Barbara? Santa Barbara County has no record of the birth. Almost precisely nine months elapsed between Robert and Shirley's marriage on April 21, 1938 and the announcement in the *Gazette*: "In Santa Barbara Calif, January 20, 1939, to Mr. and Mrs. Robert Cole Caples, a son." It could be that Cricket was conceived before the marriage and one or both parents were reluctant to disclose the impropriety for legal or other reasons, in which case they fudged the information about Cricket's birth for the Reno papers.

'Cricket' was of course a nickname. In Robert's will, he was Robert Christian Caples Griffin. By then Robert had allowed 'Griffin' to be added as Cricket's legal surname, in hopes that Shirley's fifth husband Sandy Griffin would take more interest in the boy. John remembered that "Father was shocked at this and wrote Robert [a] letter implying that [the] only reason Robert permitted this was because Robert knew he was not really Cricket's father." Prior to that, Byron and Hazel had tried unsuccessfully to get Shirley to let them raise Cricket.

It was not long after Robert settled in Santa Barbara that Dick Walton joined him and Shirley for a week's instruction in oils from Taubes. Some months later, unhappy with his progress, Robert made the month-long "hiking trip" from Death Valley to Reno (he hiked from his car) which produced an exhibition at Brundidge's of sketches made with disinfectant fluids. That was his only Reno show in 1939, to go by the papers. On the same trip, Robert befriended the boy Robert in Goldfield south of Tonopah and later sent him brushes and instructions. The only works other than the sketches made in Death Valley with antiseptics I'm certain come from this time are two dated 1939 in the 1964 retrospective: another *St. Mary's in the Mountains* and *Golden Pony*.

Robert on his Navy enlistment documents put down that he lived for two years in San Francisco before Indian Springs. Not so. The household's

move from Santa Barbara to 2070 Vallejo Street in San Francisco came in late 1939 or early 1940, lasting only until they relocated to their final common address, the Indian Springs Ranch, in October. During that year Robert exhibited several times in Reno and once in Elko. And he would cross the Sierras with or without his family to sketch in Virginia City or to visit Byron. Also he spent "a number of weeks in Las Vegas, where the region of southern Nevada was the inspiration for his landscapes" (Lillian Borghi in the *Gazette*). One of these, a pastel, *Anatomy of the Storm*, was exhibited at the World's Fair in New York and then at an International Exposition in San Francisco. During that summer he "experiment[ed] with new effects in color etching" at the California School of Fine Arts (again Borghi), I believe under Stanley William Haytor. Also he met Jean Varda, who arrived in California in 1940.

Robert's letters contain a nugget of information about that span of months in 1940 and his artwork at the time. In 1948, Robert and fourth wife Bettina had sent Sam Houghton a Christmas card with Robert's drawing of what, in a 1977 letter, he would dub his "'Push-me–pull-you' cow." I never read *The Story of Dr. Dolittle*, so didn't realize until Special Collections' Donnie Curtis enlightened me that Robert's two-rumped Holstein is a comical reversal of Hugh Lofting's two-headed gazelle-unicorn cross, the "pushmi-pullyu." The 1948 drawing came captioned with a throwaway joke line, but its true caption is the quotation Robert initialed and enclosed with the card:

> Out of the ever-arising Spirit
> God created all that is or ever will be;
> All things that dwell in motion,
> All things that find their rest,
> Now and forever.

The 1977 letter, to Sam's widow Edda Houghton, told the story of a previous artwork on which the 1948 Christmas card drawing had been based. The telling, a blend of the humility and description, humor and philosophy characteristic of his style by then, made something both more personal and more persuasively universal of the conception:

"*Push-Me-Pull-You*" Cow, 1940 Drawing of "'Push-Me-Pull-You' Cow" in a Christmas card, 1948

I recall that the job was first exhibited in the window of a print shop on lower Post Street in San Francisco. A woman, abrupt and singularly uncordial, operated the gallery. She dismissed my portfolio of random prints with a wave of the hand. "Nothing," she said, "all nothing. Why don't you travel?" But she kept the cow. "You like the cow?" I ventured stupidly. "Not at all," she said. "It's static. But it will probably sell." It didn't. A few weeks later, I picked it up. The imperturbable woman said nothing. She stared out at the passing traffic. I walked up Post Street with my double cow. It was, I suppose, no more than an incident of self-engulfing ripples, an equation in total stasis. And that, I've read, is how the Universe may end—but on a much more massive scale. Not too disagreeable, I guess. Time-Space a vast two-headed cow, the Milky Way long since Pasteurized.

I assumed the Christmas card drawing for Sam Houghton was a sketch based directly on the unsaleable double cow, until from Peter Erskine, son of Robert's friend Graham Erskine, I received a photo of the print for sale on lower Post Street in 1940. This cow has two longhorn heads instead of two Holstein rumps, and the work (later destroyed in a flood) is actually quite captivating and profound for all its being a 'conceptual' gag, and is anything but "static," thanks to the rings. In keeping with the humor of the work, Peter Erskine joked that the rings remind him of corn plasters. Knowing as I do Robert's very last, cosmic paintings, I can see their prefigurement in how the rings float like galaxies in space.

Indian Springs

"Robert Cole Caples, prominent Nevada artist, and his family have moved to Indian Springs, Nevada, where they are occupying a picturesque ranch home." Borghi of the *Gazette* was still keeping track of Robert from Reno. She said Robert chose the locale for its desert to paint, but chances are Shirley dreamed up the idea of an artist colony and picked the place. The locals, at any rate, perceived the artist colony as Shirley's. Indian Springs wasn't an old mining town like Robert's beloved Austin, which Shirley despised to judge from *City*. The onetime Southern Paiute corn and squash field, then freight wagon stop, then rail watering stop, then truck farm for Las Vegas, then vacation spot with ponds created by damming the spring, then guest ranch known around the West, was, by the time Shirley bought the McFarland place in 1940, a divorce ranch. It and the nearby ranches and the few businesses at Indian Springs used the Las Vegas post office at forty empty miles' distance.

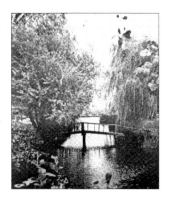

Indian Springs pond

In 1974, a student in geography, Phyllis Skelton, found information about the Indian Springs artist colony for her master's thesis in a those-were-the-days article in the Nevada Test Site's news biweekly—the site is a neighbor, by Nevada standards. Further information came from locals who were still around.

> [Shirley] had tremendous wealth and might dress for an occasion in a suit styled by Mainbocher, wearing her famous emerald, but around Indian Springs she wore levis.... [T]o create an atmosphere where [her husband, Robert Caples] could work well and be content Shirley invited many artists and intellectuals to stay there.... Walter Van Tilburg Clark, author of the *Ox Bow Incident*, stayed there for a year while he wrote *The City of Trembling Leaves*.... Mrs. Caples spent thousands of dollars to create an exciting garden spot in the desert.... Two native Mexicans were imported to build authentic

desert homes from adobe, and a special home was built for Mr. Vanderhorst, a herpetologist.... Shirley Caples thought the original ranch house was very attractive and quaint and wanted to live there, so she build a modern home for Alice McFarland, who was still living there under the life tenancy agreement.... [T]he Caples had parties for almost any occasion, and all of the activity this family generated added a new excitement to life in Indian Springs.

Borghi gave a glowing description of the place in late 1941. She noted the "community vegetable garden" and "community dining room"—but this was no commune. The resident artists, she said, paid a staff "to carry on the work" and "a musician and astronomer" to teach their children. Actually, as Bob Clark wrote of this time, "the colony"—that is, Shirley—paid for everything, "housing, evening dinners at a main house, and even living expenses in exchange for a percentage of the profit that would theoretically ensue" from sales of the artists' works. Only Walter, who viscerally resisted being patronized in any manner, "insist[ed] on paying his own expenses," as he would later insist at Mabel Dodge Luhan's Taos colony. I doubt any of the others ever reimbursed Shirley.

The Lizard, Caples' studio at Indian Springs

Some of the residents artistically embellished the exteriors their cottages. Robert added to the *mélange* by building his own studio, The Lizard, a ramshackle hut, its roof adorned by a rooster, a mountain sheep skull, and a large toothy fish painted on a board. The rooster was a weather vane featured in the 1941 Borghi *Gazette* item. The accompanying photo showed ceramics made by Shirley, the rooster and several bowls. A dilettante potter, she'd had a studio built for herself, a plainer, more solid shack, the Turtle, after the discovery of clay deposits on the ranch.

Shirley Caples at the potter's wheel, 1940–42

Caples at the potter's wheel, 1940–42

The clay deposit, and the Turtle, and watching Robert turn bowls on Shirley's potter's wheel: these elements contributed, so I imagine, to the turtles the boys sculpted from Pyramid Lake clay at Tim and Lawrence's first meeting, a symbolic plot element which, in that case, Walter first conceived at Indian Springs, where he wrote half or more of his second and successful attempt at the novel that became *City*.

On the 1964 questionnaire, Robert gave this appraisal of his sojourn at Indian Springs:

> Biggest adventure of all—had terrific time making paints, building own studio, rough-firing pottery; built etching press out of old-fashioned washing wringer, made dyes of boiled fruits and vegetables, scraped soot from studio chimney to make rich black. Ground up colored clays, ran leaves and flowers through washing wringer. The yield from all this wonderful liberation and discovery was virtually zero.

This potpourri of experiments connects Indian Springs to *City*'s Pyramid Lake turtles in yet another way. Lawrence collects "all the little technical devices he has been working on into a kind of exercise

"a book of thirty four turtles" cover (detail), created some time during the Indian Springs years 1940–42

turtle number 31

book for skills and mastery of materials. He calls the exercises his Turtles." This was at the Peavine cabin in the novel, but actually it was at Indian Springs that Walter witnessed Robert assembling his experiments and protocols into what he titled "a book of thirty four turtles." In the novel, Lawrence's "Turtles" appear to be Lawrence's way of hearkening to their play on the shore of Pyramid, as much as to say to Tim: This is a symbol of our bond, which endures. But to the contrary, it was Walter who borrowed Robert's "turtles" to affirm the bond.

The book resides today in the Caples Archive. A soft binder with brad fasteners holds forty-seven 8½" × 11" three-hole sheets, plus a title page. Each procedure—each turtle—Robert numbered on the back of a little turtle. Turtle number 10, for example, "hand print," tells how to make a print block by etching "a soft pine board with a heavy spike," and recommends printing on the "'comic' sections" of newspapers for "amusing results." This protocol can be viewed in the excellent catalog of the 1981–82 exhibition, *Robert Cole Caples the Artist and the Man*.

One small image in the turtle book, *Fish Goddess*, is technically similar to several other works from these years, such as *Jack of Diamonds* once owned by Sam and Edda Houghton, but mostly of Nevada's desert towns, mostly Austin, and possibly all produced on the same restless circuit. Two of them, belonging to Bob Clark, are of Austin, one carrying the date 1942. A variant, my favorite, is in a private collection in Reno. Walter described the technique in *City* as "black over-wash ... worked back through to the color." It must have been one of these intense Austins

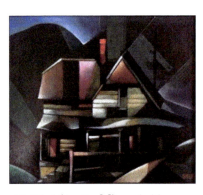

Untitled (Austin [?]), probably 1942

which Walter studied for his passionate description in *City* of Lawrence's Austin, stark representative of all Nevada's mining towns whose "fierce, brief pasts" allegorize "the grief of nameless humanity." A 1942 etching of the *Bert Acree House* in Austin in a different style and mood probably came out of the same trip. These or similar Caples scenes were displayed in September, 1942 at Creewood Studios, reported Borghi, noting that Robert was then "in New York in training in the Navy." Borghi had good intelligence: Robert only enlisted the day before, September 11.

Other works illustrating the diversity of Robert's output at Indian Springs as he shuffled styles include several treatments of manmade structures, all different from the Austins and from each

Virginia City, ca. 1940–42

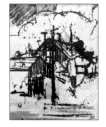
Untitled (Indian Springs), *ca.* 1940–42

Untitled (Union Square, San Francisco), *ca.* 1940–42

other. The Indian Springs years also produced the sculptured Southern Paiute head *Winnedumah* and the mural panel for Norman Biltz's home, *The Gifts of Hy-Nan-Nu*. Two other pictures, of ladyslipper flowers and of a horse, couldn't be more different save for a curvilineal dynamism seen in many Caples works. Robert's most atypical experiments at Indian Springs, begun after finding some photographic paper in a lost purse, created images on the light sensitive paper without a camera. Kirlian photography, photograms, and applications of chemicals ("chemichromes") all had precedents. Robert sought new ways to achieve color effects. The most innovative of these he termed "heliographs," produced by painting photo paper with

Untitled (Kirlian photograph), 1941

Untitled (heliograph), *ca.* 1941

clear shellac, followed by exposure to sunlight and chemicals. The surviving black-and-white photo of one heliograph is reminiscent of Pollock, Klee and Miro. Robert appears to have devoted quite a lot of time and thought to these experiments, which he exhibited in Nevada and California while continuing to exhibit more marketable works.

Walter, while working on *City* at Indian Springs or later, borrowed the arcane term 'heliograph' to describe the glint of sun off a car, just at a moment when Lawrence reappears in Tim's life. I wish I could identify all such little private references there must be in *City*, planted by Walter for Robert's benefit, and his own.

And then there are the landscapes, diverse ways Robert rendered his experience of mountains and desert. Extant examples include an energetic

Untitled (etching of mountains),
ca. 1940–42

Untitled (Pyramid Lake),
date unknown

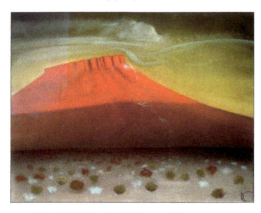

Untitled (like *Red Mountain*), *ca.* 1940

freehanded etching of mountains, clouds and sage; a study of Pyramid Lake with cloudbursts, heavy with somber joy, which I judge was done during an excursion from Indian Springs; and *Red Mountain* and a second, similar pastel which I am happy to

own, both of Southwestern buttes beneath moving clouds. Robert recalled one of the red pastels, it could be either, as "a celebration of new morning. I'd broken away from a burden of entanglements—and, as usual, at the expense of the feelings of others—and was quietly overwhelmed by the immense power of day on a mountain south of Las Vegas—it was a tremendous revelation of the earth's turning, the sense of a huge turning, ever so slowly, in untroubled space."

Indian Springs also yielded *Dharmakaya, the Golden Path*, the oil Robert reproduced with other images of his as small Kodachrome prints for accessible pricing, and which he would send to Walter in that format as Walter faced death.

Indian Springs may not have been the apogee of Robert's career, but his dismissal of the "yield from all this wonderful liberation and discovery" as "virtually zero" is only his usual self-deprecation, not justified. Moreover, Robert's searchings weren't random enthusiasms, as his synopsis misleadingly suggested. On the contrary, for it was at Indian Springs that he was thinking so systematically as to formulate what he termed a "Tree of Intentions," which, like the "thirty four turtles," Walter reallocated to the Peavine cabin, where Tim finds Lawrence

> thumb-tacking scraps of paper on a piece of wall board which covered one whole side of the earth room. The scraps were an amazing collection, birthday cards, Fisher Body ads, cartoons, pieces of wall paper, photos of ball-bearings, magazine illustrations, I don't know what all, mixed in with prints of Da Vinci, El Greco, Velasquez [sic], Van Gogh, Picasso, Braque, a hundred painters.... [H]e had drawn the trunk and wide-flung branches of a tree, in which these pictures hung like leaves.... Out at the end of each branch, he had printed a single word, Camera, Abstraction, Sentimentality, Commercial, etc.... Lawrence calls this chart the Tree of Intentions.

Robert, while Walter was at Indian Springs, presented to Las Vegas gallery-goers a "tree of intentions" comparable to the one Lawrence covered a wall of the cabin with in *City*. Borghi devoted a *Gazette* column to the one Robert made public in 1942, when "a large chart ... was used to designate for viewers the evolution of modern painting. Mr. Caples called

it a tree of intentions and graphic illustrations marked the branches of various schools of art." Borghi asked Robert to prepare a simplified version of the chart suitable for the *Gazette*. The tree became a simple line diagram, its many branches were reduced to a few, and rather than Lawrence's visual "scraps ... hung like leaves," Robert drew actual leaves, each a schematic sample of a school or type of art, ranging from mere "prettiness" to a dreamlike eye-leaf for Surrealism and finally an idealized leaf for Romanticism. Lawrence's "leaves" in *City* only partially coincide with Robert's in the newspaper—the novelist wouldn't make a contact print of the reality (in the same way that, in this near *roman à clef*, Walter disguised without disguising the hotel where Robert always stopped in Austin, the International, by renaming it the National).

"Tree of intentions" (detail), 1942

Following her brief introduction, Borghi turned the column over to Robert for his elucidation of the chart, a mini-treatise on art theory Walter wisely omitted from *City*. First Robert brushes aside a straw man who disparages "modern art" for not copying things "as they appear to the eye." Next he epitomizes the esthetics of several prominent styles, dwelling on Impressionism's focus on light and color, and on Surrealism's bent for the unconscious and dream imagery. These are stock ideas. What's more unusual in Robert's perspective is the ubiquity of the pleasures of decoration he finds in all styles (this is before Minimalism and Conceptual art as named styles, though not before Dada and Duchamp). He unequivocally asserts the legitimacy of each and every artistic impulse, by implication even "prettiness," on its own terms. Yet in the end he walks back this impartiality that spared mere prettiness, when in the section on Romanticism he makes his personal commitment clear. After discussing Surrealism, he continues:

> The same tremendous reservoir, the subconscious, has given color and substance to the most compelling work. Not when explored with the precious self-investigation of the surrealist, but when summoned up to meet the

spaciousness of the open world. These two imponderables combine in the greatest music, the finest literature, the highest art. It is decidedly apparent in the singing quality of William Blake, the somber power of Rembrandt, of Beethoven, Whitman. For want of a more precise term: the religious sense. When it is the artist's will to awaken considerations beyond the world of things, it makes little difference what his choice of subject matter may be. He is not painting the object for itself alone, he is painting the oneness that contains them all. For him, the sunlight becomes a symbol flooding the meanest surfaces with beauty, a light transfiguring the commonplace and in which only the trivial and pretty things are ugly.

Robert the autodidact would later mostly leave behind the systematizing impulse he deployed to arrive at this manifesto. The tree of intention's branches and leaves would become his "scraps and scrabbles," would become the random stacks of images from ads, cards and cartoons which he continued to accumulate, now mailed off to friends with or without comment. Quick with metaphor and humor, his surviving letters (most from the 1960s and 1970s) are just as lofty as this lecture, but unmistakably genuine, free of inflation and sententiousness.

Nevertheless, the core of Robert's upcoming mountain landscapes, his finest work, was anticipated here in 1942, when he wrote at age thirty-three of "painting the oneness," and of "the subconscious ... summoned up to meet the spaciousness of the open world."

Fascist Nativity & Letter to the Living

Well before Pearl Harbor, citizens' groups were responding to a world already at war. Robert to do his part created a stark poster for the Medical and Surgical Relief Committee of America to finance ambulances for China in its war with Japan. Robert nevertheless chose Europe as his subject—*Hitler calls it a 'New Order' but ... it has an old name.* The poster was reproduced in the *Journal*, displayed at Carlisle's, the printer, then sent up to national headquarters. Borghi reported in the *Gazette*: "Robert Caples' poster, executed in black and white, carries a skull which, plus its thought-provoking message, conveys the idea of death to liberty and freedom casting its black shadow on stricken nations." An Uncle Sam held by Bob Clark might date from the same time.

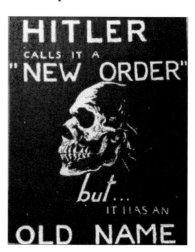

Hitler ... poster, 1941

And then, Pearl Harbor. Within days, artists in Reno joined by Robert and Shirley from Indian Springs formed the "Co-Arts group" to "render free service in an art capacity to [civil] defense organizations." Borghi's coverage is vague as to the practical connection between this mission and the basement gallery Co-Arts opened at 73 Sierra Street for displaying works of its members, among them Dick Walton, the ever-present Hans Meyer-Kassel, and artist/columnist Borghi herself, who introduced Co-Arts in the same column which caught up with Robert at Indian Springs and which printed the photo of Shirley's ceramic rooster. Borghi couldn't foresee that for Robert the war would bring an end to the decidedly prewar idyll of the Indian Springs she conjured for her readers.

It took mere weeks after Pearl Harbor for the war to impinge on the artist colony. Just north of Highway 95 the Army Air Force established the Indian Springs Airport. By March, barracks began to replace tents,

with housing for military families soon added. Explosions and engine noise broke the desert silence as bombardiers and navigators trained. Today the site is part of huge Creech Air Force Base, where personnel sit in front of monitors remotely controlling drone strikes across the world. The turnoff to Mercury, gateway to the Nevada Test Site, is just twenty miles up the road.

Sometime after Pearl Harbor Robert created another topical image. The drawing has the look of a political cartoon, if a 'cartoon' can instantly stifle any laugh. There is no caption, but the fasces in the upper left overlooking Mother Mussolini and Father Hitler dictates the title *Fascist Nativity*. When I showed the drawing to artist/historian Jim McCormick, he at once realized that Robert had cunningly echoed *Guernica*, Picasso's *cri de coeur* against the outrages of fascism in Spain. The expected cow in the manger has become Picasso's bull of war; proud papa Hitler's "Oh my goodness" hands quote those thrown high by a horror-stricken woman; and instead of the screaming horse of *Guernica*, Robert placed a pastoral ass peering dismally over the dictators' shoulders at infant death, true offspring of these parents, a nativity mimicking with grimmest irony Picasso's heartrending pieta, the mother wailing to the sky over her murdered child.

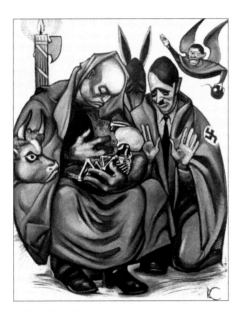

Untitled (Fascist nativity), *ca.* 1941–42

Walter also responded to the war. He with family arrived at Indian Springs in fall, 1941 and stayed until August, 1942 on the money earned from *Ox-Bow*, a novel some critics saw as a parable about the dangers of European fascism. Walter liked to say he began the novel as a mere satire of the cliché Western, a "finger exercise"; soon, however, he realized his plot had the potential "to break the stereotype, not

to the reader but to me.... make [the West] real for me." Then, in the writing, the story became layered by Walter's revulsion to the Southern lynchings then rampant. Walter once answered when a defensive South Carolinian young woman questioned why *Ox-Bow*'s villain Major Tetley had to be a Southerner: "It was those rebel sons-of-bitches who were the worst." By the late 1950s, Walter was tracing the origin of *Ox-Bow* to the fragmentary news about the fate of the Jews during the 1930s, which "he had been carrying around ... working at some seminal level in him for years" (no mention of his Jewish mother). If it's true that *Ox-Bow* was a gloss on Europe, Walter may only have become fully conscious of it when critics made that interpretation. At the time *Ox-Bow* wasn't primarily Walter's response to the world situation; that response came later in a short story written at Indian Springs.

Walter was on a roll following *Ox-Bow* and a string of short stories in major magazines. Besides writing half of *City* at Indian Springs, he completed several short stories and did substantial work on two other novels. One was *Water*, a novel of Nevada history begun in the East perhaps as early as 1934 and submitted before *Ox-Bow*. It was rejected, but earned the attention of Frances Pindyck, the agent who subsequently placed *Ox-Bow*, by winning second place in a novel contest. Before returning to it at Indian Springs, Walter had already reworked *Water* under half a dozen provisional titles. By the time he shelved it for the last time back in Cazenovia, he had produced a densely handwritten six hundred page version and then another, unfinished, of three hundred pages. This is most likely the manuscript Walter was referring to when he said in 1945, after publication of *City*, that his next novel was "well along." *Water*, like *City*, was dedicated to Robert, who until Bob Clark informed him after Walter's death wasn't even aware of the novel's existence.

The idea for the other never-completed novel Walter worked on at Indian Springs came from appraising America during a motel stop on the cross-country drive to Indian Springs—"in the satirical mode, probably," speculated Bob Clark, "the motel as a kind of Grand Hotel, cross-section of population and of way country was going." Bob supposed the stop to have been Little America, the gigantic if never grand truck

and tourist oasis in Wyoming, a place bound to put any thinking person in a satirical frame of mind. However, the nation had to wait until 1952 for Little America to open. It's not hard to imagine the kind of satirical potshots elicited from Walter by some other roadside attraction and then thought better of, what with the war. Robert recalled Walter ceremonially burning the manuscript "at the base of an apple tree near the front porch of the Indian Springs house"—the second documented instance of Walter's periodic liquidations. Was he emulating Robert's hecatomb of portraits? "I do think Robert's manner inspired, even coerced, a kind of emulation out of Dad," Bob Clark once mused. Walter had burned his first try at what became *City* in 1938. There was another burning later in Missoula, Montana in the mid-1950s when Walter was teaching there. "He was a real ham," ventured colleague Geoffrey Brown, whose fireplace consumed the novel page by page.

Walter produced at least three short stories at Indian Springs. All reached publication, and each has a bearing on the writing of *City*.

"The Rise and the Passing of Bar" reprises the theme of "Hook." Where "Hook" recounts the life and death of a solitary hawk, "Bar" follows a mustang stallion as he gains and loses ascendency over a herd. There's a story told about Walter that he once invited poet William Stafford, who had recently lost his son, to give a reading in Reno. Walter picked him up at the airport and asked about the flight. The poet said, "All right, but it's always so melancholy flying into Reno"—or, in another version, that the shadows of the hills around Reno made the approach that evening melancholy. In both versions, Walter replied, "Yes, the big picture is always sad." In his poem "Something Walter Clark Said," William Stafford had Walter say, "'Things end that were good; | the big picture is always sad.'" It was a world view dramatized repeatedly in his fiction. Walter, like Tim in *City*, was afraid of time. "Bar" served as a release valve for the fatalism which keeps threatening to overtake *City* as it strains toward its happy ending.

"The Ascent of Ariel Goodbody," written in Walter's satirical mode, is the precursor to the digression in *City* about a formative escapade in the past of Knute Fenderson, one of Tim's musical mentors at Carmel. Fenderson endeavored as a young composer to teach the Philistine cultural

establishment of Europe a lesson by promoting a concert of his own composition, deliberately the world's worst music. But when critics and audience alike lionized him he gave up, to become a musical outsider in Carmel. "Ariel Goodbody" treats the patrons of culture if anything even less kindly, with ugly caricatures of their types. The title character is a painter who comes under the sway of Christopolus, a showman/artist. This renegade bohemian is Walter's harsh parody of Greek artist Jean Varda, a man famous for flamboyance and sexual license, whom the personally conservative Walter met at Indian Springs. With that off his chest, Walter was able to create the more sympathetic Fenderson, less exaggerated than Christopolus but exhibiting many of his attitudes. Although the Fenderson set piece in *City* asks for humorous appreciation, it is still angry and nihilistic, a long, off key distraction that should have been cut.

"A Letter to the Living" is Walter's war-related story from Indian Springs. It appeared in June, 1942, in the progressive weekly *The Nation*. The letter's author is a guerrilla facing execution for armed resistance, who asserts that the abject deaths of those who lose their nerve facing the tyranny's firing squads do more for the cause than do courageous deaths, by demoralizing the executioners—a dubious assertion in view of the scale of anonymous death-dealing already well underway. I suppose his story should be judged by the standards of literary propaganda.

Recently at Special Collections I found a note Walter made at Indian Springs for a different short story with an opposite moral; in "How Pesticopolus Became a Great Man," it was to be the resistor's defiant gesture that pays off:

> Pesticopolus—The Greek who was no good because he would not talk politics—becomes hero during German occupation by refusing to accept—throwing back—bread scornfully tossed to him—then revealing when his health is noted that he has used his old skill in theft—others begin.

The Axis invaded Greece in April, 1941.

City, although written during the war, had been conceived before the war, and Walter's conception of its ending required a setting—a Reno and Nevada—not urgently reoriented by war. About a hundred

pages in advance of the ending Walter had Tim deliver an impassioned denunciation of the prewar Mussolini—it would have been about 1935—as much as to say Tim wasn't oblivious. Pages later Tim deplores a newspaper photo of the Italian dictator "jumping through a fiery hoop" next to another photo of a leggy heiress in a divorce action. But then the subject drops. "A Letter to the Living" discharged a duty by really taking on the great issue of the day, even as Tim's blessed condition prevails to *City*'s end inviolate, and Lawrence has gone off not to war but to Salt Lake City.

Sargasso Sea & Promised Land

Robert did leave, in 1942, probably in March. He left Indian Springs and went off, not to Salt Lake City but to war, roundaboutly. Walter stayed on at Indian Springs until late July or August. I can see the novelist hurrying home to make notes after fraught conversations in the main house with jilted Shirley. Hearing her go on about Robert's disdain for the Los Angeles mansion of her father Max Behr may have given him the idea to set the breakup of Lawrence and Helen in the "Sargasso Sea" of Beverly Hills—the Sargasso Sea, nursery of eels, a windless mid-Atlantic gyre of dead sailing vessels trapped by seaweed, Walter's metaphor for the marriage. When Walter was writing *City*, ocean voyage still offered likely metaphors for the exploration of human experience—think my Columbus piece that left Stegner cold at Stanford. And Los Angeles already had its anomalous reputation as both a nursery of creativity and a zone of hypnotic alienation, a "Sargasso Sea." I found it to be both when I moved there after Stanford to be with Lois, an underemployed actress (later the successful author of earnest women's novels), until I escaped what felt to be the trap—not Lois, the city. Walter, a loather of big cities (all but San Francisco), rated Los Angeles even below New York.

So Walter had Helen write Tim begging him to come see her in Beverly Hills for Lawrence's sake. Walter could readily imagine Tim's jalopy, Old Jeremiah, parked incongruously beside Helen's immodest hybrid of Spanish Mission and Versailles, its porte-cochere sentried by spindly palms with remote unnatural crowns. The porte-cochere and non-deciduous palms are my embellishments, and I have to throw in blue and orange floodlights, though I'm not sure Los Angeles yet had that particular ugliness by the Thirties. Walter added a maid to lead Tim past a pedestaled Buddha overseeing Helen's living room of five separate silk-upholstered seating arrangements teeming with *objets-d'art*. This Helen, based on Shirley, is heavier, mannered, no longer the lithe impetuous beauty based on Virginia. Helen has received a letter from Lawrence—who could be anywhere by now—hinting at suicide, she says, and blaming her without really saying what he means. She's possessive, controlling, as Shirley must have been. She

dumps on Lawrence: for coming down in ragged work clothes instead of the fine clothes he loves, just to embarrass her before her guests; for hanging out in derelict mining camps like Austin with its used-up whores and other dead-enders; for his pointless experiments in quest of originality and perfection. Some of these efforts are up in Lawrence's unused studio that she had built specially for him. The large painting, though, is different.

In the small hours Tim finds his way up to Lawrence's studio, a rooftop addition almost bare except for the few paintings. All of Austin. They capture it, for sure, "and all the other old camps like it," and "their fierce, brief pasts." The large one is of Austin, too. Tim knows the very room, the one above the bar in the National Hotel where Lawrence always stays. You can see the flooring nails through the rug, a Bible and painter's palette distorted through a pinch whiskey bottle on the dresser, things through things. Obscurely on the bed lies a naked man, corpse-like, while in a corner looms the stretched figure of a woman wearing many bracelets, her cavernous eyes pinning the man. As Tim approaches the painting, the room seems to fade, while through the window and immaterial walls Tim sees himself, and Helen, and Walt Clark their other friend, and a little apart, Lawrence. Then, ranges dotted with nut pine and juniper, and a city, part Austin, part Virginia, and Mt. Peavine and the cabin, and downtown Reno, and Tonopah's Mizpah, and Carson's capitol dome, and Bowers Mansion, and there is Tim's boyhood home by the racetrack. And through it all wend Indians, prospectors, cowboys, a surreal pageant of Lawrence's Nevada life, their mutual lives. Tim follows the sight-lines to the very top of the painting, where, "in the extreme and mystical distance, and much the brightest region ... shone Pyramid Lake."

Lawrence titled that painting The Promised Land, *Helen tells Tim in the morning. Tim grins, happy to the bottom of his heart that Lawrence was inspired by Tim's own chauvinistic tall-tale ballad, "The Sweet Promised Land of Nevada." Tim perceives the darker aspects of this great painting, while loving it for showing that "Lawrence would always desire to understand; Lawrence would always desire to believe; Lawrence would always desire that every man be himself.... Lawrence would always desire, above all, to record these desires greatly, to oppose them, like*

established truths, against the dark wilderness." The mutual recognition of these desires is the substance of their "alliance" and their "love."

Walter allowed Tim himself to become entrapped for the better part of a week, disoriented amid so much soulless opulence by Helen's parroting of unassimilated tastes and views, her endlessly superficial conversation only interrupted by intemperate emotions. Paradoxically, it's the justice Tim must admit in some disparaging observations about Lawrence that shakes Tim out of his torpor. He dashes off a proposal of marriage to Mary, packs *The Promised Land* and the smaller panels into Jeremiah, and heads for Death Valley to find Lawrence.

How did Robert see the marriage, who left not only Shirley but their son Cricket and Shirley's son and daughter? As for the children, thirty-seven years on Robert rhapsodized about Eve at five as "a little girl I loved very much" and "the most delightfully charming child I'd ever known." He never saw her again, nor Weston, who would have been about nine. The only indication of that relationship is a derisive story Robert told Dick Walton about the boy: "He saw a Jeep pass, and expressed the desire to have such a car. And Robert asked him why he wanted it. He said he wanted to take the manure to the horses." And Cricket? The only clue is that they didn't reconnect until Cricket was adult, and not on Robert's initiative.

And the marriage, the money issue aside? There's nothing in the retrospective questionnaire about it, about any of Robert's marriages for that matter, with the exception of a vignette in the cover letter casually magnifying his current domesticity with Rosemary, I imagine with an eye to Walter's disapproval of his many women and too many marriages. One day at Indian Springs Robert had been "muttering about" Shirley when Walter interrupted self-righteously, "'If Barbara were to die, I would pick her up in my arms and carry her gently to the top of the mountain.'" And when Robert married his fourth wife Bettina in 1947, Walter pronounced, "'You people never learn, do you?'" After that he cut Robert for a time, as Robert told Bob Clark. "RC sensing a cold, moral disapproval."

You people. Walter blamed Shirley for the bad marriage, but not entirely. Bob Clark got my attention when he surmised that Walter

used Helen to voice his own negative appraisals of Robert. So perhaps it was he, Walter, who discerned self-pity and judgmentalism in Robert, who thought Robert's experiments "useless," who scoffed at affectations of rough dress. Above all, it was probably Walter who believed that Robert's "perfectionism" and "obsession with originality" were indeed "self-destructive," and that when he ran off he was in truth "running away." Walter said as much in a frank segment he cut from the retrospective essay:

> Personal troubles which disturbed him deeply and the increasing sense that all the discoveries were not making the connection, had driven him to a brooding wandering in the desert, a period of self-exile in Death Valley, Austin, Virginia City, with all the old irregularities returned and multiplied.

Walter also noted, apropos the war, that Robert, "like everyone else, became restless, felt the inconsequence of what he was doing in a world where all such doing might be finished." So Robert, fed up with Shirley, seeing no way forward with his work, and wanting to do his part, joined the Navy. His brother John had been in the Navy, and would be again. Walter, whose brother David also joined the Navy, himself attempted "to reactivate a reserve commission granted after high school ROTC, but [was] turned down because of bad knees," his son reports. A good thing, or he might never have finished *City*.

Robert didn't join up directly upon leaving Indian Springs. First came the "period of self-exile" lasting about six months, during which he went "wandering in the desert," exhibited at Co-Arts, had the low-cost Kodachromes made for sale at Brundidge's, and completed *The Gifts of Hy-Nan-Nu*. Robert's state of mind was rarely as dark for any length of time as Walter represented. Robert was resilient.

On the same page as the note Walter made at Indian Springs for the "Pesticopolus" story is another for "The Alleys Are So Pleasant," to be a "[s]tudy of Robert," casting him as a failing writer "in increasing retreat world—who finally knows no street or front doors but all alleys and back doors—at last ceases writing—on theory of beauty of blank page—work in church have quarters." Works in a church in exchange

for living quarters, did he mean? The church may betoken the "saint complex" imputed to Robert in Helen's voice. Walter had no love for organized religion. As to the "theory of beauty of blank page," Walter must have heard Robert going on about the blank canvas or empty frame, Robert's personal formulation of Buddhistic emptiness. This koan-like image remained compelling for Robert over the years. In the questionnaire cover letter, speaking of the pleasure he took during the 1950s creating murals and paintings for Reno architects, Robert digressed to "the big untroubled flat walls—I used to think if only they'd pay me to leave them alone—the walls, I mean." Walter was right, even prescient, to see in this fancy a tendency toward artistic cessation ("at last ceases writing"). In 1977, when he expected never to paint again and may never have, he wrote to Edda Houghton, "I have actually hung an empty frame now and again—you'll think I'm fooling, but it's awfully hard to improve on an empty frame correctly hung on a cool wall—one has to have much talent (or else impudence) to improve on the space, and almost infinite suggestiveness, of *nothing at all*."

Walter's darkest prognosis for Robert didn't prove out, however, for Robert went on to create his best work—as Walter expected him to do, for there were two sides to Walter's assessment of Robert. Through his surrogate Helen and through the note for "Alley," Walter vented his doubts about his friend without ever ceasing to admire, idealize and love him. Tim profoundly appreciates Lawrence's Austins, the panels intimating "the grief of nameless humanity." Then for over three pages Tim contemplates *The Promised Land*, a creation of Walter's imagination, in effect pointing the way for Robert who, Walter knew as he wrote, would eventually read the description. On one hand Walter looked up to Robert and emulated him, while on the other he saw himself as Robert's protector, his older brother. Didn't he portray himself as Robert's savior from the rash adventure in Death Valley? So it threw Walter a little when he discovered in 1964 that Robert was actually the senior of the two—not by much, but the reversal slightly disconcerted him.

What *The Promised Land* resembles if anything is Tim's symphony, The City of Trembling Leaves—which makes the painting a visual

counterpart of Walter's novel of the same name. In *The Promised Land*, everything else leads from and to Pyramid Lake at the top of the panel—Pyramid Lake, the locus and symbol of their shared experience. But *The Promised Land* resembles nothing Robert ever had created or ever would—unless, tellingly, his humorous, indulgent Town House map of Reno with Pyramid Lake near the upper left margin.

The friend of Walter's who actually did take a title from Walter/Tim's ballad "The Sweet Promised Land of Nevada" was Walter's protégé Robert Laxalt, when in 1957, a dozen years after *City*, Laxalt's gem about the Basque immigrant experience appeared, one of the best reads imaginable, *Sweet Promised Land*. Just days ago I happened to meet again the woman who sold me *Sweet Promised Land* at Zephyr Books, since closed, during my 2011 voyage of rediscovery. It turns out she went to school with Monique Laxalt, who became my friend. Small Reno.

And There Was the Navy

"And there was the Navy."

That's all Robert had to say on the subject for Walter's questionnaire. Yet Walter devoted pages of his biographical essay to Robert's Navy service, drawing on what he knew, or thought he knew. Robert decided to join up, Walter's story begins, but "Friends in New York talked him out of it." What friends? Walter doesn't say. And did they talk him out of it? Actually not. One friend was brother John, still at BBDO but soon to revive his Navy commission to do recruitment advertising. John's plan was to find Robert a Navy berth which would lead to an advertising art job after the war, or, failing that, at least to keep him out of harm's way. The other unnamed friend was Barbara, soon to become Robert's third wife.

Robert met Barbara Joseph Schubart (born 1913) when she was in Reno divorcing her first husband and he divorcing Shirley (something else he accomplished while "wandering in the desert"). Barbara married interesting men. Her third husband would be the artist and poet Jorge Flick. Henry A. Schubart, Jr., her first, an artist with whom Barbara had lived in Duchess county upstate, later became an innovative California home architect. A photo showing Robert, Barbara and Henry was snapped in 1945 during a backyard get-together at the Greenwich Village home of Henry's mother. Robert followed Barbara to Manhattan to live with her and her two young daughters before enlisting. Barbara inherited her father's pride in descent from a Portuguese Jew who took part in the American Revolution. She wasn't one of Robert's wealthy wives, though she had a small trust fund from her mother, and her father had the money to support her when she

Barbara Caples, *ca.* 1944

needed it. Later he would send his granddaughters to boarding school because he wanted them out of the public system and disapproved of Barbara's bohemian lifestyle and homosexual friends.

In Walter's story the New York friends, concerned for Robert's health, convinced him to take a civilian job creating recruitment posters. An interview was scheduled. The man turned out to be a successful advertising artist whose style Robert deplored, so he abruptly excused himself, then headed for Brooklyn to enlist. Did Walter hear this tale from Robert? John's diary tells a different story. The interview concerned a Navy posting, not a civilian job. Robert was to secure a desirable spot before actually enlisting, in that way entering service at a higher rank, possibly even as an officer and avoiding boot camp. John managed the campaign with Robert's cooperation. The job sought this day was to be a stopgap, painting insignias on aircraft at Norfolk Naval Base. Radleigh was the man Robert went to see, an officer with connections at Norfolk. Robert was kept waiting a hour, then had to leave because Radleigh was too busy to see him. Robert didn't head for Brooklyn. Rather, John called to reschedule. Now Radleigh told him that Robert should have letters of recommendation from Nevada office holders. So the brothers contacted Byron, and within a week half a dozen letters arrived, including a "grand letter" from Governor Carville and one from Senator McCarran.

Caples in uniform, 1945

Meanwhile, Robert visited Walter in Cazenovia (where he had returned to teaching from Indian Spring after a leave of absence), one of several meet-ups while both were east. Walter read him a chapter of *City* (Walter sent the final revisions to Random House in late 1944; it reached

bookstores in April or May, 1945, cover price, $3.00). Also Robert had lunch with Shirley in New York, three-year-old Cricket not present. Robert found her "miserable and drinking a lot and almost going out of her mind in spite of her money," said John. When Robert did eventually enlist, he made John his beneficiary for death benefits, not Cricket.

John learned that the Navy already had all the artists for recruitment posters it needed. And it turned out that insignias were put on planes with stencils, no skill required. The advice was that Robert take his letters to Washington and make the rounds, which he did, more than once, without success. John approached Radleigh again, and upon Robert's urging yet again, seeking now any modest assignment whereby he could bypass boot camp. Robert feared he was becoming too anxious to pass the physical. Finally he "decided to keep his swearing in date" on September 11. The night before, "he felt like he was going to be executed." He joked that John looked like the warden of Sing Sing.

Robert was sent to the Naval Training Station at Newport, Rhode Island. On November 2, he was posted to the Naval Operating Base on Trinidad, further efforts by John to pull strings having proved futile. In Walter's version, because he'd given his occupation as "painter," they automatically assigned him to paint ships and barracks. In actuality the Navy "booked [him] for camouflage," a semi-artistic assignment. But through a snafu he instead painted ships and barracks. To divert himself, he told Walter, he would draw sweeping pictographs with his six-inch Navy-issue brush on the walls of latrines before overpainting them.

But soon he became ill. In mid-March, 1943, doctors on Trinidad decided Robert needed treatment at the Naval Hospital in Annapolis. There, on April 14, while still hospitalized, he married Barbara, who believed he was dying. And then, Robert's Indian portraits re-entered his life in a remarkable way. Within nine days of the wedding, an admiral's wife saw photos of the portraits sent by Byron spread out on Robert's hospital bed, and through her initiative Navy Personnel received a request from an officer in the Navy Hydrographic Office that Caples, then a "convalescent patient," be assigned to them as a cartographer to replace "a man who is very anxious to get to sea." Of

Caples this officer wrote: "He is a fine draftsman and artist, and will make a fine litho draftsman, I am sure,—and Lord knows we need 'em! He was booked for camouflage, but [they] set him to painting decks and bulkheads! He is a brother of Caples, U.S.N.A., '24." By mid-May he'd joined the Hydrographic Office. Thus the waggish cartographer of Reno and dreamer of Jigger Bob's map of creation became a Navy mapmaker.

Just six weeks later he was back in the hospital for another month and a half, this time at Bethesda. Four months later he was hospitalized again. Meanwhile he had loaned works to a USO club in Reno—his second of two minor exhibitions in Nevada while serving—, and Barbara had taken an apartment in southeast Washington. Robert now set up family allowances for her and his "stepchildren," Mallory Jay (1937) and Linda Kay (1940) (not formally adopted, as I believe none of his wives' children by other marriages were). But he never got around to changing the beneficiary of his death benefit from John to his wife.

Robert spent a third of his time in service hospitalized. His last and longest hospitalization began in September, 1944. Six months later, on March 27, 1945, he received a medical discharge with a diagnosis of "asthma due to bacterial sensitivity," part of a preexisting respiratory condition not aggravated, the final report contended, by service.

In Walter's story Robert received treatment in Reno one time, but actually he did twice. The first time was that April, when his condition wasn't acute. After visiting Walter in Cazenovia again, he went to Reno for a month of penicillin treatments from Byron. While there he got his teeth fixed. He then returned to the Washington apartment until the children finished the school term, when Barbara and the girls left for New York. They took a room in the Chelsea, a hotel renowned for the famous artists and writers who have lodged there, until Barbara rented a two-story, four-room apartment in a brownstone on 21st Street, where Robert joined them.

Then a year later when Robert's health deteriorated again, Walter's brother David, a surgeon, who happened to be in New York following Navy service, saw to it that Robert returned to Reno for more care. He arrived in mid-June, 1946, for two purposes: to receive treatment, and to obtain a divorce. Robert came close to dying at St. Mary's Hospital. Drs.

Caples, Clark and Locke, the attending physician, together treated Robert with massive intravenous doses of penicillin which saved Robert's life, but also, Walter wrote in the draft of his essay, "killed all his anti-bodies along with the strep, and any slightest cold threatened to become something far more serious." Rosemary said that his heart was involved. Strep viridans can weaken the heart valves. It could be that Robert's ill-health going forward, and even his death, trace back to the infection he contracted in the Navy.

Walter and his brother David must have met up in the East also. Presumably that's when Walter gave David a copy of *City* inscribed with a disavowal that Tim's brother Willis was at all based on him, his own brother; "but," says Bob Clark, "Dave didn't believe a word of it, and did feel some resentment at the caricature-like portrait." It was Willis's being "disconnected from nature" in contrast to Tim that rankled the younger brother, Bob told me. My sense is that they loved and supported one another without ever growing close. Their energy when they got together went into arguing politics, Walter the ACLU member and David the John Bircher.

Walter wasn't well, either, after the war. He had exhausted himself finishing *City* while teaching in Cazenovia. For over two years he put everything into the novel, then to be hit by its lukewarm reception. Babs thinks that part of Walter's distress stemmed from having been rejected for service during the war. She believes that he worked in a munitions factory "eight hours a night, five days a week or so" on top of teaching and writing. Then when his brother-in-law Wayne Lowe the superintendent at Cazenovia transferred, Walter followed him to a school in Rye, New York, a position and a locale which Walter found uncongenial. With his weight alarmingly reduced, and possibly suffering from TB, Walter resigned to take up Mabel Dodge Luhan's invitation to Taos. He wrote and recuperated there from February, 1946 until the family moved to the Lewers Ranch in Washoe Valley south of Reno in September.

Robert joined the Clarks in Taos for several weeks. According to Walter's essay, Robert was artistically paralyzed, his spirit crushed by the tedious draftsmanship demanded at the Hydrographic Office. "By

the time he was mustered out, there was nothing whatever left of the great 'liberation' [of Indian Springs], either in spirit or in hand. He was afraid to make a mark on paper, and he very much doubted that there was any real point in trying to anyway." But when Robert appeared in Washoe County Court on August 15, he testified it was Barbara who had undermined him, by discouraging his desire to be a working artist. "It made me quite ill," he stated. While to blame a spouse was the kind of pro forma expedient expected in a Reno divorce action, the description of decline sounds factual: "As a matter of fact, my weight went to 118 pounds. I was under the doctor's care and had to cut my course and finally I had to abandon it entirely."

The course Robert had to drop was at the Art Students League, where he'd enrolled in classes to begin February 5 and end May 30, 1946. Walter said it was the instruction at the ASL, and even more the earnestness of fellow veteran artists there, that restored his faith in art and the life of art. In Robert's telling on the questionnaire, the restoration was completed later, at the California School of Fine Arts in San Francisco, which he didn't attend until the latter months of 1947. It really took a couple of years for Robert the artist to shake loose again. Yet Robert's artistic paralysis was never as absolute as Walter believed. The stepdaughters remember artwork on 21st Street; and within weeks of starting ASL classes Robert entered a still life in a national art show at Pasadena; and there was something else: "The Potter and the Lizard," Robert's third creation legend, a typescript of forty-eight double-spaced pages, generously illustrated, hand-dated 1945. Despite artistic malaise and sapping illness, Robert kept his eye on ultimates. While drafting military maps quarter inch by tedious quarter inch, when he seemed to his old friend whose novel had just come to fruition to have lost touch with what Tim and Lawrence shared, Robert's mind ranged to the foundation of our world.

Jigger Bob is gone. Robert reconceptualized the creation to reflect Eastern philosophy. Nevertheless, key Native American elements remain: the inchoate beginnings of everything, the cardinal directions, the creator's animal helpers, and the feuding siblings who precipitate the division of humanity.

The creation of humanity hadn't been part of Robert's Manta legends. The new Potter legend describes the creation of both Earth and mankind by the Potter, assisted by his familiar, Agama the lizard—the first animals already exist. They and the Potter dwell in an Earthlike realm, with

The Potter and the World, from "The Potter and the Lizard," 1945

mountains, trees, etc., but it is not the Earth; the Earth is a large pot thrown by the Potter, essentially a globe, on which he paints the animals who assisted him by fetching materials to make the pot as well as four human children. The Potter, however, isn't the ultimate creator, only a sort of lower god or demiurge. Then what is the creative principle? Robert hadn't yet fully integrated Eastern teachings nor clarified for himself how they meld with Native American elements still in his parable. In consequence, he took the expedient of separating off some Eastern concepts into a story-within-a-story, "The Magic Flower," told by the Potter to Agama. The story is animated by two Eastern concepts or symbols, superseding Manta as creator: Yin/Yang and the Lotus, both conveying the unity of opposites and the spiritual coherence of everything.

The five pages of "The Magic Flower" stand obtrusively isolated from the main story, which frankly also labors under the esoteric, if less so. The nicest bit of syncretism is the assimilation of the Great Basin's feuding siblings to the Hindu/Buddhist idea of the manifest world as illusion, samsara. The Potter casts a dream spell on his four boys because, in becoming the races of mankind, or individuating, they have

also turned self-centered and selfish, that is, they have lost their way in samsara. They have fallen, as it were. Such is our condition. The spell of illusion will be broken in a hoped-for future when the boys return to being friends, that is, when they—we—realize the brotherhood of humanity amid the unity of creation.

Feuding siblings,
from "The Potter and the Lizard," 1945

Narrow, Elegant and Tight

I asked Barbara's daughters, had Robert shown them "The Potter and the Lizard," a children's story? He hadn't. Linda does remember his letters, "with wonderful drawings in the margins." Written from Trinidad and Navy hospitals, those letters are the only bright spot in the dark impression Robert left on the sisters. In years to come they made efforts to find out what they could about the enigmatic man who briefly entered their young lives. Linda learned that Barbara wasn't in the same class as "the litany of Wealthy Wives of Caples." Mallory read *City*, "looking for Robert, the mystery." She said Robert's works on their walls "were abstract, designed, in inks of sepia, terra cotta, and black. I have no recall of him actually painting in our presence or having any colour or nature associated with him. This is interesting because of the range of work he did over his lifetime. What we saw seemed narrow, elegant and tight, like him." His works from 1946 mostly match the description.

This State, 1946

Arising Black, 1946

From what they later gleaned, Mallory allowed as how their experience of Robert "does seem contrary to or potentially upsetting in a minor way of his generally positive and kind persona." That was tactfully put. While some of what the daughters remember is legendary Caples—"extremely handsome, quiet, ... wafting in and out of places"—the rest is not.

Mallory at about age eight approached Robert as he read "and caress[ed] the top of his head, when he turned and said very coldly, 'Don't do that!' I was very hurt, rejected." "The overall impression of RC is one of coldness," wrote Linda the younger sister. She remembers being frightened by violent arguments, and asked, "Was he a drinker?" Mallory remembers "standing at the top of the stairs ... late at night

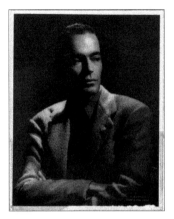

Caples, *ca.* 1944

hearing shouting and the sounds of blows. I'm pretty sure that Robert was hitting Barbara, but didn't see. Quite frightening."

Hitting, no, but *City* readers should not be surprised by anger. Lawrence and Helen/Shirley "'fight like cats and dogs.'" Lawrence wouldn't have a "decent quarrel" with Helen/Virginia, but was always "knifing" her—a style of passive aggressiveness that Dick Walton thought Robert inherited from the mannerly Dr. Caples: Robert, said Walton, "had a way of humiliating a person, didn't care to bounce a problem off, he'd let it hang there, to let you hurt.... I learned those hurts. And he dished out plenty of them to a lot of people."

Once when a neighbor attempted to molest Mallory, "instead of reporting it, Robert decided to go and give the man 'a lesson.' So Robert was both a safety, and a fear. But I think for the most part I was more than a little fearful of him." She doesn't believe Robert socked the man, but "confronted him verbally."

Mallory, a psychotherapist, learned as an adult from her mother Barbara that Robert had been homophobic, that "if she even casually used the word 'homosexual', Robert became violently angry, and she suggested it was his own latent homosexuality at work.... My guess is that Robert was troubled by erotic feelings towards men, notably his friend Clark; but I can also imagine my mother goading him that way." Dick Walton tells a little story seeming to corroborate anxiety on Robert's part about sexual identity. In 1948, Walton wrote and illustrated an article about a sketching trip he and Robert once made to Carson City's Chinatown. "Bob was very sensitive about it, because ... I referred to him in the sense of his 'Buddha position.' and he thought I described a fag. Well, I hadn't meant to." Walton had written:

Caples, "a curious Buddah," Richard Guy Walton, 1948

"Bob set down his outfit for he worked sitting upon the ground with a pad upon his knees. He held his head erect—he was a curious Buddah [sic] in that Chinatown." I don't get what Robert reacted against, but that's neither here nor there.

The question of sexual orientation came up unexpectedly in a conversation I had with Nick Cady, editor-in-chief when Robert's Indian portfolios were published by the University of Nevada Press. I had emailed Nick some photos of the young Robert which caused him to doubt he'd ever actually met Caples—the young Caples, Nick said, appeared athletic, whereas he had a mental picture from the early 1970s of an "old, bald, roly-poly" man. That's how Robert looked in his sixties, I confirmed, though I wouldn't say roly-poly. Robert was already heavy-set, I said, when I met him in 1964. Whereupon Nick asked, "Was Caples gay?" There was something about his manner, Nick thought. I said it was a question worth asking about the Caples/Clark friendship. "Not on Walter's part," insisted Nick. I had no evidence, I assured him, of anything overt on either of their parts. Nick then granted there might have been an undercurrent. Which is what I wondered when I noticed this metaphor in the Pyramid camping episode in *City*: "The cave of [Lawrence's] being began to reply profoundly to Tim's surf."

Bob Clark has pondered his father's sexuality. He brought it up in connection with Leslie Fiedler's "Montana face" essay. Walter taught in Missoula during the mid-1950s at the same time as Fiedler the New York Jewish intellectual, an incongruous celebrity in that setting. Bob Clark volunteered that he knew what the Freudian Fiedler would have said about Walter and Robert, that there was a homosexual attraction. When, months later, I asked Bob if his mother looked upon Robert as a "rival," he again invoked Fiedler, this time to deflect any implication. What Tim and Lawrence would "exemplify" for Fiedler, Bob Clark said, is a type Fiedler found in the American novel, the "Gentile American Male afraid of women and intimacy with women, escaping to the wilderness and unpressing male buddyship." Fiedler's macho type fits half-Jewish Walter much better than Robert. Gordon Chism describes his uncle Walt as an "intellectual Marlboro man—tall, rugged, and handsome, yet sensitive." That none of this implies homosexuality Bob

Clark asserted indirectly when he insisted that "[i]f Mom worried about rivals for Dad's attention and love, it's more likely it was about the string of single, younger females that he had in his life, usually, maybe always, connected with tennis."

As to Robert, while he had many male friends, "escaping" female company out of preference for "unpressing male buddyship" was hardly his character. Bob Clark tagged him "a chick-magnet." "Flypaper" was Jim McCormick's suggestive term. Success with the ladies, as they used to say, is part of the Caples legend. The young portraitist took full advantage of women in Reno for "the cure." After the war, he "cut a broad swath through the feminine side of the area." Peter Kraemer, lead singer of the Sixties rock group Sopwith Camel, gathered this from his mother, artist Zoray Andrus, a near-contemporary of Robert's, who "thought that Caples was a cad." He had affairs with several of her friends. When I talked with William W. Bliss at his Glenbrook home about my project, almost the first thing Bill said, with a twinkle, was that divorcées were for the picking in the old days, and that he and Caples had "ploughed the same ground." Bill, about fifteen years younger than Robert and himself a part-time artist, had never met Caples but knew they'd hung out at the same divorce ranches.

None of this obviates latent or covert sexual attraction between Robert and Walter. About that, who can say? Perhaps the question is as dated as Fiedler's and Barbara's armchair Freudian orientations.

However that may be, the marriage to Barbara didn't last. No one was sorry to see him go, Mallory told me. "When ... Barbara announced that Robert was gone, they were divorcing ... we all three cheered and celebrated with a special, happy dinner." After the divorce Robert joined Walter in Taos, coming and going several times over a period of weeks, still convalescing. Then he returned to New York where he once again enrolled at the ASL, for classes running from mid-September, 1946 to the end of May, 1947. Whether he lasted to the end of these sessions I don't know, nor when exactly he returned to Nevada, where on August 1, 1947, he married Bettina, the marriage that prompted Walter to scold Robert, "You people never learn, do you?"

A State Historic Place

Between Robert's return from New York and his departure for Connecticut, eleven years elapsed. How, looking back for Walter's questionnaire in 1964, did Robert deal with those years? He wrote about the battle-tested art students of San Francisco: "If painting and drawing could hold up for them, why be ashamed?" Then a few more lines—and there he broke off, as if to hide his trail, hard enough anyway to follow. John's diary almost ignores Robert for those years. And there's no more Lawrence Black to go by. And Walter in his essay? He took his cue from Robert by condensing those eleven years into just a few lines (almost accurate):

> two more years on GI in San Francisco, four years in Virginia City, three years in a little cabin behind the pools at Carson Hot Springs, and three with his new, lively, lovely and encouraging wife, Rosemary, in a small house in Dayton (Nevada) which they call Lizard Hall.

The little town of Dayton has a rich if minor history: Nevada's first precious metal discovery nearby (a bit of surface gold), the emigrant trail, early settlement, the Pony Express, Comstock silver mills, a Chinatown, Sutro's tunnel. James Fennimore—Old Virginia, the charter Comstocker—died in Dayton, bucked off a mustang on a spree. Chief Truckee died there, too, and his descendants Old Winnemucca and Sarah Winnemucca lived there at times. Long before the Paiutes, the same ancient Lake Lahontan of which Pyramid Lake is a remnant reached the site of present Dayton up its Carson River arm.

Thanks to part-time curator and Caples admirer Russ Lindsay, Robert's house at 175 Silver Street in Dayton's old district, his last Nevada residence, was placed on the State Register of Historic Places in 2006. When Robert lived there, discloses Lindsay's registration form, the house was "painted bright pink with green trim." Also, "there was a sign by the doorbell with the image of a lizard created by Caples." In 1981, an addition to the back of the house nearly tripled the tiny 539 square feet of Robert's day.

Caples' shed studio behind Lizard Hall, in 2011

"Lizard Hall" was a Caples place new to me on my voyage of rediscovery in 2011 after the talk on public murals in Chicago. I looked in vain for a sign or plaque. No one was home. A small dog climbed a sofa back to yip half-heartedly through the window. In the back I found the shed studio still standing. Walter judged it to have been Robert's "most workable studio." The house he described as having "a green blossoming patio, with large cottonwoods overhanging it, breaking up the sun with moving, leafy shadows, and an orchard behind it." But the foliage Walter remembered is mostly gone, and the little house has no view. You couldn't tell from Silver Street that Dayton sits at the bottom of the Virginia Range. All that could be seen from there in the wide valley of the Carson River were the low tops of a few nearby hills. I was disappointed for Robert's sake, but realized I couldn't really imagine what the place had meant to him then. He would later tell Joanne de Longchamps that "*anything* that speaks to me of Dayton, touches me where I live. And I don't mean in any sense of sharp regret either—just gratitude and quiet recollection."

I stood contemplating the modest scene, reflecting on how significance and emptiness mingle in the material past, and was already preparing to move on when a small sedan drove around the corner and came to a stop opposite the neighboring house in front of a building across the street, a cinder block structure painted the same soft pastel shade as Nevada sand and dust. Lettering on the window said Lyon County Parks & Grounds. A rotund, short-haired woman in her fifties got out. She works for Parks & Grounds, I thought, she'll know about the house.

"Excuse me, do you know anything about 175?"

"What do you mean?"

"It was designated an historic place. A famous artist lived there in the 1950s."

"All the houses here," she huffed, "are historical."

"Well," I rejoined, provoked by her tone, "they can't all be historic places. Like this house here," I proposed, motioning toward the one she'd parked opposite, if anything even lower and smaller than Robert's, "I'll bet it's not."

"This house belongs to the mine!" she retorted angrily, looking and pointing upward well above the tops of any features visible from where either of us stood, toward the idea of a mine that can't have operated for the last hundred years. It finally dawned on me that all the old houses around were included in the historical district of Dayton. She obviously had no idea of, nor, I was pretty sure, interest in the recent historical past of a mere half century ago. "I don't want to talk to you," she announced, looking significantly at my rented Ford Escape, "I see where you're from!" And she started to walk away, not to Parks & Grounds but toward the very house whose historical standing I had just impugned! What did she mean, where I was from? I looked at my rental: California plates!

"I'm not! It's a rental car!" That didn't really help my case. She kept walking. "How old is it?" I attempted.

She looked my way without stopping, "A hundred and fifty years."

Without thinking I gave a ludicrously self-incriminating double thumbs-up, which she disdained of course as she entered her historical house.

Driving away, I discovered that Silver Street is just one short block over from Dayton's historical Main Street with its old-timey hotels and an eatery, now J's Old Town Bistro, where the saloon scene in *The Misfits* was shot, I later learned. The cast (Gable, Monroe, Clift, Wallach, Ritter) used 175 Silver Street as a hangout, but Robert was gone by then. I also learned later that Dayton, close by his father Dominique's winter sheep ranch, was Robert Laxalt's model for the town in *A Man in the Wheatfield*, Laxalt's one book which is unambiguously a novel. Laxalt's plot about a rattlesnake whisperer whom empathy and fearlessness allow to enter his snake pit and be swarmed over without being bitten coincidentally echoes Lanier Graham's doubtful assertion about Robert Caples' training as a rattlesnake shaman.

He Was Just Robert Caples

Bettina Blythe Brower was born in Seattle in 1913. Her father was a bank cashier. She had one previous engagement or brief marriage, but alone of Robert's wives didn't come to Reno from the East for divorce. She may have met Robert as his nurse at St. Mary's Hospital. Why they married in Gardnerville fifty miles south of Reno I don't know, unless to avoid publicity. Bob Clark remembers Robert's fourth wife as an "earth mother" type, an impression she must have made on him when dressed for Virginia City; whereas in a photo from a 1947 Caples exhibition in the Mapes Sky Room, where she sits between Robert and Mel Vhay, wife of architect David Vhay, she looks urban 1940s and older than her thirty-three or -four years. You can still see the effects of illness on Robert. They were living back and forth between Nevada and "the city" (as Reno calls San Francisco). What they lived on I can't guess. He had "thought about working in a draughtsman's position—for in-law architect," he confessed to Walter in 1964. "Big pressure to accept." He resisted.

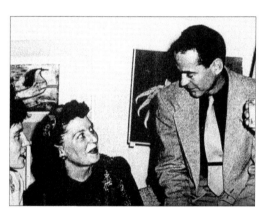

Caples with fourth wife Bettina, 1947

In San Francisco Robert picked up his prewar friendship with artist Jean Varda, who with two surrealists, Englishman Gordon Onslow Ford and Austrian Wolfgang Paalen, initiated the Sausolito houseboat community by refurbishing a retired ferryboat, the Vallejo. And Varda came over to see Robert, in Reno and Virginia City, and even made friends with Dr. Caples. Lanier Graham wrote about Varda's influence on Robert: "After World War II his friend Varda ... introduced him to the Chinese and Japanese Buddhists who became his teachers, especially Tobase Roshi. In the process, Robert's style of painting shifted from the realism of his prewar period to a more open abstract fluidity."

Graham's knowledge of his father-in-law's postwar San Francisco history was acquired at Turtle Hill between 1965 and 1970, in the course talking Buddhist philosophy with Robert surrounded by T'ang horses and other exquisite Asian ceramics, and practicing archery on the grounds. "What he did was make me shoot & shoot until 'I' was no longer doing the shooting"—Suzuki's Zen archery praxis in a nutshell. They would read haiku together, Graham recalls warmly, or improvise haiku over the chess board between moves, another means of Robert's "teaching me Zen." Robert collected Japanese scrolls, among them at least one from the brush of Tobase Roshi, Robert's San Francisco Zen master both in sumi-e brushwork and sitting meditation, or zazen. Robert would unroll a scroll "a few inches at a time." Graham didn't distinguish, or more likely Robert didn't bother to distinguish, between 1947-48 when he sometimes lived in San Francisco with Bettina and afterward when he visited San Francisco while living in Nevada. But it was during the later, short stays in the city that Robert took instruction from Tobase Roshi, since Tobase didn't arrive in the United States until 1951, sent by the Japanese government to give spiritual solace to Japanese farmers who had lost their lands as a result of the World War II internments.

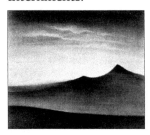

Silent Mountain, 1950

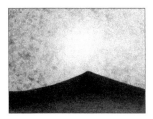

Winter Moon, 1948 (?)

Asian art's great influence on Robert, especially as his mountain landscapes progressed, didn't await Tobase. Setting aside that "realism" doesn't really describe Robert's prewar style(s), what Graham calls Robert's new "open abstract fluidity"—the Zen quality—arrived before 1951, as in *Silent Mountain* from 1950, and even *Winter Moon* from 1948, a surprisingly early precursor of later work, if the date is right. So Graham overestimates Tobase's influence on Robert, a man he honors as his own Roshi. As, in my way, do I, which explains my un-Zen competitiveness with Lanier Graham, who certainly outranks me in this field: at one time Graham taught and

sat on the Board of Trustees at the California Institute of Asian Studies, where Tobase taught and where popular Zen writer Alan Watts, Varda's co-owner of the houseboat after Ford and Paalen, was dean. But the fact remains that Graham didn't realize that Robert already knew Varda in 1940–41, or realize that Robert began meditating before the war, witness *Last Supper* with Christ in the lotus position, 1937; and there's Lawrence's "little leather pocket copy of Buddha" and "eight-fold way" in *City*. Robert didn't address this past with Graham, and by all indications never brought up Walter and *City*, as he rarely ever did. (During those same years Walter, according to one friend, Tom Massey, "would always talk about" Robert.)

Turtle Hill interior, 1973

Bob Clark, when he visited Turtle Hill in 1972 in connection with the festschrift for his father, didn't register the abundance of Asian art, in fact he asked that they move the conversation to Robert's barn studio because he found it unconducive to be surrounded in the main house by so many "colonial originals." That's more the way the interior appears in a photo Robert sent Joanne in 1973, to show her what the place was like, and more as I remember it.

No question Buddhism influenced Robert. At Turtle Hill he nurtured a potted fig tree in honor of Buddha's enlightenment under the bodhi tree; and he declared his most prized possession to be a gift from the Dalai Lama's brother, a silver-lined cup. I know about the fig tree from a letter to Joanne, and about the cup from one to Walton. But how did he meet the Dalai Lama's brother? and what merited the cup? These gaps instruct me to be humble about all I'll never know. I've lost the page of *Flaubert's Parrot* where Julian Barnes muses that the biographer's "meshed net" for catching a life may just as well be viewed as "a collection of holes tied together with string." Still, it jibes with my sense of Robert's eclecticism, what Rosemary said to Benson in 2000 about Robert's spiritual commitments: she insisted that while Robert "was

more or less Oriental in his philosophy and approach to life," in his "simplicity," he was "always searching" but professed no faith. "He was just Robert Caples"—a seeker whose spiritual comfort zone contained yin/yang and the big bang, angels and Groundhog Day and wind.

Godfrey's Desert Museum Shop

"Mr. & Mrs. Robert Caples have come to Virginia City to live the summer months," reported the *Virginia City News* in June, 1948. Their new business, Godfrey's Desert Museum Shop (the name adverted to the Caples cocker spaniel), would occupy the vacant premises of the old Sazerac, the famous Comstock saloon, kept "authentic." Already on preview were "quick sketches of Comstock scenes by Robert Caples, mounted on mats of tinted clay, from the earth of Virginia City and woods from the nearby desert." A partner (soon gone) would contribute Comstock antiques and furniture he crafted from mine materials. Both would also sell their paintings. Robert had his studio in a small house on D Street, formerly a mortuary and before that a prostitute's "crib."

Bettina, Robert & Godfrey Caples, with Peter Kraemer and his father Eric, *ca.* 1948

After passing the following winter in San Francisco, the couple came back to settle in Virginia. That July, on the boardwalk up C street from the shop, Robert established Godfrey's Dog Bar, the "lowest bar in the world." The *Virginia City News* reported the opening: "All the elite of the canine population of Virginia City received invitations, and arrived dressed for the occasion.... [H]orse meat, dog biscuits and bones were served."

In September, the Reno and Virginia papers covered the book-signing Walter held for *Track* at Robert's shop

Godfrey's Dog Bar, 1949

as part of "Authors' Day on the Comstock," when local literati including Lucius Beebe, Roger Butterfield and Duncan Emrich autographed their latest publications at different venues. All but Walter selected saloons. Robert the prankster got in on the action by autographing books with Mark Twain's signature.

The Clarks moved from the Lewers ranch at the crease of Washoe Valley and the mountains, where Walter wrote *Track*, up to Virginia City. They would live there for the next four years, Walter with extended periods away teaching. Next summer they bought a house on Stewart Street, becoming Robert and Bettina's near neighbors. After closing their shop and bouncing around, the Capleses were living in the old Wivell House perched atop a high foundation on a steep declivity, a stone's throw away on Taylor Street.

The old Wivell House, 126 Taylor St., Virginia City

"You people never learn," Walter had said of the marriage. I don't know how much the couples were socializing. In Virginia's papers I could find only one item among twenty on Robert and sixty-two on Walter to link them, the one about the Authors' Day book signing. Which is noteworthy, because the bread and butter of the papers was doings on the Comstock, with emphasis on the merchants, artists, functionaries and town characters who actually resided there, even more than on the prominent personalities who regularly passed through.

The men at least met up in the saloons, the custom in Virginia being to bar-hop along C street. A photo finds them in separate conversations in the crowded new Sazerac, Walter's favorite. (That's Robert Laxalt by the door.) And Walter patronized Robert's favorite, the less crowded Union Brewery. Gordon Lane placed them together there for me when I passed through in 1963, as I recorded in *Bea & Sherman*: "[Lane] said [Caples] and [Clark] had both been good drinkers, and reminisced about the night they had stayed up to watch an atom bomb flash from the test site but had ended the night too drunk to see it. [Clark] had

extemporized a poem, to the effect that it was just as well, but none of them could remember it later." Lane's story is an exception to the many testimonials to Walter's hollow leg, which barkeep Lane approvingly affirmed. (Walter was sober enough for a different atomic blast to write a magazine piece about it, "Nevada's Fateful Desert.") He drank slowly and standing, according to son-in-law Ross Salmon, and when he found himself leaning on a wall, he used to say, knew it was time to quit. Robert did not have a hollow leg, as he acknowledged: "I used to live in [Gordie's] many years ago.... The midnight hours extended themselves like geese across the sky, honking their brave message of 'one more for the road'. There were times when Taylor Street got away from me and I'd have to surge up the hill by less demanding approaches."

The Sazerac, Clark in the middle in glasses, Caples second from the right in back, Robert Laxalt by the door, late 1940s

The longevity of Walter's attachment to Virginia City can't be understood without invoking the impressionable days he spent there with Robert in 1937. For he became deeply ambivalent about the kind of place it turned into. He loved its colorful, complex history and the people he drank with who had roots in old Nevada. He also valued the company of intellectuals and artists drawn there by the same history, but whose presence can't honestly be dissociated from the tricking out of the town as a tourist destination. In 1958, he complained that Virginia had become "so overwhelmed by the ... *Territorial Enterprise* type tourists that there is very little of the old home feeling left in any of the bars."

The *Virginia City News* was the paper of record when in 1952 Lucius Beebe together with his life partner Charles Clegg successfully resurrected the *Territorial Enterprise*, the paper associated with Twain and De Quille. People familiar with the scene agree: Clark and Beebe

detested one another. The 6′ 3″, 220 pound Beebe, heir to an old New England banking fortune, was a provocative apologist for self-indulgent wealth, a self-proclaimed snob, brazenly contemptuous of the common man. He and Clegg famously traveled in a private railway car, *The Gold Coast*. "I'm as vain as a whore," he bragged. An extreme reactionary and ugly racist, he scorned civil rights, both the laws and the activists. This is the same man who, like some other Eastern upper crust types, gravitated to Virginia City for its tolerance of homosexuality. Already with sufficient legitimate excuses to detest Beebe, the upright and virtuous Walter Clark was also "very homophobic," that on the word of Robert Laxalt.

One thing Walter and Beebe did have in common: both drank and boasted of it—Beebe's *Enterprise* constantly celebrated heavy drinking. But to give Beebe his due, he and Walter had something else in common: both were driven writers. While he could certainly turn a phrase, Beebe's success as a writer stemmed less from creativity or artistry than force of personality and self-promotion. He had no qualms about falsifying facts for effect. Walter, while wrong often enough in important ways, respected truth, art and honor. He did write occasionally for the *Enterprise*, but drew the line at joining the board as Beebe sought, no doubt coveting Walter's name for the masthead.

Walter was of the faction of Virginia City's Restoration Campaign working to contain the town's devolvement into a self-conscious tourist spectacle under Beebe's influence. For Beebe's part, when Walter as a matter of conscience spoke out and resigned from his faculty position at the university, Beebe slyly roughed him up in the *Enterprise*. The Richardson affair, which in 1953 convulsed the campus and grew into a national *cause célèbre*, concerned the firing of a professor for publicly criticizing the university's education policies. Walter had turned down a top position at the Iowa Writers' Workshop for the sake of an entry level lectureship in Reno teaching American Lit and two sections of freshman comp. He believed he needed to be home in Nevada to write. But then his "moral fierceness" and "yearning for moral simplicity," as Bob Clark has described him, impelled him to sacrifice the position he'd expected would moor him permanently to his hometown. After letting

Walter explain his reason for resigning, the *Enterprise* quoted a "Virginia City saloonkeeper"—that would be Beebe—to the effect that employers can fire any nonunion employee they please. Years later, Walter's friend Les Gray claimed in his column in what was by then Beebe's former paper that Beebe "character assassinated Walter Clark and triggered him to leave the Comstock and the University of Nevada."

By 1957, Beebe and Clegg were still insinuating themselves into the Comstock legend by glorifying their revival of the *Enterprise*, even as they found insufferable the "cataracts of tourist trash" they did their best to attract. The *Enterprise* now ran front-page "Tourist of the Week" cartoons, ridiculing town visitors for their ignorance, bad bodies and poor taste. Beebe began spending most of the year in the Bay Area, resettled there with Clegg permanently in 1960, then sold the *Enterprise* in 1961. Walter was also living in the Bay Area then, teaching at San Francisco State. In 1968, Beebe's absence must have been a relief when the Clarks moved into their last house in Virginia City, bought as a fixer-upper in 1964. Beebe had died in February, 1966 from diseases of overindulgence, and no doubt proud of it.

Caples behind bar far left, Lucius Beebe far right, and Roger Butterfield between them at A. J. Liebling's wedding, 1949

Robert knew Beebe in Virginia City, also at the Flying ME divorce ranch, Robert's "hangout" (Bob Clark) where he met Rosemary. The couple socialized with Beebe, Rosemary Junior remembers. What did Robert think of Beebe? Dick Walton thought him a "son of a bitch," but Robert wasn't as judgmental as Walton, or Walter, or Beebe, or I. My guess is that Robert took Beebe's foibles with a good-natured grain of salt. Robert's shop, after all, purveyed Comstock antiques to tourists, not to mention those craftsy, local color "quick sketches" which, were one unearthed, might prove worthy of his talent, but I doubt it. Of his own commercialism Godfrey's Dog Bar was the send-up, in the same vein of ironic tolerance shown in Robert's Reno maps dating to his last bout of commerce nearly two decades earlier. He would have been no less tolerant of Beebe.

Godfrey's wasn't Robert's only expedient for making a living then. Also Robert drew and copyrighted an historical map of Virginia City as a postcard. Beebe either purchased the copyright or paid a fee to Robert, for the map minus Robert's initials and copyright found its way to the front page of the "Visitor's Guide" Beebe published periodically as an Enterprise supplement. Also Gordon Lane used a Caples sketch of the Union Brewery interior (featuring Bettina, Godfrey and of course

Union Brewery matchbook, 1953

Gordie) for the cover of his matchbooks, "and already they're a collector's item," said the *Journal* in Reno. Also Robert accepted a commission to design special cachets, the lot of them carried on a ceremonial Pony Express run for sale to collectors on Nevada Day. Robert didn't get rich or even flush from such endeavors, as borne out by the fact that owners

of a Reno boutique put him on a decent monthly retainer and began selling his works at prices higher than his own, when they learned he was trading them to storekeepers for necessities at ridiculous prices.

I want to say that when Robert was painting for himself he assiduously avoided commercialism, as if to earn a living wage from the unperfected labors of the soul were to assure ultimate failure. But that wasn't altogether true during this window of time. It could have been the Virginia City influence. Peter Erskine tells this story about a painting titled *Virginia City*. One day Robert met his friend Graham Erskine, Peter's father, going into a Reno Gallery where the cubistic work was hanging. Robert, who had his kit with him, explained that he meant to paint out the numbers because nobody would buy it as it was. "You can't do that!" Erskine insisted, "That's what Virginia City was all about, the numbers"—that is, the weights, the depths, the dollars. Erskine bought the painting as-is. And didn't Robert tell Bob Clark that when he needed money he would paint "another St. Mary's steeple"? Zoray Andrus, the presiding spirit of the Virginia City art scene during that era, used to say facetiously of Robert's landscapes, her son Peter Kraemer told me, that "he painted them on a long, long board and sawed them off."

Virginia City with numbers, 1951

Nevertheless I resist believing that Robert churned or doctored mountains. In Robert's mind his mountains were where his "subconscious" best met "the spaciousness of the open world" on a flat surface. I'm almost sure of that. Talking with Bill Bliss, who owns two fine Caples mountain pictures, went far to confirm me in that opinion. Bill is a descendant of Duane Bliss, who was involved with Sharon in banking and the Virginia & Truckee Railroad, and partnered with Yerington and Mills in Sierra Nevada timber and fluming for the Comstock mines. Eventually Duane and his descendants built the community of Glenbrook and other Lake Tahoe developments. I told Bill at the get-go

that I'd always oriented to the desert and Pyramid Lake rather than the Sierras and Tahoe. Against all expectations this scion of the first family of Lake Tahoe, and a fair painter himself, avowed his preference for the desert, too. What's more, Bill said that Caples had taught him to see the desert mountains, and taught the state to see them.

The golden age of Robert's mountains runs through Virginia City, then Carson Hot Springs, then Dayton. During that span the Virginia City papers covered him as an artist nine times, the Reno papers three times as often, even though he didn't live there, unless briefly. (He kept up a listing at Byron's address, perhaps for commercial purposes, perhaps from attachment.) Thus he continued to be an art notable if no longer a social notable—he had changed, his status had changed, Reno and its papers had changed. Most of these items reported group shows with fellow locals. Venues included galleries, studios, clubs, hotels, municipal buildings and street fairs. Only a single item reported an out-of-state exhibit, a Western regional show in Colorado. One-man shows took place in art galleries but also at a lecture, twice in the Reno Little Theater foyer, and once in a record shop, his last show before Connecticut. In other stories: works were installed at the Nevada Historical Society; a Caples was grand prize at a benefit for St. Mary's Hospital; he judged or juried exhibits; he created a float for Nevada Day, sets for the Miss Nevada pageant, and those Pony Express cachets; he moderated a panel on art; and he addressed the Nevada Chapter of the American Institute of Architects upon induction as an honorary member, something very meaningful to Robert.

The picture that emerges is of a well-reputed local artist with less reach than he had attained during the 1930s.

Carson Hot Springs & The Flying ME

Bettina spent a month with her father in New York. He'd moved there from Seattle, and was dying of stomach cancer. After a week back she surprised Robert by leaving for Reno to sue for divorce. John took it from his brother's letter that Robert was "shocked but not knocked out." At the proceedings in 1951 she testified that Robert called her a burden, a pest, and stupid. She was expected to support herself, but hadn't worked in the last year "because there is nothing to do in Virginia City and he won't go anywhere else." That was court room talk. She would move to the Southeast briefly, but return to Virginia City for at least another year and a half.

During the 1960s she married and divorced a Leonard Swanson, whose surname she kept. By the early 1970s she was a saleswoman in the art department at Gump's in San Francisco. She and Robert kept in contact, out of something like compassion on his part, I suppose, but sentiment, too. In 1971, he sent her *Tonopah Houses*, with a note affixed to the back, as he sometimes did to personalize his pictures or to give them context. In 1977, she mailed him a magazine. And then a few months before his death, when she was back living in Nevada, he received a collection of mementos which he saved in an envelope labeled "Stuff sent by Bettina 8/79": a photo of an etching and a couple of off-the-wall notes of his, and an old note of hers, "You have been utterly missed!" etc., with two wine glasses "= 5:00 p.m." Jim McCormick used to see her at all the openings at the Stremmel Gallery. "She

Tonopah Houses, 1960

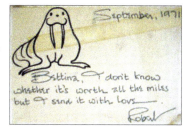

Note from Caples to Bettina, 1971, on the back of *Tonopah Houses*

continued to kind of stay on his coattails," Jim said. "It was almost pathetic." "Everyone knew her," Peter Stremmel told me, as much as to say she was pitied. Finally she was institutionalized and died, in 1995. She had a difficult life.

Robert's next stop after Virginia City was a cabin or caretaker's shack at Carson Hot Springs outside Carson City, a sojourn of about two years: Robert was still a "Virginia City artist" in the *Enterprise* in early 1953, while in mid-1955 when he met Rosemary he was already living in Carson City proper above a grocery. And he didn't live continuously at the Springs for those two years: the families of his architect friends Ray Hellmann and David Vhay, respectively, remember him living then in Washoe Valley and in Reno's western outskirts, in a house by a bridge over the Truckee River on Mayberry Drive. Vhay's son David L. describes the house as small and rough like all Robert's homes then, but it had a big deck overlooking the river, where ten-year-old David hunted crawdads. Although he didn't have all that much interaction with Robert, he "worshiped him."

Walter's nephew Gordon Chism described Robert's Carson Hot Springs cabin as "a white one-room clapboard affair, about 16 by 20 feet. His cot was in one corner and a small table with two chairs stood against the far wall. The rest of the room was his painting studio." Walter's draft of the retrospective essay depicts Robert's time there as "the healthiest life he had ever lived. He ate regularly if sparely. He slept. He absorbed sun. He swam in the hot mineral pool…. He worked prodigiously and destroyed most of what he did quite cheerfully because it was still part of his hunting." I had imagined the springs as a desert retreat, until Walter's son-in-law gave me a tour of Walter's and Robert's homes and haunts. Ross Salmon characterized the springs in Robert's day as "a hot spot." (Its successor is called Club Envy.) Carson Hot Springs was one of the places Emmy Wood, proprietor of the Flying ME, the upscale divorce ranch ten miles north, would take her guests for a night out for a change from Virginia City's C Street. Also, Emmy had "a short list of acceptable single men whom she would invite to dinner periodically. To be on the list," writes Bill McGee, a former dude wrangler at the Flying ME, "a man had to have manners, behave like a gentleman and be a

good conversationalist." Robert was high on Emmy's list. She would send a wrangler to the springs to fetch him.

A friend of Robert's from those days, law professor and diplomat Homer Angelo, remembers a lot of alcohol involved in their doings at the springs. Still, the reminiscences Homer passed along to his son Alex mostly had to do with Robert at his easel outdoors, and Robert talking art and philosophy. Certainly it can't have been all loose living at the springs, for Barbara Clark used to take Virginia City children to a Red Cross swimming class there. However, Walter's picture of Robert as a health-conscious anchorite, living "alone," is one more example of Walter's idealization, even sanitization of Robert's layered life.

The Flying ME is where Robert met Rosemary. Nevada commentator Basil Woon exaggerated only a little by styling it "a bit of the Ritz dropped down in Nevada"—it was still a ranch, albeit a dude ranch. Emmy Wood, an Eastern socialite herself, didn't advertise. Guests passed the word, and references were required. No children were allowed without Emmy's special dispensation. Guests included the Astors and Roosevelts, as well as Hollywood aristocrats like Gable and Gardner. Celebrities even came just for getaways, sure of privacy. For her wranglers Emmy had a "non-fraternization rule," which Bill McGee boasts having had little difficulty evading. For her "acceptable single men" there can have been no rule, and Robert presumably took advantage of the opportunity to plough this ground—to repeat Bill Bliss's trenchant phrase (Bill wrote the foreword to McGee's occasionally lascivious memoir).

Besides Rosemary, I know for a fact of just one other Flying ME affair of Robert's. Nancy Jackson, née Johnson, arrived in 1953 by way of Scarsdale and Vassar for a six-week divorce, then like many before and after found herself enamored of Nevada. After she stayed on working for Emmy, she and Robert became lovers. Craig Jackson, Nancy's son, who inherited her Caples collection, takes some pride, I sensed, in their affair. Robert corresponded with Nancy until the end of his life. His last letter to her contains, of all things, a long ironic riff on "Divorce!"

> I really wonder about this wild tendency toward divorce. It seems to me people are making a travesty of the institution of marriage, wouldn't you say

so? I mean what is a declaration of one's firm determination worth in today's world? It's a sorry picture.

To illustrate, the five-times-married Robert then dissected the marriage and divorce of Lanier Graham and Rosemary Junior.

Apart from the Flying ME, other tracks of Robert's through romance are still visible for the years between wives Bettina and Rosemary. While still in Virginia City, Robert lived with a glamorous divorce resident whom Babs believes was the daughter of Douglas Fairbanks, Jr. Two detectives arrived from the East to extract the woman—divorce was one thing, but she wasn't going to shack up with some starving artist.

Babs was also my informant about an affair of Robert's with a woman named Jane while Babs and she worked at the Desert Research Institute in Reno. Walter's daughter didn't conceal her disapproval of Robert's promiscuity. When she learned from me that Robert's mother Edith had been remote and unaffectionate, Babs speculated that "he was looking for a mother." It seemed to me we were trading psychological clichés, but that night I dreamed that Robert was riding in a car with Eleanor Roosevelt. The first lady once vacationed at the Flying ME. And I had just seen a photo of Robert's lover Nancy Johnson (later Jackson) in the Flying ME car. My subconscious put those facts together to endorse Babs's speculation. (Of course, it was my dream, so it could be me who's looking for a mother.)

David L. Vhay offered that he's not sure his mother Mel Vhay and Robert didn't have a fling. His hint of a smile told me that, like Craig Jackson, he felt no blame attached to his mother for coming under the sway of the legendary artist. Am I again projecting, or is this a man thing? Babs wouldn't buy it, I'm sure. Monique Laxalt doesn't, with whom I've discussed these characters now and then. As much as she admires the Robert Caples she's come to know through me, there's no mistaking her disapproval of his philandering.

Another Nancy, artist Nancy Bowers, née Bordewich, was the "fragile" woman whose emotional injuries Zoray Andrus held against Robert. Several people familiar with the art world of those years raised this particular connection. Robert kept up some contact with Nancy from the East as with some other formers.

Above all with poet and collagist Joanne de Longchamps. In the 1960s she would study prose writing with Walter. With Robert in the 1950s she studied painting, discussed everything, and was unfaithful to her husband Galen. Their attachment, which continued and flourished at a distance, is attested by the ample Caples half of their correspondence preserved in her Special Collections archive. Robert's letters included Galen. "Dear Galen, Dear Joanne" is how, for example, Robert headed his long obsessive letter about Ursa Major.

Other than when he bragged on those long-ago adventures during his twenties to Dick Walton, I find no instance where Robert boasted of his prowess or in any way showed that he saw himself as a womanizer. His self-image and the world's image of him may not have matched. Such a possibility occurred to me when I came across Robert's dim view of Norman Mailer in a 1974 letter to Joanne: "I scrupulously avoided that codpiece, Norman Mailer. In his case, I suppose the more appropriate spelling might be 'screwpulously' (with the promise of 'louse' lurking in there as well). Needless to say, he troubles me." Troubled Robert why? Perhaps he faulted Mailer as a pursuer, while perceiving himself as pursued.

So then came Robert's liaison with Rosemary, his last wife and most likely his last lover. Rosemary Riley Lake, a former Martha Graham dancer, came to the Flying ME in 1955 to divorce. In a 2000 phone interview, Rosemary told Benson how she and Robert met. Benson's transcript of this interview is one of half a dozen or so interview transcripts in his archive at Special Collections from which I gleaned information that didn't make it into *The Ox-Bow Man*. Rosemary:

> I thought at the time I was going to be a painter and was through being a dancer and all that. I was introduced by Emmy Wood who was the owner of the Flying ME Ranch out there and Emmy just adored Robert. Whenever she had guests or so forth she would always invite Robert. And she took a liking to me and because I wanted to sketch and so forth and [she] thought I loved the desert, so she had Robert come over for dinner one evening and I didn't want to meet anyone especially, but I was being polite so Robert set up a time the following day or whenever to take me sketching.

The husband Rosemary divorced was David Lake, son of Clair Lake, one of IBM's founding engineers, inducted into the National Inventors Hall of Fame. Clair Lake died in 1958, after Rosemary's divorce, yet David Lake had already been made "very, very wealthy," I was told by someone who would know, "because ½ made Rosemary very wealthy." But if Robert married her for money, as some may think, he got a love match in the bargain.

The Last Cigarette

Robert and Rosemary married in October, 1955 in Austin, scene of *The Promised Land*, Lawrence Black's best yet painting, at once spacious and claustrophobic, unlike anything Robert would ever paint. Four days later the *Enterprise* had them "now residing in Dayton (pop. 321) in a wonderful old house they are currently in the process of renovating. 'Dayton is the coming Nevada town,' they both declare. 'You watch and see if we're not right.'" They were wrong, if they were serious, but probably they weren't.

Rosemary Junior and Denny, who boarded at schools back East, started coming out for several weeks each summer. She had "a special room," he a tent out back. They hiked the nearby hills with the children of Paiute neighbors, and watched Basque sheepherders come through town with their flocks (one could have been Dominique Laxalt, founder of Nevada's Laxalt clan). The contrast is night and day between the grim retrospects of third wife Barbara's children and those of Rosemary's. Denny cherishes the "great trips" to Death Valley and around California with Robert as guide, always full of fun and stories, ever helpful. Rosemary Junior singles out a working vacation at the Drackerts' ranch on Pyramid Lake. When the children went riding, Robert "put lettuce in our hats to keep us cool," while he "would simply be out there from morning to evening" painting. She reminisces about long conversations with Robert, under whose influence she took a degree in art history at the Sorbonne and became a photographer.

Rosemary's kids got to know the Clarks, their kids, and even Miriam's son Gordie Chism, times he came to borrow Robert's convertible or Rosemary's Mercedes roadster to race in. Bob Clark stressed the impression of affluence the roadster made on him, with a look that said, Robert's rich wives! Denny found Walter, who taught him to play tennis, "very friendly ... You had to like him right off the bat." Among Denny's memories was also a visit to a woman who lived in "a great big old house" at "232 Court Street." The address stuck in Denny's memory—Court Street had charmed him. This woman was introduced as Dorothy Bartlett, a friend of Robert's father Byron. Byron had died

Dorothy Bartlett (left), Caples, Helen Marye Thomas, 1950s

of heart failure following prostate surgery less than two weeks before Robert and Rosemary married. Robert had been present for Byron's last days, made the arrangements, and kept John informed. He said "that father lost the will to live. No work. No money. Hazel."

Babs remembers many family visits to Lizard Hall. Rosemary Senior, though, told Benson that visits with Walter and Barbara "were very few.... I got to know Walter a little, shall we say." For the academic year Walter was out of state, but there were letters. 1956 was the year Robert first began saving Walter's letters. Four arrived that year, largely to propose a visit to Dayton and Pyramid Lake that never came off, as happened more often than not. In Walter's evocation of Pyramid there is a tone of appeal: "Pyramid glimmers afar—yet a-farther, I fear.... Meanwhile—we will shortly speak—a little—in Dayton, whatever else. Our love to Rosemary. Concentrate upon that image for two until I can see—the sun and then the stars in the smooth water." The appeal would become more pronounced when Robert lived East and as the chances for such a sentimental journey grew ever more remote.

In 1957, Robert and Rosemary sidetripped from Varda's houseboat to visit the Clarks in Mill Valley. Then Walter spent two months of his summer off from San Francisco State in Virginia City, mostly for the sake of time with Robert. From there he wrote Barbara that he'd dined and picnicked with Robert and Rosemary, and was lunching in Dayton after working out with Denny in Carson twice a week. Walter and Robert planned "an overnight behind the Pyramid," but I suspect it didn't happen. Then when Rosemary accompanied her children back East, Walter came down and stayed with Robert in Lizard Hall. Walter was intending to work, to write. But one day, Robert would later remember for Bob Clark, "apropo[s] of nothing" Walter proclaimed, "'Caples, I

couldn't write another *Ox-Bow Incident* if I tried.'" He brooded, drew "a curtain of sound" around himself listening to records, would spend the dinner hour and evening back up at the Sazerac without Robert, then "left rather abruptly without explanation" after eleven days. Knowing Robert was back in his studio producing day after day may have been too much for the blocked writer. It was a wasted opportunity for the friendship. There were no letters during Robert's last year in Nevada—nor the next.

The sketching lessons Robert gave Rosemary at the Flying ME failed in effect. Not yet "through being a dancer," she joined the pro-am Reno Ballet Arts Academy and Theater. Walter Brown, Walter Clark's plainspoken friend, told Benson about Robert's "madcap ballerina wife, who ... got drunk and was dancing on the table, and fell off and broke her leg." "Madcap" Rosemary's playfulness appealed to Robert hugely. For one thing, she had a whimsical way of making up words, which Robert delightedly collected: "propacity," and "profundant," and "sloo-age." Or she would redefine a word: "Polyunsaturated" meant "Someone who has been married several times." But I believe it was her physical playfulness, her capacity to clown with her body, that won the physically reserved Robert's adoration—an adoration still sweetly transparent years later in a 1975 photo taken on Ray Hellmann's sailboat at Lake Tahoe, where Rosemary pretends a wire and foil champagne sealer is a Bozo nose.

Caples' fifth wife Rosemary dancing

Robert and Rosemary Caples on Ray Hellmann's boat on Lake Tahoe, 1975

Drinking was part of the life. Ray Hellmann's son Boone isn't the first to invoke the TV series "Mad Men" to describe the kind of drinking that went on. The same with smoking. Robert smoked upwards of three packs a day, unfiltered Pall Malls—my brand until I quit at forty-two—before he switched to Kents. Denny remembers him at the easel with one cigarette in his mouth and two more he pulled from, one on either side held by alligator clips! David Chism repeated Robert's darkly humorous story of how he quit. Robert's doctor summoned him to his office, invited him to smoke, then asked if he'd enjoyed his "last cigarette." He would die if he didn't quit.

That happened in 1956, the year Robert started saving letters—the brush with mortality on the heels of his father's death may be what brought on the new mindset. Years later, Robert told the story with more details to Ken Robbins as encouragement when Ken was struggling to quit:

> For myself, I stopped smoking only because the doctor (Dr. Cann) made it clear to me that I had but one choice: either lose two-thirds of my stomach in ten days or give up smoking. I asked him, "Could I think that one over?" He suggested, flipping through his desk calendar, that I make my decision right then and there. He reached for the phone. That was nineteen years ago, for heaven's sake. Well, I haven't smoked since that fateful afternoon. But I died. I died, and rose again, on the hour. I did everything but leave my room through the window.... The first four days were the worst—after that, it was only terrible. But, for all of that, I'm awfully glad that I stopped. I still dream about smoking.

If Robert's agonies sound exaggerated, it's because he left out the fact that Dr. Cann (George A. Cann, married at one time to Dorothy Bartlett) made him quit tobacco and alcohol simultaneously. The omission may have been because Robert did later drink again, if moderately. I don't know how much Rosemary Junior saw firsthand, but she gave the tandem withdrawals as the reason that Robert "suffered enormously." He remained "in bed for a few months."

Robert and Rosemary left Nevada at the end of 1958. Rosemary had never expected to reside in Nevada beyond her six weeks for divorce. Robert changed that for a while, but she wanted to be near her children

and wouldn't take them out of their Eastern schools. Also, she had lived in a colonial house with David Lake, and desired another. She on her own found and bought Turtle Hill in 1957, the trip that enabled Walter's unsatisfactory eleven days alone with Robert at Lizard Hall.

David Chism ties Robert's part in the decision directly to his health. Robert had received a diagnosis of "subacute bacterial endocarditis," and was told he had five years to live. Robert calculated that he wouldn't be able to survive in Nevada, so seized the opportunity, thinks David, to be taken care of until he died. That Robert lived another twenty years David attributes to advances in medicine.

What Robert told Walter, Babs told me, was, "I can't get another divorce."

Rosemary Junior holds that it was a decision made out of love: Robert "would have gone anywhere that [Rosemary] had chosen.... They were so in love."

As I conceive of Robert, it also mattered that Byron was no longer alive in Reno to anchor Robert in Nevada.

And I can see one more reason. During the years preceding and into his fifth marriage, Robert's art peaked. The prospect of leaving Nevada may have coincided with a creative winding down.

Nearly on the eve of departure Robert had one more Nevada exhibition, advertised on Thanksgiving Day, 1958, on page 2 of the *Journal*. Robert's droll copy pegged the notion of the bitter end to out-of-state travel, while mocking himself for lack of worldly success.

> TOM DOOLEY TO VISIT RENO BEFORE HANGING. Special dispensation will allow killer to fly into Reno from out-of-state. Last request is to see painting by the famous ROBERT CAPLES. Now on display at Mike Mirabelli's Record Shop, Village Shopping Center. Adv.

"Tom Dooley," the Kingston Trio's first release, the song credited with the folk revival's breakout into the major media, was number one on the charts in 1958.

In Search of the Mountain

Soon after leaving the Navy Robert made an etching he titled *Passage*, a work conforming to his New York stepdaughter Mallory's characterization of him and his style of art then as "narrow, elegant and tight." The poor reproduction on this page is taken from the 1964 retrospective catalog, where all the reproductions are poor.

Four or five years later, in Virginia City, Robert put the word 'passage' in the title of another work, a painting. *Passage* and *Silent Passage*—a coincidence? Comparing the two, it seems to me that *Silent Passage* turns *Passage* inside out.

Both these works may be psychological self-portraits—that's my notion, probably not Robert's conscious intention. My background of two decades and two books in the field of dream psychology inclines me to interpret them that way. In *Passage*, Robert's difficult frame of mind at the time is figured forth in the rigid, uncomfortably symmetrical composition. Dreamlike dungeon walls separate the viewer, the ego, the painter from his full personhood, represented by the rectangle of light emanating from a distant, uncertain source.

Passage, 1946

Silent Passage signifies Robert's psychological and therefore artistic breakthrough. Now the ego no longer needs self-centeredness for balance, it emerges from darkness floating securely off-center on supportive waters of the unconscious. The confining rectangles have expanded to become the geometry of the open world, and an indirect glimmer has become the world's light, the sun's and moon's, while the man wonders at the world.

Silent Passage, 1951

Walter, who had an eye for transitional works of Robert's, owned *Silent Passage*, and in his very last letter to Robert recurred to "the little man in the boat"—that's what the Clarks called the painting, says Babs. It was only after drafting this paragraph that by pure chance I learned the sexual slang meaning of the expression, which would have tickled Robert.

The year of *Silent Passage* was also the year of *Silent Mountain* (reproduced in an earlier chapter), a peak and ridge silhouetted against a dawn sky, a work as tuned to fundamentals as Japanese brushwork or Chinese landscape. I want to believe that through *Silent Passage* Robert found *Silent Mountain*—that what he broke through to in 1950 was psychological freedom to explore how best to make pictures of mountains.

Silent Passage—Silent Mountain. Robert wrote to Joanne, in 1972, about "silence ... arrowed by light," and in 1977, "I envy you having been to Pyramid. There is a dream of blue silence that remains forever undisturbed for me." Silence is the spirit of the desert, whether horrible and threatening as desert silence mostly seemed to those transiting overland west, or grand and sublime as it increasingly seemed to those who came to work and settle. Walter's last publication while alive was his introduction to *Lady in Boomtown*, a memoir of the Tonopah mining boom in which Mrs. Hugh Brown spoke of both aspects in a transforming experience when, after a hard ride, she reached the top of a range. "Ranges of mountains, towering one over another, marched away into the distance.... The vastness, the eternal quiet, the beingness! ... I had a revelation of the significance of life.... The encircling desert would never again close in upon me and trap my spirit in despair." Mrs. Brown experienced "the eternal quiet" as an amplifier of visual space and distance, naturally enough. For Robert, the aural phenomenon possessed a paradoxical priority which shaped his painterly act, a facet of him salvaged from forgetting by my novella *Bea & Sherman*:

> "When I conceive a painting," I later recalled him saying, "I don't see a space filled in a certain way. Most painters do, they say, but I don't. I hear a sound. I suppose I must call it a sound. The sound of silence. Perhaps it's because of the way mountains fill space, silently. At any rate, I carry the sound in my head for a while, feeling out the particular way it sighs or whistles or rustles–"

"Silently."

"Yes, silently."

Months after that conversation, when Robert sent me *Dark Range* as a wedding present, I responded, "The painting came today—humming with silence." I must say that when I read that today, I identify with Walter, who often reached for intimacy by responding to an engaging thought of Robert's.

If you take into account all Robert must have destroyed and those dispersed who knows where, he must have produced hundreds of mountain pictures from 1950 through 1958. His painterly explorations yielded an array of styles. To begin this survey, he produced many works in the style of Silent Mountain, three of which still exist on pages of the 1964 catalog, and half a dozen in the Caples archive, as photos taken in 1953. I'll bet some of the originals hang on walls within an easy drive from where I sit. I've seen one, a striking moonscape owned by Bill Bliss.

Rockcandy Mountain (Upainishad) is Robert's aggressive exaggeration of vertical features where tilting blocks of crust forming Great Basin ranges expose their broken, uplifted faces, and lower features, largely submerged in alluvium, Robert gave tips like meringue. Robert continued to make variants of *Rockcandy Mountain* until

Untitled (like *Silent Mountain*), ca. 1951–53

Untitled (moonscape), ca. 1951–53

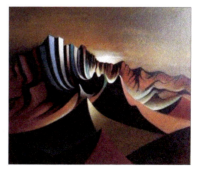

Rockcandy Mountain (Upainishad), 1951

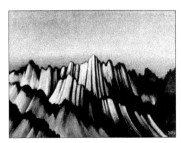

Untitled (like *Rockcandy Mountain (Upainishad)*), mid 1950s

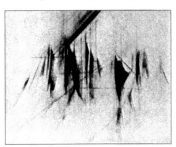

In Search of the Mountain, 1951

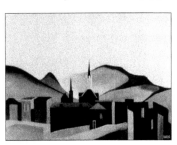

From the Painter's Window, 1952

Untitled (scalloped mountains), date unknown

he left Nevada. Its title, considered ludicrous by Robert, was bestowed by Hans Luginbuehl of Luginbuehl Gifts in the Riverside Hotel: "[S]ome of those titles ... my Lord. Hans Luginbuehl had to have titles for his books [ledgers], I guess. I seldom gave much thought to titles."

Another style is exemplified by a 9" × 11" pencil sketch. In 1978, when a third, non-Indian portfolio was under consideration, Robert selected eleven candidates for the University of Nevada Press, among them this work, saved for last. He notated the choice in his understated way: "*In Search of the Mountain*. 1951. Pencil sketch only (but closer than most to what I hoped to encounter)." Given how he singled it out, its title takes on added meaning. Don and Pat Soli of Reno bought the drawing from Margaret Bartlett in 1968. Robert had told Dr. Soli it was the inspiration for many of his mountain scenes. Robert must have said something comparable to Margaret Bartlett as well, for when she sold it to the Solis, it came with this note: "To Pat & Don Soli / You have the jewel." I think of it as a sonogram of silent substance.

Also selected by Robert for that third, unrealized portfolio was *From the Painter's Window*, another Virginia City with St. Mary's steeple. What stands out in the composition is the dark edging of the mountain topography. Robert's scallops, I'll call them, stylize shadows and the

contrast effect of a ridge against a lighter background of sky and slope. For several years Robert pursued this style in a series of mountain images, most of them preserved by black-and-white snapshots. Some include clouds, a subject he occasionally focused on, to produce effects for any cloud lover to appreciate. The mountains themselves in his cloud pictures vary in style. Possibly the finest of them renders the mountains almost realistically as if seen from a higher peak, yet because of how the clouds drape and partially conceal them, the image overall conveys the very essence of the space the mountains occupy, of the space between them and the viewer, and of the viewer's own space. And so it is a picture of the space unifying all.

Untitled (mountains and clouds), sold in 1953

Untitled (mountains and clouds), 1950s

Untitled (First National Bank of Ely mural) (panorama), 1956

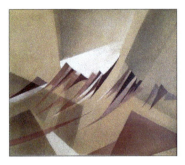

Stone and Sky, mid 1950s

That painting probably dates from the mid-1950s, based on some similarity to a painting in the First National Bank of Ely, Robert's gift to the bank when he installed a mural there.

This mural, pride of bank president John Gianoli, exemplifies Robert's abstract style of mountains. Gianoli's father was president when the bank commissioned the mural for its new building in 1956. Robert used part of the Ray Hellmanns' unfinished home as his studio to prepare the 364 foot-square acoustic tiles that would be assembled into the fifty-two-foot mural. This style owes something to conventions of abstraction during those years in both fine art (Lyonel Feininger, for example) and industrial design (think linoleum). In several paintings, such as *Stone and Sky*, Robert stretched the style to explore features of the seminal pencil sketch, *In Search of the Mountain*.

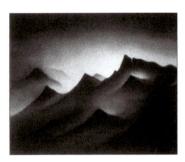

Untitled (luminous mountains), mid 1950s

There is a work, known to me only from a snapshot in Robert's archive, where the luminosity seems to reach us not reflected off the rock of the mountains, but as if inherent in and emanating from the rock itself. This phenomenon, or way of perceiving, became increasingly important in Robert's worldview. It remained a cosmic truth for him even after—perhaps especially after—he had ceased to paint in Connecticut.

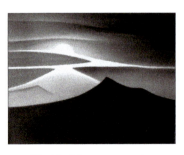

Untitled (moonscape in earthtones), mid 1950s

There is a powerful moonscape owned by Bill Bliss reminiscent of the one Robert gave Helen Mossman at the Union Brewery. Another moonscape is one of several drawings which Walter salvaged among work notes of Robert's, now in Walter's

archive. Yet another treatment of the moon is the elegant mixed media drawing, *Death Valley Moonrise*, a detail of which was used for the cover of the 1981–82 catalog. It is one of a number of works which, although they differ greatly one from another, could be grouped as having the properties of calligraphy. The work more or less of this type which most moves me is in the fine Caples collection of David L. Vhay. Tink Vhay and his wife Muffy call it brown mountain. The current flowing between mountain and viewer, and behind and above the mountain, and seemingly through it, is suggestive not just of ordinary wind but of solar wind, or of "the wind that blows between the stars," as Robert would later write in *The Potter and His Children*.

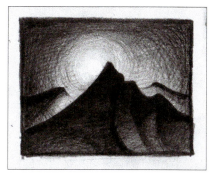

Workshop study (mountains and moon), 1956

Death Valley Moonrise, mid 1950s

Untitled (brown mountain), mid 1950s

Finally, ten mountain sketches, never presented to the public, are preserved among Robert's procedural papers in his archive. If you look at these upside down, their tremendous dynamism leaps out.

Mountain sketch, date unknown

Mountain sketch, date unknown

A Globe of Heavy Light

The Nevada Museum of Art was still the Sierra Nevada Museum of Art on Court Street when acting director Marcia Cohn Growdon prepared the catalog for the 1981–82 Caples exhibition. She wrote that "his landscape paintings are a distillation of the essence of the rugged Great Basin landscape.... He discovered that he was not interested in any particular landscape ... but in a landscape that was an essence of landscape." William Fox, a guiding presence of today's museum at the cutting edge of environmental art, calls himself a Caples admirer—not for being cutting edge, but for well exemplifying an old-school Romantic way of representing nature as if not impinged upon by human activity. I hope Bill Fox agrees that even in the Anthropocene there's still a place for art about a universe so imperturbably large and whole as to shrink blankets of cheat grass and the giant scars of copper mines to insignificance. He seems to do so by quoting a later article of Growdon's, where she again interpreted Caples' mountains in terms of essences: "The substance of the mountains and the volume of the air are sucked out in favor of the essence of mountains and glowing atmospheric effects." Growdon repeated that Caples landscapes portray "no place in particular."

the essence of mountains—their substance disembodied—no mountains in particular. These notions seem all to imply or to rephrase one another—but do they? Certainly Robert strove to approximate the essence, the idea of mountains. He was an instinctive Platonist, and actually did study Plato, attracted to the irreducible mysticism of this forebear of Western rationalism. Robert was all Platonic to write that "anything pursued to centrality will become interchangeable with anything else—it makes no difference what the object may be." I don't find, though, that when he succeeded in rendering their essences, his mountains seem any less substantial or less particular for that. It's like saying, as Walter did, that Robert's Indian drawings aren't portraits because he sought the essential Indian. But the Indian drawings were for a fact portraits, and the better the portrait, the more successfully it conveys the essential. I once made a comparable mistake when, during an interview for a previous book, I told Chicago blues poet Sterling

D. Plumpp I assumed that blues lyrics were imagined paradigms of the human condition, not stories from life. Plumpp brought me up short: a blues writer may modify for effect as any artist may, but his material narrates particular experience. That's how it achieves universality. I don't say Robert never imagined a mountain or never extrapolated from several, only that his material was directly, intentionally experiential. In one of his off-the-wall notes he epitomized the method he pursued as "*Subjective naturalism*": "An art with no conflict between image and perception. Perceiving the outer world not in opposition to the self, but regarding the self as part of it. An art of complete empathy and, at the same time, of abstraction. '*Subjective naturalism*.'" The clincher for me is that Robert's mountains really are at once substantial and abstract—*empathy* and *abstraction*. Not particularity, but egocentricity, Robert judged, is what engenders "images as earthbound as potatoes." This is how he made Buddhistic selflessness his own.

Walter's questionnaire for the 1964 biographical foreword, "On Learning to Look," asked Robert for "concerns or feelings that moved you from one phase to another." Robert's first answer was "Light 'arising' from the form—emergent rather than reflected." Walter then wrote that "mountains" became for Robert "the targets and breakers and even dispensers of light," but revised to say that "[e]verything" became "the targets and breakers and even dispensers of light." The change from mountains to everything is theoretically correct, for in principle mountains are objects like any other. I do wish, though, that Walter had left it mountains, for it was in making mountain pictures that Robert best translated his deepest intuitions about the world into images. In some, a mountain at its base or from its canyons positively radiates—a phenomenon which Walter's family all learned from Robert to see; in most, the dispensation of light by rock is something which I, for one, would not have recognized were I not expecting it. And even then, I mostly don't perceive it as such; instead I react to an inscrutable power of the image which, so I believe, derives from Robert's apperception of light in matter.

In the midst of his mountain period, Robert explained to a *Journal* arts writer what light meant to him.

A Globe of Heavy Light

> Had a very interesting talk with [Caples] about his reasons for painting the way he does ... the why of the "Caples look." ... He has a very definite aim, in painting as he does ... some think too many of his paintings look alike, well perhaps it's because in every painting he is striving for the same goal: that of expressing the inner glow which exists, he is certain, in everything, every scene, every mountain.

As time went on, Robert the lover of words attempted in various places and ways to verbalize his apprehension of light, something fundamentally intuitive and immediate—mystical, if you will. He wasn't systematic about it, and I won't try to be.

To Bettina: "How simple it is. I believe in light. I am in love with light. Light is at the center of all life and all meaningful experience. Light is the visible likeness of God—and all that is beautiful is the luminous shadow of the light."

To Walton: "I told someone—part of the family for all too short a time, a gently stoned son-in-law [Lanier Graham]—that I had come to 'see' our Earth as a globe of 'heavy light.' He liked that. I don't mind it myself." Then is there any doubt that Robert's mountains are substantial?

An off-the-wall note: "substance, mass, opacity"—then just below, he wrote: "light is the substance" and "space is the 'spook,' the 'idea.'" So light is substance and mass, and even opacity. The notion is paradoxical, an antinomy, but comes out of what was authoritatively experiential for Robert.

To Walter: "Light [is] a 'messenger of space'"; and to Ken and Emily Robbins: light is "a condition of space that gives all other dimensions meaning—no light, no anything."

Again to Ken:

> I remember crossing over from southern California into Nevada one midafternoon, happily skid-stopping my yellow car right smack into a lot of brush just off the deserted dirt road; then, jumping out, I dropped to my knees and threw whole handfuls of desert powder up into the already dusty air—the stuff came down all over me, and I blessed it all. This is carrying things to extremes I know, but that lovely Nevada dust fed my spirit like nothing else. My eyes were closed but there was an uprush of light inside.

From the inner light of joy to the light of all creation—for Robert there was little if any difference. Again to Walton: "I put that particular faculty [sight] above all others; not that I see especially, or even commonly well, just that I see light and Creation as one." And to me, condensing for my benefit what he'd tried to convey in *Potter*: "The story believes that there is a point of light at the center of all darkness, certainly it tells that the search ends in a beginning—the infinite source of Being itself." This was a more confessional way of speaking of "the inner glow which exists ... in everything, every scene, every mountain."

Robert told me at Turtle Hill that his mountain paintings germinated from a "sound of silence ... because of the way mountains fill space, silently." That was my rather flat paraphrase in *Bea & Sherman*. Happily I can also quote Robert directly on the entanglement of sight, silence and the stuff of the world. My letter to him had described camping at the Needles with my then partner and her four-year-old son. Robert answered:

> Yes, I know where you were at Pyramid. We drew water from those standing pipes—ate Kentucky Fried Chicken. We had blowing paper napkins and wheeling creaking gulls above and below us. I watched the midafternoon sun make substance of silence, saw the wind put blue on blue. It was wonderful, just to watch. It was like waiting for yesterday's angels—I knew they would never come. Why should they? I loved the day.

Something Robert wrote to Joanne proves an influence of Eastern philosophies on his apprehension of sight and sound, here correlated with space—an influence, or a resonance, an affirmation of what he discerned already:

> I guess what I'd like to say—but as one draws nearer the center the words are harder to come by—what I'd like to say is that, little by little, the spaces between the atoms seem to expand, there is an immensity in nothingness, something approaching what those old Tibetans called the 'pure light of the Void.' Some old Chinaman was pleased to call it 'the silence of the Inner Room.'

pure light of the Void—silence of the Inner Room. Light and silence. Ultimate reality, in other words, referenced by metaphors that came naturally to Robert. This isn't doctrinaire metaphysics—it is philosophy as exposition of direct experience and as guide to a path.

Robert's second answer after "Light 'arising' from the form" when Walter fished for "concerns or feelings that moved you from one phase to another" was again articulated by Robert in terms of Eastern thought: "A sense of 'rightness'" was his second answer—something which elsewhere, on another off-the-wall note, he singled out as a marker of "subjective naturalism" when achieved. Japanese Zen, Robert's principal study, has a concept *shibui*, usually translated as simplicity or subtle simplicity. My father taught me the term when late in life he practiced the art of Japanese flower arranging. My father's *ikebana* teacher translated *shibui* as just-rightness. That Robert was conversant with the term emerges in *Potter*, Robert's attempted spiritual synthesis, where Pali the Parrot exclaims, "Holy Shibui!" ('Pali' references early Buddhism.) Here is more of Robert's answer to Walter:

> A sense of 'rightness'. Seven times 'a sense of rightness' ... 3 times not enough. Have gotten by with much less—may never hit 7. Have gotten by with no times. Had to. 'A sense of rightness'—something inside—a bubble in the brain—as with a carpenter's level—something inside slides into center position and the reading is 'Leave it be.' The bubble is behind the eyes, the reading cannot be forced, cannot be ignored.

And this, by a winding path, led Robert to the self-admonishment which Walter took as the organizing text of his biographical foreword. Following "Light 'arising' from the form," Robert's first response to Walter's question about artistic "concerns and feelings," and "A sense of 'rightness,'" his second, came third, and only third, "To look with awareness.... To look in every way except 'at'."

Where Is the Little Man Inside?

When will Walter bring out another novel? Is Clark writing? Such questions, once asked by concerned or puzzled contemporaries, still linger in the past tense: *What happened to Clark?*

Walter's drought for published fiction began after *The Watchful Gods* in 1950 and lasted until his death in 1971. "I'm really getting scared something has happened to me that I don't understand," he confessed to Barbara as early as 1952. "I've never been blocked up like this before.... As if I'd fallen into something like the paralysis Robert had about painting when he came out of the Navy." But to say simply that Walter developed writer's block is not quite right. The drought years saw the appearance of "On Learning to Look" for Robert's 1964 retrospective catalog, also articles and reviews—what Walter called "duty pieces," notable among them some sure-footed forewords to Western themed books. Just no fiction. But in fits and starts he did write fiction. Many short stories were conceived and aborted, and he attempted at least three novels, amounting to hundreds of pages: *Admission Day*, *The Man in the Hole*, and *Way Station*, all parts of "a Western epic," as Benson termed it, dramatizing Nevada's "historical decline." Why was none of this material published?

Because it wasn't good, and Walter, an unrelentingly honest critic, had to realize it. When submissions to Random House his publisher met resistance, apparently he didn't struggle. Later, as death approached, he did, however, give his son to believe that he might not mind if unpublished works were to see the light of day—"as long as they were clearly posthumous releases, things that did not satisfy his own critical judgment." Yet Bob Clark, as Walter's literary executor, thought so poorly of the novels that after debating with himself he decided not to let them appear even with that qualification, for fear of undermining his father's reputation. His ambivalence arose only from the fact that Walter hadn't destroyed certain works as he had so much else. "Especially difficult has been the decision whether to publish some of the unpublished stuff," Bob explained to Robert in a letter.

Dad's agent [Frances Pindyck] is eager to see some of it. I think Dad himself had some of those uncertain and shifting desires that must afflict most artist[s] in these cases. That is, I think he would have liked to see his total published output a little larger, just as long as it would be clear these were works that hadn't met his own high standards. I've now read two complete novellas done in 1947, neither of which Dad submitted as far as I know, though one got as far as a typescript. They both involve chess symbolism, and, it struck me in reading, were neither in the vein he is known for (that's no great matter) and nowhere near as good (which, it's obvious enough, Dad thought himself). My fear is that, regardless of quality, and regardless of an explanatory preface, Random House or any other large publisher would push them as 'exciting new material from the author of *The Ox-Bow Incident*' and not only would it be a sham on the reading public, but reviewers would cut them to pieces and Dad's perfectly sound and justified reputation would be hurt—the whole thing looking like an effort to cash in on that reputation (which it would be by Random House).

Bob Clark went on to tell Robert that he was currently reading *Water*, which he later told Benson was "pretty unreadable."
What these failed efforts lacked was the fluency of his major works. When Bob studied the manuscripts of *City* and *Track* at the Library of Congress, "both substantiated my impression that Dad wrote quite fast, with very little immediate revision—instead he'd write a few score or hundred pages and throw them out in a lump," only later to edit wording. That was the method Walter espoused to his writing students. One student, who had been studying "Hook," asked Clark if some technical aspect of composition had been intentional. Clark replied, "You can't think about something like that while you're writing." This was the young writer's "'ah-ha!' moment ... in learning from Clark how to flow." The student's son, Kevin Fagan, told the story. Ironically enough, the elder Fagan went on to develop a lifelong writer's block of his own. Walter may have idealized flow because, in his own process, it was both his strength and his vulnerability. Of the unfinished novel *Way Station* Bob Clark said, "he worked not exactly on the book but on the first chapter of the book and for weeks and weeks at a time on the first paragraph of that book, which never did get beyond the draft of the first chapter."

In the trajectory of Walter's writing life there is really no way to separate his loss of spontaneity, or flow, from how his content became ever more cerebral—his tendency always, visible already in his *Desert Wolf* satires of 1930–31. Walter's discarded first pass at the material of *City*, predating *Ox-Bow*, was apparently mostly philosophical dialogue between narrator "Walt Clark" and Tim Hazard. Even the version we know was freighted with philosophical dialogues until Saxe Commins at Random House asked Walter to bring down the overall length—by half. Laird cites the enormous total of two hundred thousand words cut to produce the final draft. And doesn't Tim lament of his sixth or seventh try at the symphony of leaves, "A falseness creeps in. I float to the surface and labor like a scholar"? By the time of the unpublished novels of the 1950s, the tendency proved insurmountable.

Among Walter's late published output is an essay in semi-dialogue form, "The Writer and the Professor," an examination of the inhibition of creativity by critical thinking. The title continues, "or, Where is the Little Man Inside?"—the creative genie. That was the question. The essay, based on a 1959 lecture, was prepared for publication by Walter in 1962, the year his life first became affixed to the Doten project, at a time when he still envisioned its creative possibilities. Was he seeking grace from "the little man in the boat"? Robert's *Silent Passage* hung then in Walter's house. But on the last page of the essay he hinted it might already be too late, as it proved to be. Why? *What happened to Clark?*

It isn't a pleasant question, so I sympathize with how Max Westbrook struggled with its attraction in his little study of Clark that came out in 1969, during Walter's lifetime—and how unpleasant must that have been for Walter?

> Such questions seem unfair to the author, seem to invite easy-chair conjectures, sometimes smell slightly morbid, and certainly constitute an external approach to problems which, if legitimate, ought to be available for study in the literature itself. Still, though we may feel guilty for having come upon the question for suspicious reasons, there is often an uneasy feeling that the problem raised does have a legitimate, intrinsic existence. Thus we may snort righteously at men [sic] who raise the question and yet find our

holy selves interested in deriving an answer. What did happen to Walter Van Tilburg Clark?

Westbrook, too squeamish after all, didn't really make much of an effort to answer the question. But Walter is dead, and time has passed, and others have, and my holy self is morbidly interested enough to consider their speculations, of course.

So, to begin with, it's been said that Bernard DeVoto's review of *The Watchful Gods* sank Walter's spirit. Could DeVoto's accusation of "low grade Western mysticism" have stopped Walter's flow? I doubt it. He "wasn't one to dwell at length over critical comments on his work," Bob Clark avers. Or did Walter, as Stegner proposed, "fall victim to the perfectionism that he specifically repudiated in his character Lawrence Black?" Perhaps, but if he did, it begs the question, why? So does the notion that Walter had said everything he had to say. L. L. Lee, a particular partisan of *Track*, supposed that "in its very success, its expression of the ambiguities of our existence, Clark would encounter a meaning he could not go beyond." Bob Clark said much the same about his father's short stories, that they "perfectly embodied" Walter's ideas, "and then you're done with it." It's a feasible psychology, but does it fit as compulsive a writer as Walter? Writers repeat themselves—Walter's stories do—and little lost. Or had the "times passed him by"? That's another of Stegner's conjectures: "styles changed, the Sixties came along." It's true that Walter and the Sixties didn't mix; but his fiction stopped flowing in 1950. Stegner, who gave much thought to Walter's life, also said, "He peaked too soon." Bob Clark meant something like that when he twice quoted to me Wordsworth's memorable line about lost youth—"'Nothing can bring back the hour of splendour in the grass'"—as, in effect, Walter's literary epitaph. Again, that begs the question.

Likewise teaching. Walter was an exceptionally devoted and accomplished teacher of creative writing—over four hundred of his students made it into print. All extolled his skill, dedication and charisma. At San Francisco State they called him, so Walter's student Charles Brashers remembers, "The Younger Brother of God." "He really did love teaching. He wasn't reluctant at all," insists Bob Clark, "yet his

notion of himself depended upon the writing." There his students were, "cranking out their novels," while the teacher had run dry, and teaching seemed to blame. "I am kept so busy, what with all the papers and so many new lecture preparations.... I just can't preserve the energies sufficiently any more to work fully at both the teaching and the writing." That was his admission to friends in 1954, followed in 1956 by "while I'm teaching, that's where I feel alive and in the present—while the writing has a tendency to slide both ways from the living divide, into the dead past and into the never-arrived-at future." Without doubt teaching beat out writing. But why did he let it go on? Year after year he looked forward to "a full summer" vacation to devote to writing, only to accept invitations from writing conferences instead, to earn a needed stipend certainly, but also to avoid the empty page. And during the school year at San Francisco State he succumbed to the social and cultural temptations of the city.

Another distraction he could have avoided was public speaking, "to clubs, other schools, teachers associations and TV and radio audiences." Lecturing, and teaching for that matter, were constructive outgrowths of the despised flaw of compulsive talking that was forever wrecking young Timmy's chances with Rachel in *City*. Yet Walter permitted himself self-admiration (if touched with irony) in the obviously autobiographical depiction of Tim in his twenties as a gifted talker, perhaps not altogether making the connection to the despised flaw: "Then he was magnificent, a natural phenomenon, like a volcano in eruption. He would go on for an hour or more...." Jim McCormick knew Walter in the 1960s. By then he "spoke slowly" both on stage and in conversation. "Everything was considered." But he was still Timmy: a "compulsive talker" (Ray West); "never knew when to stop" (Richard Scowcroft); "a wonderful storyteller and sometimes to the point of absolute boredom" (Walter Brown)—so friends remembered him and his endless monologues. Robert punned that Walter's conversational style was "more 'exhaustive' than lively." But his double-edged gift served him extraordinarily well as a sought-after public speaker. New Left historian William Appleton Williams attended a Clark appearance at the University of Oregon where he spent ninety minutes unpacking a

yarn of the Old West: "Nobody squirmed, nobody left, and at the end we were so moved that we did not applaud for at least 10 seconds—which of course seemed an eternity." To get a taste of his public style, I listened to a recording Special Collections holds of Walter reading his story "The Indian Well" in 1967. His reciting voice was measured, gentle, practiced, very distinct. You can tell he enjoyed holding his audience. On top of consuming time and energy, public speaking cost Walter's writing by solidifying his public persona at the expense of introversion, "the Little Man Inside."

And then he threw himself into the journals of Alfred Doten.

The Doten Project

From the day nineteen-year-old Alf Doten left Massachusetts by ship to become a forty-niner until his death in 1903, he kept a journal. After prospecting and farming in California, Doten moved on to the Comstock, where he eventually wrote or edited for the *Territorial Enterprise, Gold Hill Daily News* and other papers. Like too many Comstockers, he died a destitute alcoholic. Doten's seventy-nine notebooks, recording his personal life, mining matters, political trends, entertainments and more, surfaced in 1958. In 1961 the University of Nevada purchased them for publication.

It was university president Charles J. Armstrong, not press director Robert Laxalt, Walter's mentee and friend, who proposed Clark for the project. It had been Armstrong who conceived the possibility in the first place of getting two books out of the journals, a general audience treatment, to be Walter's responsibility, and a weightier scholarly endeavor. Walter's first contract gave him eighteen months, from July 1, 1962 through 1963, without school year vacations. His position as writer in residence entailed no other duties, at that early stage. After six years at San Francisco State, Walter moved back to beloved Nevada.

The press's Editorial Advisory Committee (later Board) ambitiously expected to bring out one volume of the scholarly edition in time for the state centennial in 1964, but then settled for Walter's smaller task as the press's contribution to the celebration, with submission of the manuscript scheduled for January of the centennial year. That wouldn't happen.

What Walter initially had in mind is hard to know. Barbara Clark said it was to be "a batch of excerpts ... strung together with comments" with focus on the Comstock. Benson thought a nonfiction biography. Editor Nick Cady and colleague Robert Gorrell believed a novel. Walter once told Gorrell he was on his ninth out of what Gorrell estimated became as many as twenty tries at chapter one. Then, without reaching chapter two, he suspended the attempt: "the rationalization was that he had to edit the diaries before he could do the novel because he couldn't tell what was in the diaries until he did." Whatever the first intention, Bob Clark's take is that Walter couldn't find enough supporting materials

for it outside the journals, so "set to work on the notebooks themselves" for a book consisting of Doten's words with some commentary. In short order the conception grew to cover the entirety of the journals. Thus it was Walter's own initiative to broaden the press's directions, until eventually he encroached on the scholarly edition. That job had gone to Russell R. Elliott, chairman of History & Political Science. But when, in late 1963, Walter's contract was to be extended, Elliott resentfully withdrew, citing redundancy with Clark's scheme. Walter then accepted the scholarly edition. First he would finish the general audience version, already well behind schedule, then take four to five years for the larger project. What transpired is that the former vanished into the latter, which Walter had not quite completed before dying eight years later. Editor Nick Cady, who hadn't yet arrived when it was decided, couldn't really say why Clark was assigned the larger project, given his poor record meeting deadlines. Cady wondered if Laxalt acted out of "pity" for his older friend who couldn't write fiction anymore.

Was Walter also blocked on Doten? Yes and no. The general audience book never came to be, and there were delays all along, yet Walter put in an astonishing amount of labor—much of it self-imposed, not to say gratuitous. Instead of marking up the nearly ten thousand page transcript, triple-spaced for his convenience, he hand-copied every last word he wished to retain onto new pages, in this way consuming far more time than his rather slight commentaries required—the final product, *The Journals of Alfred Doten* in three boxed volumes, is less a scholarly annotation than a somewhat edited-down preparation of Doten's raw text for the use of future scholars. Walter would put a good face on his progress for *Territorial Enterprise* columnists when he and Barbara dined out in Virginia City. But Editorial Advisory Board minutes and various letters tell a story of one deadline missed after another. Then in 1968 he had prostate surgery. The next year Barbara fell ill and died. He still hadn't resumed work on Doten by April, 1970, when he wrote to Robert, "I don't really understand why I find it so hard to go back to him." Though frankly bored by that time, "the unthinking but meticulous plugging [Doten] requires" should have been just the thing, he realized, to fill the empty hours. "But I am scared of him."

Laxalt had been warned in 1961 that a bad launch would be a serious faux pas for his new small press, as it proved to be when scholars wishing to use the journals had to be put off again and again—a lawsuit over the delay was even filed or threatened. Finally in May, 1970, Laxalt resorted to requesting "a higher echelon nudge" from Chancellor Neil Humphrey: "We would appreciate a letter from you to Walter Van Tilburg Clark to the effect that you are gratified that the editing of the journals will be completed by July 1.... I might suggest a delicate mention by you to the effect that after eight years, we are all looking forward to what we know will be a monumental contribution to the western scene." Delicate or not, Humphrey's intercession didn't have the desired effect. Not until after the July 1 deadline did Walter pick up Doten again. But by January, 1971, procrastination had set in once more—Walter was terminally ill. In a February letter to Robert, he unconvincing asserted his hope "to complete Alf Doten before he completes me."

Almost from the start Walter worried about overinvesting in the Doten project. He'd entrapped himself in another writer's never-ending verbiage—a writer, what's more, who faltered and finally failed. Walter perceived the contours of "classical tragedy," and couldn't fail to identity. Just months into his contract he was already joking that he might find himself "materializing in 1864 and signing my name Alfred Doten, Esqu"—this in a business letter to an academic he'd never met. Grim levity about becoming Alf Doten right away became part of his persona, his excuse and apology to the world for not doing his own writing, half confession, half exorcism. Underlying it was dread of self-loss and a foretaste of death. In 1963, Special Collections was a "windowless mausoleum." In 1966, he deemed himself "the walking dust of Alf Doten." In 1969, he mailed Robert a long improvisation pretending to be Alf Doten as a Virginia City character but in the present day. For a fact he was now affecting an obsolete frontier font for his letterhead.

Bob Clark in his Doten preface described poignantly how it was with his father then: "[E]vening talk after a session with the journals always found Alf present, one way or another. Dad wondered jokingly whose life he was living, anyway, and whether he would outlast Doten or no. The joke grew grimmer as illness set in."

. . . .

So, what did happen between Clark and fiction? Was it inhibiting perfectionism? Or rough handling by critics? Was he talked out? Had the times passed him by? Had he peaked too soon? Overcommitted to teaching? Over-identified with a public persona? Then mired himself in Doten? However close to Walter's biography, however plausible, these speculations don't solve the puzzle. It's a conundrum that invites while perpetually refusing a solution. So when I lay another speculation of my own on the table, I realize it will satisfy no one.

My guess, though, is *Rachel*.

A Dream of Woman

Rachel Wells, "Tim's great single love." Rachel at the racetrack with her parents, slight, still, solitary. Rachel, object of Tim's futile searches and chaste fantasies. Rachel infuriated by Tim's indecisive chivalry. Rachel the little soldier. Rachel exasperated by Tim's nonstop chatter. Rachel who rebuffs, who ignores. Then at last wondrous Rachel of the blessed evening at Bowers Mansion. But then Rachel who crushes all hope, spurning Tim's tasteless moss-agate brooch.

And adult Rachel, still Tim's chaste fantasy when fantasy comes chastely to life swimming naked on Mt. Rose. Then Rachel of Tim's waking dream, releasing him, and he finally letting go.

Now Tim realizes he loves his childhood crush Mary and proposes by letter, and they wed. Now Tim writes his symphony of leaves with Rachel still in his heart. Now symphony and novel merge and together resolve into an idyll of domesticity and creativity, with Mary.

When I was twenty-something and discovered *The City of Trembling Leaves*, I knew there was a real Rachel. To know that, it makes no difference whether you grew up a university president's son or a boy who lived across from the county racetrack in Reno or the son of a flower-arranging pediatrician in Chicago.

The Chicago boy had a heartbreaker named Wells in his young life, too: Anne Wells, who came to town, won me and dumped me the summer after seventh grade. That's why I picture Tim's Rachel as blonde, although she wasn't.

November, 2011, and my voyage of rediscovery had brought me to the Clark archive. When I ran across Walter's high school graduation yearbook, it came to me that the *Re-Wa-Ne* might contain clues to the identity of Rachel. I turned to the seniors. One portrait had been cut out! I flashed on the sweet scene in the yearbook office where Tim and Rachel banter as they tussle for photo souvenirs—the first sign that Rachel feels any attraction to Tim. Tim grabs a print of him and Rachel side by side in tennis garb, but then cuts it in half, handing his image to Rachel and keeping hers. And didn't Tim have Rachel's graduation picture on his desk when he came home that evening, the magical

evening with Rachel at Bowers Mansion? The cut-out had to be Rachel! I went to the library's intact copy of the *Re-Wa-Ne*.

Marian Lowes Cheney—"Pat." A beautiful girl. She was prominent lawyer Everett Cheney's stepdaughter, an actress and a Mackay Day queen at the university (the drawing of her in the *Gazette* may be by Robert). In her yearbook portrait, Marian's jacket has a fur collar—and Rachel wears a coat with a fur collar, and also a fur-trimmed dress, the gray dress Tim just knows the ill-fated moss-agate brooch would look good on. Marian in her fur collar had to be Rachel.

Marian Lowes Cheney in *Re-Wa-Ne*, 1926

Marian Lowes Cheney, Mackay Day Queen

But when I leafed through the *Re-Wa-Ne* for confirmation, instead I found Ruth Thatcher. It was Ruth pictured with Walter in tennis garb (but not really side by side; the photograph is sadly a composite), Ruth who played mixed doubles with Walter, and Ruth on the yearbook staff with him, all tracking Rachel. As it does that the George Thatchers lived in the Court Street Quarter, that they divorced, and that Ruth left Reno for college after high school, whereas Marian went to the hometown institution before transferring out of state.

Ruth Thatcher and Clark in *Re-Wa-Ne*, 1926

One other parallel: at college Rachel had her own disappointment in love, and it appears that Ruth Thatcher did too. Rachel "nearly killed herself over a broken love affair ... her mother had taken her to Europe"; and as for Ruth, in January, 1929, the *Gazette* placed Walter at a small send-off party for Ruth, her mother and a friend. Their six month trip to Europe would commence in the middle of the term at Stanford, suggesting an urgent matter of the heart.

Ruth Thatcher in *Re-Wa-Ne*, 1926

So, Marian Cheney or Ruth Thatcher? The weight of the evidence favors Ruth. Ruth and Rachel: both Biblical names beginning with 'R'.

After I thought I'd finished sleuthing, I found two eyewitness confirmations. When Bob Clark asked Robert in 1972, "Who was Rachel?" he gave Ruth's name. And in Margaret Bartlett's unprocessed archive at Special Collections is a small envelope on which she wrote, "Save for Walter." In it is a photo of three young girls, on the back of which Monte penciled, "Walter Clark's Rachel Ruth Thatcher 1st on left."

And so, Ruth Thatcher.

But then why did Walter cut Marian Cheney's picture out of his *Re-Wa-Ne*? And the fur collar? Was Marian the real, the secret Rachel? I'd have preferred Marian to Ruth, whose healthy face suggests less to the imagination than Marian's, who had Rachel's "wild, shy eyes" if either did. But you never know what eccentricities a wholesome face like Ruth's may be hiding.

So let's say Ruth. She was born in 1908 in Tonopah, daughter of George Thatcher, who early in his career partnered with George Bartlett, and later became the close friend and lawyer of George Wingfield. Ruth's middle name happened to be Clark. She married Dennis Hogue in San Francisco in 1934. The Hogues lived in Nyssa, Oregon, on the Idaho border, and later in Twin Falls.

In a 1932 letter to a friend, Walter mustered his dignity to speak of the end of his hopes: "As for the lady side of the problem [of

existence]—my long winded romance died—of a lingering illness. Too long apart." He said he'd been living a bachelor life for two years. Depending how you interpret this, the romance such as it was ended between 1930 and 1932, that is, it lasted well into college—from Walter's perspective at least. Ruth returned to Reno after graduating Stanford. That September he and Ruth partnered for mixed doubles in the state championships again. That and the send-off party in 1929 are all I can discover about the "lingering illness" phase. Meanwhile Walter must have been keeping up a long-distance relationship with Barbara Morse, whom he'd first dated in 1928 or 1929. Barbara had gone back East after graduating in December, 1929. Walter moved to Vermont for graduate work in September, 1932. He and Barbara were married by the bride's father, a Presbyterian minister, on October 14, 1933, in Elmira, New York, her hometown. Bob Clark supposes his mother "more or less vamp[ed] the relative innocent Walter."

In 1937, Walter spent much of the summer in Nevada, without Barbara. Then, back in Cazenovia, he wrote a story, never published, "A Dream of Woman," about the bitter disappointment of a boy's unrealistic fantasy of love.

The Falsity of Mary

Barbara Morse Clark. She was smart. She played international chess by mail, and at home occasionally trapped aggressive Walter by playing a cautious defense. Also she wrote "a bit," as Walter put it, mystery stories. None were accepted, although he coached her. She never held a paying job, but took pride in volunteer work. She was the practical one. Besides cooking and cleaning, she paid the bills and even handled household repairs.

"She was not as good-looking a woman as Dad was as a man," says Bob Clark. But it was on grounds of personality that Walter's blunt friend Walter Brown said, "Nobody could ever figure out, least of all I, how or why they ever got married. Totally unlike, except in their love for smoking and drinking and telling tall stories to each other." (It was "common knowledge" in Virginia City that both were alcoholic, says Peter Kraemer.) Whereas early on she was the more "fun-loving, high-spirited" of the two, Bob assured Benson, appraisals of her later personality convey a less attractive impression: "flint-edged" (Walter Brown), "feisty" (James Schevill), "bouncy and unpleasant" (Charlton Laird). No one said likeable. When Walter would bail Robert out "between wives" by buying paintings, recalls Bob, his mother went along for Walter's sake, but was "sardonic" about it. She thought Robert "irresponsible and, in her stoic New England opinion, whiney and self-pitying." Robert didn't much like her, either.

Barbara Morse, University of Nevada junior, 1928–29

In her prime she could hold her own with Walter, but in time she faded. Robert Laxalt's daughter Monique remembers her at their home in the 1960s as "self-effacing," "totally second-fiddle." Judy Nash, daughter of another Clark friend, said likewise, "He overwhelmed her."

Walter did love Barbara, to go by extant letters of his during the stretches he lived away for teaching. But did he really need to live away

so much? Was he unfaithful? "I never knew a woman not to fall in love with him at once," volunteered nephew David Chism, who believes there were other women. Friends of Walter's disagree. "[W]omen were always chasing him around. He wasn't aware of it though," said Walter Brown, adding, "it was part of his ignorance." Brown found Walter "out of touch with humanity." Charlton Laird said he "didn't think [the Clarks] ended with any deep affection to one another, but he was faithful in word and deed." I raised the question with Babs by repeating an insinuation of Peter Kraemer's, that professors take advantage of their position, especially English professors. Babs wouldn't have it. Perhaps to demonstrate her open-mindedness, she then revealed that Walter Senior did have an affair—a woman in the Physical Education Department at the university.

But what about all those attractive tennis partners? Bob Clark doesn't believe any overt sex was involved. Attraction, but no sex: shades of Tim and Rachel! When as adults those characters swim naked but apart in Tim's "sacred pool" on Mt. Rose, Tim resolves not to "touch her with a look or a word or a thought." Critic Edmund Wilson belittled Tim as "lacking gumption to make any determined play." That's unsympathetic, yet Wilson was onto something: Walter was more than a little "priggish." In his writings, he conspicuously associated extramarital sex with shame. Apart from some unconsummated heavy petting, the only real sex in *City* is the one time Tim makes love with the singer Eileen, an aberration followed by a disproportionate seizure of guilt. Bob believes his father's sexual mentality was shaped by "Victorian mores inherited from his parents." Friend Herbert Wilner found himself "inhibited with him from any kind of locker-room talk." In none of Walter's letters to Robert is there a single word about sex. Robert considered his old friend incapable of a possible affair Bob Clark queried him about: "The insistence upon no dependence on another person, especially women," Bob paraphrased. "Cannot imagine the affair other than Platonic." And Walter Brown again: "He wasn't a stud at all. He had the manner of one, and played the role of one, but never a functioning stud." Brown, who was nothing if not direct, even asked Barbara "whether she was worried about the number of women who were chasing Walter and she said, 'Oh, oh, no. They keep chasing, what they don't seem to understand

is I have got Walter.'" Once when Rosemary mock-seriously threw "her arms around him saying 'I love you, Walter,'" he rejoined, "My love is for my wife alone." It sounds like a levity that wasn't really light.

And yet, when Robert observed that marriage creates "a third person," Walter retorted, "I don't want any third person breathing down my neck."

Walter from adolescence was enthralled by an unreciprocated love. Other girls couldn't loosen his obsession with Ruth Thatcher (or Marian Cheney). It wasn't until a year, or two, or three after meeting Barbara in college that he finally acknowledged the death of his "long winded romance." They married in 1933, purportedly after Barbara coerced him by getting on the other side of a lake and refusing to go home until he proposed. Fast-forward a decade, and husband Walter was writing about his "great single love." He may have been trying to write Ruth out of his system. If he succeeded, he paid a price. The thing that eventually proved fatal to him as a writer was not that he compromised in life—to do that is the human condition, and unavoidable for him, given his predicament. It's that he falsified his writing. That's the gist of *what happened to Clark* by my conjecture.

City wasn't Walter's first attempt to write Ruth out of his system. His MA thesis "Sword Singer" retold in verse the Tristram and Isolt story—a tale "of unattainable love." There are two Isolts, the beloved but unattainable Isolt of Ireland and Isolt of the White Hands, whom Tristram weds.

> Somehow it seemed that she held out to him
> Another life, where he could hide from memory
> Yet never be untrue to his one love.

Walter returned to the Arthurian legend in *City*, where young Timmy explicitly casts Rachel as Isolt of Ireland in his romantic fantasies, and Mary as Isolt of the White Hands, the second-best—Mary, the "old friend whom" adult Tim "could not desert or injure." Further on, Tim has a revelation that he really loves Mary, he proposes by letter, and they wed. The plots of poem and novel ironically diverge. In Walter's poem, as his exegesis makes clear, Tristram weds Isolt of the White Hands "as

much out of fear of hurting her as out of desire for forgetfulness. The step is a grave error, for he finds himself unable to pretend sufficiently, and in addition to hurting her has added a burden of remorse to his already heavy one of memory." The outcome in the old tale is of course tragic. But in the novel, at its end, composer Tim and housewife Mary abide with their children in ideal and idyllic happiness. And the Clarks? Bob Clark once asserted that the "agonizingly dull" Mary resembles his mother Barbara in a mere few details only—she feeds birds, she reads Trollope. Descriptively that must be true, for Bob is in a position to know, but functionally not necessarily. The novel's idyllic denouement in effect said to Barbara, and probably he did actually say, "That's us." The Clark marriage possessed more the form of the novel, in that they stayed together, but more the tragic inner truth of the tale.

I'm hardly the only one for whom the ending rings false. Edmund Wilson found himself "left rather blank." Another reviewer who mostly praised the book complained of feeling cheated by the ending. Yet another blamed the happy ending for *City*'s falling short of the human condition. But no one manhandled the ending as harshly as Hubert Saal in his presumptuous fan letter preserved with mine at Special Collections:

> I was disappointed in the ending. Really let down after everything else.... Mary is vague, incomplete, unsatisfying. (For some reason I don't think you cared much about Mary....) Tim never should have married Mary Turner. I didn't want him to. No one I know, after they read the book, will want him to, and I don't think you wanted him to, at least not the writer part of you.... [Y]ou feel called upon, a trifle wearily here I believe, to justify Tim's love for Mary, and at this crucial time in the book give us the long passage about their early love and an excruciating passage ... about Mary feeding various birds and looking very desirable in the process. The passage was out of tone with what the book needed at that point.... I believe you felt the falsity of Mary.

the falsity of Mary. Walter planted glimpses of her at intervals, thereby attempting to establish a context—a pretext—for Tim's eventual revelation of love. Thus, about to leave Reno for Carmel, Tim realizes he's "going to miss Mary," and so on. They're not obtrusive, such posted

signs, but perfunctory, leaving Tim's proposal, when it comes, to seem egotistical and even insulting: it never crosses his mind that she might refuse him. Of course she doesn't, she couldn't, she's not an actualized character. Now that would have actualized Mary, to refuse him.

There is a pattern to Tim's emotions throughout *City*, from high to low, ecstasy to depression. After the euphoria of running like a stallion in the hills, a "deep, dark tide" swamps Tim when he remembers he made a fool of himself with Rachel. The miserable fiasco of the moss-agate brooch follows the elevated mood at Bowers Mansion. The elation of reconnecting with Eileen triggers extreme remorse. Tim is conscious of this pattern as something he needs to mature out of. At Carmel, he achieves a "clarity, calmer and more enduring than the wonderful ascents into exultation or descents into furious despair.... [No] substitute for the exultation, but it could sustain the work through lapses." There comes another high/low of creativity, and then his waking dream of Rachel, where he experiences a former way of being, the "forgotten boy, almost a stranger, capable of a kind of ecstasy which no longer existed." Rachel and that boy recede into the past—"he had been forgiven his past, and might move without it." And so he leaves Rachel and ecstasy behind, together. But he doesn't. When Tim's symphony of leaves finally comes to him in the winter cabin above Tahoe with Mary, the music is about Rachel, and "[a]ll the other people in this story moved around her." Unconvincingly Walter adds that the symphony is also about Mary, "feeding various birds" as Saal snickered.

The ending shows Tim stabilized, not high, not low, just right—but so right that he must have reached a steady-state euphoria, which is an oxymoron. Walter leaves Tim in a constant inflation followed by no deflation. The deflation would play out in the rest of Walter's life, in the dark tones of the fiction he subsequently published—*Track* and some stories—and then in his flawed efforts and his publishing silence.

It's not that Walter never got over his Rachel—maybe he didn't, but let's say *City* purged Ruth Thatcher from his system. What he never got over— as a writer—was swearing a false oath with *City*'s ending that the premise of his marriage was true, that when he married Barbara he'd already not only shaken his obsession but found a different and even better love.

Did he "pretend sufficiently" to convince Barbara? I doubt it. How could she have felt except badly about being tagged the second-best Isolt? Thus Walter's fidelity. Any betrayal would have been explosive. You can't blame him for trying to save his wife's feelings. The trouble is, he had to falsify his novel to do it. For Walter the moralist, dead serious about his art, this nexus of untruth became a wasting disease. *City* was the novel of his he talked least about, and the only one he never gave a lecture on. Henceforth he would produce nothing with the loving heart of *City*—even though it was Walter's favorite of his books and, he usually said, his best. He would never again mine his own life in that way. Bob Clark wonders how his father ever wrote such a book as *City* in the first place, so strong was Walter's aversion to the personal. I don't believe the possibility has occurred to Bob that the aversion which governed his father when Bob was old enough to perceive it strengthened and became dominant after *City*, a result of the fabricated ending and everything it entailed; that the blind canyon of the book on a personal level combined with its relative failure on the public level to cause Walter's retreat from the personal, and ultimately his silence.

City incomparably captures the magic of beginnings, but neither the dignity nor pathos of endings. That's why the critic thought Walter's happy ending falls short of the human condition. Monique Laxalt said something perceptive in this connection. I had asked about Walter's appearance, since the Clarks had been frequent visitors at the Robert and Joyce Laxalt home during her childhood. She said he was "ageless—in a way old, in a way young." Then Monique, who esteems the novel *City* and has given a lot of thought to Clark the man because of the friendship between him and her father and because of the two writers' comparable standings in Nevada's cultural history, ventured, "Maybe he was locked into the age of Tim Hazard his whole life." I think that's right. I think it's why *City* gloriously gives "praise" but does not attain to "prayer," in Robert's terms. But no one can stand still. The praise emptied out.

Walter said, "I don't want any third person breathing down my neck" when Robert aphorized "about marriage creating a third person."

Bob Clark said that Walter made "a lot of little notes" for stories where kicking over the traces, "find[ing] a new woman, or something, would make the writing come."

Barbara said, "I have got Walter."

Walter said, "The big picture is always sad."

Tim says, of Lawrence, "*He has faith in time. I'm afraid of it.*"

A Setting and the Means

> We live at what was once a busy country road; now it ends beyond our property in deep woods and immense patches of huge fern.... The upper end of the road, about a thousand feet or so from our house and barn (remodeled) joins an east-west paved road.... Now and again, we can hear the faraway moan of a passing truck, and this rather seldom. All else is silence.

Robert was describing Turtle Hill near New Preston, Connecticut for Ken Robbins in Reno. When Ken later wrote something about howling coyotes, Robert answered, "For ourselves, we have a den of foxes on our north acreage, close to the high cliffs that extend deep into the state park beyond." A previous owner of what was once a working farm had created five terraces retained by dry stone walls, "sort of randomly formal," where Rosemary devotedly cared for "seemingly endless gardens." Apple trees were "scattered over the acreage." The house, painted white with black shutters, stood on a slope backed by woods opposite the pond, with Robert's barn studio between to one side. From my long-ago visit I well recall the former horse pond, depicted in *Bea & Sherman* as "bordered [by] cattails and water lilies except where a miniature pier jutted out as a landing for [the] boat, a playful flat-bottomed [paddle boat] about the size of a cement trough, painted with fanciful flourishes." Later Rosemary and Robert added "stone emplacements at either end" of the pond, with a "flagstone path" between, so "we can walk from one to the other, counting turtles and frogs as we go."

After Rosemary Junior got engaged in 1965, Rosemary Senior thought it prudent not to invite her daughter's fiancé Lanier to Turtle Hill until just before the wedding, for fear the estate would overawe him.

The buildings dated to the 1770s. Inside the farmhouse, leaded casement windows interrupted the plank walls, some in bays with storage benches. Relieved by a few sofas and the T'ang horses and Japanese scrolls Lanier Graham admired, the rooms took their character from colonial furnishings: bentwood chairs, well-worn tables, pewter plates and vessels. Electric lighting was restricted in favor of brass

candle holders and ironwork candle chandeliers, with TV banished to an outbuilding, in case there was something they absolutely needed to watch. Abstinence wasn't rigidly imposed on others, however, for on Thanksgiving in 1968, with Robert's son Cricket and brother John as guests, they watched TV for an hour like a typical family.

"We have that memory in common," I said quietly and smiled, when David Chism, not a man quick to expose himself to a stranger sniffing around family business, reminisced warmly about sleeping in an upstairs bedroom at Turtle Hill. Something about the dark wood and the slanting roof over the bed made our overnights there memorable for both of us. The little room bestowed a "sense of 'rightness'" that had to do with being a guest of those hosts. It was all *shibui*. In my novella "the quiet isolation of the farm" impressed me, and Robert's "companionship with his wife, the chess sets standing ready in every room, the appointment of the house and studio.... I felt I was being allowed the privilege of seeing the potential beauty in all details of life."

No question Robert had the advantage of a setting and the means to enjoy gracious living such as wealth like Rosemary's can provide. I hadn't the detachment to consider then how he'd fare in a Lower East Side walk-up with the tub in the kitchen, or in public housing with noise coming through the walls, or in a double-wide somewhere, ill and alone. He didn't have to face that. But he wasn't insouciant about his luck, for he sometimes worried that the neighbors judged him for living off Rosemary's money, and that John and others thought him a failure.

Rosemary, I was told by someone who knew her, was one of those very wealthy persons whose good fortune intensifies their common humanity. She was "warm" and "caring," and occasionally apologetic about her money. All the same, she spent in a style that would have been irresponsible had there not been so much—a tiger skin coat is one example of her extravagance. In after years Rosemary lost her money to a chiseling realtor, in David Chism's version, or to an unscrupulous lover, in Rosemary Junior's—these could have been the same person. Lost her money, relatively speaking: she was told by an appraiser that her antiques were worth even more than her gem of a property, owned free and clear since 1973.

It was Rosemary's extravagance, along with her caring, responsible for Robert's "desert" at Turtle Hill. In my novella, he stage-managed the surprise—as he must have for other visitors before and after me—by asking me to "Walk ahead" along a path past the pond through some trees, beyond which "I found sand. It covered about a hundred square yards. To one side stood a dilapidated shack. Rusty wheels, harness gear, miner's implements were littered about, also a horse skull." As Benson told the Caples legend, "[H]e missed the desert so much ... he had several loads of sand trucked onto the farm in order to create his own small version of Nevada." The sand came all the way from Nevada, at least initially, three or four truckloads, so Rosemary Junior advised me. However, she also said the desert was her mother's doing, first and last. Babs knew this already, when I brought it up, and Bob was glad to learn it, as was I, I admit—the self-indulgent folly runs against a puritanical streak I got from my father. Rosemary also supplied collectibles from the real desert and had the shack constructed with a working fireplace. They would sometimes sit in there to drink and talk. But Robert on his own, not so much. Rosemary Junior believes he "balked" at the whole concept. Her ex-husband Lanier, who tends to see Robert without rough edges, has a different idea, that "he would go & sit & close his eyes & feel he was AT HOME."

Can Robert ever have been wholly of one mind about the little desert? No, just as he never was about the move to New Preston and Turtle Hill—his home for twenty years, which, in a certain mood, he would sardonically curse as "dePreston, disConnecticut." But in a different mood he told Joanne, "I don't fight New England the way I used to—no more glaring at all the chlorophyll any more, nor do I call up Torrington Rock & Sand [in Connecticut] the way I used to, asking John to bring in another five cubic yards of sand." It wouldn't surprise me if Robert smiled about the "desert," swallowed his reservations and let himself get in the spirit, and not for Rosemary's sake only. He needn't have taken me to see the desert, nor others such as Edda Houghton and her daughter Monica, when they visited Turtle Hill while East looking at colleges. Monica doesn't remember Robert, but does "the skull in a sandbox."

In time the "desert" fell into neglect. When David and Nikki Chism delivered the gift of a Nevada sage from David's parents to Robert in 1975, "the Connecticut rain forest had taken over, and most of it was green." To Miriam and John Chism Robert wrote in thanks that he had potted the shrub and placed it in a "deeply recessed window" in his studio. Hopefully air currents from there wafted to him its so evocative perfume.

Star Passage

Caples went to Connecticut in 1958 and into "retirement ... no longer painting," states a Nevada Museum of Art website, "but devoting years to writing and illustrating a children's book." Or did Caples continue "painting until the end of his life, walking out every day to the barn he had converted to a studio," as Benson believed? Neither, in fact. Marcia Growdon got it loosely right when she wrote that Caples painted "elegant, haunting landscapes" of mountains into the 1960s, and then "a series ... that dealt with the cosmos." However, on the next page Growdon reverted to the legend: "Except for *The Potter*, Caples did not paint after moving to Connecticut in 1958." The truth is that Robert did paint in Connecticut. Fifteen works in the 1964 retrospective were created from 1959 through 1962, and some dozen more from those years can be identified, plus single works from 1969, 1970 and 1975. So Robert was fairly productive as a visual artist for several years in the East before changing direction.

Of the Connecticut works I've actually seen, whether the originals (about half) or in reproduction, almost all reprise or develop styles and subjects from Nevada. So, for example, *Tonopah Houses* (1960) must be Robert's last treatment of Nevada mining towns, "one of his best" in the opinion of Jim McCormick. A document in Robert's hand says, "Design built from drawing done in 1940." And *Talking Stone* (1962) is probably the last painting Robert based on petroglyphs. And most of the rest from Connecticut treat mountains.

Two of these mountains are like sentimental book ends for all the mountains Robert painted after leaving Nevada, by virtue of having 'remembered' in their titles. *Remembered Country* (1959) mixes the vertical ridge features, calligraphic lines, scallops and aerial perspective familiar from various Nevada styles. *The Remembered Mountain* (1962)

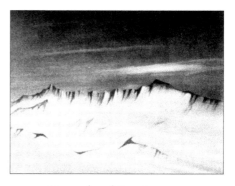

Remembered Country, 1959

returns to the stark silhouettes of the *Silent Mountain* series.

There is a mountain painting of unknown date which may have been made in Connecticut. Its wavelike, snow-capped mountains exhibit the enduring Asian influence in Robert's work. He even signed as if with a Japanese signature stamp, or hanko. Perhaps he was thinking of Hokusai's well-known woodblock print of waves.

Untitled (wavelike mountains), date unknown

There are three Connecticut mountain paintings featuring high contrast flat planes, the three progressing toward a formal essence: *Desert Land* (1960) isolates the flat planes; *Iron Hills (East Jackson Range)* (1960) further abstracts the formations; and *Stones of Drogio* (1961) carries three-dimensional abstraction to the verge of losing contact with representation. Walter bought *Stones of Drogio* when it came to Reno for the 1964 retrospective, on installments due to heavy expenses fixing up the red house in Virginia City. "I can't think of another painting," he wrote to Connecticut, "yours or anyone else's, I've so much wanted to have around for permanent looks-at since *Silent Passage*. Simplicity, endurance, monumental silence." In 1978, when Robert was exchanging thoughts with Ken Robbins about a possible third portfolio, *Stones of Drogio* was on Robert's list. "Those patient stones!" he wrote, "—waiting

Desert Land, 1960

Iron Hills (East Jackson Range), 1960

Stones of Drogio, 1961

for the final explosion of stellar light to swallow them up. I see it as a statement of patience: God knows what He is doing—the fires of Genesis burn in the downward sun as well; all will be rekindled anew."

Dark Range (1962), Robert's wedding gift to me, is also on his third portfolio list. It belongs to another cluster of paintings, from 1961 and 1962, where Robert pursued the free angularities of the important pencil sketch *In Search of the Mountain* (1951). The freedom of the design and its detachment from the margins link *Dark Range* to *In Search of the Mountain*. *Workshop Study* (1961) also stems from the sketch, by way of the latter's Nevada follow-on, *Stone and Sky* (mid 1950s). *Workshop Study* apparently led to a series which includes *Invention*, *Invention 7*, *Inscribed in Black*, and *Notation on Wood*. These four works wouldn't bring mountains to mind if viewed without knowing the artist's history. All from 1962, they probably came as progressive simplifications, Robert's usual trend. They appear together on the same page of the 1964 catalog, in a different order.

And then there are Robert's cosmic paintings. In *Bea & Sherman* I remembered noticing "star clusters" among the clipped images on the bulletin board in Robert's studio.

Dark Range, 1962

Workshop Study, 1961

Invention (middle right), *Invention 7* (middle left), *Inscribed in Black* (top), *Notation on Wood* (bottom), all 1962

Ambient Planet, 1949

Dragon Nebula, 1960

Starblock, 1961

Untitled (cosmic), probably ca. 1961

Robert treasured a note with Einstein's minuscule autograph, and even celebrated Einstein's birthday. One of their TV necessities at Turtle Hill was to watch "all the moon shots and all the first astronauts," Rosemary told Benson; and that Robert "was fascinated by outer space." And told Growdon, "Why, the only thing that Robert would have given anything for was for us to take off in a space ship and orbit around our world and the universe!" This passion is akin to his quest for deep meaning in mountains. And like fossils of a common ancestor, there exists a style of his work showing the affinity of earthly mountains and astronomical space in Robert's development. Although still "narrow, elegant and tight" in the manner of Robert's other works from the late 1940s, *Anatomy of Space* and *Ambient Planet* anticipated both the form of *In Search of the Mountain* and the subject of the cosmic series.

Dragon Nebula (1960), perhaps influenced by pulp Sci-Fi illustrations, calls to mind the magnificent images from the Hubble telescope such as the Eagle Nebula of 1995. *Starblock* (1961) invites contemplation of the tremendous energies and distances of the universe. And there are two more cosmic works, probably from the same time, surviving as poor, out of focus photo images in the Caples archive. And *Secret of the Grass*

(1962), visually somewhat similar to *Dragon Nebula*, signifies that Robert, like Walt Whitman in *Leaves of Grass*, was pondering the continuity between the cosmic and the earthy.

Finally, there is an untitled painting of a leafy branch with daisies which probably dates to Turtle Hill. Robert painted many

Secret of the Grass, 1962

renderings of leaves during his last five or so years in Nevada. The most unusual was commissioned by Graham Erskine for above his mantel in 1958. That fall Robert first painted a layer of leaves on a 4′ × 8′ plywood panel, which he then left to season for a month submerged in a swimming pool at Bowers Mansion. Finally he painted the rest of the leaves and the branch. The panel has been donated to the university by Graham's son Peter. More typical are the leaves Betty Bliss rescued from the Dayton shed studio, which I now own, and the two of leaves reproduced in the 1964 catalog, *Holiday Leaves* (1953) and

Panel of Leaves (1958). All these of leaves, the Erskine included, seem bland, merely decorative—yet *Panel of Leaves* was the only work among those Robert contributed to the retrospective which he desired ever to see again, as he insisted in his cover letter to Walter's questionnaire. Why? The answer lies in the title he gave to a very plain print of a couple dozen lanceolate leaves, preserved as a photo in the Margaret Bartlett

Untitled (leaves, rescued from the Dayton shed studio), before 1959

archive. He called it *Dark Galaxy*, revealing quietly what he invested in the whole series: leaves are cousins of Robert's cosmic series.

If *Secret of the Grass* wasn't literally Robert's last painting during the early Connecticut years of 1959–62, symbolically it may as well

have been. It didn't help his morale that when he exhibited his "night sky" (cosmic) works at a local gallery, there were no sales. Robert was "devastated," Rosemary Junior told me. Earlier Rosemary Senior through her connections had arranged a show for Robert in a Manhattan gallery. It hadn't been well received, either. These frustrations in the art world of the East exacerbated Robert's chronic insecurity as an artist, he who at twenty-three had been "well known in New York circles" for his portraits, the *Journal* once boasted. In place of painting, Robert went back to his creation fable and a fourth attempt to express in writing what mattered most to him.

Years later, well after he'd truly put away his tubes and brushes, Robert looked back to blame his thwarted painting career on the shock of seeing his life's work gathered together in the 1964 retrospective catalog (he hadn't attended the exhibition). To Ken Robbins, 1978:

> I wonder, did I ever tell you what a disastrous event that 'Retrospective Catalog' was for me? ... It took over a year for that to blow me out of the water, but there hasn't been so much as scattered cordwood on the surface since.... Anyway, I surfaced with a make-believe beard, a parrot, and talking mud. It's been peaceful here ever since.

Here Robert implied that he continued painting up until the catalog overwhelmed him in 1964 or a little after; and that working on *Potter* then restored his peace of mind. But what Walter, in 1964, took from Robert's informational letter for the catalog essay was, as the essay neutrally alleges, that "[f]or the last two years" Robert had done "no new painting" because of *Potter*. Robert's letter had confessed to Walter about "The Book": "I did not want to confess it. It's the same old rubber Albatross—the Potter. He won't go away. It's a b------oh, the hell with it. I can't tell you Walter. It's just that it won't go away. I had to start it again.... It's finished now. And so, almost, am I." He also said, "Pictures for the book, yes. But not painting," and "these are not the images I want to see built." And said, "Rosemary alone has never asked me why I am not painting—never once. Even though I've asked myself the question, she never has. It has helped enormously. I'm highly sensitive

on the subject." That was 1964. "It's finished now," the book was, Robert supposed. But he went on revising for another seven years.

So either the retrospective catalog stopped Robert painting in 1964 or 1965, or *Potter* did a couple of years earlier, or perhaps a synergy of causes stopped him. Whichever, Robert eventually abandoned painting for writing. Not that his artist's conscience ever excused him completely from the lifelong imperative. About to depart for Sardinia with Rosemary on one of their many trips abroad, Robert wrote to Joanne: "I'm leaving a lot of unfinished work scattered everywhere about—(particularly one gut-clutching failure); and God will most surely punish me." That was in 1966, in the midst of *Potter*. A dozen years later and not for the first time he once again prepared his studio, so he informed me, but didn't follow through. In the meantime he released some of his unexpressed urges as an artist by designing and creating ingenious chess sets.

For the Christmas following Barbara's death in 1969, Robert in sympathy gave Walter a painting, *Spirit of T'ang*, dated November, the month of her death. Then in 1970, Robert built (as he liked to say) his last painting as far as I can discover, *Star Passage*. A copy of Robert's carefully prepared note to be affixed to the back reads: "'The dragon reveals himself only to vanish' Okokura Kakuzo—Contemporary Japanese author. Robert Caples: 'STAR PASSAGE' White tempura on a dark field. 1970." *Star Passage* appears in weak reproduction near the end of *Potter*, either created

Star Passage, 1970

for or borrowed for the book. As probably the last in Robert's series of cosmic paintings, it marks no particular progression from *Dragon Nebula*, *Starblock*, or *Secret of the Grass*, although painted at least eight years later. It was, however, the culmination of a different series of paintings, those with the word 'passage' in their titles. *Passage* of 1946 signified Robert's struggle to find a way out an impasse of negative

self-absorption after the war. *Silent Passage* of 1951 was Robert's breakthrough to the psychospiritual freedom of the many mountain paintings to follow. Now *Star Passage* of 1970 brought a different breakthrough, one that led Robert away from painting altogether.

The last work Robert offered to public view was a portrait, but unlike any before. Joanne had requested that Robert draw her portrait for the title page of her book, *The Schoolhouse Poems*. She sent him several of well-known Hollywood photographer Richard C. Miller's old publicity photos of the former starlet, then Joan Cullen, to work from. Robert needed two years to complete the job. *Portrait of a Poet, 1975*, an adaptation of one of Miller's head shots, made Joanne's seductively downcast eyes wide open to the world. And her flaring hair: distracted neither by the glamorous teenager's locks spread as if on a bed pillow in the photo, nor by the coiffure of Joanne's middle age, her cigarette-holder-and-over-the-shoulders-fur-stole persona, instead Robert treated the hair as a spiritual emanation, something seen in petroglyphs, to express Joanne's consuming love of life.

Portrait of a Poet, 1975

The Wind That Blows between the Stars

Caples went into "retirement ... no longer painting, but devoting years to writing and illustrating a children's book." The language of the Nevada Museum of Art website conveys the impression that *The Potter and His Children* inaugurated a radical departure in Robert's life. That's what anyone would assume who was unaware of Robert's trail of creation stories—the site's author, Joan Elder, hadn't delved into the museum's Caples archive. It's what I assumed before I went item by item through the unorganized materials. What they show is that Robert had long aspired to be a writer as well as a visual artist. In addition to the Manta manuscripts and the earlier Potter, I discovered a note to Robert dated "S.F. March 1938," which had accompanied the gift of a book from author William Saroyan. From the date I surmise that Robert had met Saroyan in the city and asked him to read the second Manta manuscript. "To Young Writer Caples," says the note, "this book of and about the mystery and magic of the Word, with all good luck."

"It's finished now," proclaimed Robert in 1964. In fact it was just beginning. In 1966, he sent *Potter* revisions to Walter for comment, and again in 1967. Then he attempted a hecatomb:

> One day in 1968 I remember spilling everything relating to the story into a cardboard carton and starting for the door—the hell with it, I said to myself. I can't take it anymore...and I really meant it. Too many confusions, too many threads in the story, all leading off into even greater complications, some broken short in the telling, others leading on forever, it was all too much for me.... And I gave up.

But he pulled himself together, downed some bourbon, "And the following day, still feeling somewhat shaken," he told the Houghtons, "began to unscramble the notes, maps, sketches and pages of manuscript, one from another." Walter would see a new manuscript in 1971. Robert's labor of love was a struggle right up to publication.

And it shows. While *Potter* is the most fully realized of Robert's four creation legends and the most cohesive, it is also the least readable: too

labored, too obscure, and at 215 pages too tedious, the occasional laugh and much simple sweetness notwithstanding. Walter the honest critic—who treated even protégés Robert Laxalt and Joanne de Longchamps politely but unsparingly—couldn't bring himself to be direct with his oldest friend. Walter called it "a beautiful job" and promised to send it to his agent, at the same time warning Robert that the publishing world would find it too long for children and too childish for adults. He tactfully steered Robert toward a vanity edition by saying that "private printers" would do a better job with the illustrations. He even offered to "go halves." The important thing, Walter insisted—surely thinking of his own struggles with Doten—, was for Robert to get the Potter off his mind, "so he'll let you paint again." Did Robert accept all this at face value? Walter "couldn't abide my book," he told me in 1977.

As Robert explained in defensive letters, he intended *Potter* for "the very young," but never "just." In outline the story is simple, you could say. As in "Manta the Earthmaker" and "Here Is the World," a creator, now the Potter, uses animal helpers against animal adversaries for the creation—in *Potter*, the creation of his Children, or humanity. Robert tipped the Native American lineage of his last creation legend by having the children cry out from the Potter's oven, "Let us out!"—the very words the "mother of all Indians" heard coming from her water jug before she released the first of each tribe, in the Washo legend of creation depicted in Robert's Courthouse mural. In *Potter* the newly created children become the Potter's shop assistants as he proceeds to create our World. But once again, the selfishness of the new creatures leads to a fall, so explaining the present state of things: the first humans of Native myth become divided into tribes; Manta's first animals get turned into land masses; and the Potter sends his Children to "Dream School"—the world as we know it—there to remain until they become compassionate, that is, transcend illusions to become enlightened.

The make-believe of this "easy fable" would, Robert was convinced, "make agreeable picture-sense to a child," while an adult could choose to "go somewhat behind the words to become involved in more demanding things, and that is entirely up to the individual reader, I wouldn't want to spoil the story for anyone." The underlying "implications" of the

story, he insisted, "dwell at some distance beneath the surface words, a little like obscure fish in a quiet pond." Had this simile been behind Robert's quiet aside about the hidden life beneath its surface when fifty years ago I stood beside him contemplating the pond at Turtle Hill? Unfortunately, the surface of his story doesn't give the same easy pleasure to contemplate. At the level of story the book simply doesn't succeed, as Walter realized but couldn't bring himself to say. Robert himself called the land of Eon "boring," yet didn't see the difficulty. The narrative is jerky, often uninteresting, and for a child much too long. For an adult, it isn't the "easy entertainment" Robert intended: it is not often enough entertaining, and there's no avoiding the all but explicit directive to go "behind the words" on every page.

So, what was he getting at? From Robert's esoteric synthesis of philosophy, religion, astrophysics, biology and more, Guy Richardson's review in the *Journal* sympathetically extracted a core promise of humanity's awakening from illusion into universal peace through love and compassion. If only it were that simple, but it can't be, not when "Bear Sugar" means DNA, or "'we've been through this sort of thing before—I guess we can face it again!'" stands for "the 'big bang' theory" spliced with Hindu/Buddhist cosmology. When Robert complained about no one seeming to get it, Dick Walton replied, "Your images are too broad for most to tangle with, and your implications are not easy for most people to navigate…. Both you and your father were masters of the unsaid and very few can cope with this." But like the thoroughly intuitive personality Robert was—someone who speed reads what others need spelled out—Robert couldn't see why people didn't get it: "What," he asked Morrie Jellett, expecting no answer from that quarter, "was required of me, I wonder, to make things any clearer?"

Robert "borrowed" from Rosemary, he told me, to have *Potter* published by Carlton, a vanity press. Carlton's product disappointed him bitterly. The type was "too light," the illustrations "muddy," "not rich enough," and the dust jacket "terrible." Robert sent Carlton his recently appeared first Indian portfolio "just to show them how well things can be done." It didn't help. Even when he paid extra to have them redo the "mandala," they took the money, then never performed the work. "[T]

he wretched outfit, they couldn't do anything right." These justifiable gripes went to John, Morrie Jellett, the Houghtons and who knows who else. In spring of 1971, President N. Edd Miller extended the Board of Regents' offer to Robert of "the honorary degree of Doctor of Fine Arts" to be conferred at that June's commencement in Reno. In declining, Robert said how pleasantly stunned he was. "Furthermore, your word came at a time when a lift of the spirit was most urgently needed." Without being specific, he told Miller he'd just been coping with a disappointment—he meant the proofs from Carlton: "It's like planning an eagle and getting a grebe." The print job was the grebe.

But the text itself, Robert still believed, qualified as an eagle. And it demonstrates how very differently from painting he related to writing that this man who seldom ever promoted his own art, and wished never to be seen as doing so, now publicized *Potter* himself without restraint. In the Caples archive are close to fifty letters about *Potter*, most from Western friends and acquaintances, to almost all of whom he'd mailed complimentary copies. "I have many, many letters about it," he complained to me in 1977, "most of them begin: Just imagine!—you've written a *book*! How proud we are to have a copy all of our own."

It was worse than that. A typical letter would say, I'm so glad to have your wonderful book, particularly the drawings, or, The drawings are wonderful and I expect to tackle the story soon. Not the response Robert wanted, for whom the drawings were emphatically secondary.

There was one letter, however, most earnest about the text. It came from acquaintance Morrie Jellett of Walnut Creek, California, who bought the book himself. Jellett's letter initiated an exchange lasting more than two years, with five letters on Robert's side totaling fifty-two long pages. To read them you would think Robert esteemed Jellett as an acolyte. Instead they reveal just how far for the sake of *Potter* the frustrated author would extend himself for someone whose mind he didn't respect, but who at least asked sincere questions. To Ken Robbins:

> [A] man in California has written me several letters—all of them questions— why this, why that? ... For example: 'Why a nine-mile-smoke?—why not ten?'... but, believe me, he is not a candidate for the 'Potter', ... he's a most

practical man. I think it's funny that he ever got the book—Morrie, of all people! It's all very friendly but it's a far cry from the calm give-and-take that I might have hoped for when the book was first published.

As far as I know, Richardson's in the *Journal* was the sole review Potter received. So instead, Robert advertised. He placed a small straightforward notice in *The New Yorker*, where his son Cricket worked selling ad space. He also placed a series of classified ads, for example, "Hang in there, Children, we're bound and loaded—but where were you when the goat exploded? Potter, Carlton Press, $6.50." Robert's ad copy says more for his whimsy than for his salesmanship. You might suppose there's an exploding goat in *Potter*, but there isn't. He should have consulted brother John the direct sales whiz.

Other steps Robert took to promote *Potter* were to design a poster, "The Potter's World"—for what application I don't know—, and to make a prototype for a globe map. Both poster and globe were based on the world map with land masses in the shapes of animals printed as the book's final page, itself an update of the quasi-Mercator projection in "Manta the Earthmaker" from 1934. He also got an estimate on the globe as a balloon. Neither globe nor balloon was manufactured, presumably because of the prohibitive costs quoted.

The Potter globe prototype

The globe is the culmination of Robert's engagement with cartography reaching back to his Belle's School wall map of Reno. It represents the awareness of space and spirit expressed with playful passion in *Potter* and contemplatively in his last, cosmic paintings, a hyperawareness which would outlast all his endeavors of art. Ken Robbins must have grasped this vital sensibility, for to Ken he began to intimate the dimensions of his large perceptions. In the exchange about coyotes and foxes, he continued:

> I'm aware of the coyote talk from many years ago. There were lots of them around Pyramid Lake in earlier days, especially on the far side of the lake.

Our foxes speak with the same frantic sadness, a wild moon-provoked sadness that seems to go back to the last Ice Age. Then, as suddenly as it bursts upon us, all is quiet again—but for moments after, the silence seems to dwell in a different dimension. It's a curious spell. I think we all know it deep inside, these are those far between moments when the roof no longer shuts out the stars.

But hyperawareness didn't immunize Robert against mundane vexation that *Potter*, his life's summation, went underappreciated. "Just think," he despaired to me, "five thousand copies were printed, four thousand six hundred copies were returned to pulp. Some were lost in the mail." There weren't the earnings to reimburse Rosemary, he lamented. "She says she wouldn't have it—and that's just as well too." When he received a letter from some reader gloating over typos, he groused to Ken:

> I doubt if anyone could guess at the wilderness of non-response that surrounds my slowly gathered together efforts to communicate through word and symbol; it's been a little like trying to start a fire with wet leaves, I suppose—but I thought they were all ready to be whirled aloft in a spiral of flame and legible smoke.... [W]ho has seen the shape of Myrios against the night sky or listened to the wind that blows between the stars?

The wind that blows between the stars—those far between moments when the roof no longer shuts out the stars—how much more enlarging and relatable these pure word sketches than Robert's dragging narrative and arcane allusions. I wouldn't trade them for ten whole *Potters*.

Sporadically Robert went on trying to interest publishers in a second edition of *Potter*, until finally giving up in 1978 after Scott Meredith, the respected literary agent, who praised the drawings as "superb," spelled out the book's deficiencies. Around that time Robert vented to Walton about some thoughtless, possibly hostile comments of Cricket's—substantively not very different from Meredith's, nor from mine here—which still stung years after the fact:

My son said, four or five years ago, "I read your book." "Did you?" I said. "You never told me." "Didn't I?" he said. "No," I answered. "You never told me." "That's funny," he said. "I thought I had..." Entire conversation. No. He had three words more. He opened a can of beer that went "spisst!" It was a sunny day, we were seated outside. "Too many names," he said. "It couldn't be helped," I said sadly, watching the son of a bitch swallow. "Too many concepts..." And that was it.

This Posthumous Feeling

In August, 1968, the Clarks finally moved into their dream house in Virginia City, the same "little red house" Walter had rented in 1957 to write in, he'd hoped, and to be close to Robert down in Dayton. Now, just weeks after settling in, Walter experienced pains so severe he had to withdraw from teaching that semester. To justify further delay on Doten, he notified Robert Laxalt that he was due for prostate surgery. "No signs of anything malignant, happy to say, but total time required apparently not readily predictable." Exploratory surgery discovered cancer. A second operation followed a week later.

Walter came through the surgeries and was doing all right, when he was blindsided. Barbara began suffering abdominal pains. That was in June, 1969. By September they knew she had inoperable gall bladder cancer.

When Walter wrote to Robert in August, he said nothing about Barbara's illness. Instead, he talked about "this posthumous feeling" that had intensified after receiving an honorary doctorate from the university, something "that has been growing on me ever since I started Alf." But as a matter of fact six years before Doten his friends the Kuehls heard him call himself a "literary zombie" with "a posthumous feeling," brought on by perusing an academician's comprehensive Clark bibliography—he was then about to turn forty-seven. And at fifty-four, he had already grimly joked to Robert about being ready for the "old folks home" because he wasn't writing. These premature anticipations had as pedigree the intrinsic fatalism inscribed in his stories, the fatalism caught by William Stafford's line quoting Walter, "'Things end that were good; | the big picture is always sad.'" Now Barbara's illness on top of his own brought fatalism to a head.

Not until two weeks before her death did Walter let Robert and Rosemary know that Barbara was ill and "in St. Mary's Hospital, enduring the late stages of terminal cancer." He asked them to send her "a few cheerful words." Himself, he was "getting along fine ... but please, Robert, not a phone call. On paper I can get by. The loud voices shake me up too much still—as they do Barbara." As if Robert with his

soft, musical bass would have been loud. Barbara died on November 12, 1969. Not until after the funeral did Walter write to let Robert know. Bob Clark puts the delay down to "the lack of the personal in [Walter's] everyday life.... Best friend," he insisted, "didn't mean the same thing with Dad" as it does for most people. That's probably so, and yet in 1971 he would write Robert many letters, rich letters, disinhibited then by the approach of his own death.

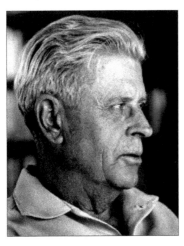

Clark at 60

He aged perceptibly. When Nick Cady called on him with Robert Laxalt on Doten business, they found the house in disorder, and Walter unbathed. Babs remembers some very rough times then. "And we'd be sitting there playing chess or something, and he would say, 'Oh, your Mom's getting dinner ready.' And I'd say, 'Oh, really, Dad?' And he'd say, 'Yeah, and you're using the can opener.' And that went on over several months." When Robert hadn't heard from Walter for a while he grew concerned and phoned Walter's sister Miriam, asking her to pass along the message. Walter replied by mail, thanking Robert, particularly for his "thoughtfulness in not phoning directly." He repeated things he'd already written. Then a month later he informed Robert at length that he'd appointed himself "Custodian of the Outer Comstock"—collecting trash on his walks—in almost the identical language he'd used in the previous letter.

It was in this state of mind that Walter accepted Robert Laxalt's invitation to write an introduction for the first portfolio of Caples Indians. Laxalt issued the invitation without consulting Robert, which was typical of a certain high-handedness on Laxalt's part in his dealings with Robert. When Robert protested the imposition on Walter, Laxalt replied, "He was not only willing, but eager to do it. And I know he would have been hurt if we had not asked him." That was in mid-April, 1970. By late June, when Walter hadn't followed through, Laxalt informed Robert that they'd decided to use Walter's essay from

the 1964 retrospective catalog instead. In the end they used an excerpt of several pages.

Along about then Walter had an angry run-in with Dick Walton at the Virginia City post office. The two had a history of animosity. Walton recalled the incident to Robert some years later.

> Walter Clark shouted "Name dropper! Name dropper!" at me [because] I'd mentioned the name of Margaret Bartlett, calling her 'Monty' as all had at one time. I ... had spoken out of mystical turn. Christ, how he was hung over that post office bench hanging on with what was actually one long last breath which went on too long like some of his chapters. I left the post office laughing ... wondering what the hell he meant that Margaret Bartlett had destroyed the life of Caples—his ending monologue shouted to the Postmaster General who surely heard him in Washington D.C.

I too wonder what Walter meant about Margaret Bartlett destroying Robert's life, and why he considered Robert's life destroyed. Robert's life wasn't destroyed. (It's a curious psychological twist that, soon after this, the unstable Margaret warned Robert in a letter not to let Walter destroy his life: "My concern is that he doesn't destroy you too, as he has me.")

Anger isn't surprising in someone coping with illness and bereavement, especially someone by nature prone to anger. The "crochets" and "wicked severity" of the failing mustang stallion in "The Rise and the Passing of Bar" portended Walter's own decline. He knew it about himself, that he was angry. As early as 1932, in *Ten Women in Gale's House*, he marked his own penchant for "mockery and bitterness." The "main emotion" in even his early stories, noticed Bob Clark, is "something like misanthropic anger. *City* is different, of course," Bob added, "but that doesn't count in a way." But even in *City*—Walter's least embittered work—Tim Hazard is given to "prolific flights of condemnation," grows "malicious," "heavy and angry," would "harangue," or turn "savage," "contemptuous" or "ferocious." Equally telling are those expressions of anger Walter wouldn't have registered as such. In the very first paragraph of *City*, in Walter's much loved paean to Reno and its trees, he misanthropically condemned treeless cities as "moribund," dismissing by implication the

life experience of their inhabitants. He passed that judgment explicitly in an interview the year before he died: "They don't know what a tree is," he snarled, those who adapt to life in "silly towns." Which is nonsense. I grew up in a silly town, Chicago, loving its trees, its arcades of elms over side streets, and not least its trembling cottonwoods, slow and shiny, their wormlike catkins fragrantly rotting on concrete sidewalks. What's more, if space is the visage of time—"distance became time," once wrote Walter—then a building no less than a tree can make the world real and the body present.

Walter "always had something to be indignant about," remembered Walter Brown, "the people around him were all a bunch of boob humans." Here was the dark underside of Walter's idealizing. Brown saw Walter as "completely blind to the whole love factor." Hard words from a friend, who also said that Walter's bright sparkling blue eyes "looked straight down into your soul." I think of Nathaniel Hawthorne's precept, that the unforgivable sin is to look into the human heart without compassion.

Some months after Barbara's death, Walter interrupted a really touching self-exposure of his vulnerable state to fume to Robert about the vehicular invasion of the Comstock by "the omnipresent God-damned tourist," who spoils "even the final privacies without raising his fat ass off the seat." A month later, he again inveighed sarcastically against tourists. And against "self-centered divorcees," and hippies protesting ROTC on campus. He once complained to the son of friends, a Sixties Berkeleyite, that the hippies were ruining Virginia City; the young man, Rusty Nash, replied that he'd read all his books, and was sure Walter couldn't really mean that? But he did. Peter Kraemer, coming of age then in Virginia City, took Walter the liberal Democrat for a "dour" rightist and "curmudgeon." Well before his illness Walter evinced undiluted hostility to the counterculture. In a 1964 letter to his son, who was contemplating a career of writing, Walter vilified "the scores of little self-appointed saviors, beatnik 'poets' and 'fiction' writers in S.F. and elsewhere, from the author of 'On the Road'—I forget his name—and so does everybody else." In a 1967 letter to Robert, he perorated at length against "Haight Street '*avant garde*'"

poets and the counterculture in general. Nick Cady told how Walter, looking out the window from the press office in Morrill Hall, would become exercised about students walking on the grass. No one in the least caught up by the times could have perceived leaving the paved path as a transgression. Bob Clark has said that his father "had a pretty violent temper." Not physical violence, "but his temper was something to be wary of." At dinner when I interviewed Bob in Helena, his wife Wendy brought up Walter's anger as something Bob and she had discussed. Bob then related the incident, to be found in Benson, where Walter as chaperon faced down some burly football players trying to crash a dance. That was when Walter was teaching in Montana in the 1950s. In Benson's version, Walter stood his ground and called the ringleader "Bub" to intimidate him. But as Bob told it at dinner, it was Walter's flying into a rage which intimidated the younger man.

The anecdote also speaks to Walter's physical courage, his lifelong virtue. The tie-up scene in *City* records his conduct during Reno High's then annual hazing scrum at Whitaker Park between entering freshmen and upperclassmen. Tom Wilson's oral history authenticates Walter's conduct: "[H]e just absolutely wouldn't give up, even when he was tied up, he was throwing himself around the ground in a frenzy, and finally Thurber Brockband took pity on him, and I did, too. We realized that he was goin' to hurt himself, and decided to untie him." Courage, and again rage.

The courage with which Walter faced death was mental as well as physical, if the two can be distinguished in that circumstance. His mental courage—what Bob Clark calls his "moral fierceness"—had conspicuously been displayed in the Richardson affair by his placing himself in the vanguard of vocal opposition to President Stout and by resigning. He dispensed tough criticism to students, expecting them to be as tough as himself. And never gave quarter on the tennis court. Jim McCormick played with him only once. He laughed about it: "It was one of the worst decisions I ever made!" Walter gave himself no quarter either, not with his failed efforts to produce publishable fiction, and not when his time approached. His role models for meeting death may well have been those emigrants he'd been studying for Doten, all those who

went West throwing their lives to the wind. Courage dovetailed with his native fatalism. "The beast has got me," he told Robert Laxalt. Walter Brown said, "There was a kind of strange rapport he seemed to feel with the little buggers in himself. Good for them. Bully. Suicide was never too far from his mind."

Perhaps rage—curmudgeonliness—was how he diverted self-pity, for if he had any, as well he might, he never showed it directly. The rage would eventually pass, leaving the courage and real acceptance. In a business letter to Robert concerning the first portfolio, Robert Laxalt added: "Joyce and I had a delightful evening with Walter in Virginia City a couple of weeks ago. He has made a remarkable comeback from his depression after Barbara's death, a testament to a hard core of courage. He is as alert and thoughtful as we have ever seen him."

That was in December, 1970. In the fall, Walter had become fit enough to return to teaching. But around the end of the year his worst symptoms recurred, now with bleeding. He needed another surgery. In his letters to Robert nothing was said to indicate the severity of his condition and treatment until January of 1971, when he let Robert know he would be "returning to St. Mary's for a third bout of whittling at my lower plumbing," possibly to be followed by cobalt radiation.

Memorable Salvage

Previously the friends had exchanged no more than three letters a year. Then in 1971, the year of his death, Walter wrote to Robert at least sixteen times. From Robert's side only the "Hang in there, Walter" card survives, but clearly he rose to the occasion.

February 14, while undergoing cobalt radiation treatments after his third surgery, Walter was being taken care of in a small apartment at the Chisms' in Reno, where he hoped to resume work on Doten, he told Robert. But he didn't. His letter conveys for the first time a readiness to let go. There's a sweet chattiness in the close observation of what his dear companion Dogette gets up to. The approach of death has released him, restoring some of that gentleness seen nowhere in his writings as in *City*. It may have helped that he was again permitted boilermakers. His only symptoms were back pain "and a certain boiled macaroni limpness."

February 23, he brings Robert up to date. He hopes to return home to Virginia City and drive himself down for "the burns and still have enough left to complete Alf Doten before he completes me." He sounds more like his old self, only without the old curmudgeonly bitterness.

March 3, Walter thanks Robert for a gift, then just three days later for another—short notes and gifts, mainly drawings, of a bird, of leaves, are Robert's way of opening his heart. Their etiquette precludes phone calls. Walter after two months has ventured out to a high school basketball game in Reno, and afterwards gone for drinks "with son Bob, Bob Laxalt, Ross Salmon and others, then a rare prime rib dinner." Here is presence and simple gratitude. In surrender he is ceasing to expect anything of himself, except courage.

March 15, he is back home, enjoying independence and the long views "down through Six Mile Canyon and out east at range beyond range." All that about basketball and dinner in his previous letter gets repeated. Then, bothered by something amiss, he confesses, "I am a very old man today."

April 6, Walter writes twice, first briefly to encourage Robert to accept the honorary doctorate and come visit, then to say that Laxalt

and Cady had just dropped by, ostensibly to discuss Doten, but really "as emissaries for President Miller" urging Walter to take up the cause, which he does: the degree would be a worthy honor for "Nevada's foremost artist"; the experience, he could assure him, was "really not that painful," he wouldn't have to say anything in public but thank you; the university would benefit from distinguishing someone outside the academic world; it would be a satisfaction to his friends and admirers. Any beseeching is on behalf of the university. His own wish to see Robert he expresses with simple, heartfelt directness: "Would like equally much to see you here." This was a change. Before, Walter had always pressed Robert to travel out, explicitly or else hinting broadly by evoking shared experience, especially Pyramid Lake: did Robert remember the Leonid meteor shower over the lake?—the water level is up or is down—he longs to forget today's world, "fry a couple steaks (one for you) behind the Pyramid." Cumulatively, Walter's invitations were importunate, some of them close to imploring in a way Robert might well have found off-putting. He would return to Nevada for the first time after a dozen years only when Walter's death approached.

April 8, Walter begins informing those outside his immediate family of his doctor's terminal prognosis. With Robert, he's slow to come to the point, misinterpreting Robert's notes and letters possibly to mean he is dying, too:

> The reindeer came from the Potter's house, speaking of Easter and the long trip home. But, in company with the messages brought by the other creatures before him, I am left wondering whether he is speaking of one trip or two. Did Miriam write you or phone you? Or son Robert? Did you read through my poor cover? Or have you bought the big ticket too. That is what is worrying me, Lordy, I hope not.... So perhaps we should be clearer. Yes, the doc gave me my one way ticket for the long voyage.

He alludes to Doten, but dwells on preparing his yard for spring. And, "There was a beautiful sunrise this morning, clear, slow and very quiet—silent—with the near hills dark and distinct of outline against it." He's saying he sees Caples mountains and is revealing his serenity

with death, his letting go. "Don't worry about me. I am not hit hard by the word at all. I knew it before he told me, long before." He thanks Robert "for the Panamints. There is a clock beside them, but it does no harm. I don't really see it anymore." He is leaving the world.

April 22, "Your letters have been wonderful," he humbly thanks Robert, "like a long visit with you at Turtle Hill." Robert is more conversational now, enumerates his concerns about Carlton Press, tells a funny story—this going by Walter's replies. When Robert again deflects the honorary degree, Walter, "saddened," allows:

> if book worries, or your painting, or reluctances about anything in these parts or concerns about anything in those—make the coming heavy for you, don't. The letters and the pictures have said it. They are a fine visit. It would be great to have you here.... But I have to admit that today I'm much less certain about going to Gordon's [Union Brewery] or driving the Scout to water. But perhaps that is only today. I have good days and bad days, and today has been bad.

He is winding down. The formerly verbose author will write six more letters to Robert, none exceeding a page, all with larger handwriting.

April 27, five days later he announces that he's been "deputed to put another big one to you," then guardedly he makes the case for those wanting Robert to paint Governor Paul Laxalt's portrait for the capitol gallery in Carson City. In the afternoon, Walter continues, he'll see his doctor in Reno, hoping to learn more precisely how long he has left.

April 28, what he learned from his doctor caused him to resign immediately from the English Department, he informs Robert by a single sentence embedded midway in a letter thanking Robert for the "People Crackers," a treat prepared by Rosemary which proved an "absolutely unprecedented success" with the finicky Dogette, whose behavior at a family dinner on the occasion of his resignation Walter described in detail with great affection, as if his own situation were of no particular interest.

May 13, Walter welcomes the very good news that Robert would be coming out solely to see him. Robert and Rosemary would stay at Miriam's, and that seems best to him, too, because of how poorly he

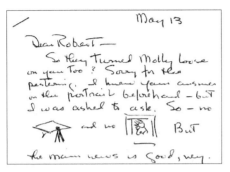

From Clark's letter to Caples, May 13, 1971

feels. The meds have knocked him off food, "even off the drinks if you can believe that. But I'll be done with that before you come." He answers Robert's concern about whom he might run into at the Union Brewery, "Really haven't seen anybody in Gordon's in three years whom you'd have to dodge. All is much changed."

Late May, Robert and Rosemary travel west, she to meet her new granddaughter Jennifer in San Francisco. Robert departs Reno before June 5, the day honorary degrees are conferred.

June 14, about a week back, Robert and John speak on their mother's birthday. Robert phones John:

> He told me about trip west to see Poo's [Rosemary Junior's] baby and Walter Clark. R & R flew direct from Hartford ... to San Fran. Stayed at Fairmont Hotel.... Robert explored San Fran, which is getting too much like N.Y.... After 1 day, Robert left for Nevada and stayed at the home of the Chisms.... Robert believes that no one in Reno knew he was there. Clark spends half his time in bed. He has pain in back and groin. Moves very slowly. Takes him 3 minutes to navigate a room. He talks only of small things. Rosemary came to Nevada for 2 days. Then they returned to San Fran and flew from there.

Robert doesn't tell John that Walter's dream of a journey back to Pyramid with Robert had finally come to pass.

Also June 14, Walter writes, "Dear R & R—This to Turtle Hill, in hopes you are there again ... all bugs overcome." Neither man had been in top form for the Pyramid expedition. He is "relieved, in a way, that the weather was ... dismal, and so absolved us from our lack (Robert's and mine) of noble effort. And Wadsworth and the lake and the drive home by the desert, were at least memorable salvage." So at long last Walter had returned to Pyramid Lake with Robert, but in company, both ill, on a cold, overcast day, maybe not getting out of the car. He ends, "Love

to you both, and it really meant much more to me than I had any way to show."

In the same letter, he tells Robert he is separately returning galleys of *Potter* which Robert had brought for him to proofread. He "liked the conclusion" better now, "though I must admit I fall far short of the Potter's faith in other and resolving worlds. But the Potter, I agree, must believe. Otherwise it would be as Conrad put it in *Heart of Darkness*, 'altogether too dark.'" Here is a simple, admirable statement that his and Robert's world views don't accord. And that his darkness has not been sacrificed for the partial peace won in advance of death. He has gone off all medications except over-the-counter analgesics and feels better for it. He is his own man again.

July 22, he has just returned from a week of chemo and cobalt. He thanks Robert for more of Rosemary's dog treats and for a drawing, it reminds him of *Silent Passage*, which he implicitly interprets as a meditation on death, as he may always have viewed it and as it may have been.

August 15, Walter's final letter opens in mid-dialogue,

> Yes, he's a fine owl, and I find myself listening to his soundless hooings often in the night, when I find myself often watching, also, the strange and growing luminosity—from a street lamp through slowly moving black locust shadows—of moon and cloud above the little man in the boat. Both talk to me quietly with a most useful kind of unspecific knowledge.

He thanks Robert for another drawing, reports doings in Virginia City, then closes: "Me—I like owls and moons and clouds. Love to you both—Walter."

Walton sent Robert a note that "he'd better get here quickly if he wanted to see Walter." And letters about Walter's condition from Bob Clark, Babs and Miriam "shook him." John's diary, September 25:

> He is flying to Reno from Hartford. Avis car to Virginia City—Silver Dollar Hotel—or if no room there—to Carson City. Then drive to home of Walter Clark who is worse than on Robert's previous visit and who is not expected to recover. Robert does[n't] even know for sure if he will be able to see Walter....

Robert feels that he should be available if Walter is able to talk to him. Walter represents the West. Walter and Robert had a lot of plans—climb Mount Job, etc. They both loved the desert. Now these plans are out.

Robert flew on September 28. He and Walton met up in Virginia City, where Robert photographed Walter's headstone, commissioned after Barbara died in 1969, already in place with Walter's name and date of birth inscribed. Other old friends Robert renewed contact with included Edith Holmes and Hazel Erskine, and also Walter's doctor and ally in the Richardson affair, Fred Anderson, whom he saw at the Chisms'. Robert planned with Joanne de Longchamps for her to show him her converted stone schoolhouse "under the high-breasted peaks of Mount Rose," as she described it, "twenty minutes from trembling leaves here and gone," but on the day appointed Robert became ill and wasn't well enough for the drive, and he left before they could get together.

Babs and Bob were Walter's daily companions and caregivers. Babs and her family lived in Virginia City. Bob had been about to join his family in France for a year but instead delayed to care for his father. Before the finish, Walter "was even kind of cheerful," Bob told me, "was enjoying the vacation." He could forget about Doten, about writing altogether.

"He was released from his burden at last and could simply sit and enjoy sports on TV." Benson's summation, while not inaccurate, doesn't go to Walter's elevation of awareness and recovered sense of self.

When things got bad, Walter's brother Dr. David Clark supplied morphine, more than enough to keep him comfortable: enough for a fatal dose should Walter request it. Injections were administered by Babs's mother-in-law Nell Salmon, a nurse, who lived nearby—she would have been the angel of mercy. Benson:

> Then came a terrible night when, as his son recalls, "the pain was much too much for Dad's mind and body to bear, overriding any morphine dose we would have dared to give him, and he went more or less out of his head, tearing out IV's and things that were already attached." That's when he had to be taken to the hospital in the county ambulance, followed by ten days of heavy sedation.
>
> He died on November 10, 1971, at age sixty-two.

Gaining Height against the Wind

Monique Laxalt, then sixteen, took the call from Nick Cady to let her father know that Walter was gone. When she conveyed the message, Robert Laxalt blanched. "It's the end of an era," he said. Laxalt saw his mentor Walter as of a different stratum of time. Now, forty-five years later, Walter Van Tilburg Clark and Robert Laxalt are names usually paired in the same past, as they already were when recognized for being the first honorees of the Nevada Writers Hall of Fame, inducted together in 1988.

Walter and Barbara had selected grave sites in the Clark family plot at Reno's Masonic Cemetery, commonly thought of as part of Mountain View Cemetery. But when the time came, they chose the Masonic Cemetery in Virginia City, their home. Although Walter wasn't a Mason (PEN and ACLU were his organizations), his father had belonged, and the children of Masons have burial rights. Walter and Barbara lie in a bordered plot toward the top of a rise, where Babs' parents-in-law Clint and Nell Salmon later joined them. The view of town and mountains is superb.

Robert didn't attend the funeral. He had said his goodbye. Pallbearers were the Salmons, father and son, Wallace Stegner, Walter's peer if not close friend, novelist Herb Wilner, Walter's student in Iowa and then friend at San Francisco State, and Charlton Laird and Robert Gorrell, Nevada colleagues. In an essay revisiting *City* two decades on, Gorrell described the winter-like day of the burial, when "just as the casket was lowered, the sun broke through. And from the ridge of the nearest hill a flight of birds, perhaps starlings, swooped above us, wheeled, and disappeared to the north. Everything seemed to stop as we watched."

Among the watchers was Joanne de Longchamps. A year later she recalled those starlings in an anniversary poem, "Late Letter to Walter Clark," which closes:

> Those who met on a snowhill
> for the opening and closing
> of cold earth given you,

> spoke of deep grayness—then
> of stasis mercifully broken:
> the sun rayed out in a skyspace,
> catching a sudden spiral
> and wheeling wings granted
> the healing movement of birds.
>
> Invisibly, a great hawk soared
> and scattered the starling flock:
> "gaining height against the wind ...
> the light golden in the fringe of his plumage."

The weather's "deep grayness" and the "stasis mercifully broken" by sun and starlings refer metaphorically to Walter's painful years of creative failure, now "mercifully" ended. The symbol of Walter's essential soaring spirit, the invisible, imaginary "great hawk," evokes and quotes Walter's story "Hook," which recounts the triumphal life but hard decline and demise of a hawk.

"Hook" is lauded as a *tour de force* of narrative point of view, where Walter empathetically rendered the experience of a nonhuman creature without anthropomorphism. With only a few lapses, Walter did an outstanding job of minimizing anthropomorphisms through most of the story. But then the point of view breaks down when the soaring hunter-warrior is reduced to an earthbound life of mere survival. Driven, I believe, by a profound subconscious prescience of the course his own life would take, Walter attributed negative, all too human moral emotions to Hook during the downward arc of the bird's fate. Hook feels "disgraced." He experiences "shame." He rolls in the dust "ignominiously" to soothe a wound. The sight of a tree he used to perch in heightens the flightless Hook's "humiliation." Then Hook's final fight to the finish with a farm dog is "enough to burn off a year of shame."

His failure to publish new fiction was Walter's shame, and cancer was his farm dog. Ill, he did transcend shame, "'gaining height against the wind.'"

Nevada's Second Most Famous Recluse

Carl Heintze, the would-be Clark biographer, thought me "fortunate to have known and been able to keep in touch with Caples. He appears in his later years," understood Heintze, "to have been almost inaccessible to others." Robert's obituary in the *Journal* styled him "Nevada's second most famous recluse, after the late Howard Hughes." Such attributions reflect and fortify the legend of Caples as a man of extreme isolation and disconnection once he left Nevada.

More accurate, though, is Joan Drackert's summation. Robert had known Harry Drackert since the 1930s, and Joan since 1946 or so. She said Robert was "shy, something of a loner who didn't enjoy crowds, yet retained a close, thoughtful, lasting relationship with those he considered his real friends."

Even before the two trips to see Walter in 1971 changed things and Robert began thenceforth to travel out to Nevada, Nevada friends saw him in Connecticut—Walter and Barbara (twice in 1960, while Walter held a fellowship at Wesleyan); Edda Houghton, with Sam and then with daughter Monica; Babs and Ross Salmon; Margaret Bartlett twice; Gordon and Sue Chism; Mrs. Marjorie Knickerbocker (a Virginia City friend); and Graham Erskine with his son Peter. All these at least. Also, Robert preserved financial and professional ties with Nevada: a checking account which he never stopped using at the First National Bank of Nevada in Reno where Rosemary kept her trust account, and dealings with galleries such as Newman Silver Shop, Luginbuehl's, and later Stremmel. But Robert's strongest link with Nevada from Connecticut took the form of the letter.

This means of keeping Nevada vital truly fructified after Robert began returning to his spiritual home in 1971. I know of 11 letters Robert wrote to Nevada that year. He would live for eight more years. Tallies of his Nevada letters known to me for those years are 10, 29, 30, 32, 15, 24, 24 and 22. And these counts do *not* include the lost "flood of little notes and drawings" to Walter in 1971, nor the scores of notes that doubtless accompanied *Potter* West, nor the steady stream of illustrated story letters to Norinne Buck's grandchildren, nor the considerable Bartlett

correspondence, nor lost seasonal greetings. There must have been many more letters to the Chisms than the few extant. Miriam was a particular friend. And others to his architect friends (Vhay, Hellmann, Erskine, Crider), and recently I found 6 to the Drackerts, and who know what other friends, and add business letters to the bank, and to galleries, and to Robert Laxalt at the university press. Just the letters for 1971–79 tallied above without all these others average about one every sixteen days, and each of these brought a response or was a response.

The bottom line: from when he first returned to Nevada in 1971 to his death in 1979, it's safe to say that, on average, no week went by without mail between the "inaccessible" Robert Caples and Nevada.

Robert's major correspondents for all the Connecticut years, ranked by the known number, or in the case of Monte Bartlett and Walter, the estimated number of items he mailed to them, were Monte (near 150), Joanne de Longchamps (64), Kenneth Robbins (including business letters) (52), Walter (in the 40s), the Houghtons (35), and Richard Guy Walton (17). Minor correspondents were Jack McAuliffe (concerning the university's centennial medallion) (about 12), Bettina (about 10), myself (living then in Oregon) (8, plus those not saved before 1976, and some not saved after), Morrie Jellett (concerning *Potter*) (7), Norinne Buck (not counting the many to her grandchildren) (6), Nancy Jackson (and her husband) (at least 4), and Peter Stremmel (at Stremmel Gallery) (4).

Margaret Bartlett. Monte married twice (Millar and Thornton), but never got over a romance at twenty-three or -four with seventeen-year-old Robert. "My love," she proclaimed fifty years on, "there isn't a day you won't find me waiting still." To get closer to Robert she cultivated Walter. When she histrionically offered to bequeath Walter her notebooks "written almost entirely to RC," Walter refused in alarm. His distaste grew with her imbalance until he ceased communicating. Meanwhile, she'd been sniping at Walter in borderline rants that got no rise from Robert ("I shouldn't blame old Water Closet Clark for not having any beauty except yours—I haven't either"). Eventually her "interminable crucifixion bit" made Robert impatient. Monte was, he explained to the Houghtons, "both tormented and tormenting":

> I call occasionally. It's a helpless feeling—and hopeless. As you know, she identified herself most strenuously with the book [*City*], but only, I'm afraid, for reasons of the Caples tie-in—the story and her own story are diametrically opposed. I doubt if she has ever broken through the words to discover anything of moment or meaning to her.

Robert didn't mention to the Houghtons the years of letters from and to Monte, his innumerable postcards with artistic and philosophical bon mots. If he was motivated by compassion, there is also in his messages real tenderness and openness, abetted by their long-ago sexuality and a certain affinity with her irrationality. And he genuinely appreciated her devotion to *Potter*, sycophantic as her adulation of his genius comes across. But as Monte grew more unhinged, his letters normalized toward the almost parabolic, sometimes transpersonal wisdom of his other late letters. Familiarity came to cost too much.

Joanne de Longchamps. To Joanne Robert displayed his delight in art, nature, and language. He would be chatty, or remember childhood, or play with words, or even repeat a dirty joke. With all correspondents he spoke less readily about downs than ups, but least with Joanne, wishing to be seen as joyful. He was reticent as with everyone about his illnesses, but didn't hesitate to bring up death, always contextualized within his larger views. And he rhapsodizes about the special beauty of his former lover: "You are truly a knockout, if you don't mind my oversimplifying a power of presence that could turn the whole Aegean upside-down." After a phone call, he wrote that thinking about her meant thinking about

> just about anything from stars to jade-green frogs, I guess—and a lot of things less easy to fix in the mind. Like the slow rotation of the sun and its spaced-out family of luminous dust. Or our pond this morning; it looks like something poured by Corning Glass, and holds more promise of renewal than a thousand books. So you see, your voice, far away in fact, was very near in truth, and I am grateful.

Still, Robert was also friends with Joanne's embattled husband Galen (who would divorce her), sometimes addressed letters to both, and

always spoke lovingly about Rosemary. After Robert died, Rosemary sent Joanne an envelope from Robert's papers labeled "de Longchamps," containing in no order many of his little slips of paper with quotes, etymologies (real and fanciful), significant numbers, bits of ancient cosmology or legend, uninterpretable word associations—Robert's stock of sequins to decorate his letters to Joanne with. Much as for Monte, he was a beacon of spiritual clarity for the brilliant, troubled alcoholic Joanne.

Ken Robbins. Nick Cady, then chief editor at the university press, was almost incredulous when I told him about the large correspondence between Robert and the press's business manager. Ken, said Cady, was after all "a low key, not very interesting kind of a guy." About half Robert's letters touched business matters, but even the straight business letters were colloquial, philosophical, appreciative of life. He talked about the seasons, weather, and living things at Turtle Hill and out West, comfortable subjects with someone toward whom Robert wished to be warm without being intimate. But increasingly over time Robert opened some of his inner life to Ken. "The two men admired each other very much," and Ken, a former journalist, "was a very good writer," his widow Emily told me. Robert dwelt on *Potter*, at length or by referring to images or characters as a kind of key to his world view. Ken's negative reports concerning Northern Nevada's growth drew from Robert lamentations about development there. After a return in 1973, he wrote with a curmudgeonliness to rival Walter's that "a condition of vulgar and irreversible ruin had been visited upon the entire region." But for all that, Robert always talked to Ken yearningly about return visits, wished for, planned, imminent, canceled, or actual. They met at least twice with their wives for lunch at the Drackerts' Silver Circle Guest Ranch, in 1973 and 1975, and possibly also 1972. Ken had converted to marry Emily, an observant Catholic, and was "a very moral person" himself, says Emily. That's why Robert didn't invite them to evening drinking parties at the Silver Circle.

Samuel G. and Edda Houghton. Sam Houghton (HOE-ton) was the Boston-born, Harvard-educated "son of an industrialist," daughter Monica told me. In Nevada he got into mining and politics, was also an

editor, prolific board member, fair watercolorist, and conservationist. His wife Edda, later Edda Morrison, was equally active, especially in arts organizations. Both were Caples friends and collectors since the 1940s. Robert's correspondence spans thirty years. And there were phone calls. The letters are neither long nor short, the longest six pages, to Edda. Robert spoke of travel, children (Cricket twice), grandchildren, nature, Nevada, the arts. He enclosed many offbeat clippings. Spiritual and philosophical concerns are hinted at but not elaborated. He would explore experiential nuances such as the passage of time, but not say much about his emotional state. And yet he would, infrequently, interject "I am awful" or "All is stasis here." Was depression in the fabric of this strong friendship? Monica cautioned that her parents, both highly literate, spoke in terms of "ennui" but not "depression." Life is "sad" but also a "humorous condition, to be mocked" in ironic answer to the sadness. "That's the nature of the friendship as I came to understand it," concluded Monica. Her interpretation makes it possible to hear the ironic humor in "I am awful" and "All is stasis here," both of which occur jarringly and otherwise incomprehensibly in, of all places, Easter cards. On the other hand, there is a letter from Robert to Sam unmistakably written out of depression, about "this condition of unpeopled aloneness," "this paralysis of being," "this block of stillness at center."

Richard Guy Walton. Dick Walton saved a 1946 card from Robert, then several items in the early 1970s, then after a lapse there began a real exchange in 1977, starting with Walton's postcard from the South Seas. For Christmas in 1937, Robert had given him *Moby-Dick*, inscribed "For Moby-Dick Walton, the Sparks whale, from the Bell Street Ahab." "It was Caples who had an idea what Melville would become to me," Walton explained to Joanne. "So, when I got to Bora Bora I worded a postcard in the style I had learned from Robert and his father.... 'When gliding by the Bashee isles we emerged at last upon the great South Sea...........'" I can almost hear Robert intoning Walton's satirical words in the voice that had told the story of the old man who demonstrated knapping for *Arrow Maker* at Topaz Lake, "And so we left with two great sackfuls of groceries, and I took him to the car." Or almost hear Robert at his desk silently intoning the Potter's voice, sonorous

like Byron's, "[W]atch for the round-faced moon—you'll see your picture painted there, O Rabbit. Indeed, your picture is fixed on the moon's bright face forever." The communications initiated by the Bora Bora postcard exhibit an appetite on both sides to reminisce. The old friends also vigorously traded ideas as in days gone by, two independent thinkers who had always respected one another. "I find it interesting," Walton said to Robert, "that we manage a closeness at this hour, perhaps a closeness never before achieved between us." The letters slowed in 1979. Robert wrote his last to Walton on July 27.

Deep Hunger for Pathless Aridity

As the opening of the 1964 Caples retrospective approached, everyone was asking Walter would Robert be there. "I tell them I think not," Walter wrote to Robert, then prodded in his big brotherly way, "Everybody wants to see you." That was the wrong thing to say to an introvert with boundary issues. Even in declining the honorary degree in 1971, a chief reason Robert gave—verging on the inappropriate in a business letter to a university president he didn't otherwise know—was "a persistent sense of inadequacy" which would cause him to "swoon away" before he could reach the podium to accept the parchment. But "I love Nevada with all my heart," he assured Dr. Miller. "I hope to return to it someday."

Whatever the causes of the inhibition that kept Robert from returning sooner, the visits to ailing Walter before and after commencement day broke the ice. Publication the year before of the first Indian portfolio, *The Desert People*, might have contributed to the thaw, and likewise even the offer of the degree, a gesture probably recommended by the portfolio's popularity. And then *Potter*, finally out that year, gave Robert reason to revive an array of Reno connections as he distributed his work, for once without a "sense of inadequacy." Also, the birth of Rosemary Junior's daughter Jennifer in San Francisco gave Rosemary Senior a reason to travel west. And something else that may have freed Robert to return to Nevada, sad to say, was Walter's death. With Walter on the scene and himself absent, didn't Nevada perceive him as the person Walter had fixed on the page, not as he perceived himself? Robert "didn't particularly like the treatment he received" in *City*, he told Bob Clark, because Walter "romanticized" him, especially in the Death Valley and Luigi's bar scenes—that's what Robert "accused" Walter of, of romanticizing, in an "argument" they had about the book, says Benson.

Romanticizing is mild next to the candid rejection of Walter's misperception of him which Robert conveyed to me in 1977. After obliquely rebutting my own romantic image of him, based on the Death Valley episode, he continued:

I've not looked into Walter's book for many, many years.... It's just possible that Walter's character Black has more going for him than I. This could be. It was certainly true of Walter. The less I responded like Black (I'm sure he was thinking the chess board) the less real I became to him. I suspect I finally became an unsettling fiction to him, an upsetting betrayal of good sound invention. It's an odd way to let someone down but I'm afraid I did.

"Odd," I would think, for both men, the models for Black and for Hazard.

Robert, Like Walter, had an attitude about the fixative of biography in any case. When it came to himself, Walter "was against biography on principle—on [the] literary principle, anyway, that it wasn't important to the work." Bob Clark conceded this to Robert almost a year after Walter's death, in a letter composed with real or rhetorical reluctance to transmit Charlton Laird's invitation for Robert to contribute to Walter's biography for the essay collection Laird was assembling with Bob's assistance. Bob shouldered the assignment of approaching Robert, in spite of his father's adherence to the anti-biographical slant of the then prevailing New Criticism, an adherence which really reflected Walter's governing desire for privacy—the predisposition which caused him not to save or later to destroy personal papers. Bob assured Robert there was "no 'family' pressure on you to comply," at the same time trying to make it as easy as possible for Robert to do just that. What they wanted wasn't "literary assessment" but biographical fill, things Robert alone would know. He could make a conversational tape. Or Laird could get some colleague in Robert's vicinity to conduct an interview—"possibility," wrote Robert in the margin. Or a questionnaire could be worked up. Or "nothing at all," offered Bob, next to which Robert wrote, "best," and that's the option he chose. Informed by Bob's letter that "an earnest graduate assistant" proposed a biography of Clark as his dissertation, Robert wrote "drown him"—on Walter's behalf, knowing Walter's aversions, but also, I'm sure, wanting not be probed and characterized any further himself in a Clark biography—as his life eventually would be in Benson's.

If so, I worry what he would say about all this—not "drown him," I hope! This book is my gift to both men, but especially to Robert, in return for all his gifts of beauty and wisdom still sustaining me in my

old age. Also in return for *Dark Range*, and for a small earthen oil lamp from Egypt—a hint of light in matter it took me most of a lifetime to catch. The only gift I can remember giving Robert is a chess set I made for him out of tufa crystals from Pyramid Lake. It upset me when his next letter didn't acknowledge the gift. I can see now that he may have taken it as an intrusion into private domains. Unless for some reason the chess set never reached him. I never brought it up.

Robert did later speak to Bob about Walter for Bob's work on the Laird volume when Bob visited Turtle Hill. And I think I can comfort myself that Robert had some ambivalence, some normal vanity about his biography being set down, or else why would he have cooperated with Walter by letter and questionnaire for the retrospective essay, Walter's second go at Robert's life? Unless it was to correct the record. If so, Robert was disappointed. Several months after receiving the "lousy" catalog and reading Walter's essay, he commented to Bettina in a letter that "in looking for me under rocks I think Walter forgot to remember the times we've stood on mountain tops...." And while he may have been more candid than that to me about Walter's portrayal of him in *City*, what he told Ken Robbins in 1978 about "On Learning to Look" was scathing. After describing his distress at seeing his life's work epitomized by the "dismal art" and blaming the corrosive action of that experience for deterring him from further painting, he addressed the essay:

> Walter's profile of me was a little like holding Adolf Menjou under water [the voice self-assured, undeterred and unintelligible, I suppose Robert meant]. However did he come up with such a strange and frantic jargon to represent my speech? I can only think it came from his having talked more spaciously than he could endure to listen. It's just possible that, hearing ahead, he never found it necessary to listen to more than the first word or two of a sentence. And even silences lose their meaning. I still wonder who it was he sought to know—a curious projection.

My sense is that Robert's avoidance of Nevada had to do with Walter and his misperceptions. Robert had grown away from Walter. While the bonds of youth and mutual influence never extinguished, he distanced

himself from someone who didn't know him for himself, so Robert believed, and perhaps never had.

What's certain is that Robert did journey back after Walter's death. Here is what I know.

In late 1972 or January, 1973, Robert met with Jack McAuliffe in Reno to discuss the university's centennial medallion, and also saw Ken Robbins.

Robert and Rosemary made it to Reno for a week or ten days in late April or May, 1973. He consulted with Jack McAuliffe about the centennial medallion again, and accompanied Rosemary to confer with her account executive at the First National. They spent Easter with Rosemary Junior and Lanier and Jennifer in San Francisco.

There followed two years of hankering for Nevada. Four times in 1974 trips were planned, then cancelled. Along the way he wrote to Sam Houghton, "I have it in my heart and head to walk the moony flats of Panamint Valley—maybe not far, but far enough to hear the silence closing in; I have a deep hunger for pathless aridity." And again to Sam, "As you know, the West exerts its profound pull at all hours—especially when the moon is a slender crescent aloft in a pale evening sky. It's then when my breath is caught somewhere behind my heart; and I'll never get over it." When Sam urged him to "Come West" (as in "Go West, young man"), Robert answered, "Say, did I ever tell you that Horace Greeley actually lived in this house? This very acreage was part of his estate.... I think that's sort of funny, don't you? A sort of cosmic belly laugh." In January, 1975, he assured Ken, and he was right, that

> we will make it this year, that I know.... It isn't that my thoughts don't travel west every dawn-gray hour—they do. I have two windows that stare at me each morning, two paling lids that lift ever so slowly, reminding me that the house we sleep in is tilting towards the sun. Often I think how dark and still it must be above Pyramid Lake at this same hour; or sometimes, that great valley [Smoky Valley] between Austin and Tonopah!—how cold and remote under the stars... but west, always the thoughts drift west.

Robert made up for 1974 with two memorable visits to Nevada in 1975. The first came near the beginning of summer. He saw Ken and Emily

for lunch and Joanne and Galen for evening drinks at the Drackerts' Silver Circle. The highlight of the trip was a sail on Lake Tahoe with the Hellmanns—that's when he was photographed adoring Rosemary with the Bozo nose. To Ken:

> Say, we sailed around that island in Emerald Bay just a few days after we saw you both.... [T]ilted (as the earth should be) at a steep angle, we slid around the island in great style, sailboat, ice-cold drinks [Robert had vodka], late afternoon, what could have been nicer? ... And you would have been sent by the steepening light on the mountains to the immediate west—like something lifted up from Yosemite. It was a holy sight.

On the second trip of 1975, Robert and Rosemary arrived past mid-September. By early October Robert had prepped with George Herman for their radio interview, lunched with Ken at the Bundox, and been to the Needles at Pyramid Lake. Then came the best part, a flight over Pyramid with David Chism, who had piloted a refueling tanker during Vietnam. David says Robert and Rosemary were like kids, whooping it up in the back of the plane as he climbed and dipped over the lake, took them down to the Carson Sink, over to Virginia City, then back. From Connecticut, Robert wrote thanking David's parents Miriam and John for their hospitality, and especially thanking David for the flight: "Our heads remain filled with sunlight and magnificent clouds—and Lord! Those wonderful hills! It was a fabulous day. I only hope we can do it again—my eyes remain hungry for every mountain peak, every rounded summit, every valley." Two years later, the ecstasy of that adventure still lingered when Robert replied to something I'd written about Pyramid:

> [A] friend took us flying. A delightful plane, sturdy and eager to skim the bottoms off clouds. Now that was a day. David guided our flight along the entire shore of Pyramid. Lord, but there were places, hidden places—the whole northeastern shore; wonderful. Up one shore, down the other. We were exhausted just from looking. It occurred to me that pelicans can never look up—I began to feel exactly like one. How many angels did we miss?—

beyond counting. The next day only the spell of blue was left. Blue, and the meerschaum white of bird palaces. Your note tells me that you were there, and that is good. I'd love to share a time with you on one of those farther shores.

Next came an early summer trip of several weeks in 1976. They stayed with the Drackerts one last time at the Silver Circle, which was up for sale. Robert saw Walton in Virginia City, and Ken twice in Reno. And the Grahams came over from San Francisco. Meet-ups with Peter Stremmel and Morrie Jellett didn't materialize. July Fourth they spent in Austin with Bob Clark and his family.

Back in New Preston, Robert received Norinne Buck's thank you for a photo reproduction of *Hands at the Bar* he'd had made to replace her stolen photo of it. Robert's acknowledgment is where he revealed his old private joke about "dePreston, disConnecticut," adding, "I feel better about New Preston now—but it did take a whole year to come out of chlorophyll shock. Another thing, we get West more often now, that helps too. Besides, I so love Nevada that ten thousand Connecticuts couldn't budge its well-remembered mountains from my spirit."

The trip to Nevada he'd just returned from proved to be his last. After that, trips West were wished for, even planned, but none came to pass. His failing health stood in the way; and Rosemary was ever bent on transatlantic travel.

Ten Thousand Connecticuts

November 19, 1979, John Caples wrote in his diary, "Robert died Sat Nov 17 while D & I were in London." Robert was seventy, just shy of seventy-one when he died.

He had been living away from Nevada for over twenty years, ensconced with Rosemary in tasteful country luxury relieved by travel abroad almost every year. But as he gladly confessed, "ten thousand Connecticuts couldn't budge its well-remembered mountains from my spirit."

What else can be known about Robert's life in Connecticut?

He still loved cars. He got a sporty Plymouth Satellite. Rosemary bought an MG, then later added a Bentley convertible they named Phoebe. They were afraid to drive Phoebe into New York for fear it would be stolen or stripped—those were high crime years. When they viewed New England colors and covered bridges in the fall, they took the Bentley.

They had dogs they were attached to.

They traveled to England, the continent, the Middle East, but mostly Greece, Rosemary's passion. Robert found all the travel an enlarging delight and a burden.

And it took a physical toll. His health had never been good. By the time he reached Connecticut he was a semi-invalid, with death never far from his mind.

He resumed drinking, with a time-out in 1964 on account of amoebic dysentery picked up in Israel. He drank fairly heavily at times, at others not. By 1978, probably due to poor health, he had adopted the routine of a single vodka martini with Rosemary at five.

What else? Friends. Robert's best friend in Connecticut was Eric Sloane the landscape artist and illustrator. Apart from the Rolands, connections of Rosemary's I believe, Sloane and his wife Ruth were the only non-family guests at Rosemary Junior and Lanier Graham's wedding at the Stanhope. Robert played chess with Sloane, enjoyed his jokes, and endured his proddings to paint. Sloane's own prolific art Robert admired less than he did Sloane's success. Of Robert's other

friends in the East I know next to nothing, only the letters from Eastern addresses he received for *Potter*, in all about a quarter the number from the West, eight from Connecticut, the rest from Maine, New Hampshire, Pennsylvania or Virginia. So he had connections. I don't recognize any of the names. And in a 1979 letter Robert spoke casually of "Someone who had dropped in to say hello." He was no Howard Hughes, no recluse.

What else? Family of course. There were Rosemary's children, Rosemary Junior and Denny. They grew up, had troubles, married, had more troubles, had babies, made visits and were visited, and outgrew their troubles largely.

And Cricket, Robert's own child. Facially he looked like his father and was as handsome—"gorgeous" and "a ladies' man" like Robert, says Rosemary Junior, who "had a crush on him." Unlike his dad, Cricket never married. He had a slight accent, difficult to identify but not affected, says Denny, apparently the result of spending his formative years with his mother Shirley in Hawaii and a variety of other places. When Robert arrived in Connecticut in 1958, Shirley was living not far away with her fifth husband Sandy Griffin. Cricket lived with Shirley when home from Lawrence University in Wisconsin. Until then father and son had had little or no contact. Either Rosemary Senior was responsible for bringing them together, or else Cricket reached out, not Robert.

Cricket graduated with a degree in English in 1961, then enlisted in the Navy. He served in the Mediterranean, missing Vietnam. Following discharge in 1965, a conversation with John helped him decide to enter journalism. It worked out that he sold ad space at *The New Yorker*. He liked the job and did well. He had a city apartment and a house in Connecticut not far from Turtle Hill—quite a fine place, judging by John's description. A trust fund from Shirley gave him a small income and access to the capital at age thirty-five. Meanwhile Sandy Griffin had lost and squandered Shirley's huge fortune, leaving her no longer rich by her or Cricket's standards.

Cricket and his childless Uncle John had a significant relationship of their own, which included Shirley. Uncle and nephew saw each other

quite frequently. Cricket sought John's professional opinion of the letters he wrote to sell ad space in *The New Yorker* (John found them "great!"), while Cricket would listen as John, still nervous about public speaking, practiced speeches. Cricket told John that "he craves family but not on Shirley's side.... He likes to see Robert and me." "When Robert first sees Cricket," Rosemary told John's partner Dorothy, who told John, "he likes him for a few hours but then gets tired of Cricket." At Turtle Hill they grew "fed up with Cricket continually dropping in without warning, especially at mealtime." In 1969, Cricket was seeing Robert "almost every Sat," he told John, but "he is not allowed to go to Turtle Hill unless invited." Robert had little or no interest in acquainting his son with the family history. When John showed Cricket a drawing of Byron by Robert, "He said Robert had never shown him [a] picture of father!" John, not Robert, gave Cricket an album of family photos. All the same, in his "Things That Matter" envelope Robert saved a birthday card from Cricket, which opened, "Dear Father," and closed, "Best wishes from a grateful son to a lovely human being."

After about ten years Cricket left *The New Yorker* to partner in a wind energy start-up in Litchfield. He was the marketing manager, working without pay. When John reviewed a promotional booklet Cricket wrote, he found the product plagued with bugs. It was a farsighted concept, but too far.

The failure seems to have undone him. He turned to drink, and had to sell his house and move in with his mother and Sandy Griffin, where the three drank heavily together. About a year before Robert's death he took a solar power job in New Hampshire. But shortly after Robert's death he came down with cancer. Cricket died at just forty-two.

And John, the older brother to whose diary I owe many of the facts in this chapter. The brothers traded visits, John and Dorothy to Turtle Hill, Robert and Rosemary to John's summer house in Brewster, New York not far away. John always came to Thanksgiving and Christmas at Turtle Hill, until he started going to Florida for the holiday season. "Robert phoned" is a fairly frequent entry in John's diary. In the last decade it was almost always Robert who phoned John. When, in 1971, John took stock of those who had benefitted him in life, Robert's name

didn't make the list of twenty-three, which included both of his parents and both grandmothers. Yet it's quite clear from the diary that Robert meant more to him than he to Robert. While he judged Robert, he couldn't help looking up to him as the better person. A recurring dream he had about Robert says as much. In one version, John, Robert and Byron drove to "the nice cool woods," where Robert was free to enjoy himself, "but father and I had to return to the hot, unattractive city." In another version two decades later, "I saw Robert sitting in my office. He said—let's get away to the woods. I said—all right—as soon as I get this work cleared up."

And that's the gist of what I've managed to learn about Robert in Connecticut, that is, about the circumstantial framework of his life leading up to his death. His inner life is best illuminated by his letters, which as I've said perhaps too often display the beauty of his mind in late maturity. I've intended all along to bring more of Robert's letters to light. Earlier drafts went straight from "Rosemary was ever bent on transatlantic travel" to a chapter stacking examples and excerpts of the letters in chronological order, with a few snippets from other people's letters and from John's diary interspersed where they tied things together. The letters, I thought, spoke for themselves while also providing a sort of open lattice of narration sufficient to bring Robert to the end. It worked for me, but less well for others, in particular one of the anonymous peer reviewers for a press which eventually rejected the project. That reader liked the book and recommended publication, and s/he offered several valuable suggestions for revision, which by and large I've followed. One suggestion was that I do something about the "unusual chapter" of excerpts, which "contains excellent material" but "feels," this person said, "dropped in and not adequately integrated." She or he thought it needs to be "introduced or contextualized in the author's voice." S/he was right. So that's what I'm doing with this chapter, as best I can.

And now, Robert's letters.

His Own Landscape

1973, March 6—Robert to Joanne de Longchamps
Last night we were sitting by our fireplace up in the main house ... , Rosemary knocking out something big on her embroidery easel ... stitching away like mad. And there was the fire, wrapping itself around the logs, a great mare's tail of bright flame being pulled and twisted in the black updraught, all fed by seasoned applewood. And the sound. What a wonderful sound! Like some medieval banner being blown and pummeled by a stormy wind. I loved listening. I thought how these are the same, the wind and the flame. And the ocean too—how all speak with the same voice. Just who can tell, with closed eyes, the wind from the fire? Or when the fire is caught full and steady, the flame from the sea? And I thought, moving somewhat deeper into the sound, can it be that we, all of us (but I was thinking particularly of you, Joanne, and of me) are both brought and carried away by not one angel, but three? The angel of fire I can plainly see. The angel of wind I know and believe in. The angel of water eludes me as an image but rushes in most convincingly as a force. What a lovely way to arrive!—what a splendid way to go...who could ask for better companions of the way? I like it. I like the whole thing. Not pain, no—but the stillness that comes after. And today, the wind again! Lord, it's blowing out of the northwest with a huge tree-bumping thrust—and it's a wind that has that curious quality of sadness in it, the thing that makes the heart ache with a kind of homesickness for things only half-remembered—or perhaps for things never known at all? You know just what I mean, I know you do. Do you think these are the three angels passing overhead, is this all something remembered in the blood, forgotten in the bone? And this curious sadness, this sense of home beyond the wind, do you think the trees are aware:—whatever it is they say, they say it wonderfully well under the wind. But it's that curious mixed sense of melancholy and fulfillment, both at the same time; it's this that I'm trying to tell. We've known it all of our lives, I guess—the whole human race. And for all I know, the sad-eyed monkeys as well—maybe the monkeys most of all? Like the wind, it's a condition of spirit that gives, and takes, at the same time.

1973, August 16—Robert to Ken Robbins
After our return here [from Nevada], I sank slowly into the most oppressive kind of haunting melancholy.

1973, September 27—Robert to John Caples
"It's a terrific world" [postcard from Greece].

1973, November 22—John Caples diary
R & R arrived noon [to John's country house] in small MG car. They preferred to sit inside by grate fire. Rosemary had champagne, Robert had Heaven Hill [bourbon], D & I had Scotch. We talked for ¾ hour. Then Robert & I walked the path, then at 1:15 we started for L'Auberge. Cricket arrived 2 P.

1973, December 4—Robert to Ken Robbins
Where were the Greek Islands now? ... I am locked in a kind of stillness, not so bad a thing really, but lonely.... [T]here is, and has been, a haunting spell of homesickness for the Nevada desert. I suppose, deep inside, the Aegean blue and the blue of Pyramid bring all sorts of echoes of a remembered music of the mind.... [There is] a place on the island of Patmos—a place I called Temple Rock, and climbed every morning that we were there; it was like a part of Nevada broken loose and lifted to the sun.

1974, February 1—Robert to Joanne de Longchamps
Anyway, Joanne, you know the drift of my thinking: the unspoken outweighs the spoken, always has, always will.... I have something to tell you about my dying over the years that becomes more and more amusing, the more I think about it—it's building up to something too funny....

1974, February [no number or weekday]—Robert to Joanne de Longchamps
I got to wondering if that bit about my own demise (as they love to say on policies), that is, how I get laughing, just thinking about it, would be amusing to you at all? Maybe not. I happen to think it's funny—certainly it's not something I'm about to share with Rosemary; that is, the funny part. No, I don't think she'd see it my way at all—we love and need each other very much, and the Lord knows there's nothing funny about being left alone; it's just the way it's happening that cracks me up.

1974, April 24—Robert to Joanne de Longchamps
I told Bob Clark in a letter some while ago that I was going to retire this year

and take up painting. I have a lot of clippings here about art materials and some data on 'How to Mix' books, everything I've always wanted to know about mixing paints but didn't know where to turn. It could happen. Now wouldn't that be something if I hung in here long enough to knock out just one painting that I could live with?—what a way to go!

Please be patient with me, Joanne. I'll try to make that portrait-drawing happen, I truly will. It's just that I'm scared of drawing—it's been a long time.

1975, February 25—Robert to Joanne de Longchamps

I mean, there you are in the new gallery, selling things, and here comes "The Schoolhouse Poems," and above all, the sound of you, positive and expanding right along with the Cosmos. No big surprise to me. I think you're terrific, always have. And I hear you about the portrait drawing or whatever. I hear you. But will anything ever happen along, do you think? Will the dying artist wrestle one more likeness out of the ether?—I like to think so. ... I really like it here.

1975, February 26—Robert to Ken Robbins

Lord God, what a case of flu! ... I have been in the Potter's oven. I suppose it is all part of the pattern of life; one gets on in life, has more fingers than years left—and then gets fired. It's really brutal, if one wanted to take it personally. It doesn't occur to me to take it personally.

1975, March 15—John Caples Diary

Robert phoned ... just to chat and to see how I'm getting along.

1975, July 25—Robert to Joanne de Longchamps

I'm guessing we'd have a memorable time no matter where we met—but the Drackert 'Ranch' was perfect. And we'll do it again. That's for sure, I know it in my heart, we'll do it again.

... [T]he whole truth comes down to a matter of so few words. Didn't I say it? "Love looks well in the middle of the page." And so it goes; total brevity, I guess, would spell a total everlastingness, a vibrant point of ultraviolet light hidden at the center of all creation: one elegant God-spun photon equaling one multiverse.... I don't necessarily equate daylight with brilliant, searching light, I sense it almost more fully at early morning than at high noon. No one

could guess, looking at the bulk of my paintings, that I knew daylight from the bottom of the Con. Virginia shaft—but it's true. I was aware of light as a presence, even in those overcast days. It's only now, as my eyes bring me less of detail and my knees welcome the less steep approaches, that I begin to truly sense the intrinsic light in the darkest stone. That sounds a little fancy, I guess, but what I'm trying to say is not too easily put into words. I've known high noon to be a kind of midnight. The daylight I'm thinking about is as much in the form as around it. It has something to do, I think, with the beginning, the middle, and the end. First light or last, these two become one—who knows? Maybe day is night turned inside-out, it could be as simple as that.

1975, probably August—Robert to Joanne de Longchamps

Portrait of a Poet, 1975 ... This is a far cry from what we both may have expected; believe me, the drawing seemed to take its own direction. I certainly don't ask that you use it—only that you know that I tried.

1976, January 8—Robert to Miriam & John Chism

And here, in my own corner of the barn, is the rooted sage, the treasure of the year.... The single thing that works against success is the altitude ... The only compensatory circumstance I can think of is the vacuum in which I find myself most of the time.

1976, August 7—John Caples diary

Robert said that Robert Clark looks 5 years younger than his 36, but Cricket looks 5 years older than his 36. He shows the effect of his worry and disappointment about the wind rotor.

1976, August 27—Robert to Morrie Jellett

I may find myself involved in trying to paint just once again—all I ask is one decent image, and that could take all year! ...

... I know what it's like. I very nearly gave up a saffron-colored ghost in Athens a few years ago [to] wretched hepatitis! It's a rough experience and leaves one feeling very much at the end of the road. I'm not entirely sure I ever came back all the way—and maybe that's the way it is with these things. It could be that's how it's always been with the big Mix-Master; we're promoted

along the road against our will—always being promoted a little more steeply into Eternity, a little nearer the place of beginning light....

And that's our pilgrimage. I couldn't have written the Potter if I'd not known this to be so. That promised pilgrimage to the place of Arising, the place of Ariel, [is] not fanciful to me, not in its deeper sense of ultimate meanings. That bridge of stars is built for everyone who ever was—none can fall from it, none can choose not to follow it.

We glimpsed the stars and the moon for a brief time the other evening.... Later, in the course of falling off to sleep, I got to thinking about the moon, how supremely beautiful it was, sliding along above those dark masses of wind-driven cloud, like a great silver ark, floating free from its perch on Ararat.

And, as I rebuilt the image in my mind, it was borne in upon me once again that the Lord is much too involved in his Creation than to leave half of his story hanging in emptiness, unsolved, unreckoned with. Who has ever read the moon as pure silver on one side, a buffalo chip on the other? The moon is a bright miracle in the round; it has a dark side only to us. And isn't that true of life itself—and death? As with the moon's changing faces, aren't these two truly one? And neither face less wonderful than the other—if only we knew the great Design!

I suspect it's right in there somewhere, a great field of Power, touching all things, sustaining all things, informing all things—and, like the wind, caught by nothing.

We can sense it, I think, spiraling slowly in a limitless ocean of stars. And then, even as we watch, the image changes, the whole geometry changes—God becomes a single point of light, Creation a crystal. But nothing falls from the big frosty wheel—not so much as a single atom's worth. And that, I think, is the reassuring part—the breathtaking (and breathgiving) continuity of being.... I'm sure that this was what the Potter had in mind on that last day—the day he jumped up and scared the poor Parrot so, the time he shouted, 'Shall the harvest be less than the promise of the field?' He knew it might take 'a thousand times a thousand years,' he also knew the roar of the Solar Spirit, the lion pounce of the Light to come—he'd heard it in the wind, 'The wind that blows between the stars.' He'd seen the magic name written in white fire, he knew—and rejoiced in knowing—that deep inside every sentient being there is a sense of awareness, a sense of everlastingness that is at one with the Giver. This, I think, is the supreme miracle of them all—that all is of one substance: turnips, mice, mountains, stars and men, all of one cosmic dust.

I'll admit that babies blown to bits in Belfast, bodies washed ashore in Lebanon, all the elaborate butcheries of the world would seem to contradict this blind faith of mine. I would have been hard-pressed in the hold of a slave ship, no doubt about that! But I'm speaking of something for which no adequate language has ever existed, something so deep inside that terror has never found a home there—and it's inescapably ours, whether we seek it or not, a place of all-encompassing serenity, truly a place of new arising. I'll confess that Dream School has more than its share of nightmares, no doubt about it. It could be that the pain is the cost of admission, who knows? It's a punishing price, all right. Sometimes more than the trip has been worth—though I should hate to believe this. I couldn't believe it—I like it here.

1976, October 26—Robert to Miriam and John Chism
We are so surrounded by scattered color that we go sloshing around the place like rats in cornflakes, kicking up a lovely sound.

1976, November 26—John Caples diary
Robert's birthday. R & R were due [in Brewster] at noon. Got lost on the way.... Rosemary invited us to ride in her Bentley. Very smooth ride. Beautiful dashboard of dials, etc, beautiful red leather upholstery.

1977, January 31—Peter Stremmel to Robert
Would you ever consider resuming your painting and drawing, and having an exhibition in our gallery? ... You are still quite well-known and widely respected out here, and such a show would be of great local importance.

1977, February 4—Robert to Peter Stremmel
Oddly enough, I've been thinking a lot about painting recently—even went out and bought a lot of brushes. They look very new, and they scare me a little. It may be that nothing whatsoever will come of this restlessness—but this is a promise: should anything happen along, it's all yours, this year or next—if there is any merit.

1977, March 22—Robert to Joanne de Longchamps
I think of how bones have a way of dissolving into stars, this takes some of the hurry away, right? And how!

His Own Landscape

1977, June 6—Robert to Joanne de Longchamps

I stop here to say my most favorite of all words—love. Was there ever a better?

1977, July 21—Robert to Ken Robbins

It most certainly is not that I do not wish to paint—never that, I promise you. More accurately, it's that the Lord has been using me as a somewhat inferior brush in knocking out His own Landscape. It may be that He's about through with such a stubbornly slow instrument—but I hope not, I'm all for one more cloud. If only we could be born with wide open vision! So much precious time is lost—I mean in learning to see the simplest things.

1977, August 15—Robert to Joanne de Longchamps

I strenuously resist going to Greece this year—even for a short stay. I guess I resist going anywhere these recent months. I think it has something to do with the clock putting on sneakers some time ago—the thing has been following me down here [to the studio] on clear mornings.

But still, the West remains a lively pull, it just remains to be seen how things go. I only hope that 'go' is not going to be spelled with a capital 'G' in my case, I really like it here. Lord, there are moonlit seas beneath our feet, a whole flock of Perseids streaking across our heavens at this very hour; what a place!

1977, August 26—Robert to Peter Stremmel

I lay awake for two hours, thinking. And, as I lay there, two mice at the far end of the dark room debated immortality. I think they were using sign language mostly; at any rate, I missed the punch line. Something about "which lighteth every man..." and that sounds like John to me.

And then, and this was the pretty part, I heard a most remarkable bird. The morning light was just beginning to tell in the room, rather like the gloom that must prevail in the stern of the Andrea Doria, when a single bird sounded a single clear note in the woods to the north of our house. It was a note of purest silver. Believe me, I've never heard anything quite like it before, and God knows we have a thousand birds around here. There were seven or ten notes, each one precisely the same, each wonderful tone precisely spaced apart by exact intervals of holy silence. It was as if the first moment of morning had magically produced Krishna himself, the dark god with the silver flute.

Now I will never forget that gift of inner stillness as long as I live.

... I *like* it here. I've devoted the better part of two years just hanging on to the planet. I mean to stay. Nor is this determination born of any panic. Far from it.

... I'll write you again in a few days—you deserve a more substantial letter.

1977, August 30—Robert to Peter Stremmel

A long quietly spent weekend at home has put the birds back in the trees where they belong and has sent the mice back on their incisors—so why not me to mine? ... Anyway, let's see if I can chew my way through to a little clarity. All right, let's take bite number one. If one can make a 'decision' that has a "probably" in it, then I made such a decision several years ago; I decided that I'd probably not undertake to paint pictures again. One reason, and an elegantly compelling one, was that, basically, I don't like pictures. I find an open wall more richly prefigured with drifting images than any abruptly interrupted space. Now it takes only bite number two to uncover a more uncomfortable truth behind this somewhat simplistic conviction: the lumpy part is that I came to distrust and regret my own pictures—or 'paintings' I should say (just to get away from Sierra Furniture). I really began to wonder. I thought to myself, do you truly know what you're doing? The answer was a sprawl of contradictions. I pressed the questions even closer: do you know how to do what you do so unevenly? The answer was a long-delayed no. Well, Christ, I thought, if a man doesn't know what he's doing, and couldn't do it well, even if he knew, then why does he presume to offer his work for sale? Because he must survive. Even the mice dig this one.

Now for bite number three. Rosemary and I have discovered a peaceful way of life in New England; what with planning everything very cautiously, that has made it possible to attend to our long-delayed schooling. And this embraces not only each other, but everything from the spidery roots of unusual flowers to the vast white clouds above the most hidden away Greek islands. Believe me, and I say this almost secretly to you, the world has opened up for us both as it never did in earlier years. I feel I must keep this very close to the vest because I am wary of any great display of fulfillment, even if it be a modest one. I point to nothing here except the sky.

Now for a rechew on bite number three. Since we have managed to become part of the landscape here in our extremely quiet way, and have survived

comfortably through the long blowing winters, me with my endless books, she with her love of music and home, I am long since spared the need to raise thirty dollars before the nineteenth, or else... But you see what has happened?—one is liberated into even more punishing doubts. What do you do with a painting that's halfway good?—or three-quarters good. Or plain lousy? God tempers the pot-boiler to the hungry goat.

And are you good for one more bite? It came to me a couple years ago that things were beginning to crystallize out. (I choose that word with the utmost deliberation.) I began to see the rocks of Monterey more clearly here than when I sat on them, twenty-five years or more ago. I began to hear the wind in the stone, high above Ruby Valley, more clearly than when I switched off the motor of my semi-destroyed car, just to listen. I know you must be weary of the old Eliot bit, but where else, or what other words, will serve us as well?

> We shall not cease from exploration,
> And the end of all our exploring
> Will be to arrive where we started
> And know the place for the first time.

He really knocked it out there, I think. So here I am in New England, for God's sake, hearing the wings of pelicans, forty feet above their shadows. They above their shadows, not me above theirs!—though, who knows?—that may be the more accurate reading.

To answer your question, I haven't painted anything yet that I like. To be even more precise, I haven't painted a Goddamned thing. This, however, doesn't mean that a bash of things won't happen along—I need a couple of years to wind it up.

Shalom, Bob

1977, October 11—Robert to Tony Shafton

It's been a low time actually. Some tests were run that proved that I still have animal blood. I didn't think so myself, I really began to wonder. It pumped like blood, but it didn't seem to be carrying anything—just whoosh and plunk, whoosh and plunk—and some profoundly wearisome dreams. Oh, lots of nice people but the rooms kept changing shape.... But a four-week headache, just enough to snug up on all the fancy strings at the back of the neck, has dragged me down. Now I'm on a drowsy medication and feeling pleasantly remoted....

Then you require of me 'to say in words' just what is wrong with me. Lord, Tony, I can't even put into words what is right with me; I dwell at the pot-end of my own personal rainbow—I look toward heaven for the larger signs. Who, for God's sake, truly knows what's wrong with him? ...

Well, so it goes, and love remains, I think, for all who love. And that is good, right?

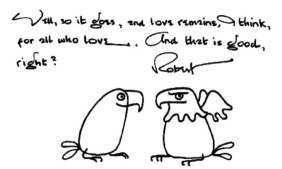

Caples' letter to the author, October 11, 1977 (detail)

1977, December—Robert saved a newspaper article on end of life euthanasia

1978, January 12—Robert to Tony Shafton

We've had a difficult time, Rosemary and I—the flu.... Our New Year's was memorable for its simplicity: Kleenex and champagne.... I am a psychic mess, inside and out. I can't make anything happen in my head that doesn't wind up with a sneeze....

I've just reread your letter. It's a little hazy as to how—I mean, in what regions of approach—I am to answer you, on your side of your letter or on mine. There seem to be two shores to graze upon—and a river of darkly luminous prose in between. In short, how many goats are we? And are we black or white goats, I wonder? I like to think that there is a shepherd who will pipe us home—I'm probably asking for too much. Or, at least, too soon. I hope it happens late in the evening of our lives, at a time when the sun has what I have come to think of as its cathedral slant. That, I have come to believe, is the loveliest time of day. It's just as well I like it, the time is fast upon me.

Did I tell you that I've cleaned this place up, this 'studio' of mine? It is stripped clean, or nearly so, and has become an accusing finger. I walk in

here only to find myself on the defensive.... It was a comfortable shambles before, now it's strange to me—strange and unforgiving. I've uncovered an old command. I've upended a mummy. An ancient jingle of mine drifts back into my thinking: Case and jar have this in common—they hold what's left of Tut-ankh-amen... All that I know is that I'm actively uncomfortable down here now. And I did it all myself. No, that's not quite true. Well-intentioned people, one man in particular, kept prodding at me to 'get going.'

I was at peace with my own spirit, a self-made failure; now—and in this eleventh hour (not always next to midnight) I am become a fugitive in my own sudden wilderness. Not the wilderness that it was, certainly—but the roof, like my hair, is gone.

Things—and I know this beyond any doubt—will never be the same again. That's how it is, Tony, and that's how it has to be.

I'm glad the carrot cakes were baked [by Rosemary for Christmas gifts] before all this happened! Wasn't that wonderful cake?

A later thought was, "if this can be done with carrots, think what the Lord might do for us!" I'm still waiting. The condition is one of love and sad attention, fear, mingled with uncertainty, rather like the Virgin Mary. You [being of Jewish ethnicity] wouldn't know.

Caples' studio at Turtle Hill

1978, February 14—Robert to Tony Shafton

I've done it, a case perfect, right out of the books job [Book of Job?]; the plug is pulled, the lights are out, the whole machinery of self-determination

is destroyed: worm gears, Universal joints, ball bearings, the whole damn machine is shot. And I did it all by myself—with, of course, the initial shove from that eager gallery. God damn that agreeable person for triggering this shambles. I am stalled right in the middle of a rising tide of guilt feelings. And none of this was there ten months ago. Nor has it been so bad as in the past five or six weeks. Now my very dreams are going to hell, crowded with busy strangers who have 'things to do' and have no time to hear me. My peaceful wilderness is being black-topped. I couldn't thumb a lift in my own obsessions. My room down here is almost tidy now. Perhaps when I die, which can't be too very far away, they'll say, "How very neat he was!—and look, those brand-new brushes, all standing there as if he'd just stepped out for a moment..." I'm glad you like it, lady. It's people like you, with their damned imitation birthday-date books, who have destroyed it for me. Yes, people like you who say, "You mean he hasn't painted for—oh, no! Not That many years..." All right, Midge Polyp, it just so happens that I don't like pictures very much—especially on walls. I'd much rather do a still life on you than trouble an innocent wall. And while we're at it, why is still life two words, stillborn one? Are they trying to tell us something? Jesus, why didn't they leave me alone. I was just beginning to fold my bones for a long downward glide; a Cosmos, turned inward upon its self-sustaining self, yet always expanding, was just beginning to make comfortable sense to me. I had a nice place here. Now it's, its—I don't know how to say it, room, head and heart are starkly accusative, I am become the Ancient Mariner, damned by his own shipmates. I think it's no wonder, nor any great loss, that I can't write a letter. There's no news in this predictable ruin.... Traces of nausea, some confusion of spirit, a wasting cough, depression, anxiety, feeble gestures toward the head, as if troubled by gauze. The signs are all there. I'd say it's a matter of time.... I only know that I wanted to say hello.

1978, March 7—Robert to Tony Shafton

[A] neural lump is developing at the base of my skull, neatly situated between the top vertebra (the atlas?) and the skull itself—it is truly sharply uncomfortable on trying days, nor does it respond to any analgesic in my possession. It's a damned shame, because I was just going to get into painting—now this! It only shows how foolish it is to plan ahead. I mean, here are all these panels, ready and waiting—and the brushes! How eager

they look in their shiny-new tin cans, as if ready to be plucked into action. But there's this bright ring of fire that comes, now and again, to dance in the left eye. And a hand over the eye doesn't help much, the bright ring remains, about the size of a rat's halo, I'd say, maybe a little larger? Can you imagine trying to paint through that?

It's rough luck, but I'm not going to rage against it. It's all because of the year to come, I guess (my last), I imagine everything will have cleared up by then. The thing to do with what's left of this year is to get the images clear—inside, where they matter. That's what I mean by clear; the impalpable in focus until that's taken care of, right? Maybe I can read this delay as a blessing after all. The pain that flares up in my lower right abdomen (the one I mean to discuss with the doctor) is no more than a bauble of discomfort compared to the hunt of beauty out of reach.... I apologize for such a random telling. It has to do, I think, with want of normal sleep. Once the muscles in my legs stop cramping up—what causes this, I wonder?—I should be back in more familiar territory.... I'm very grateful that you will never answer this letter of mine. What with your devotion to scatological summation. I'm guessing it would make pretty steep reading, even for a punctured masochist.

So I will cherish your silence while, one by one, these several pains subside. Actually, it's all my father's fault. He said, "You are a Caples—and a Caples never fails." It's one of those rare cases where a mother is not at the root of it. She said, "A lean horse for the long race," and then, all bones, she died.

And now, just to prove that I am still an artist at heart, "How are you?" That's what my painter friends say just before they hang up. Maybe you'll tell me after my next letter? For myself, it's been difficult going, as if it mattered!

<div style="text-align: center;">Love, Robert</div>

Chess? Yes!

1978, March 8—Robert to Dick Walton

Painting for me? Painting has been at a standstill for many years, a gate swung shut on a much-believed-in path. When I saw that I didn't have the ability to build what I most fervently believed, when the light eluded pigment, I stopped. Not in a day, of course, not even in a year.

... I sense I'm beginning to die, and that keeps me a little more lively these days.

1978, March 28—Robert to Ken Robbins

I don't know how to tell you how delighted I am that the decision was against the painting portfolio! And especially so if the emphasis on Virginia City still persisted.

1978, April 7—Robert to Tony Shafton

I wanted you to know that Spring is truly here. The hills and wide valley to the west tell the whole story. I love this season of the year. And who doesn't?

One bird. Just one bird in the earliest grey-blue hour, sings a most remarkable series of clear, prolonged notes, like a tiny Krishna on his flute. I heard the same magic notes last year, the same time, the same month, the same tree. I went to the window yesterday morning, a window upstairs and north, hoping to glimpse the bird—or god?—but could see nothing but the big shadowy trees in the half-light. I don't know why I should have felt compelled to see the creature. I think I shall never try again; to hear is all that one might properly expect of such a hidden, motionless hour. I like to think the bird signals new beginnings to the world in a time of restless wondering. I like to think the bird addresses himself to us both (what are miles to magic?) and to all who watch the darkness of the morning light. So, as I say, it's Spring—a season of foreverness.

Which reminds me, how are you doing hylozoically speaking?

Good-by and love again,

1978, April 18—Robert to Dick Walton

I took my own life back in 1964—or was it 1965? I forget. I only know that things began to march into a valley of quickening light after that. Believe me, there's nothing like killing yourself for getting away from a draggy situation. I woke up dead, heard the birds, saw the sky, and ... best of all, as days melted into days, nobody remarked any difference.... I tell you, it's lovely to be dead. I mean, what is there to wrestle for, to dread, or to deny? And you may believe it, it's the first time I've been able to hear the silence in a stone. Each stone its own low tone.... Oddly enough, and even as I praise the gift of peace, there has been lurking in the less resolved reaches of the spirit, a creepy, half-hidden determination to make a few drawings—the sort of things that ghosts must feel when they make things jump on a table. Now why can't I leave well

enough alone? I've never been happier, never more aware of the gift of a new awareness; never so grateful for the gift of an enduring companionship. And the time for reading! But, oh no. This crazy urge to draw begins to haunt me. I never could draw a straight line, what am I supposed to do now?

1978, June 5—Robert to Joanne de Longchamps
I used to hear the Old Man drawing in the early air by his open window, then exhaling like a beached seal. And I'd wonder through my impossible hangovers, 'Why doesn't he just stay quietly in bed, for God's sake?' Now I know better. It was his way of saying hello to the event of day. He believed in life. So do I....

... I fully expect to take my own life rather than turn into a crooning vegetable; the thing is, will I know? This worries me, and I'm working on a self-coma test.

1978, June 14—John Caples diary
Robert phoned me at the office. In commemoration of Mother's birthday.

1978, June 23—Robert to Dick Walton
And this is what I wanted to talk about at the very beginning of this letter—the swift march of days, the sense of lengthening night. I want very much to have some idea of where we've all been before I go, to be able to call out to someone, "Did you hear..." No, I've not heard a substantially full answer; and time is running out. So, as I say, I read, and look, and wonder. And am always grateful. Truly, it's only in the past few years, like ten or so, that I've seen the light shine through the rock—not very clearly and not through all stones, but enough to spell out the essential transparency of matter. I am comforted but far from fully informed. One could use ten thousand years and still be doing Braille with God's handiwork. I can only know that we are written into the ground of Being—and always erased into slightly higher meanings.

... Your asking me [about Byron] reminds me ... of a time many years ago when, just because I happened to be thirty-five miles from the place, I impulsively grabbed a bus and proceeded with the setting sun into the town of Fostoria, Ohio. Both parents having been born there, I thought why not roam around and reacquaint myself with old, dimly remembered scenes. I'd

spent many childhood summers there. Grandmother [Brown, Dr. Robert Caples' remarried widow] was always dying and there were wide lawns and pretty flowers everywhere about.

Anyway, I left my small hand bag—I guess it was no more than a briefcase, at the ancient Hays House, and went touring around, finding my way to both grandmothers' houses.... I returned to the midtown section, found a sort of counter café and worked my way through a damp cheeseburger and a kind of rice custard. And this is the part I wanted to tell you about—my return to the hotel. An old dry balls was behind the desk, just standing there, waiting. I suspect nothing much ever happened. I don't think much of anything ever happened at the Hays House. I suggested it might be nice to have a room for the night. The old fellow swung the register my way. I signed in. "You've been here a long time?" I said. "I mean in Fostoria..." He looked up from my signature. "Fostoria?" he said. "Oh, a long time." "Do you remember Jessie Richards?" I went on, "she lived out on North Main..." He stared at me. "Jessie Richards!" he exclaimed. "Not Jessie Richards?" "She was my mother's mother. Her name was Edith." "Edith!" he whispered. "We used to stay here, my mother and I. Her name was Caples." I pointed to my signature in the big book. "She married Dr. Robert Caples' son, Byron H. Caples—they called him Bunny. Do you remember Bunny Caples?" "Do I remember Bunny Caples!" The silver-haired old fossil stared with disbelief at me. He closed his eyes and swayed. "Bunny Caples!" he sighed. "Well, he's my father," I continued. "He and Edith had two sons—one, the first son, is named John Richard, the other Robert—that's me." "You!" he said. "You're Robert Caples?" "Our uncle, of course, was William A. Richards. Do you remember Billy Richards?" The man's eyes rolled helplessly behind his bifocals. "Do I remember Billy Richards!" He leaned way forward now. It was difficult to tell whether he was chuckling to himself or crying softly. "Billy Richards," he whispered. "Oh, not Billy Richards..." I reached for my key on the big red tag. "That's my briefcase," I said, pointing below the mail rack. "Yours?" he said, "that's yours!" He picked it up and gave it to me. I showed him the worn RCC below the broken lock. "That's me," I said. "The middle C stands for Cole. My grandfather's name was Robert Cole Caples. The big red brick house with the white pillars—and the big pine tree! Remember?" The old man clutched at the counter edge and rocked back and forth. "Oh, that tree!" he breathed,

"that great big tree!" "Bunny used to climb that tree to get away from his older brother Ralph. Do you remember..." I took the briefcase from the countertop. "I'm going to bed now," I said quietly. I was done with questions. I'd guess the old fellow was closing in on ninety and weighed about a pound for each year. "It's time to sleep!" I said loudly. "Sleep..." His eyes looked like freshly opened Pismo clams, the tiny ones. He stared at me again. I felt myself fading into nothingness. He was alone again even as I stood there. I looked back from the top of the wide stairs. The old man hadn't moved. "Goodnight!" I called down, but he never heard me. I doubt if he'd heard the big wall clock for years—it was part of the silence.

And it's that way with me, I guess. The only clock I hear ticks for us all, and I'm glad that it does—no better time was ever told.

1978, November 25—John Caples Diary
Robert's eyes were bloodshot—otherwise he seemed okay. D [Dorothy, or Dotty, John's partner, later wife] thought [incorrectly] maybe it was drinking. Rosemary said he fell twice—down stone steps.

1979, March 5—Robert to Joanne de Longchamps
I suppose it's just possible that one of the penalties for being young is not being old? Now that stacks up to a curious sort of bind, doesn't it? I mean being young turns out to be a little like being a brand-new birdhouse on a stick. The music, if it comes, comes from afar—but who knows how to pray in April? Praise—yes. But prayer is a shy visitor. Prayer wears night feathers and lives in a dark tree, under the moon. The voice, however, is silver, and the path is up.

1979, March 28—Robert to Ken Robbins
I was [in Salt Lake City] once, years ago, and for much too short a time, it's the mountains I remember now. I truly thought of living there. Walter has me there at the conclusion of his City of Trembling Leaves. He took me to Wadsworth to meet the Salt Lake City bus. He knew I liked the place. He almost had me believing I'd really taken off in those early days. I was still in the Navy when I read the book and his amazing recall made it all seem very real to me.

1979, July 18—Robert to Tony Shafton

I started dying again in early May and that went on for weeks—finally the friction of deliberated breathing checked the downward slide and the balance swung to the daylit side. I'm glad, too. I really like it here. And I mean more than our parcel of green land, I mean the whole round planet—though it always seems to flatten wherever we go, with slightly tilted hills on the edges. The Orient is fish bellies and bare feet—how about you? The thing is, I can't hold the full rotundity steady in my mind. I know the Earth is round, heavens, I wrote a whole book about it—but it still wobbles out of control for me, with Chicago sliding out of sight, like a wet bathmat on the edge of a big tub.... I remain grateful, knowing that [the sun] will follow its westward path, setting like a great golden hen on the egg of Tomorrow, not for me but for all who must come to see. Can you imagine? All of those countless eyes as yet unformed, unopened to the miracle of light, the whole wide adventure as yet undreamed of. It may become a world that neither you nor I would choose to know, perhaps it is coming to be that even now? I find myself remembering spacious things that were with much more wonderment and affection. I loved the desert then. It is an absolute cathedral to me now—and may it be left so for millions yet to be....

May your ship move of itself over the wide water!

1979, July 19—Robert to Joanne de Longchamps

And thank you for letting me share the stone poem, I like it very much. And I know of knowplace where God could be more neatly found—except maybe in a little stone in the middle of the road in Nevada.

As for Rosemary and me, we are having a lovely sameness together, along with the daily time differences that make our getting together again such immediate events. Someone who had dropped in to say hello saw us grabbing gladly at each other—it was midafternoon and I had just come up to the upper garden, and our visitor looked at us in astonishment. "How long has it been since you two have seen each other?" she asked. "At lunch," I said, letting go. And it was so. And that's how it is with us here, we find time very elusive, a very tricky treasure. I have a somewhat driven feeling, trying to keep calendar clock and heart in any kind of unison. And then of course, there is that deeper pulsing in which we all share, the big Jehovah

clock with the profound weights and that sun and moon face. And that glittering pendulum! There are no springs in those gravity-driven works, only the soundless, all-pervading Law. Is it any wonder we're glad to see each other? ... For myself, I'm reading myself silly, trying to make friends with the bottom of the sky. Particle physics, for God's sake! I understand so little of what I read. But I keep trying. I want to have the most well-informed ashes in the New Milford Crematorium, you know, urn while you burn. I'm looking for definitions—they're not easy to come by. Know along with me that the Cosmos is alive with rotational spiralings, that Heaven is more subtle than a slender serpent in silver grass; nothing holds still for long.

Except just one thing—our favorite word, Love

Undated—Robert to ?

It's only recently that I've begun to feel the deeper impact of where I've been over the years. I remember, too many years now to count and number, when I slept on a flowering meadow, high above the sea; that was down below Big Sur somewhere. The meadow was undercut by the sea, wonderfully dug out, forty feet below....

Later, perhaps an hour or so later, I awakened, hearing the sea pounding and echoing beneath me, even though I was far back from the cliff's edge. And, pressing my ear even closer to the ground, I could spell out the shape and speed of the incoming tide. The sound was white sound, swift, now slow; massive and flat. I both felt and saw that the ground trembled a little. And I knew that the deep roots and slender stems of the flowers trembled too. Now this told me something of the impact of the sea. And now, and it is evening, I feel something of this happening in my life—I mean, inside, where the deeper tides are. It's late, I know, but it is not yet the end of the day. Not quite. Besides, there is something awakened in the bones and blood that was not there before. Perhaps I thought those flowers were frightened those many years ago?—perhaps. I know better now. If I were to paint again, it would be somewhere in this field of knowing. So, who knows? Perhaps there will be something in the long slanting light yet. It's my favorite time of day—and, sometimes, it looks wonderfully like morning! I know better, but it's a comforting sermon.

1979, July 27—Robert to Dick Walton

I was better than half-persuaded that my life hung in a delicate balance of spider webbing and crow's feathers, everything was very iffy. Things are not too substantially in order yet.... I'm not too excited at the prospect of Greece again—it seems to me we've been there more often than I ever got to Yerington, but it does mean a great deal to Rosemary, she has made the most lively friendships there, the women weep when they see her, weep when she leaves, and that's more than ever happened for me in Nevada.... I have the vacant eye of the man who hears the eternal surf on an unpeopled shore.

1979, August 3—Robert to Norinne Buck

I was enormously pleased that Pete Winnemucca would let me have the magnificent object for an entire week so that I might make some sketches of it. And, as you can well imagine, I would put [the war bonnet] on reverently now and again and go bouncing around in my Reno studio, just to make the feathers toss and fall—it was like having a great bird on one's head.

1979, August 26—John Caples diary

Yesterday Robert phoned. "I have found it is best not to plan anymore. I just go along with whatever the plan is. Rosemary is fed up with visitors, so we may go to Greece in Sept. I'm leery of it. I'd rather stay here. But I'll go along with the plan. Have not felt well...." Tough.... Whose fault? Father left for Reno in 1923 when Robert was 15 and failing in school. Nobody to discipline him.... He left for Reno where father spoiled him with money and no regular schooling. And gradually he came to depend on someone else to support him. And now he is completely subject to the whims of a rich woman.

1979, September 4—John Caples diary

Robert just phoned. They leave tomorrow JFK.... He still has traces of his throat ailment.

1979, October 26—John Caples diary

Robert [back from Greece] phoned 8:30. O.K. for his birthday lunch tomorrow at Capriccio—about 1 PM. He is taking anti-biotics for his throat. Feeling groggy from anti-biotic. Also headache and ear pain.

1979, October 27—John Caples diary

D said later: "Robert looks terrible." His face is blotchy, eyes bloodshot.

1979, November 8—John Caples diary

Robert phoned thanks for birthday lunch. He is on a second and slightly stronger series of anti-biotic pills, and feels groggy—stays close to bed.... Robert says I should see [while in London] the most wonderful drawing Leonardo da Vinci ever did—at the National Gallery, 2nd Fl. St Ann and the Virgin.

1979, Monday, November 19—John Caples diary

Robert died Sat Nov 17 while D & I were in London.

I Will Miss Him in This World

Saturday had been John and Dorothy's last full day in London. Sunday they flew to New York and went home to their separate apartments, still uninformed.

> Rosemary phoned D Sun p.m. D phoned me 10 p.m. Said: "Rosemary is going to phone you." She did. Rosemary said, "He died at home. He died well. In my arms. Lung failure. He was losing weight. Heart problem. He went to sleep last night—8:30. No funeral" (these are the notes I wrote while Rosemary was talking). "He will be cremated in Bridgeport. Remains to Litchfield. I will take him to Nevada. I'm going in morning to sign papers and take care of things. He had a beautiful doctor. Consulted with him last week. Said not to take Robert to hospital. Said Robert could not take hospital. Doctor came by last night. Robert had pain for 2 days. He was comfortable during the last 10 days. Bed a lot. So tired. He enjoyed book you sent—history of Caples family. And your picture." (That was on newsletter "BBDO People" I enclosed with book) "Robert enjoyed it when I read aloud selections from the Caples book."

With four dots John closed the subject of his brother's death. Then, up at 4:00. Unpacked. Organized London souvenirs. Pondered photo captions for a publication. To the office. A week's mail. Bank. Told secretary Marie Lauria about London. Lunch with friend. "Had fun talking as usual." Then, closing Monday's entry, "Rosemary phoned again this p.m. This time emotional." And John's emotions? *John, I want to say, hush. Your brother.*

Not for another eight days, not even on November 26, Robert's birthday, does John return to Robert, not until Rosemary called again:

> "Rosemary [Jr] left yesterday. I want to go to Reno and see Mary [Miriam] Chism and her husband John. They were great friends of Robert. I want to get a room at the Univ. of Nevada and have a small reception to meet Robert's friends. No organ music. Robert and I believed in God but we did not go to church. I'd like to get Mrs. Graham [Dawn] Erskine. She is a concert pianist and has a beautiful voice. Perhaps someone could read excerpts from Robert's

book. Or a poem by Walt Whitman. Or the 23rd Psalm. Robert left a list of Nevada phone numbers, so it would be easy to phone his friends. I'd be glad if you have any ideas for the reception. I want to show you some beautiful letters about Robert that I received. I'm doing everything slowly." ... I phoned D and told her Rosemary's remarks. D said: "She wants to put on a show like she did at Poo's wedding at the Stanhope Hotel." Previously D had said: "I said to Rosemary—'You may be getting married again.' Rosemary replied: 'Keep your fingers crossed.'"

At lunch on the 29th, "Rosemary talked a great deal, fast & tense," repeating her plans. She left John a folder of condolence letters to photocopy for himself. He thought them "nice. Some are beautiful. I have found average people, who make no pretense of being good writers, can if they feel strong emotion, write as well as professional writers." Next day he returned the folder with a cover letter which he copied into his diary, thinking its commonplaces worth preserving. The following day he composed and copied his own condolence letter, "written in a way that she could read it at the reception for Robert's friends if she wanted to." I won't quote John's wooden condolence/eulogy, written by a professional who does not, like "average people," require "strong emotion" to write well. I know I'm being hard on John. Robert would have smiled at his brother's constitutional detachment.

Cricket doesn't come up in John's diary or anywhere else in connection with Robert's death, except in Robert's recently executed will: only if Rosemary predeceased him was anything to go to Cricket, ten thousand dollars, with everything else going to the beneficiaries of Rosemary's trust, presumably Rosemary Junior and Denny. There's nothing about paintings or keepsakes to go to anyone.

Dick Walton up in Virginia City didn't learn of Robert's death until midweek. "My loss is so heavy," mourned Walton, "that I feel simply heavy. The rains will come later." The Reno friends who called to let him know promised to save him the Reno obits. "Nevada Artist Caples Dies" said the headline in the *Gazette*, "Legendary Nevada artist dies" said the *Journal*.

Rosemary scheduled the memorial for December 16, a Sunday, at 2 p.m. in the Pine Auditorium of the Jot Travis Student Union. Walton

remembered it as "a small gathering of people, and of every generation." Phyllis Walsh was there, who saw to it that Avery Winnemucca and other Pyramid Lake Paiutes got seated in the first row. Walton "had a poignant few moments with Bettina." The Clark family was represented by Babs and Ross Salmon. I don't know about the Chisms. Unaccountably not attending was Rosemary Junior, though living so near and so devoted to Robert. Nor did John attend. Nor Cricket.

Dawn Erskine must not have been available, for music was provided by cellist Peter Lenz, one of Reno's musical Lenz siblings. Rosemary briefed Robert Gorrell, more Walter's friend than Robert's, who recited favorite poems Robert had made notes on, Frost, Shakespeare, Donne and Blake—"visionary" poems, according to art critic Jeff Kelley's *Journal* coverage, all on the theme of aging and death. Kelley, who never met Robert, had a penetrating grasp of the person. As much as Kelley admired the art, Caples' "vision of life," Kelley wrote, "the continuity with which he seemed to have looked at things, was better than his art." I would not dare, nor care, to go that far; but Robert himself, ever self-critical as a builder of paintings, would have put his art and his life in the balance and would, I'm sure, have agreed with Kelley, all the while "wary of any great display of fulfillment," to quote that explanation to Peter Stremmel which comes as close as anything he put in writing to a final renunciation of painting. I would say that when Robert stopped painting, his life became his art; possibly say even that Robert consciously stopped painting in order to make his life his full-time art, though I'm only half-sure of that—as Robert may never have become fully sure of it. "It most certainly is not that I do not wish to paint," he confided to Ken Robbins. "More accurately, it's that the Lord has been using me as a somewhat inferior brush in knocking out His own Landscape." Kelley's article, like the memorial, ended with a quote from *Potter*. "And toward the final pages," concluded Kelley, "are spoken the words 'Behold the world.' I believe he did."

I had sent a Christmas greeting which wasn't reciprocated, and no carrot cake arrived. I guessed the truth, but didn't know with certainty until mid-February, when Rosemary informed me with an apology that she'd discovered my envelope among unsorted mail. "Robert died at home

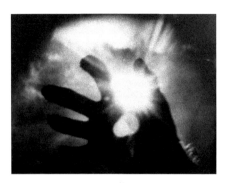

Hand of Robert Caples and the sun

and as he did live, so did he die. With dignity, serenity and a kind of majesty." She told me she'd taken his ashes to Pyramid Lake, "his true place of identity." And "Robert enjoyed hearing from you and never forgot your visit here…what a chess game!" And she enclosed a small black-and-white photo inscribed on the back: "This picture is one of Robert's hand taken with a child's toy camera. I think it is the essence of Robert. An extraordinary human being." I understood this as Rosemary's recognition of a unique bond between Robert and myself. When, in 2011, I visited the Caples archive, I discovered with a twinge of humility that mine was just one of many prints from a set of photos Robert had taken of his own hand held up before the sun—his final heliographs, so to say. Also in the archive is a note signed by Rosemary that looks to be an early draft: "a child's .98 camera—just a viewer—no settings etc. Terrific." Many prints presumably had gone out from Turtle Hill as precious mementos to first and second tier mourners.

I also found my reply to Rosemary in the archive:

When Christmas passed, I knew. Robert let me understand some years ago that he was seriously ill, but always avoided or humorously deflected questions about the mere diagnostics. He did, though, say quite a lot about the sensory and spiritual experience of dying. It was characteristic of his correspondence over the years, always to be intimate, but rarely personal. Robert was beautiful. Even his lows were full, and his letters were always hopeful, and more: hope-giving. Tenuous as our connection was over these decades, it was one of respect and love. I will miss him in this world, and I express my deepest sympathy to you with at least some real appreciation of your loss.

Robert's being is still present to me in *Dark Range*, the wonderful present he gave me as a wedding present (he professed dissatisfaction with it). In my mind's eye, it has always been the ridge above the east shore of Pyramid [the Lake Range]. I'm glad to know he's there.

I Will Miss Him in This World

Rosemary's reply was still among my own papers:

> Your letter to me was so beautiful that I feel [the need] to respond at once to say thank you. You knew Robert so well and as you said…you met but the one time. That was his gift…the gift he so wanted to share but was not certain he would ever leave, the gift of love. He did. Robert loved LIFE and he reached out to share with others. You were one of his chosen.

.

When they talked on the phone, Walton asked Rosemary for a copy of the Arno caricature of Robert as a memento of when their studios were across the hall in the Clay Peters Building. She promised to send him the original, but never did.

Near the first anniversary of Robert's death, Rosemary wrote a very warm letter to Edda Houghton. They had both lost husbands and understood one another. Edda had been most helpful arranging bequests to the museum. Rosemary would also loan artworks to the 1981–82 retrospective, and attend. She planned to contact the university library about donating Robert's notes and drawings for *Potter* there. Somehow that didn't happen. Life goes on. Rosemary had a new hunter and show horse, Bacchus. She went dog sledding in Greenland. But she never remarried.

.

John had never seen the 1964 retrospective catalog until Rosemary gave him a copy several months after Robert's death.

> Reading Clark's account of Robert's life gave me the impression, as a practical man, that they were both crazy—Robert's misspent life and Clark's weird style of writing. But when I came to Robert's drawings [and paintings] I was entranced by their beauty…. Then here were extenuating circumstances in Robert's erratic life…. [A]ll of Robert's failings were outweighed by the originality and beauty of his work.

Sevenmile Canyon

In 2011, my son Matt, who at thirty-eight had never been to Nevada, flew in from New York to join me after I'd finished at the Caples archive, Special Collections and the rest. What I most looked forward to with Matt was Sevenmile Canyon on the back side of the Lake Range, where a view of Pyramid Lake rewards the hike and climb of several hours to a saddle of the ridge. That's what I wanted to share with Matt, the heady expansion of space as you top the rim to the revelation of the lake below in the cupped hands of the mountains.

The November day was still wet and cold when we slowed through Nixon the little reservation town, then rounded Marble Bluff. In a few more minutes the lake disappeared at a distance behind the south tip of the Lake Range, which separates Pyramid from the playa of Winnemucca Lake, parallel and on our right, its tufa castles with their petroglyphs high and dry above the south end of what was once an ephemeral body of water fed by the overflow from Pyramid, and before that, when the castles formed, was a long finger of ancient Lake Lahontan, where Paiutes or their predecessors left fishing points of stone and bone near what today are well-defined dry beaches, or benches. Deeply incised near the north end of the playa were found the oldest known petroglyphs in North America, fourteen thousand years or more – ancient, but recent, barely yesterday compared to the mountains, whose alluvium thousands of feet deep is the stuff of the playa. I didn't know all that about the prehistory and geology when, after so many years' absence, I missed the turn-in for Sevenmile Canyon and drove past. I knew we'd gone too far when I recognized a grove of spring-fed cottonwoods surrounding a ranch house at the base of the range. We got out with my U.S. Geological Survey map to reassess.

"Look!" Matt said softly. "What are those?"

It took me a moment to pick up the racing herd of antelope, too far away to make out the black pronghorns of the males. "I've never seen any here before!" I whispered as we watched the silent tawny forms glide on invisible legs until their white rumps vanished over a slope. Then we turned back south while Matt armed the GPS that came with the rented SUV.

The post I'd missed was much taller than I remembered. "That's it!" INDIAN LANDS and ALL LAWS ENFORCED could still be made out in two columns painted on the face of this old friend, a rusted T-iron, signage of an earlier epoch. With PLPT across the top—Pyramid Lake Paiute Tribe.

About a mile in, past the spring-fed cattle trough and around a low hill, the unimproved track abruptly ended on a flat before a bouldery narrows. "This is it," I smiled. "Right there is where Bob Hanneman found the arrowhead." I had earlier told Matt the story, how years ago, before vehicles beeped if you left your lights on, I'd returned from the mountain to find my Isuzu Trooper's battery dead. I hiked and hitched into Fernley. The office walls of Hanneman Garage were covered with an astonishing display of obsidian points. On the drive Bob Hanneman and I talked about the family's collection. At my car he got out, said "This would be a good place to look," and within seconds bent down and came up showing me a perfect tiny point on his palm. I no longer remembered, I'd told Matt, how many years it took for it to dawn on me that Hanneman had jerked my greenhorn chain. But before coming out this time I wrote a letter to the garage, reminding Bob and asking him in the spirit of the joke if he hadn't had the point in his pocket all along. I got back a simple and sincere reply: he remembered the day, and he really did find the point.

We hefted our backpacks. The mouth of the canyon was just as I remembered it, bounded on one side by a low sheer rock face where lizards take the shade in summer. A mostly underground spring supported a dense stretch of willows that had to be circumvented, a long thicket culminating at a dry waterfall of solid rock as carved as any river rapids, evidence of the power of water over millennia in this dry land. Within the last three years as I write, the canyon has been scoured by a cloudburst that carried away every single willow and all the big sage opposite the rock face, leaving nothing but torn roots dangling from newly dug walls of sand like electric wiring at a demolition site.

"Look!" said Matt again after we'd been following the canyon for a while. Above us on the ridge to our south a solitary stallion stood observing us. So Matt had spotted the antelope, and now the mustang,

who was a scrubby, big-headed fellow. We started slowly ascending again, both we and he, keeping an eye on each other, until finally he came to the end of the ridge where he veered off and disappeared.

We began to notice our boots growing second soles and heavy fenders of mud. I'd never been there in late fall or winter, and tried to convey to Matt how different it was in the heat, in the dryness, and under a blue sky. We were stopping now to shake our feet and scrape one boot with the other. It wasn't a huge deal, but it made the climb harder, especially for me, then a couple weeks shy of seventy-four. I was already beginning to stop periodically to catch my breath.

We had been climbing over an hour when Matt bent down and came up with an arrowhead—just like Bob Hanneman! He asked if I was sure, for it wasn't an intact point. But there was no mistaking the obsidian and the knapped edges. The antelope, the mustang, now the arrowhead: this son of mine has eyes. He must have been as deeply satisfied as I, but it wouldn't be his way to say so. Matt would make a good Westerner. "Maybe Hanneman wasn't jerking my chain after all," I grinned.

Once high enough for snow cover the walking got easier, until the final long climb up a steep amphitheater of scree and irregular rock and staggered hedges of sage and other stiff shrubs. Finally we crested the ridge at the bare saddle, a windswept mustang crossing mounded by weather-flattened cairns of old dung, where we achieved the sudden outlook over Pyramid, Matt's first from this elevation, the lake muted under gray November clouds, not summer sapphire or blue topaz or teal but still much the brightest region.

Soon Matt wanted to climb higher in the direction of the nearby unnamed peak. I told him to go ahead, my legs were tired, I'd catch up. A few yards away the ground drops off nearly straight down the forehead of the uplifted block which forms the range, with the lake three miles distant and thousands of feet below. I'd once seen a magnificent white mustang making long defiant switchbacks down the precipice at speed. Walter had once seen a stallion on this range, too; it became the stallion young Tim Hazard ran with in his mind when he ran free on the hills north of Reno, the totem of Walter's youth, his years of praise. Down at the distant bottom was the rough

shoreline of Artillery Bay. From across the top of the lake, a young Jigger Bob may have seen Frémont's company just there, struggling past the caves of a few so-called "Diggers" of a different ethnicity in January weather to advance the cannon they would soon have to ditch in the Sierras. And along that same shore passed Bar, Walter's aged, imaginary stallion, in decline.

"There is no redemption at first sight," wrote Nevada poet Shaun Griffin, in a prose piece about the Great Basin and its deserts. "All this emptiness is, and only after years, its own redemption."

From where I stood I could just see the Pyramid to the south far below, tiny beyond a nearby diagonal slope, and to the north the Needles, like a distant precinct of Cambodian temples at the end of the lake, closed now to the public, as is the Pyramid. I had written to the Tribal Council asking permission to take my son to the Needles on the strength of my half-century history at the lake, but had been denied. Robert, or else Rosemary, had sought and been granted permission by the tribe for Robert's ashes to be scattered in the lake. Harry Drackert, by then long gone from the Pyramid Lake Guest Ranch, drove Rosemary to the lake from Reno on "a cold and beautiful day" before or after the memorial service in 1979, to leave Robert's ashes. There they were down there, Robert's ashes, a gray suspension in gray water. I have my own plans. I want my ashes spilled just below where I then stood, where the Sevenmile Canyon saddle drops off, so that some of me will wash in a dozen or ten thousand years as far as the lake, if there is still a lake. Many people desire to make Pyramid their final resting place. A tribal policeman once came after me on the flat south of the lake where I was hiking, to be sure I wasn't one of those half dozen or so outsiders, he told me with chauvinistic satisfaction, who commit suicide on the reservation every year. He was a Mohawk from Upstate New York who had married a Paiute.

I walked the way Matt had gone, and saw my son's silhouette stock-still against the gray clouds, contemplating the place that is the center of my world. Shaun Griffin, who is as sociable as it's possible to imagine a nature poet to be, wrote in a different mood: "We have no real presence here without each other. This land will not save us."

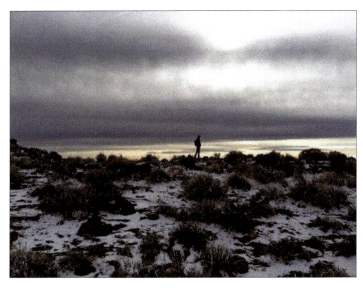
Matt against the clouds gazing down at Pyramid Lake from the Lake Range

When it was time to start down, Matt paused, and I beside him. He said he couldn't remember the last time he'd been someplace where there was absolutely no sound of man. None, I thought, except each other. Yes, this was the place of silence, of light, of radiant stone, and of the wind that blows between the stars. And of the slight tinnitus I became conscious of as I listened, which just as quickly faded.

And the place of love. We were turning to go when Matt said, "I'm glad we made this trip." I halted. We traded a look, then I stepped over and hugged my tall son.

"So am I."

As he went ahead I stopped for one last view of the lake, from there just a small triangle of lucent surface vanishing in the notch of two crossing slopes. How perfect! Was this final tear-blurred glimpse the very last time I would ever see Pyramid from the Lake Range? I had lived and now was old. I held the moment, then faced away and continued after Matt down the mountain.

It wasn't to be the last time. But now the last time has probably come and gone.

Sources and Credits

As the reader already knows, I have relied greatly on the resources of several institutions for the research that went into this book, chief among them Special Collections of the University of Nevada, Reno Library; the Robert Cole Caples Archive at the Nevada Museum of Art; the Nevada Historical Society; and the Archives Center of the National Museum of American History. In addition, I have made use of the resources of many other libraries, museums, government offices and so on. Hundreds of newspaper articles and scores of books and other print sources have also been consulted.

Further, I owe a large debt to the several dozen people who consented to be interviewed, among whom must be singled out Clark's children, Robert Clark and Barbara Salmon, and Caples' stepchildren, Rosemary Brittain, Denny Lake, Mallory Pred and Linda Schubart.

I had gone back and forth about how it would best serve the character of this book to present the sourcing and additional comments in notes, before arriving at this answer: no notes at all between the covers; instead, all notes to be available elsewhere. This solution satisfies my scholarly conscience, while honoring the intention that guided me for five years and more: to write a memoir, tell a story.

Accordingly, anyone wishing to identify sources or to peruse further information which, for reasons of style or space, was not incorporated in the text, is directed to Special Collections, University of Nevada, Reno Library, where will be found the endnotes, bibliography and index for this book.

Many persons in Nevada and around the country either generously allowed me to photograph or else sent me images of their private holdings of Caples artworks, some of which are reproduced in this book. For reasons of privacy these individuals will not be credited here, although several of them are mentioned in the text or are among the following to whom I am grateful for permission to reproduce photographs and cards created by or connected with Robert Caples.

David Chism: Photograph taken by himself of Robert and Rosemary Caples with the Chism sage, 1975.

Robert Morse Clark: Card painted by Caples, *Let Heaven and Nature Sing*, not dated; and photograph, 1942, of Caples' painting *Dharmakaya, the Golden Path*, 1941 (the original artwork is in the Collection of the Nevada Museum Art, mixed media, 13½ × 17¾", Gift of Dr. and Mrs. William C. Miller).

Peter Kraemer: Photograph of Bettina, Robert & Godfrey Caples, with Peter and his father Eric, ca. 1948.

Barbara Clark Salmon: Card painted by Caples for Clark, "Hang in there, Walter," postmarked March 15, 1971.

Linda Kay Schubart: Photographs of Barbara Caples, ca. 1944; Caples, ca. 1944; and Caples in uniform, 1945.

Holly Hellmann Shonnard: Photograph of Robert and Rosemary Caples on Ray Hellmann's boat on Lake Tahoe, 1975.

I am grateful to the following organizations and institutions for permission to reproduce artworks, photographs or other graphics.

A. Carlisle & Company of Nevada: Ad for Caples' A. Carlisle & Co. map of Reno, Nevada State Journal, June 11, 1932.

Anthropology Research Museum, University of Nevada, Reno: Paiute sage bark cap, author's photograph.

Archives Center, National Museum of American History, Smithsonian Institution, John Caples Papers (NMAH AC 393): Jousting knights, Robert Caples' earliest extant artwork, not dated, pencil drawing; Byron H. Caples, ca. 1930, printed copy of Robert Caples drawing; and five photographs: Edith Caples, before 1930; Robert Caples as a boy in Manhattan, ca. 1915; Jessie Richards (?) with John and Robert Caples, ca. 1910; Robert Caples napping, probably at 1045 Bell Street, Reno, ca. 1932–38; 1045 Bell Street, Reno, titled "THIS LITTLE HOUSE" in the hand of Robert Caples, ca. 1932–38.

Cuchine Collection, Ely, Nevada: Caples, *Tonopah Houses*, painting, 1960, author's photograph; Caples' note to Bettina Swanson, 1971, note on the back of *Tonopah Houses*, author's photograph.

SOURCES AND CREDITS

First National Bank of Ely: Caples, untitled mural, painted on soundproofing tiles, 1956, author's panoramic photograph.

National Nuclear Security Administration Nevada Field Office: Indian Springs pond, photograph from *NTS* [Nevada Test Site] *News*, August 5, 1966.

Nevada Fine Arts LLC: Caples, *Jigger Bob*, charcoal drawing, 1933.

Nevada Historical Society: Caples holding his son Cricket, 1939, photograph (C-621); Shirley Caples at the potter's wheel, 1940–42, photograph (C-622).

Nevada Magazine: Caples in 1938, "a curious Buddah," drawing by Richard Guy Walton, article August–September, 1948.

Collection of Nevada Museum of Art, Gift of Houghton family in memory of Samuel G. Houghton: Robert Cole Caples, *Coyote Summons the Animals*, 1955, Watercolor and tempera on paper, 17¾ × 23¾".

Collection of Nevada Museum of Art, Bequest of Rosemary Riley Caples, Original artworks by Robert Cole Caples: *Dr. Mouse*, Not dated, Ink on paper, 4¾ × 3"; *Talking Stone*, 1962, Oil on canvas, 17⅞ × 13¼; Untitled (Pyramid Lake), Not dated, Pastel on paper, 16¾ × 13⅞"; Untitled (Mountains), Not dated, Oil on paper, 18 × 24"; *Ambient Planet*, 1949, Oil on board, 15 × 17⅞".

Collection of Nevada Museum of Art, Center for Art + Environment, Bequest of Rosemary Riley Caples, Robert Cole Caples Archive, Artworks in reproduction and original artworks by Robert Cole Caples: *Washoe Indian Legend of Creation*, 1935 or after, Detail of postcard, Postcard size 3¼ × 5½"; *The Riding Lesson*, 1932–1936, Postcard, 4 × 6⅞"; *Map from Manta the Earthmaker*, 1934, Photocopy of original map, 11 × 8½"; Untitled (Old Man), Not dated, Color photograph of original artwork, 9⅝ × 7⅝"; *Hands at the Bar*, Early 1930s, Color photograph of original drawing, 14 × 11"; Untitled (Burden Carrier), ca. 1933–35, Color photograph of original drawing, 13⅞ × 10⅞"; *Map from Manta the Earthmaker*, 1934, Detail of photocopy of original map, 11 × 8½"; *Washoe Indian Legend of Creation*, 1935 or after, Detail of postcard, Postcard size 3¼ × 5½"; *a book of thirty four turtles*, ca. 1940–c. 1942, Detail of color illustration from the cover of "a book of thirty four turtles," manuscript size 11 × 8½"; Untitled (turtle number 31), 1940–1942,

Ink illustration from "a book of thirty four turtles," Original manuscript size 11 × 8½"; *Untitled*, ca. 1941, Heliograph, 10 × 8"; *Untitled*, 1941, Kirlian photograph, 9¼ × 7⅝"; *Untitled (Fascist Nativity)*, ca. 1941–42, Color photograph of original artwork, 9¾ × 7¾"; *The Potter and the World*, 1945, Color pencil illustration from "The Potter and the Lizard," Original manuscript size 11 × 8½"; *Feuding Siblings*, 1945, Color pencil illustration from "The Potter and the Lizard," Original manuscript size 11 × 8½"; *This State*, 1946, Color photograph of original artwork, 3⅞ × 6"; *Birthday Card with Union Brewery Matchbook*, Card not dated, Matchbook 1953, Detail of printed card with matchbook taped inside, Original card size unfolded 12¼ × 9¼"; Untitled (like *Silent Mountain*), 1953 or earlier, Detail of altered Black & White photograph of original artwork, original photograph 4 × 5⅛"; *Untitled (Scalloped Mountains)*, Not dated, Detail of color photograph of original artwork, original photograph 4⅛ × 5¼"; *Mountains and Clouds*, 1953 or earlier, Detail of color photograph of original artwork, original photograph 8 × 10"; *Luminous Mountains*, Not dated, Altered color photograph of original artwork, original photograph 3½ × 5"; *Death Valley Moonrise*, 1950s, Detail of color photograph of original artwork, original photograph 8 × 10"; *Sketch of Mountains with Process Notes*, Not dated, Charcoal and rubbed chalk on paper, 10¾ × 23¾"; *Sketch of Mountains with Process Notes*, Not dated, Mixed media on paper, 8½ × 11"; *Untitled (Cosmic)*, Not dated, Detail of color photograph of original artwork, original photograph 3½ × 3½"; *Secret of the Grass*, 1962, Detail of Black & White photograph of original artwork, original photograph 8 × 10"; *Star Passage*, 1970, Mixed media on black paper, 11 × 8½"; *The Potter Globe Prototype*, ca. 1971–73, Color photograph of original artwork, 3½ × 3".

Collection of Nevada Museum of Art, Center for Art + Environment, Bequest of Rosemary Riley Caples, Robert Cole Caples Archive, Miscellaneous items: Robert Cole Caples, Untitled, Not dated, Note, ¾" × 3"; Robert Cole Caples, Untitled, Not dated, Note, 1 × 4"; Photographer unknown, *Caples, 1970* (the young man to his right may be his son Cricket), September, 1970, Color photograph, 3½ × 5"; Peter Arno, *Caricature of Robert Cole Caples*, Detail of color photograph of original artwork, 7⅞ × 5⅛"; Photographer unknown, *The Lizard, Caples'*

Studio at Indian Springs, Color photograph, 5¾ × 8¼"; Photographer unknown, *Caples at the Potter's Wheel, Indian Springs*, 1940–1942, Detail of Black & White photograph, 7⅞ × 5¾".

Nevada State Museum, Carson City, Nevada Department of Tourism and Cultural Affairs: Caples, *Triadic Fish*, 1950, painting; Caples, *Washoe Legend of Creation*, 1941, painting, sketch for *The Gifts of Hy-Nan-Nu*.

Pyramid Lake Paiute Tribal Council, Composite photograph, *Paiute men in war bonnets above Pyramid Lake*.

Re-Wa-Ne (Reno High School yearbook, photographs by 1926 *Re-Wa-Ne* annual staff): Marian Lowes Cheney, LD-7501-R-46-R43-1926 p20; Ruth Thatcher and Clark as tennis players, LD-7501-R-46-R43-1926 p106; Ruth Thatcher, LD-7501-R-46-R43-1926 p49.

Special Collections, University Libraries, University of Nevada, Reno, Caples artworks reproduced in *Robert Cole Caples: a retrospective exhibition, 1927–1963, Church Fine Arts Building, University of Nevada, September 15–October 15, 1964*: *Geronomo Mirabel*, 1927; *Death Valley Dust Storm*, 1937; *Passage*, 1946; *Remembered Country*, 1959; *Iron Hills (East Jackson Range)*, 1960; *Workshop Study*, 1961; *Invention* (middle right), *Invention 7* (middle left), *Inscribed in Black* (top), *Notation on Wood* (bottom), all 1962; *Dragon Nebula*, 1960.

Special Collections, University Libraries, University of Nevada, Reno, Caples artworks in the Art Collection: *Margaret Bartlett*, ca. 1930; *Harry Drackert*, 1930s; *Reno Dick*, early 1930s; *Water Carrier*, ca. 1933–35; *Hunting Lesson* (original), ca. 1933–35; *Hunting Lesson*, ca. 1933–35; *Arrow Maker*, ca. 1933–35; *Story Teller*, ca. 1933–35; *Cradleboard Weaver*, ca. 1933–35; *Fire Maker*, ca. 1933–35; *Rock Painter*, ca. 1933–35; *Cooking Woman*, ca. 1933–35; *Indian Images*, 1950s; *Portrait of a Poet, 1975*, 1975.

Special Collections, University Libraries, University of Nevada, Reno, Photograph Collections: **George A. Bartlett Photo Collection, P-1990-02**: *Dorothy Bartlett*, 1928, photograph of Caples drawing, -237; *Georjean Bartlett*, ca. 1930, photograph of Caples drawing, -250; Untitled (business or professional man), 1930s, photograph of Caples drawing, -887; **Gus Bundy Photo Collection, P1985-08**: Caples behind bar far

left, Lucius Beebe far right, Roger Butterfield between them at A. J. Liebling's wedding, 1949, -10590; Clark at 60, ca. 1969, -22504; **Lorenzo D. Creek Photo Collection, P2710**: Jigger Bob, Tribal Policeman (detail), not dated, -5112; **James R. Herz Collection, P1992-011**: The Town House exterior, -7206a; "Portrait of a Paiute Family," ca. late 1890s, photographer James Heany, -2452; **Walter Van Tilburg Clark Photo Collection, P-2269**: *Walter Van Tilburg Clark*, 1928, photograph of Caples drawing, -P; **John Albert Marshall, Pyramid Lake Dude Ranch Collection, P2006-04**: Outing at the Pinnacles, Pyramid Lake, 1932, -103.

Special Collections, University Libraries, University of Nevada, Reno, photographs and drawings in publications: *Artemisia* (University of Nevada, Reno yearbook): Bessie Davie, Mackay Day queen, Artemisiayearbo01928 univ_0253; Evelyn Turner, Mackay Day artemisiayearbo01928 univ_0251 queen; *Nevada Desert Wolf* (University of Nevada, Reno humor magazine), AC 0272:—*AND HAVE ONE YOURSELF*, woodcut by Caples, Dec 1928 p17 top left;—*AND NO ICE*", woodcut by Caples, Dec 1928 p17 bottom right; Untitled (courtship), woodcut by Caples, Dec 1928 p16 bottom left; Untitled (marriage), woodcut by Caples, Dec 1928 p16 bottom right; *Bessie Davie*, drawing by Caples, Oct 1928 p8; *Evelyn Turner*, drawing by Caples, Dec 1928 p8.

Special Collections, University Libraries, University of Nevada, Reno, miscellaneous papers and collections: **Walter Van Tilburg Clark Papers, NC527**: Workshop study (mountains and moon), 1956, Caples drawing; Clark, letter to Caples, May 13, 1971 (detail); **Robert Cole Caples Correspondence with Anthony Shafton, 2011–17**: Caples, letter to Shafton, July 18, 1979 (detail); Caples, letter to Anthony Shafton, October 11, 1977 (detail); **Joanne de Longchamps Papers, 84-09**: Robert Caples on Samos, 1972, photograph; Turtle Hill interior, photograph enclosed with letter from Caples to de Longchamps, January 8, 1973; **Carl Heintze, Interviews of Walter Van Tilburg Clark's Associates, 83-15**: Clark, map of Taos, New Mexico, letter to Helen, February, February 28, 1946 (detail); **Houghton Family Collection on Robert Caples, 2006-04**: Caples, Push-Me-Pull-You Cow, drawing

on inside of Christmas card to Samuel G. and Edda Houghton, 1948 (detail); **Margaret Bartlett Thornton Papers**: Dorothy Bartlett (left), Caples, Helen Marye Thomas, 1950s, photograph; Caples' fifth wife Rosemarydancing, not dated, photograph (detail); Caples' studio at Turtle Hill, not dated, photograph.

Stremmel Gallery, Reno, Nevada: Caples with fourth wife Bettina, 1947, photograph.

University Libraries, University of South Dakota: Avery Winnemucca, in *Coyote* (University of South Dakota yearbook), 1923.